D1294345

W STORIES

EDITED BY STEFANO TONCHI
WITH ARMAND LIMNANDER AND KARIN NELSON
DESIGNED BY JOHAN SVENSSON

ABRAMS, NEW YORK

CONTENTS

FILMS

By purchasing this book, you have exclusive access to the feature
films above. Go to www.abramsbooks.com/wstories and enter the access code.
The access code is: wstories5films

FOREWORD

BY MIUCCIA PRADA

Of all the creative disciplines, is fashion still considered the most superficial? For many people, the answer is yes. Even if art, cinema, and music have their celebrity excesses, they are always valued for telling truths about the world we live in. I believe that fashion can do the same. Just look at history: The evidence is clear. Fashion not only mirrors our time—it is also a language that society speaks, full of accents, dialects, and hidden meanings. Fashion might seem fleeting and perpetually on the brink of extinction, but its temporary nature is precisely what makes it last forever. Today's fashion is archeological material for future historians.

An often overlooked level of cultivation and intelligence goes into this language of fashion, whose tools may be deemed "light" or "superficial." But there is always a depth of knowledge necessary to support the edifice of fashion. I bring it to my own work—frequently referencing visual arts, politics, and cultural history—and I detect it in the work of others. Designers, art directors, and photographers channel these influences as well and translate them into the kind of imagery contained in this book.

As you scan this selection from *W*'s archives, you will come across themes of aging, gender, power, and impotence. The photographs don't just please the eye—sometimes they also disturb the mind. This is what I enjoy the most, because it reinforces my belief that fashion doesn't appropriate issues in a vampiric way. Fashion can deepen our imagination just like great cinema and literature can, because images are stories, and stories create images. The history of any society at any time would not be fully told without describing how it dressed itself.

INTRODUCTION

BY STEFANO TONCHI

Since its inception, fashion photography has mixed art with commerce and used visual storytelling to accomplish the dual goal of elevating fashion and selling it. Creating glamour and generating desire season after season is no small feat, which is why *W* has always allowed photographers to work in a way that makes it possible for them not just to show clothes but also to translate their most personal dreams and obsessions into narrative portfolios.

Yet today, in a world where lightning-fast Instagram posts compete for attention with snappy Twitter messages, long-form photography has become a rare and precious outlet for creative expression. This disappearing art is a form of storytelling in which repetition and hyperbole are seen as a necessity rather than excess. Sequences of carefully considered images are strung together over several pages, imitating the language of cinema; indeed, these stories are often like stills of never-released, imaginary movies. On occasion, they are even shot with movie cameras that can deliver, frame by frame, the same quality as the most sophisticated photographic equipment. The resulting work has a life beyond the pages of our magazine—and in this book, we have included scannable codes you can use to access several of these short films online.

At *W,* fashion photographers often work like film directors, with access to all of the resources—and, sometimes, the budgets—of an independent Hollywood production, without worrying about box office returns. For every project, our lensmen create storyboards (scripts) and assemble a crew of stylists (costume designers), hair and makeup artists (production assistants), prop stylists (set designers), and lighting technicians. They scour the globe for locations and go through lengthy casting sessions to find the perfect characters.

In fact, most of the images seen here feature models who are celebrities in their own right, like Kate Moss and Amber Valletta; or actresses who have such an iconic look that they can easily play a model, like Tilda Swinton. Some of the photographers, such as Tim Walker and Paolo Roversi, are dreamers for whom shoots are inspired by memories and fairy tales; others, like Steven Meisel and Craig McDean, make a point of defying social stereotypes; and others, like Steven Klein and Mert Alas and Marcus Piggott, explore controversial topics like aging or the dichotomy between good and evil.

What these visual powerhouses share is a uniquely imaginative mind and a commanding knowledge of historical references. As you will discover in this book, they all use a combination of film stills, old photographs, personal recollections, drawings, and artworks to develop original narratives and strikingly new photography. The pages that follow offer some of the best fashion photography of the past two decades, and give us a peek into the personal processes that make it all possible.

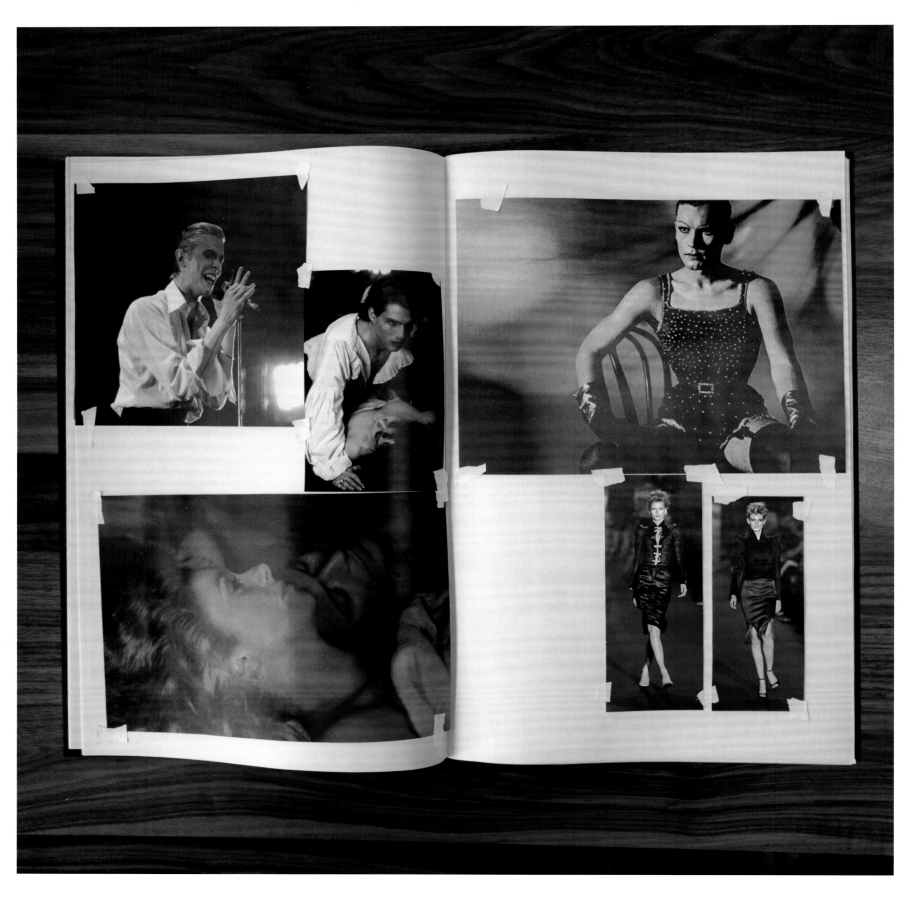

Clockwise, from top left: David
Bowie at Wembley Stadium in
London, during his Thin White Duke
tour, 1976; a film still from
Interview With the Vampire (1994);
a film still from *The Damned*
(1969); two looks from Yves Saint
Laurent's fall 2004 collection; a
film still from *The Hunger* (1983).

ASEXUAL REVOLUTION

ON THE DARKENED STREETS OF L.A., *W*'S FORMER FASHION DIRECTOR ALEX WHITE EXPLORED THE CHANGING NATURE OF MALE AND FEMALE STEREOTYPES.

Steven Meisel's definition of beauty is broad. He finds it in effeminate-looking men, masculine-looking women, drag queens, heavier models, older women. He's been drawn to these types ever since he began his career as a photographer, in the late '70s. Whether it's his transgender muse Teri Toye, whom he met early on, or the model Maggie Rizer, whom he shot for the cover of Italian *Vogue* in the late '90s—subsequently launching her career—Steven notices something beautiful in many people that others don't initially. It's a way of seeing the world that translates into his photography: Even when he strives to capture imperfection, the composition of his work is perfect.

This story was the first one Steven shot for *W*. He had been doing a lot of work back then for Italian *Vogue*, and that was his outlet for creative expression. Dennis Freedman, *W*'s Vice Chairman/Creative Director at the time, offered him the same sort of freedom—and in this case, that meant exploring notions of androgyny, sexual ambiguity, decadence, and nihilism. For visual inspiration, Steven and I studied German expressionist cinema and Luchino Visconti's *The Damned*, as well as David Bowie's Thin White Duke persona and the film *The Hunger*, in which he plays a vampire. We cast a great group of models including Karen Elson, Jessica Stam, Missy Rayder, Hannelore Knuts, and Boyd Holbrook. The fashion took cues from Tom Ford's final collection for Yves Saint Laurent—a sleek, sensual, jewel-toned swan song.

We shot for three days on an old film-production set in L.A., and then one night at a shipyard, starting very late and finishing early in the morning. We played Chet Baker songs for most of the time. I think at the beginning, the guys may have been a bit uncomfortable and guarded in their heels. But people will do anything for Steven, and it's not like it was the first time men were wearing women's clothing. In the end, it was all about the chemistry between the models, and there was a lot of it.

The story ended up being on the cover of the issue, and it raised a lot of eyebrows. Admittedly, it wasn't the usual newsstand-friendly portrait, but it also wasn't intended to be perverse or provocative. Sexual subversion is hardly anything new in fashion. And there were music videos and films at the time that contained similarly explicit subject matter. The pictures were merely a reflection of what was going on in pop culture, but American fashion magazines were conservative back then—they still are, for the most part. To me, the story evoked a sense of self-confidence and vanity more than anything overly erotic.

PHOTOGRAPHED BY STEVEN MEISEL
STYLED BY ALEX WHITE
PUBLISHED IN OCTOBER 2004

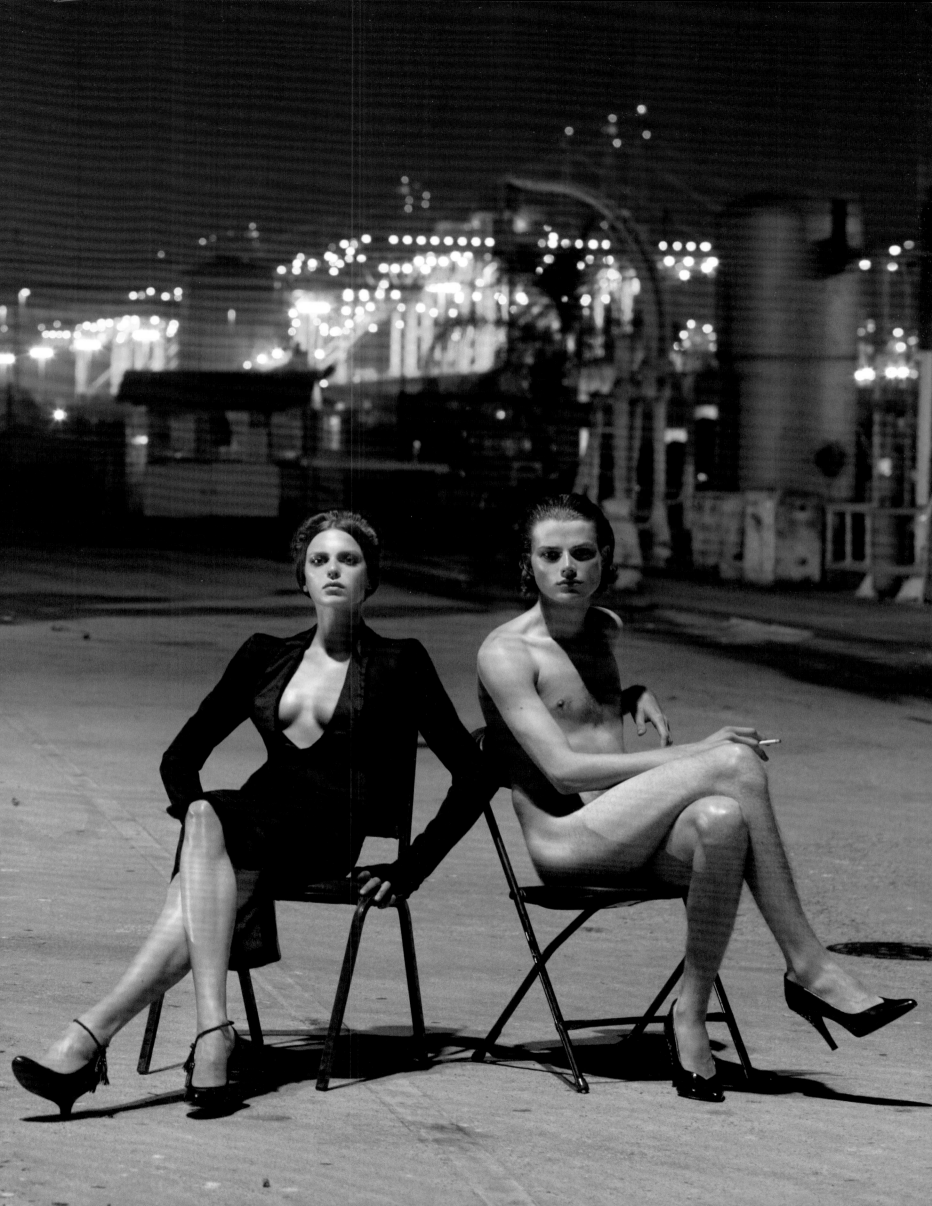

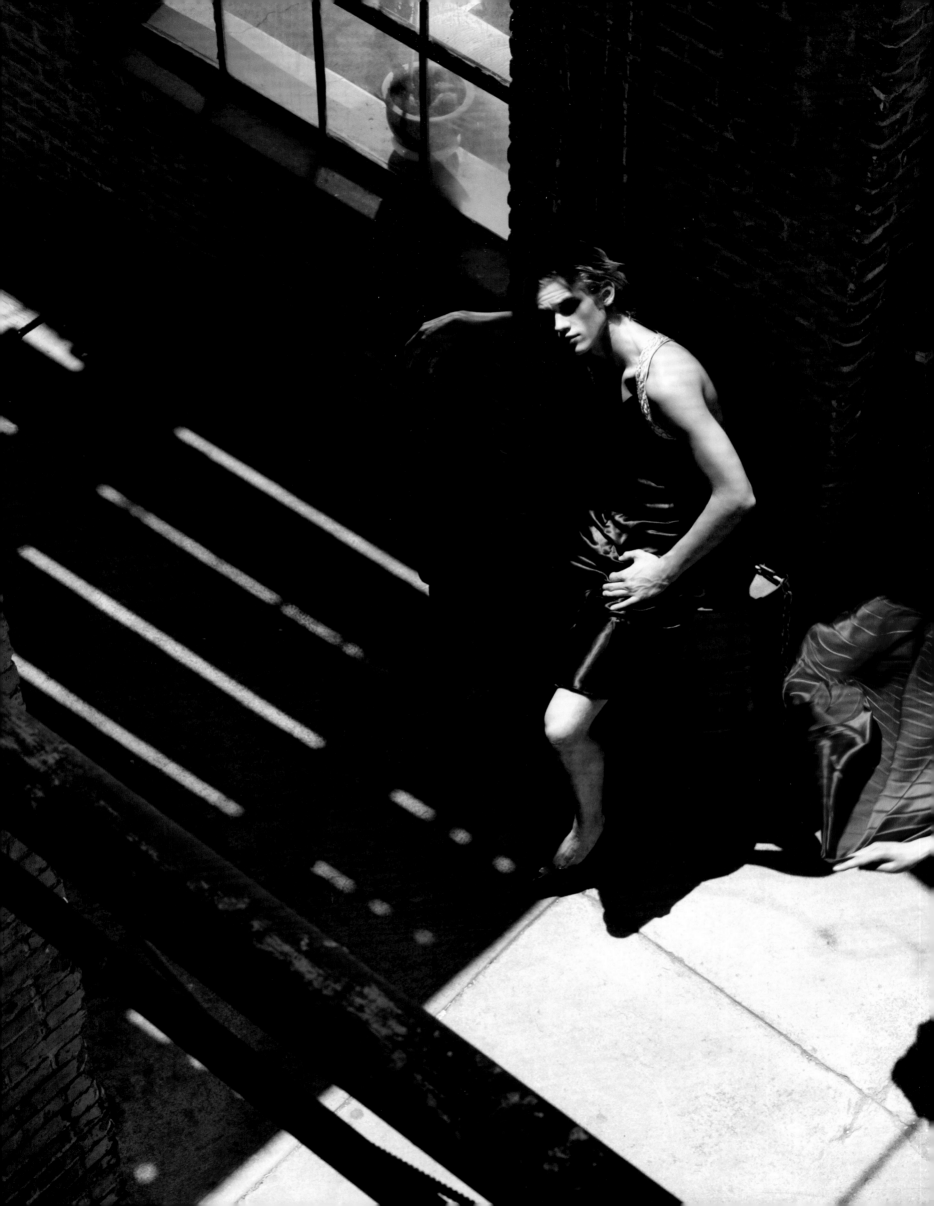

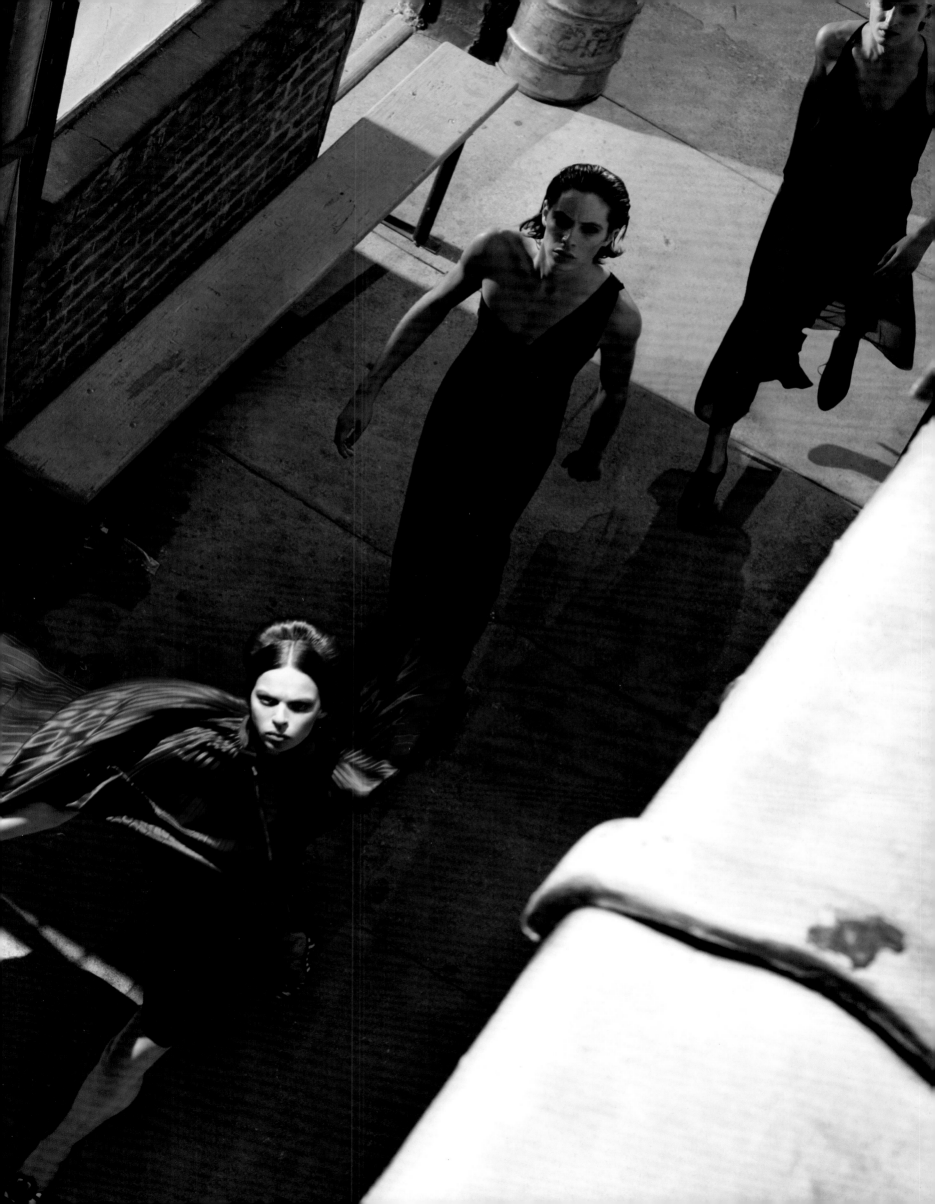

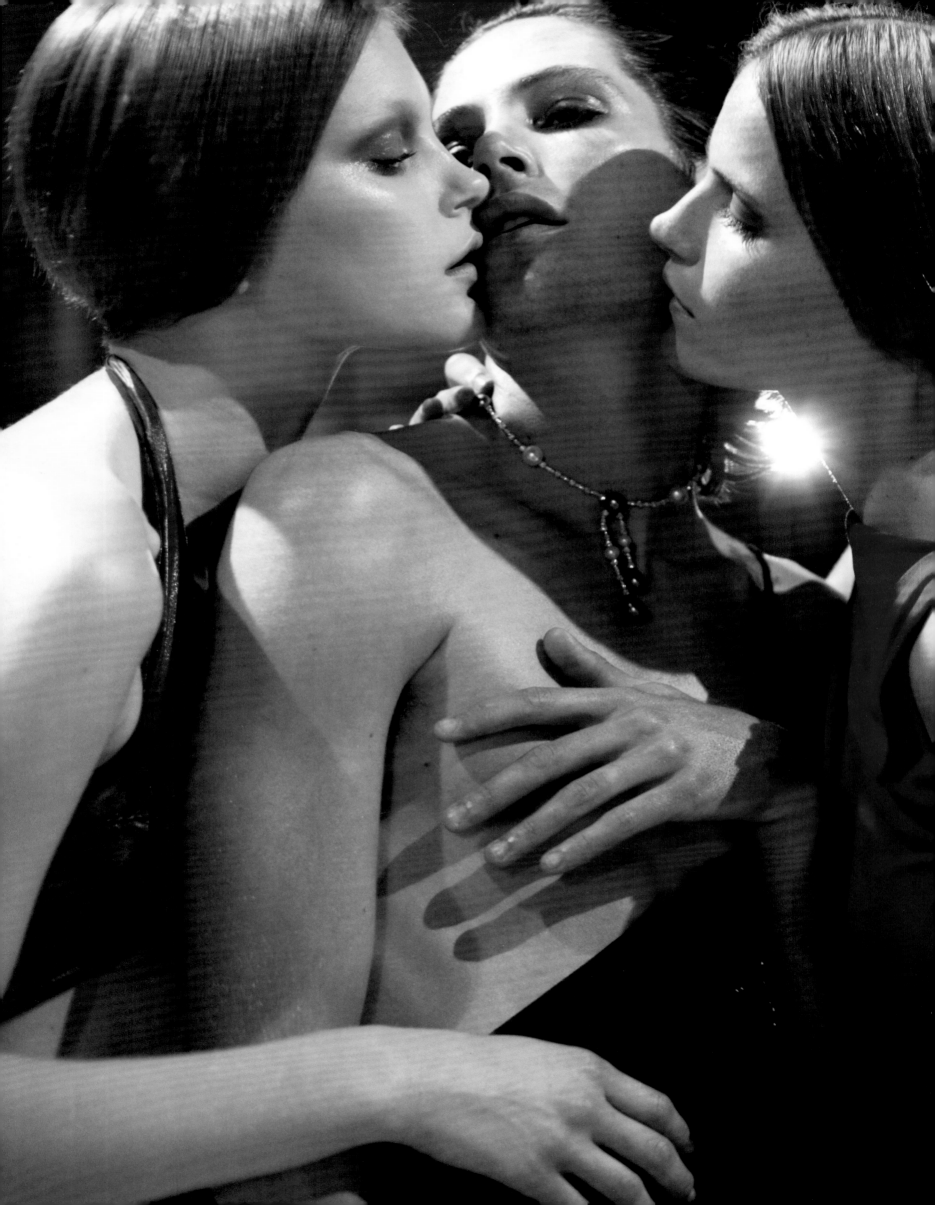

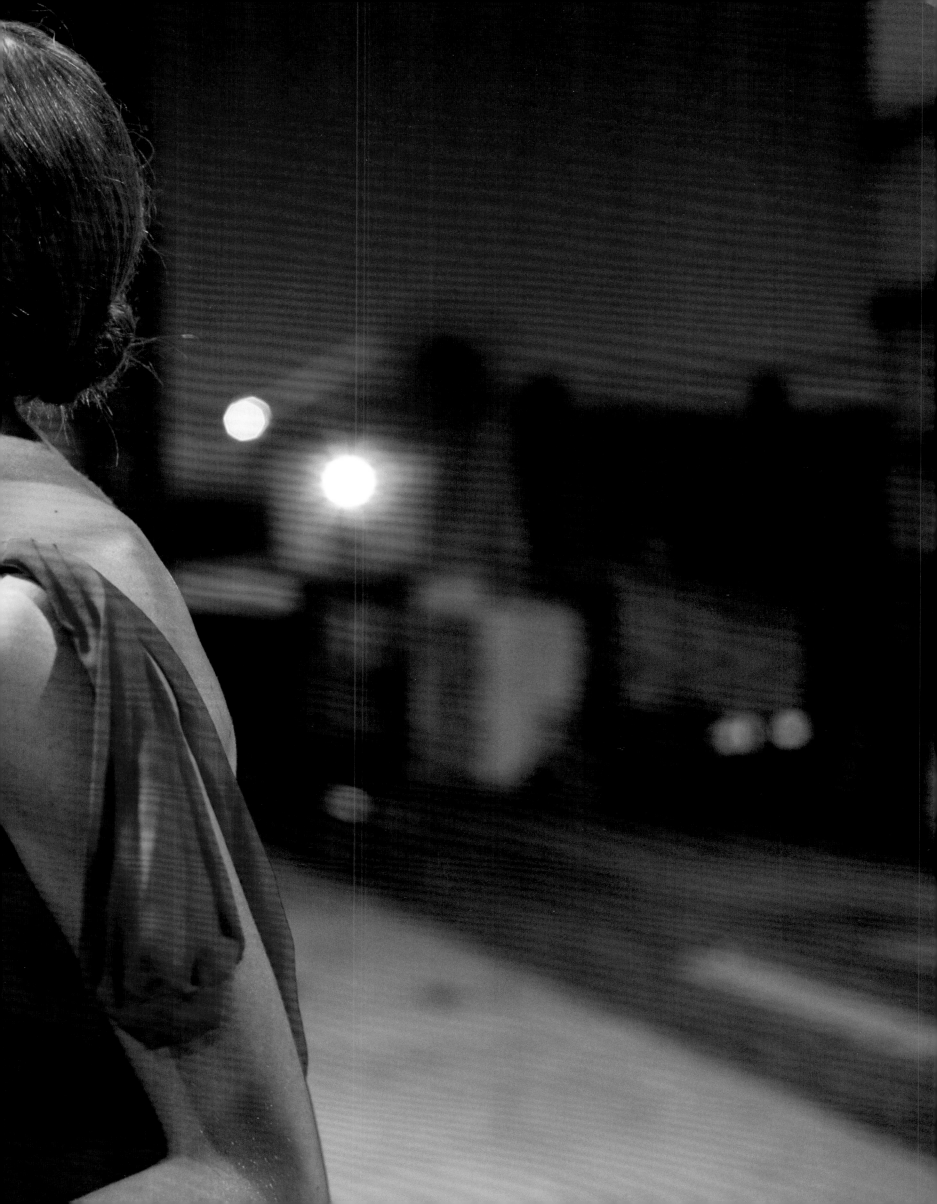

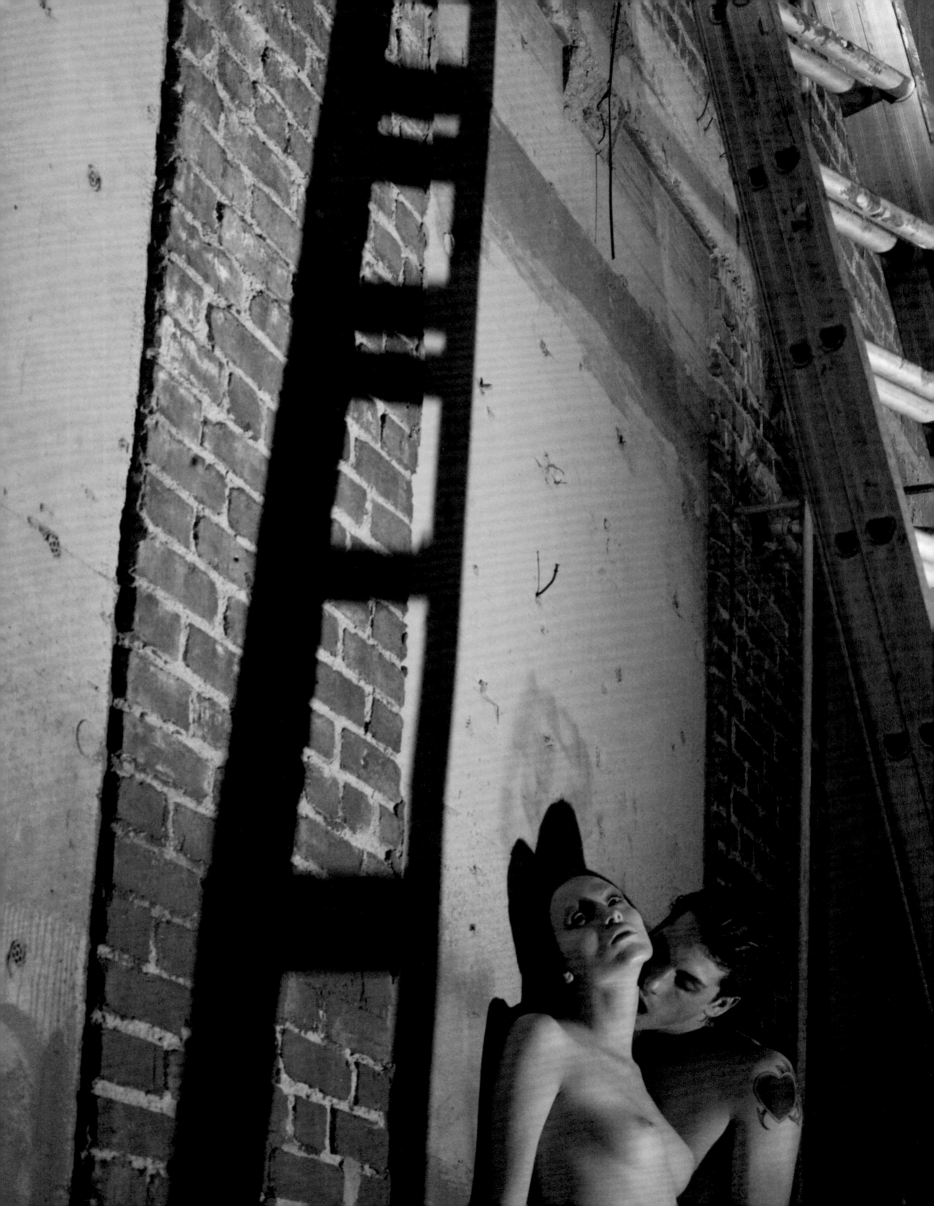

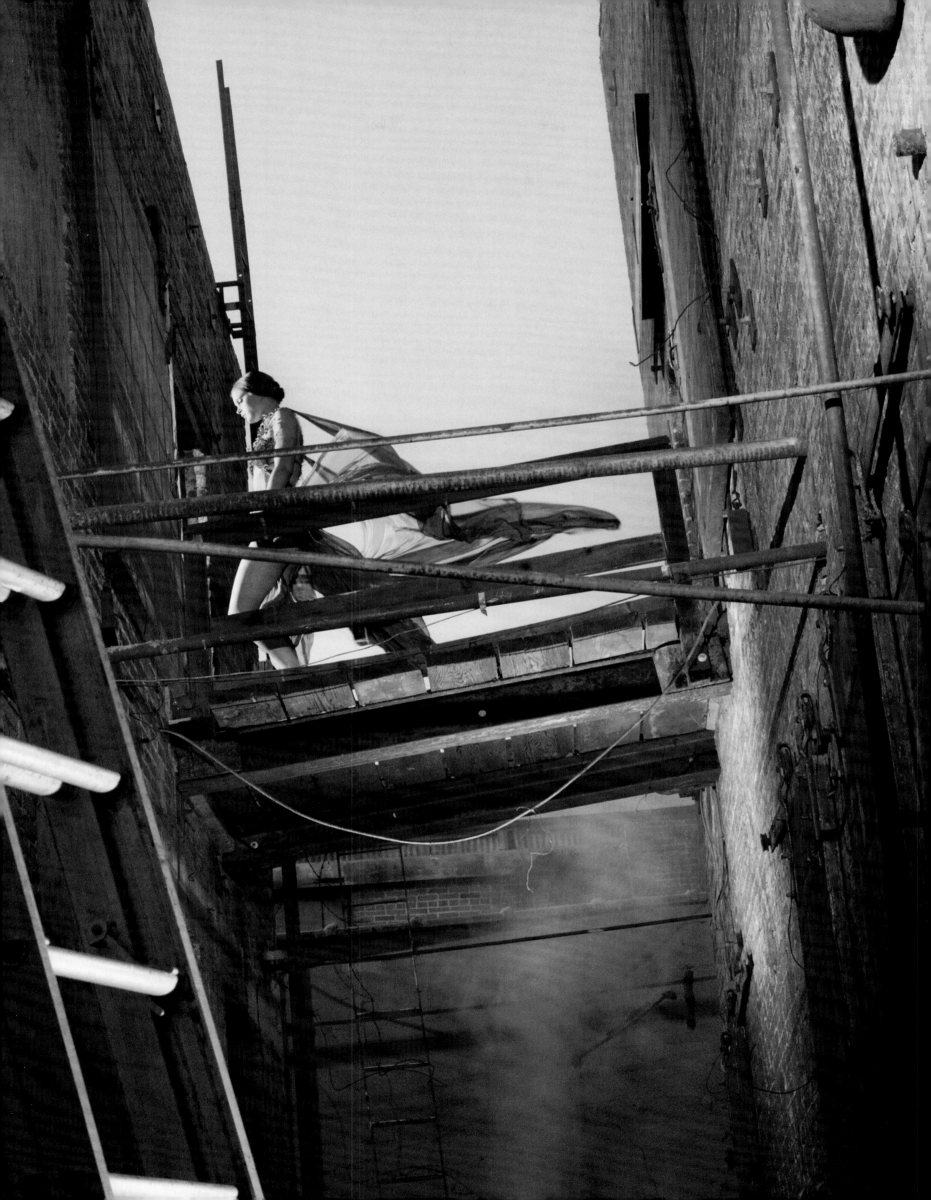

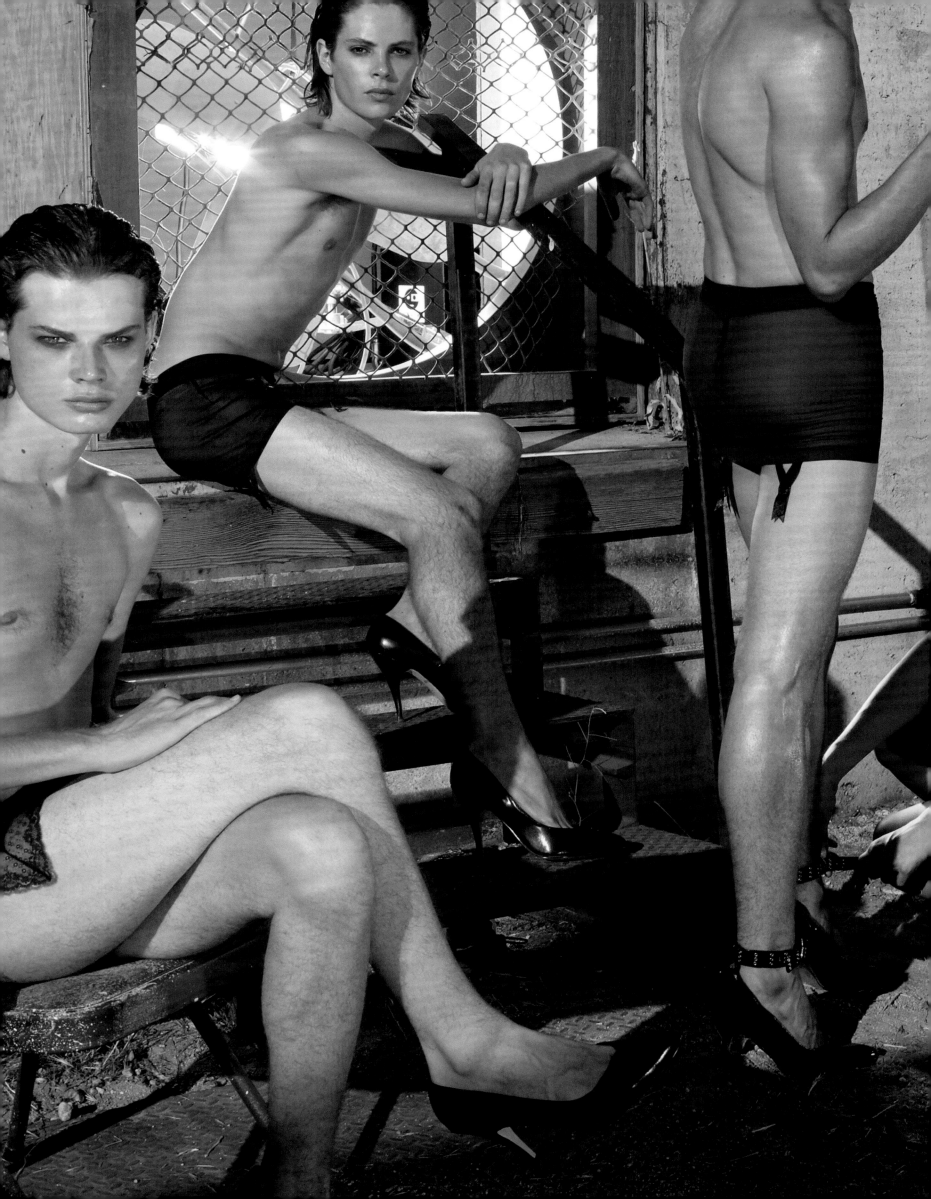

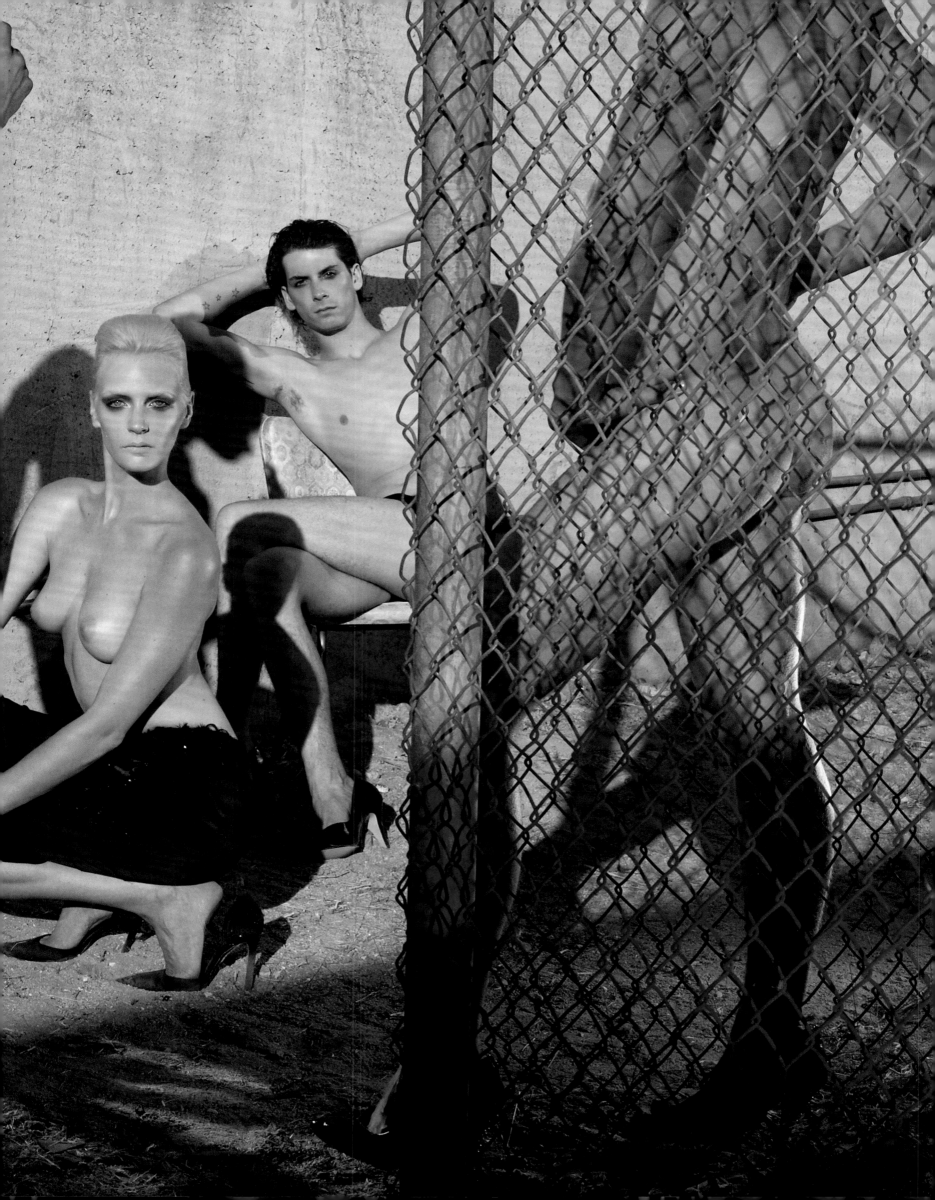

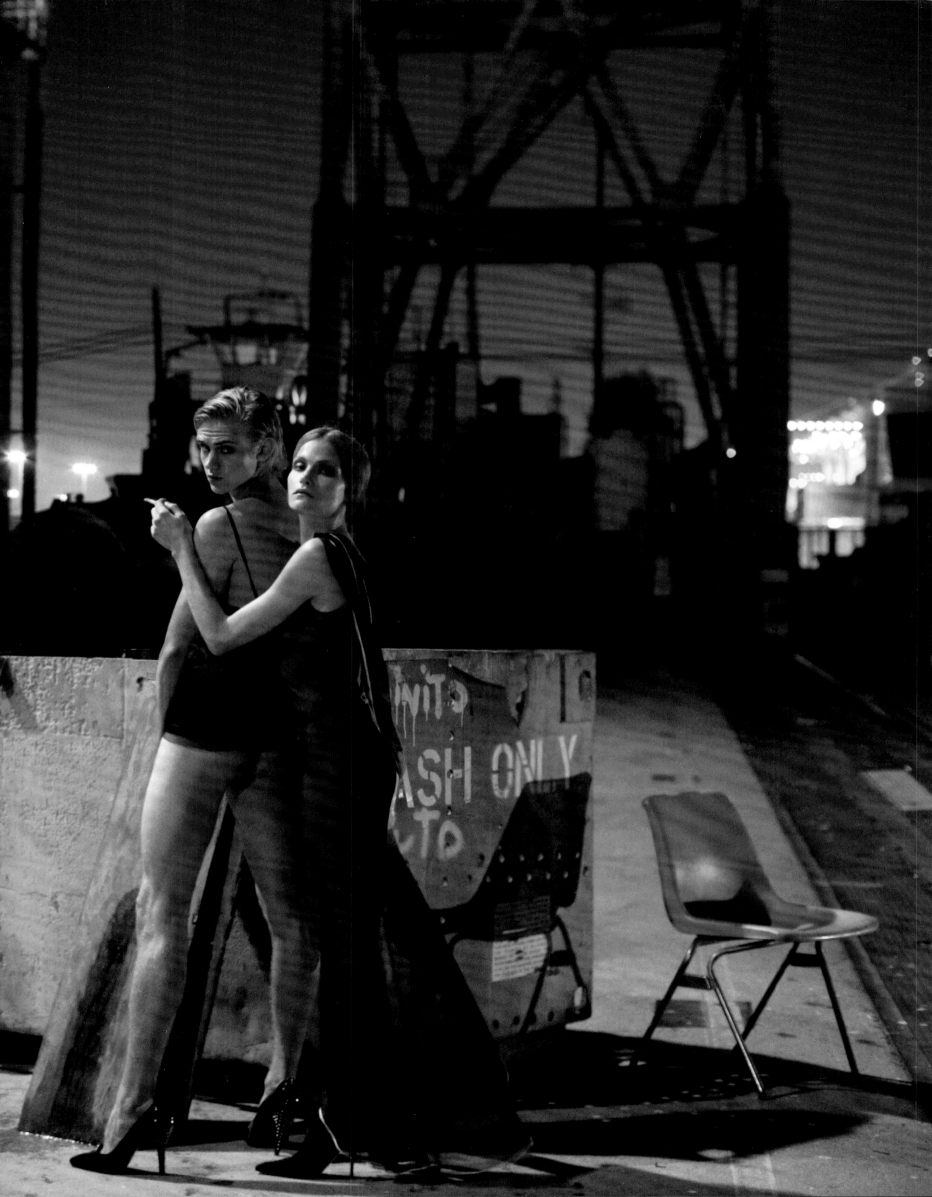

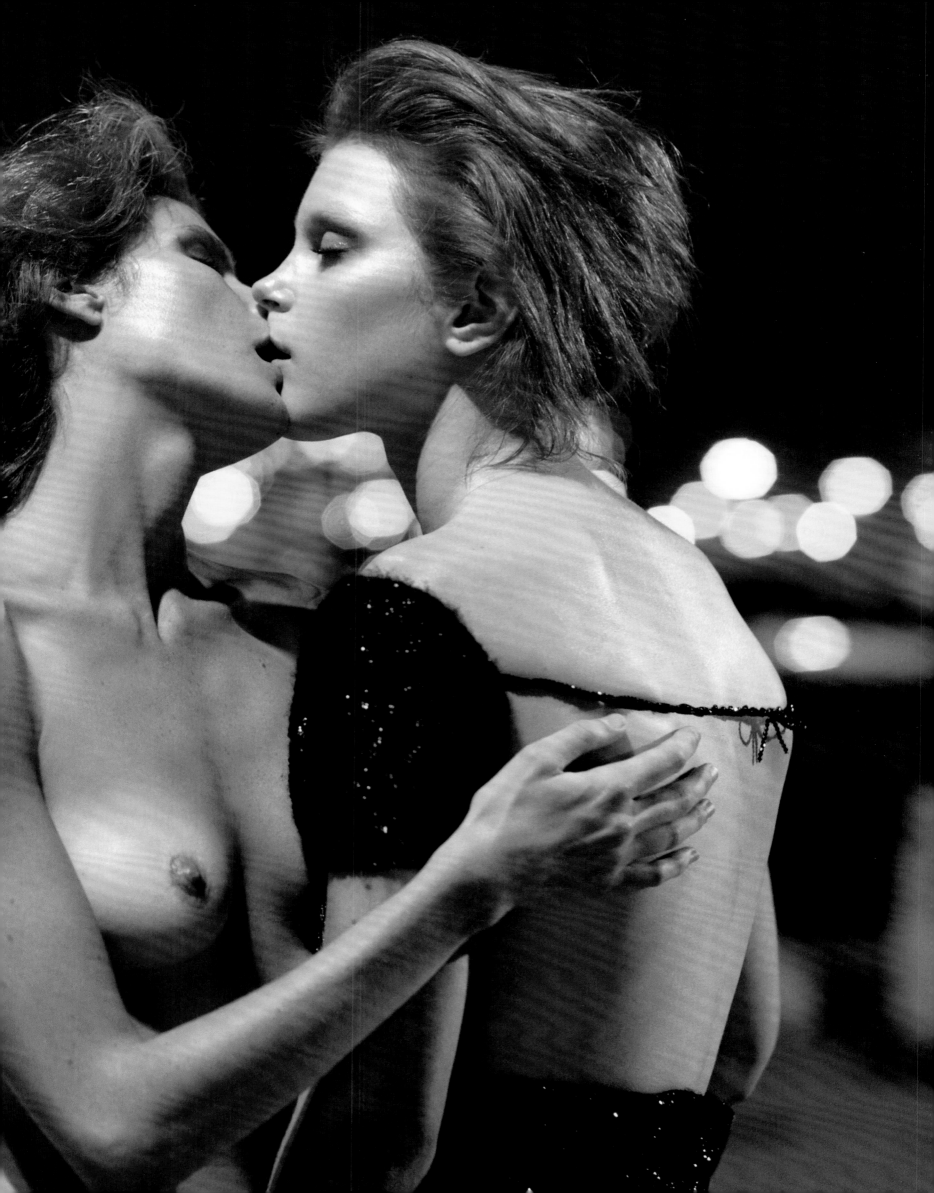

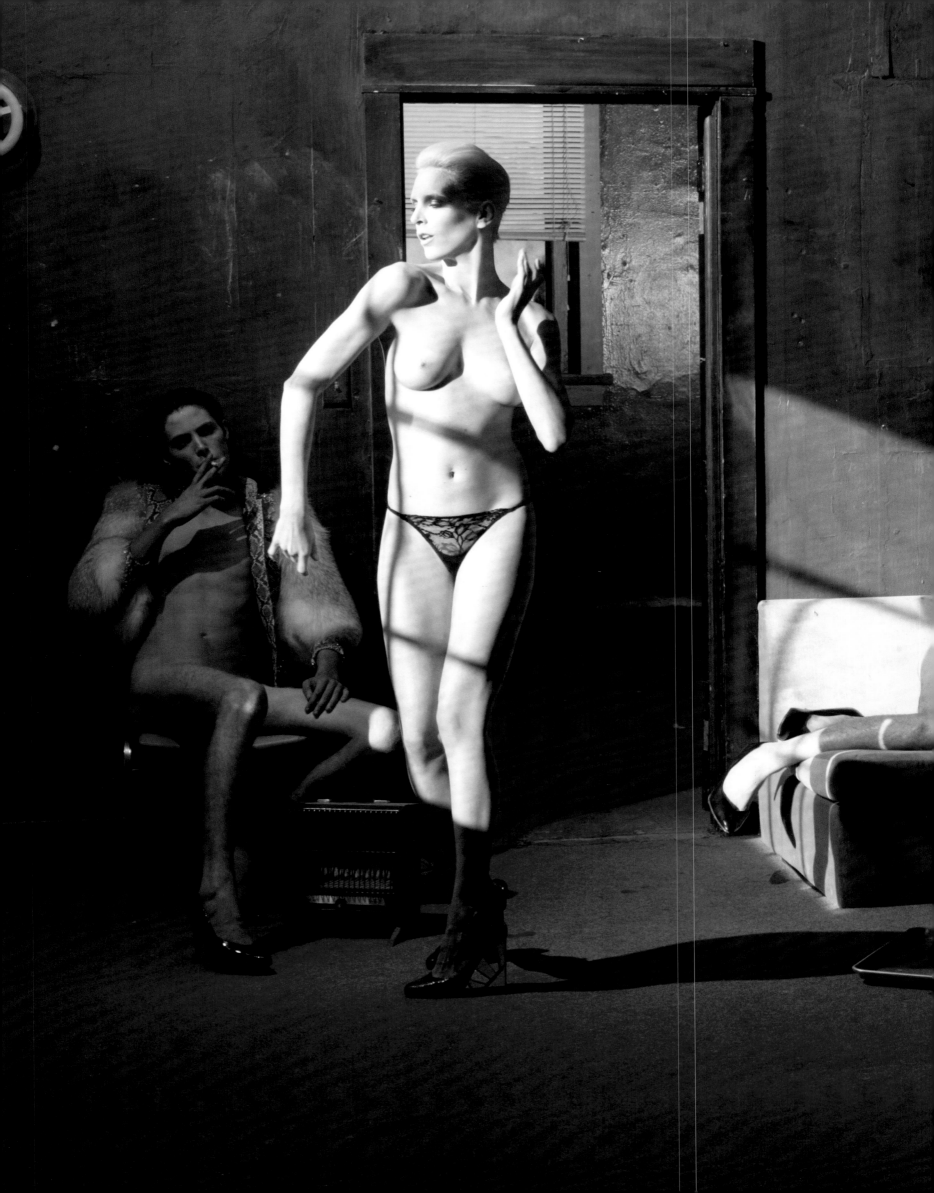

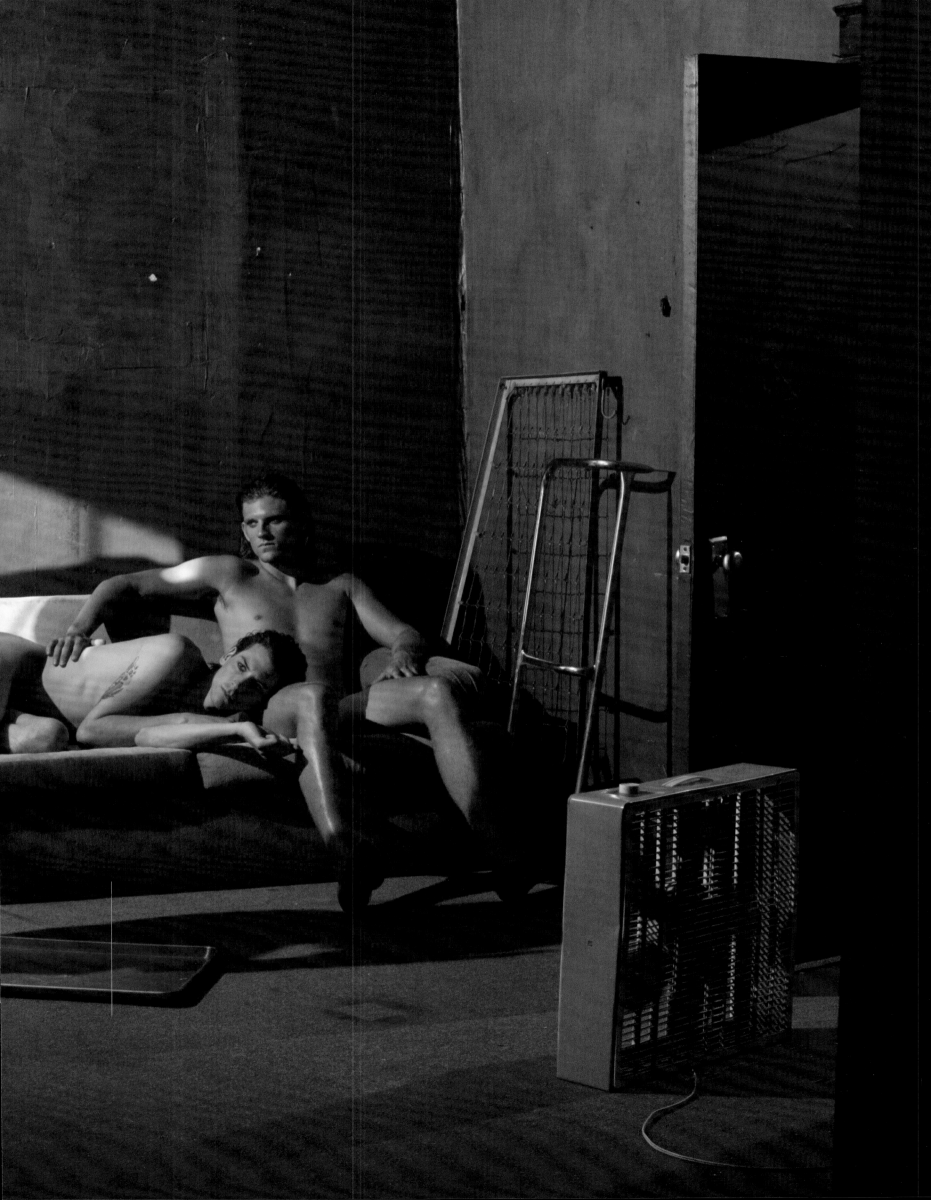

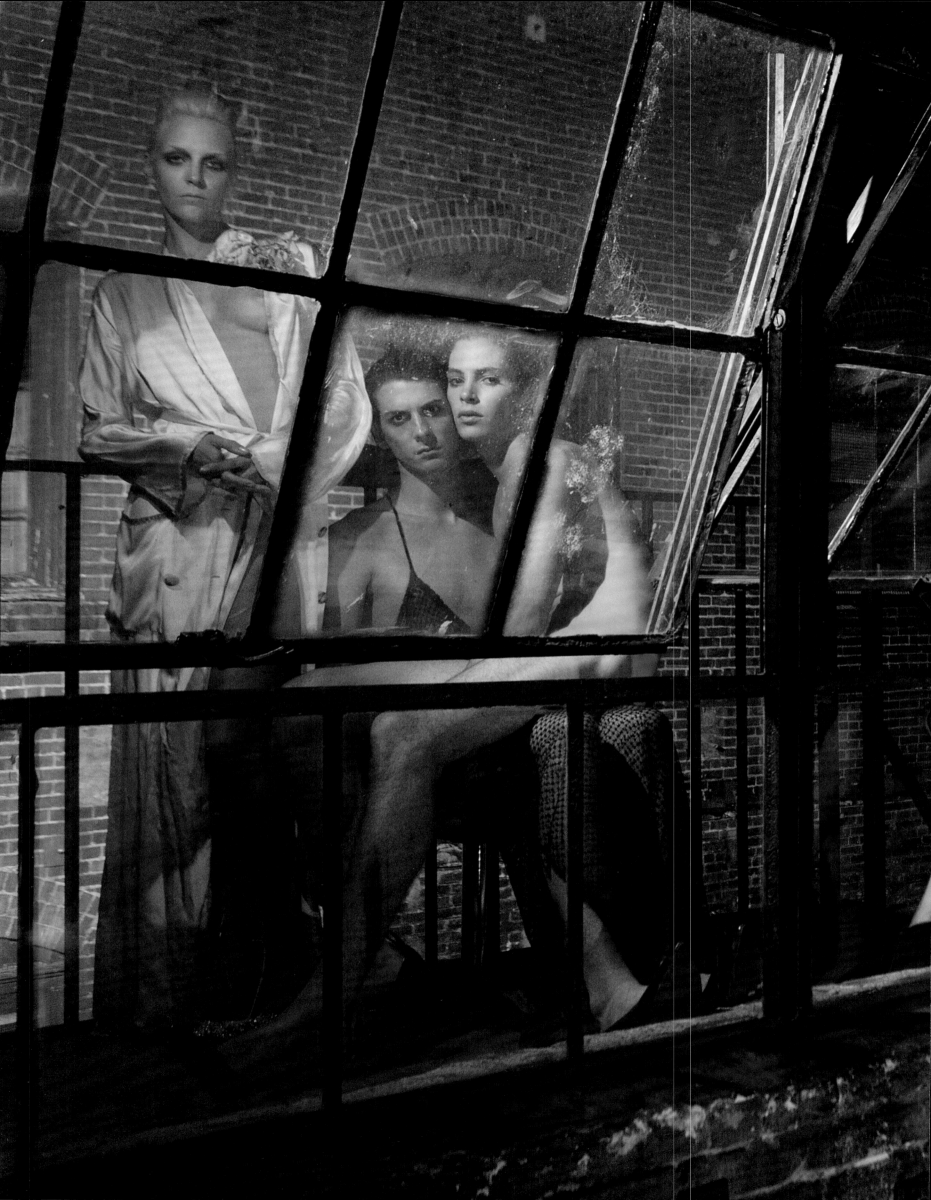

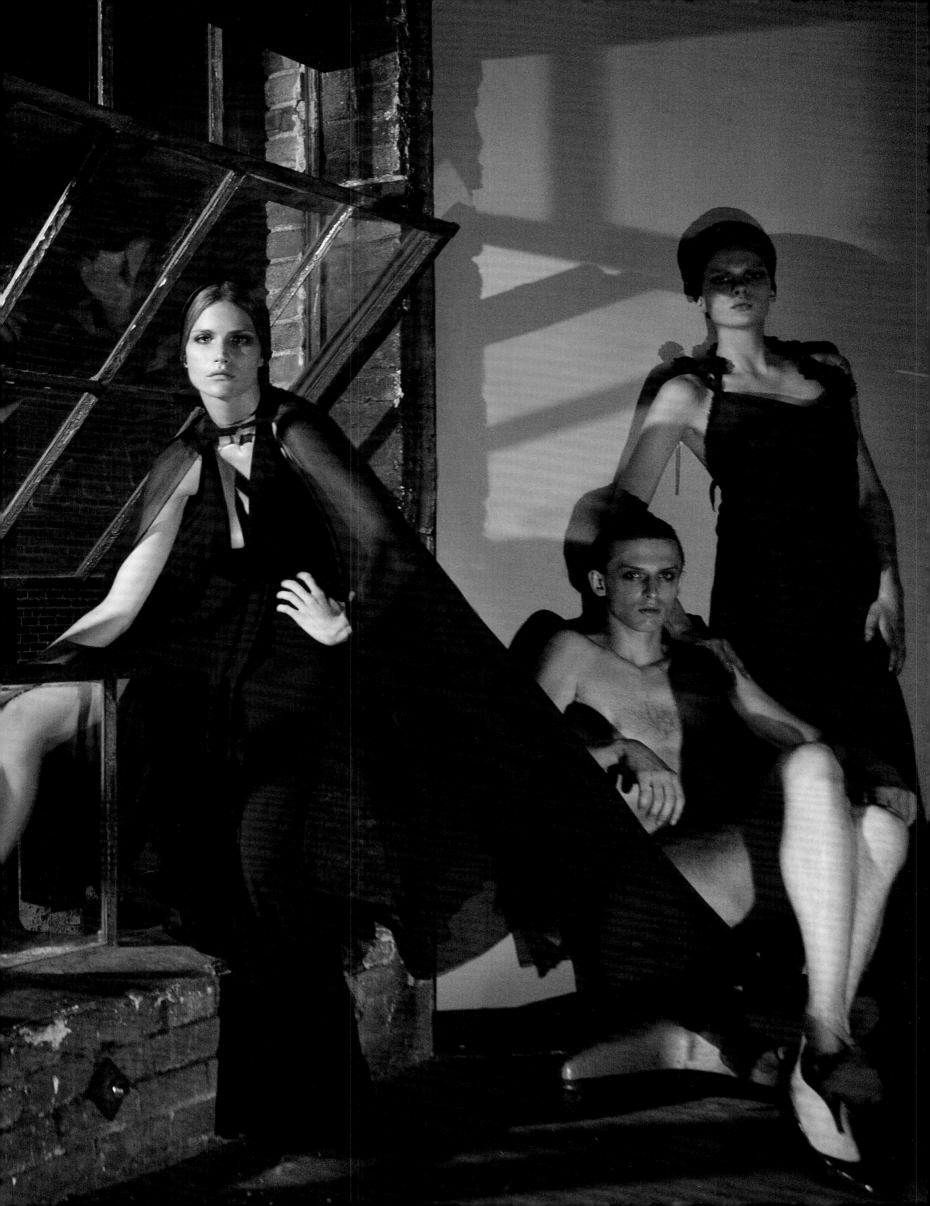

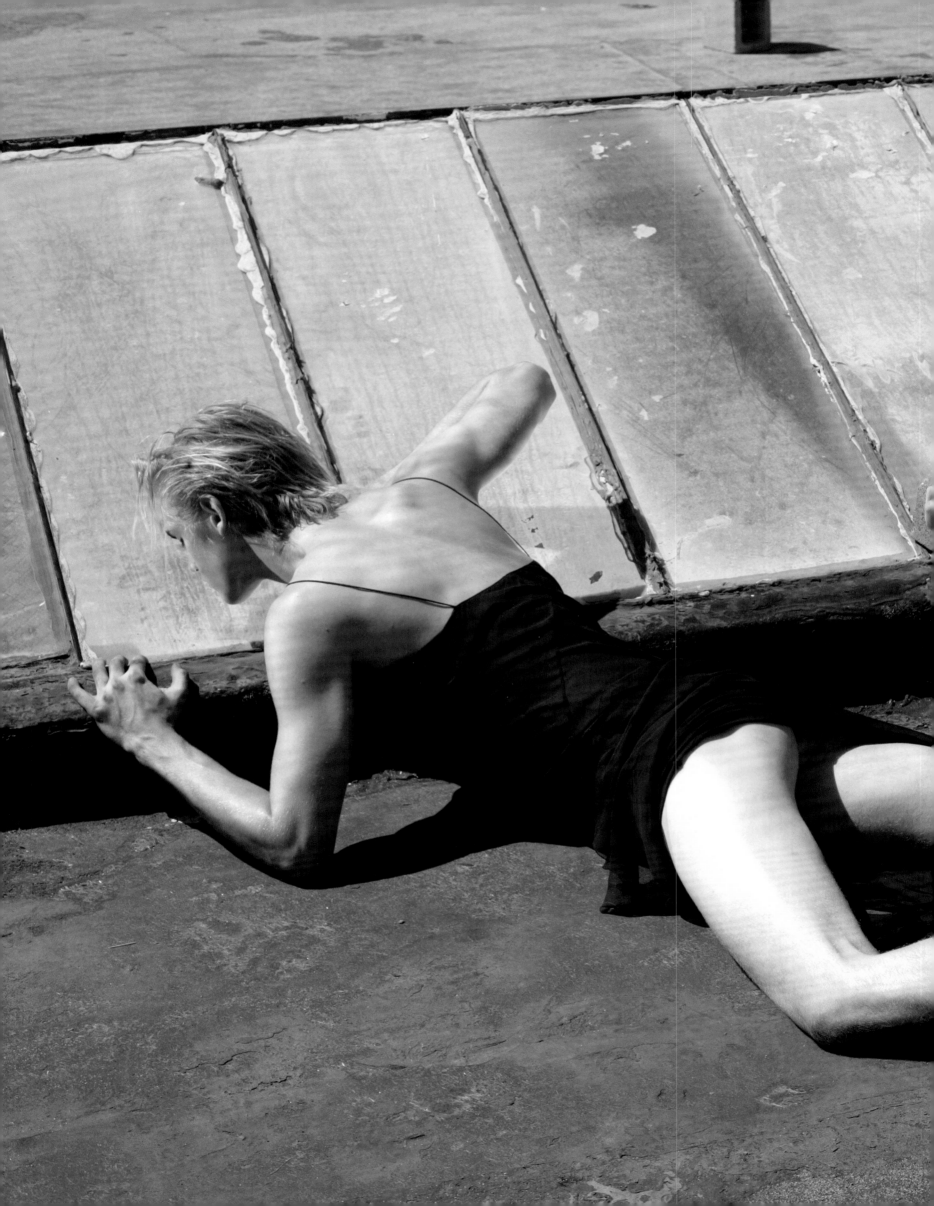

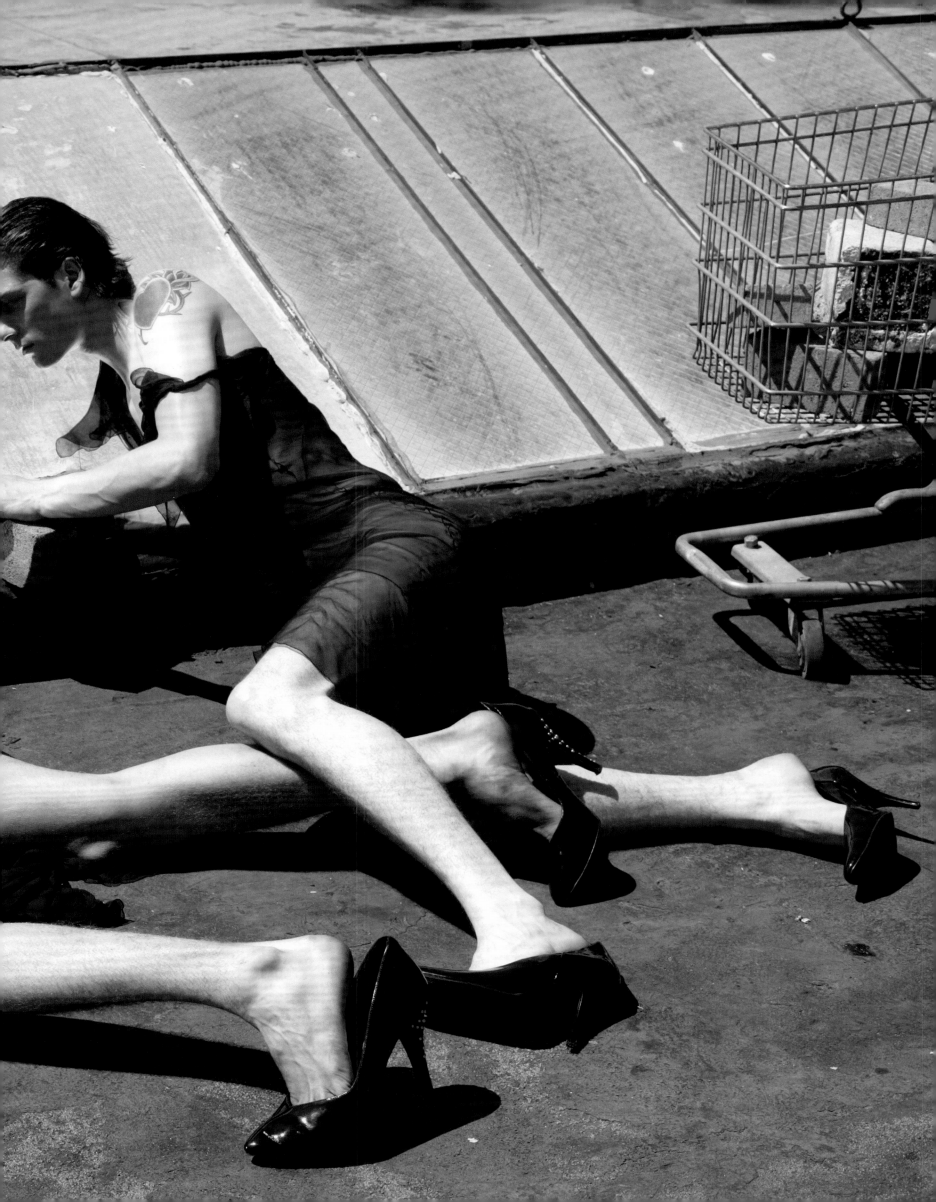

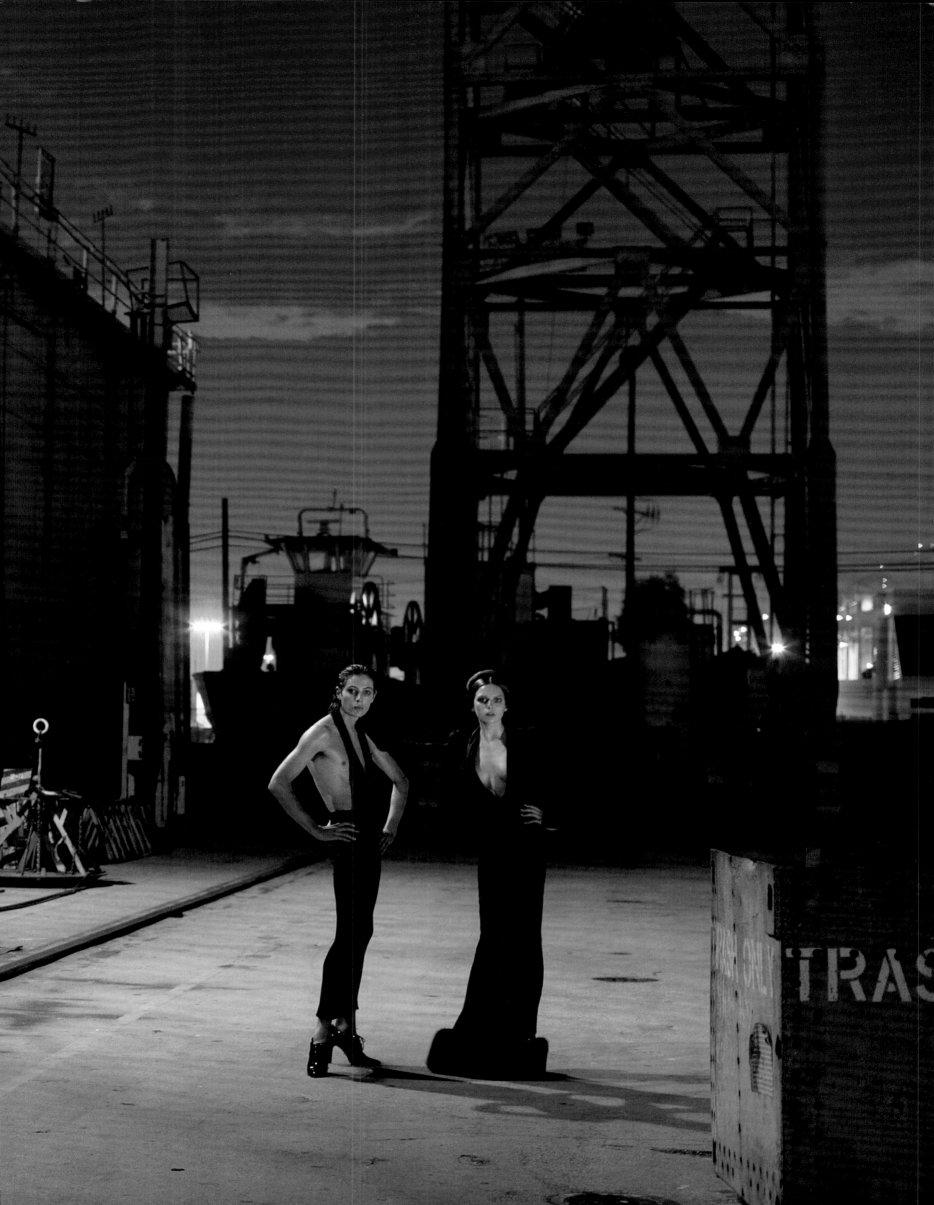

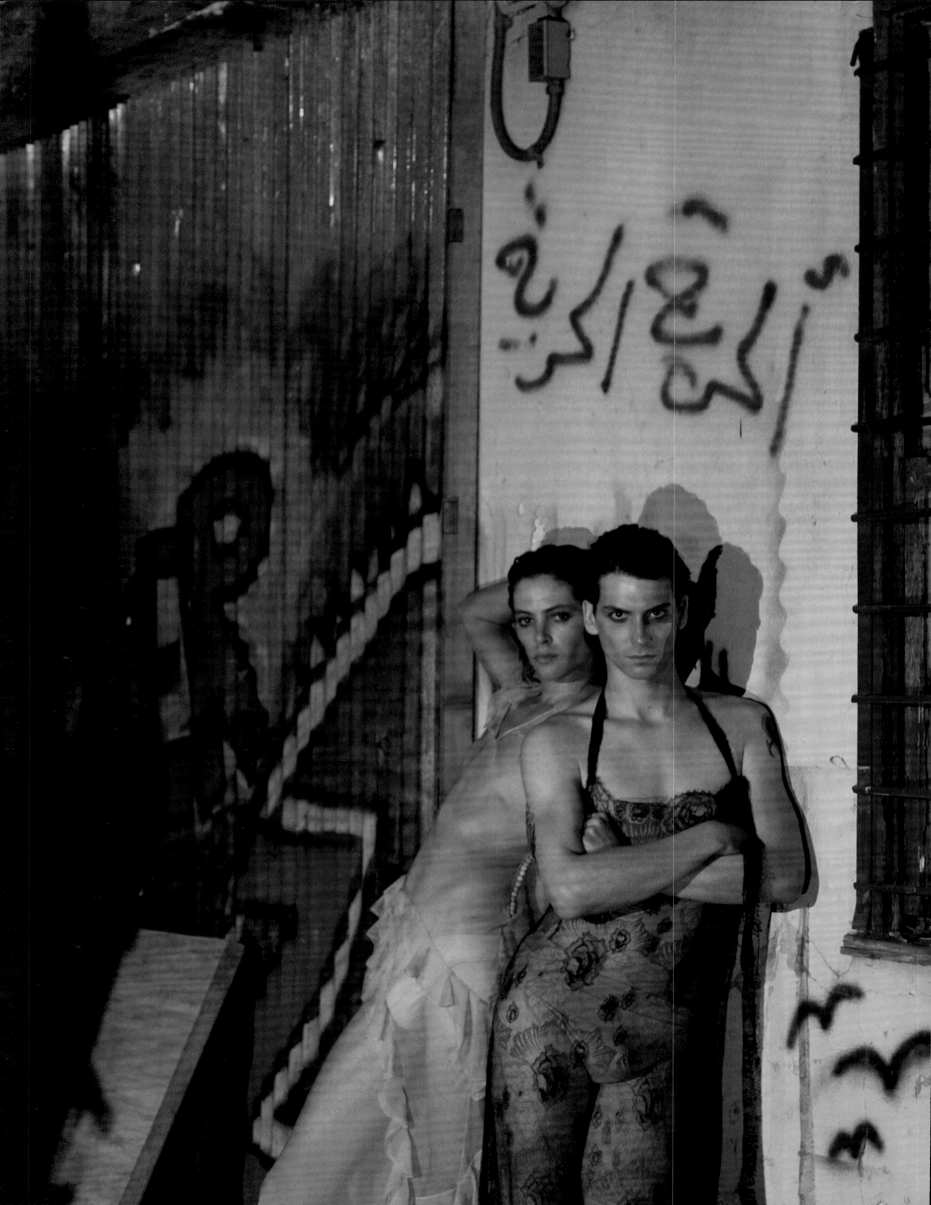

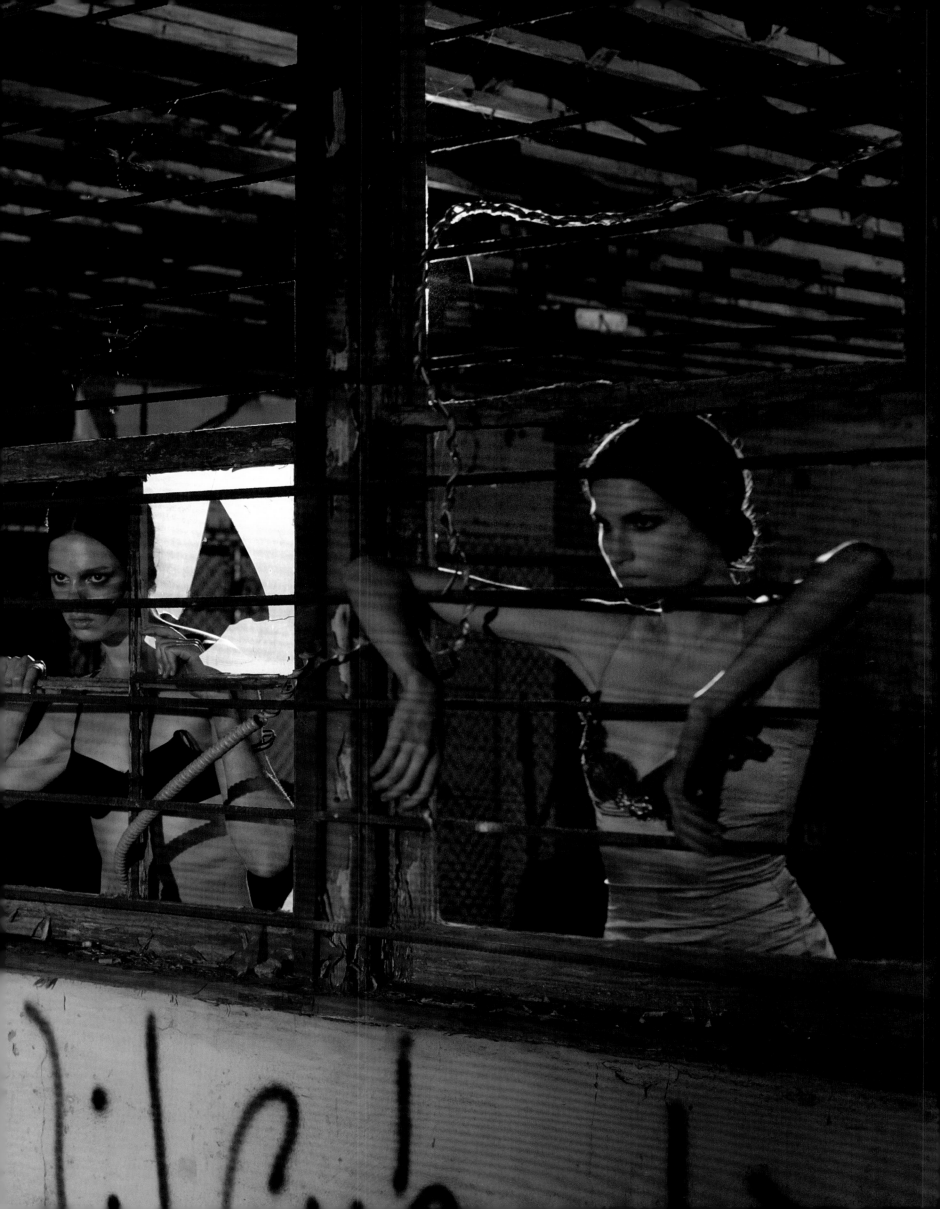

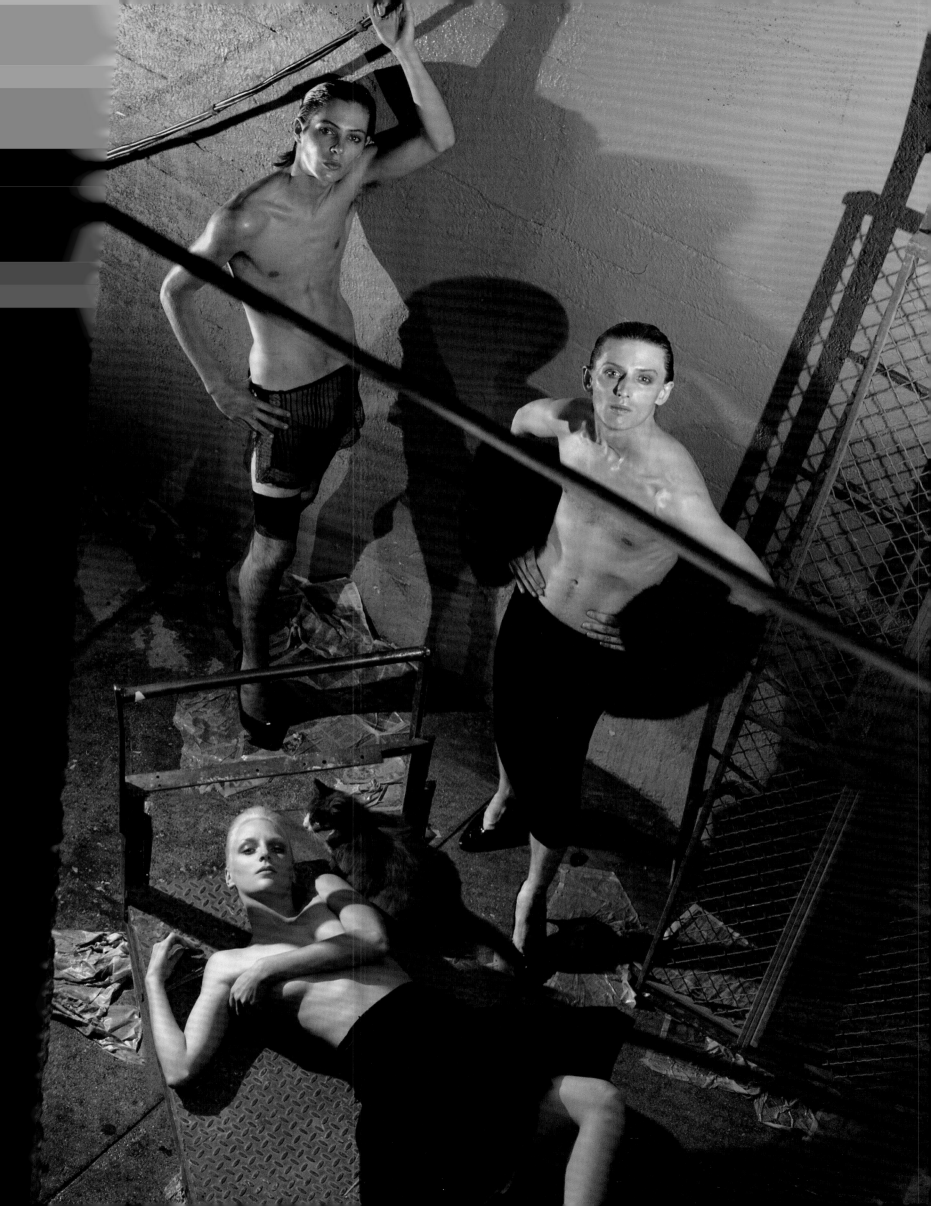

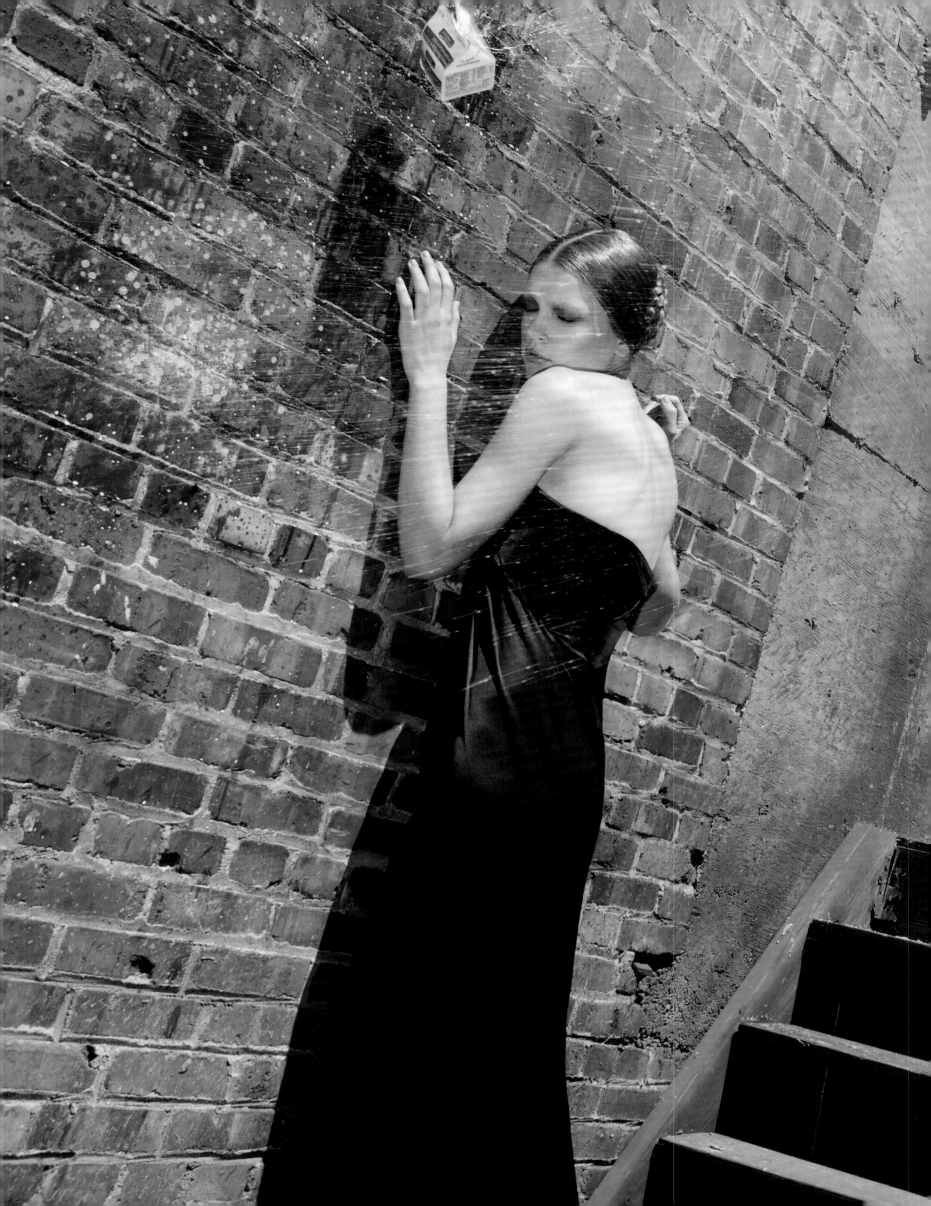

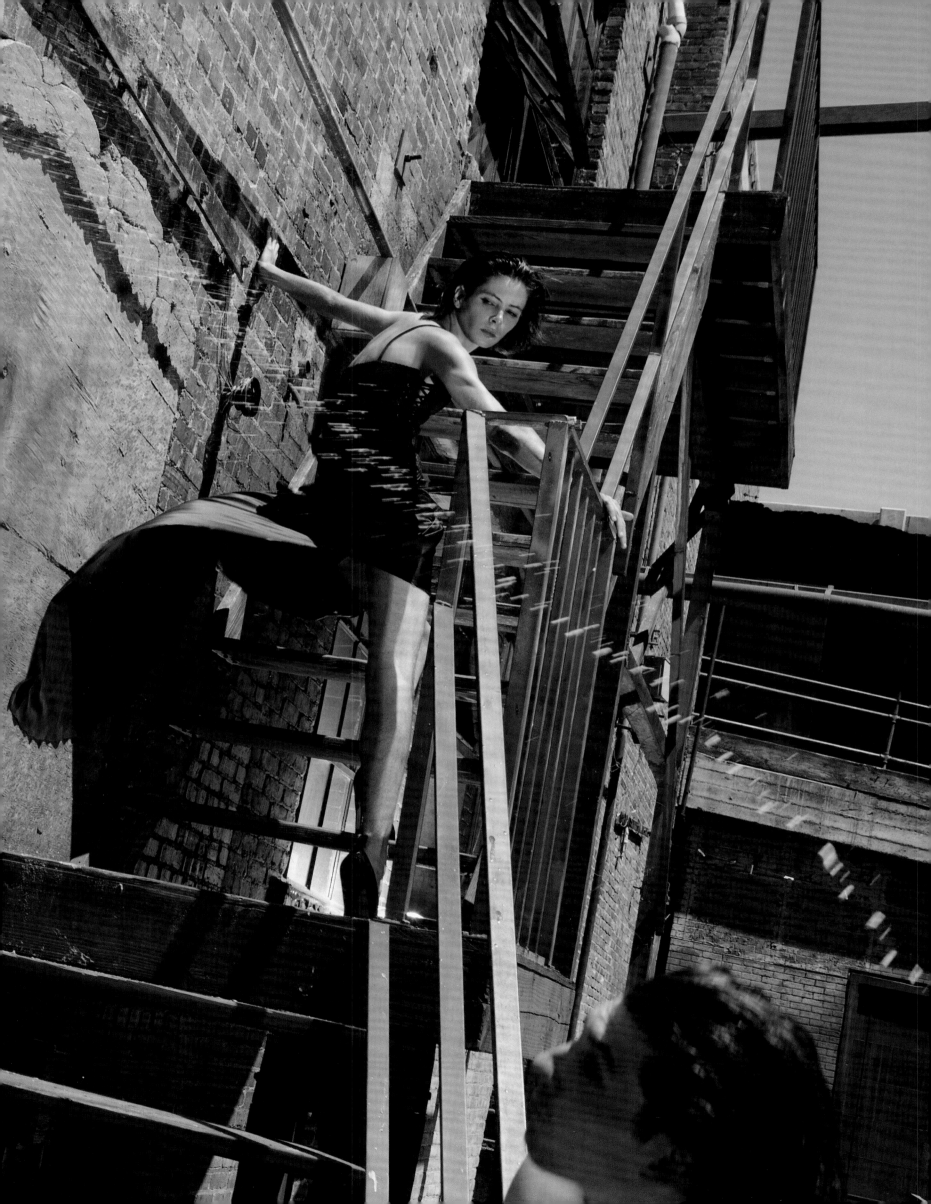

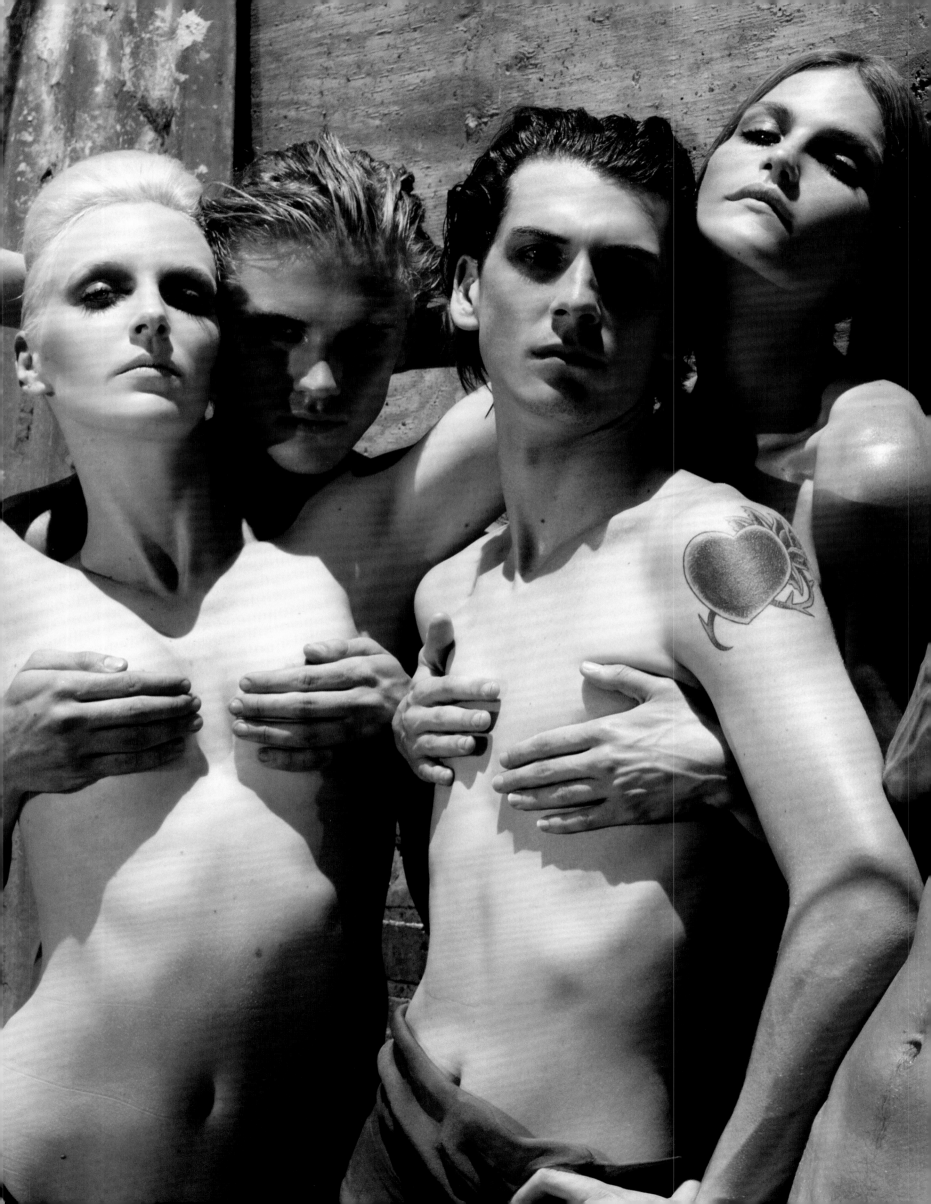

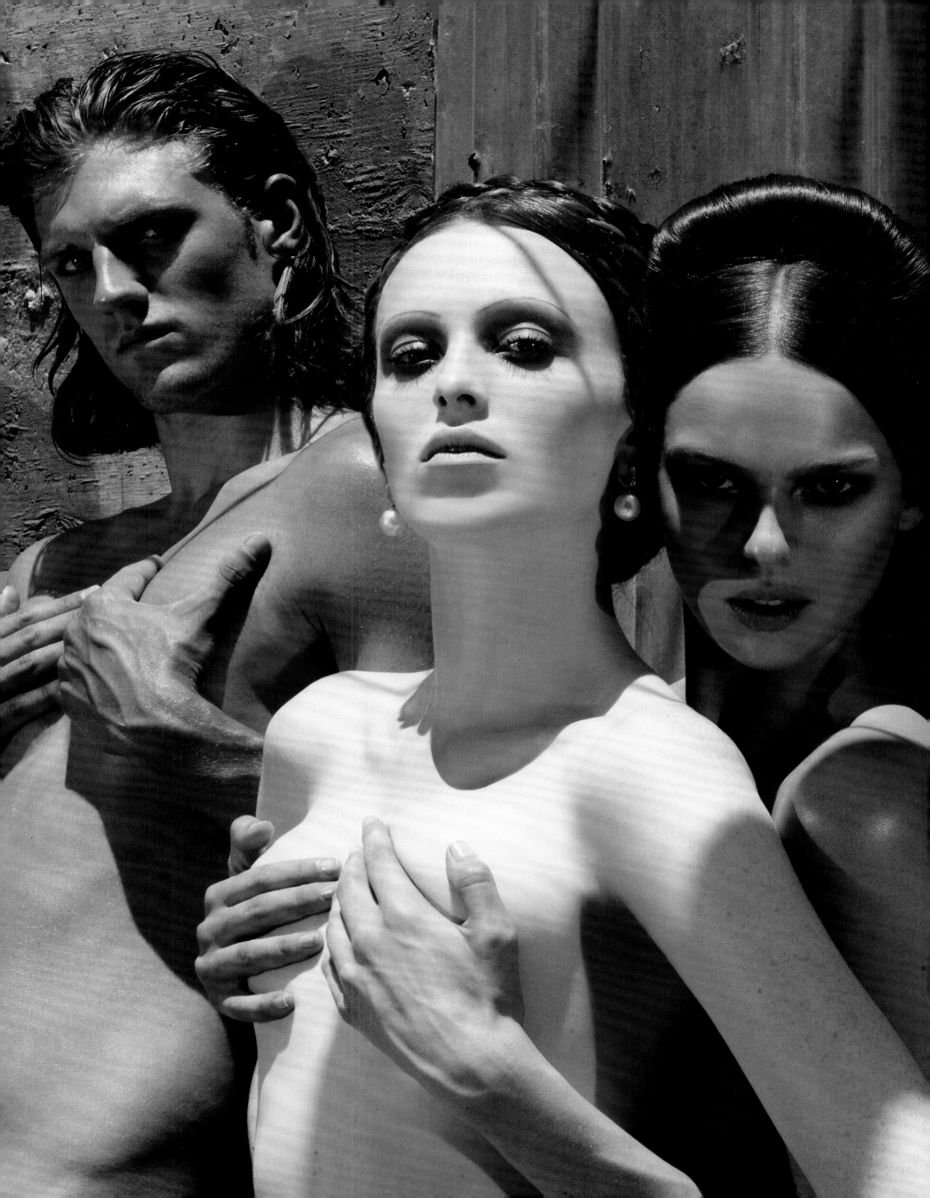

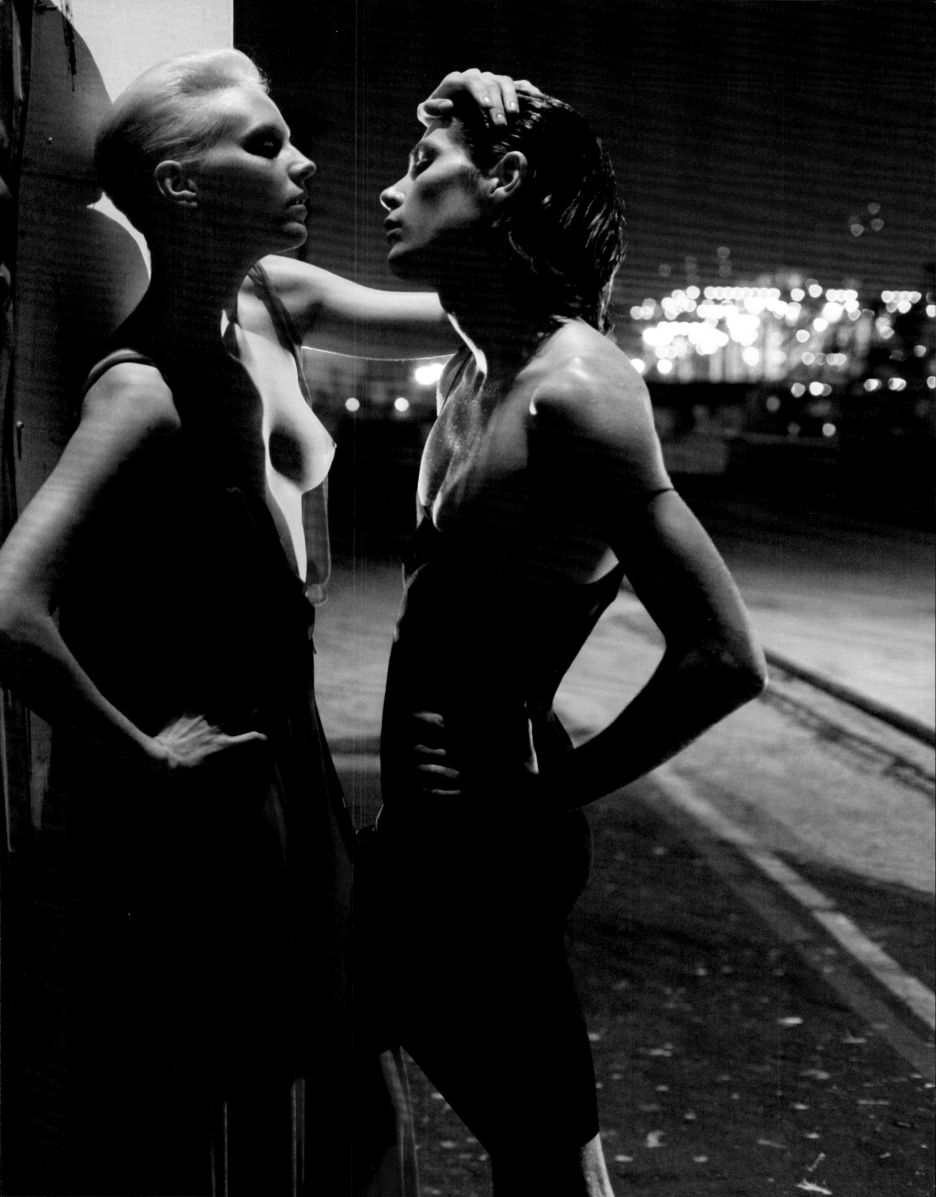

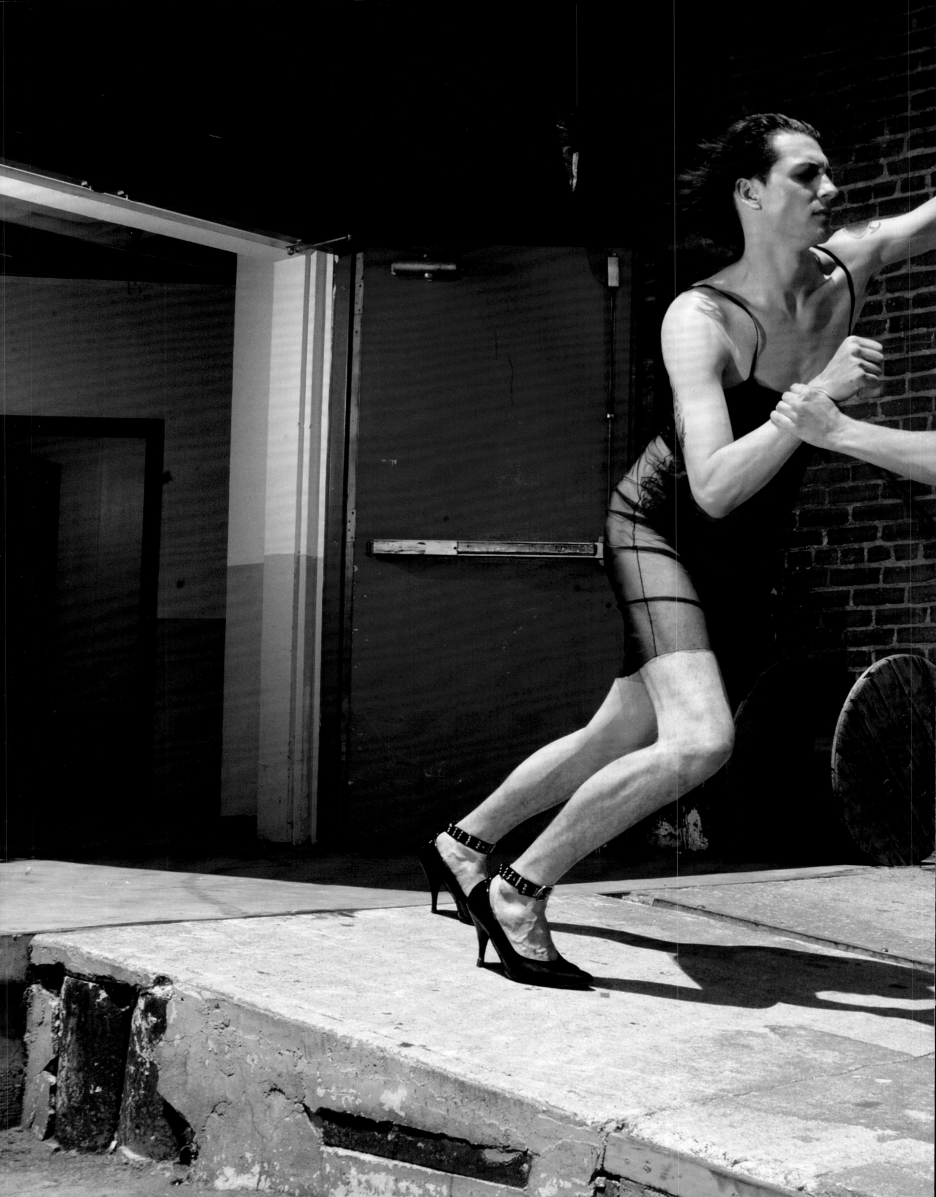

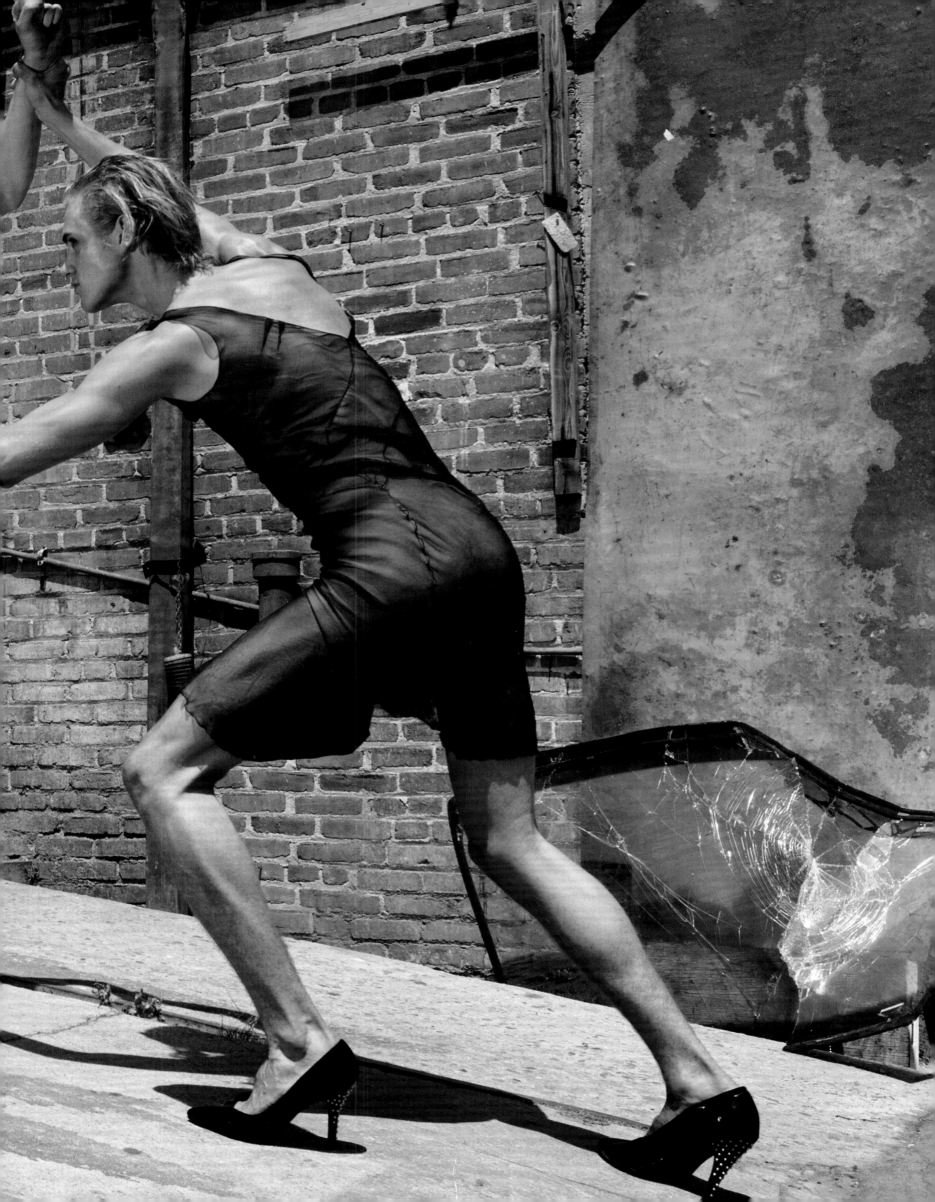

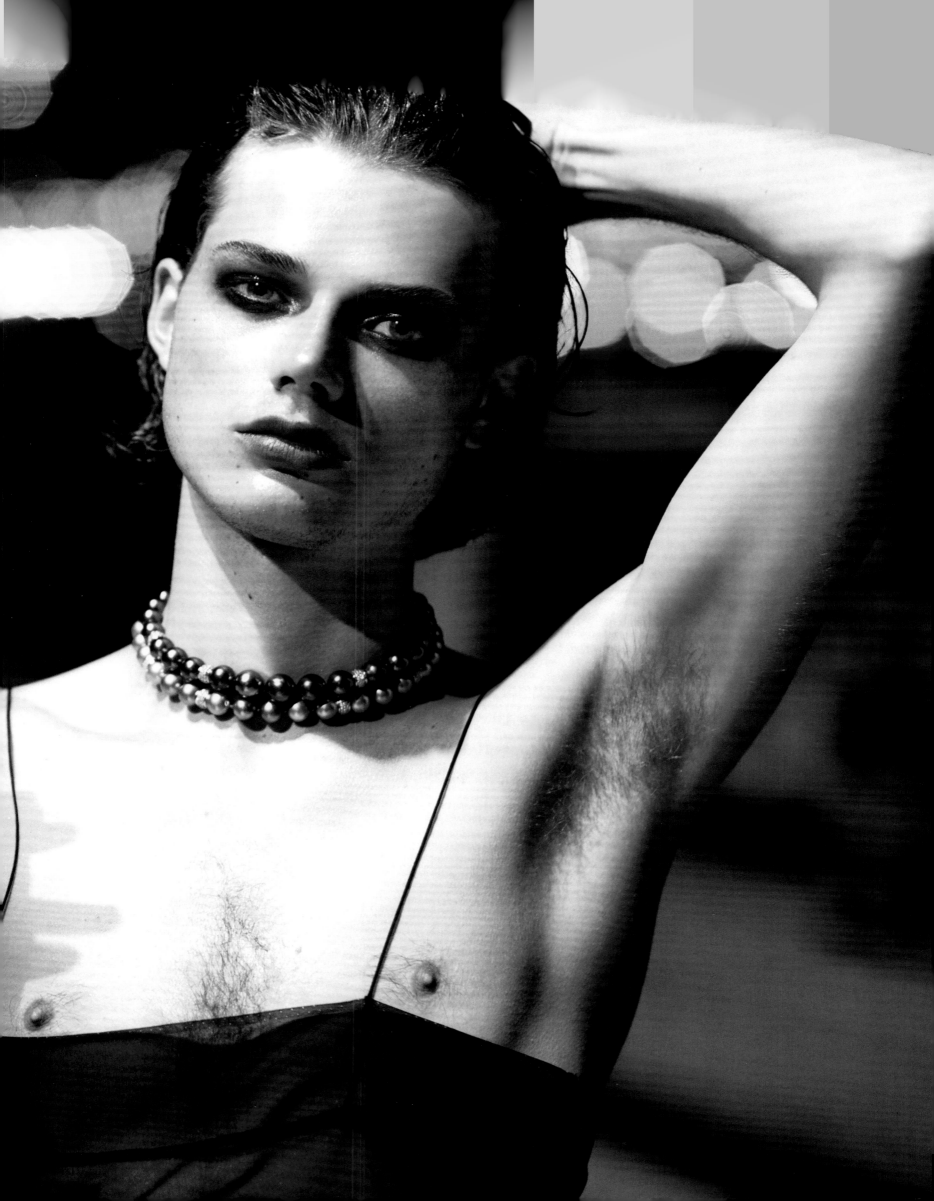

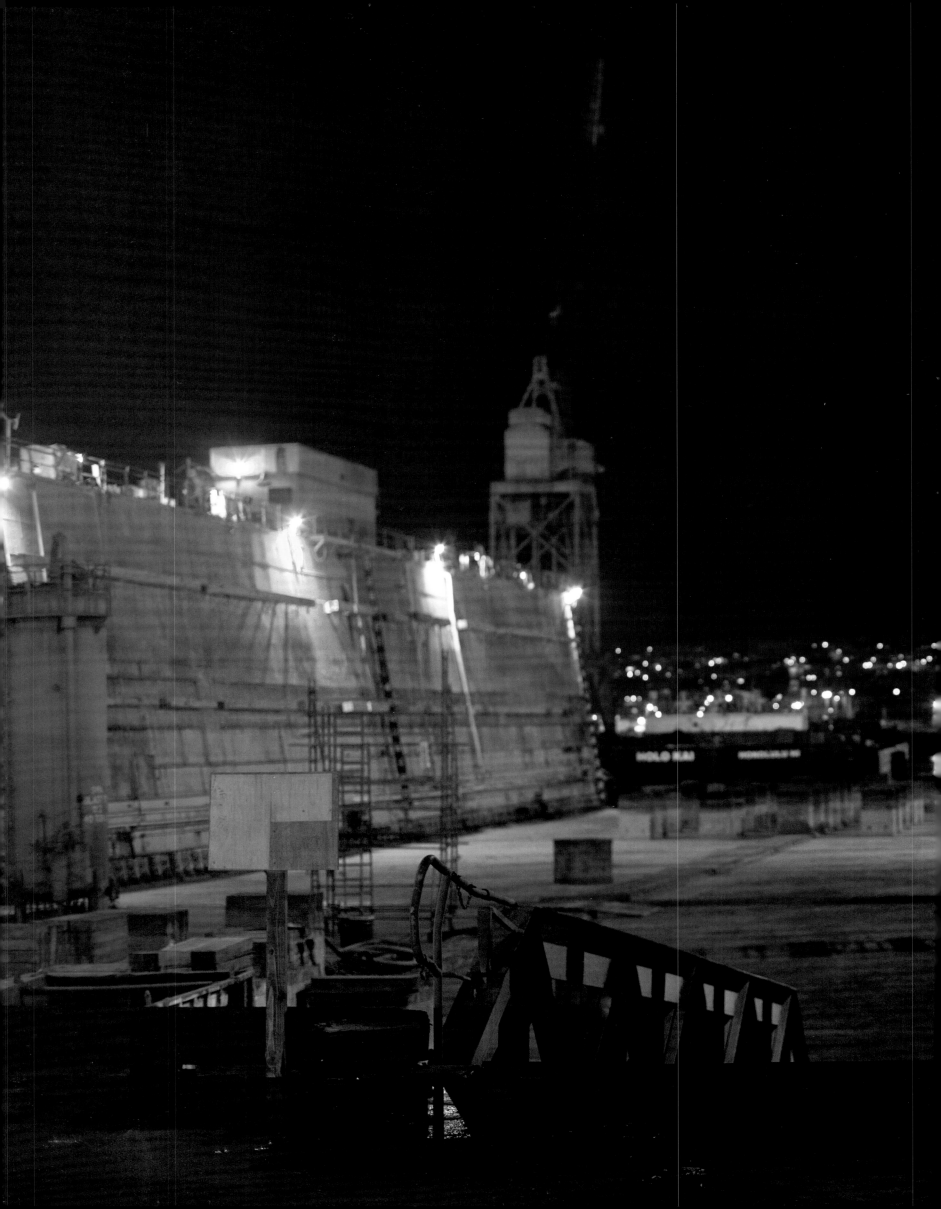

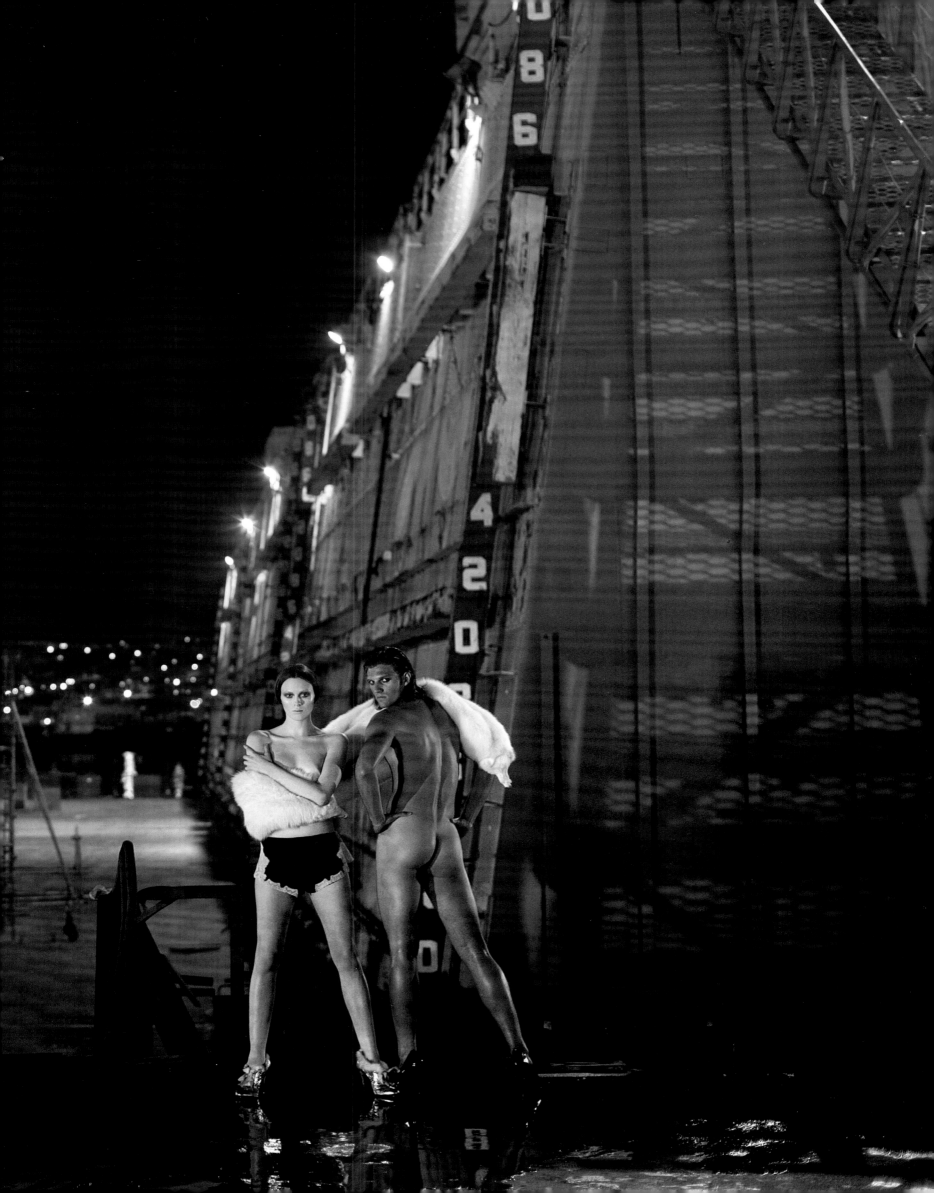

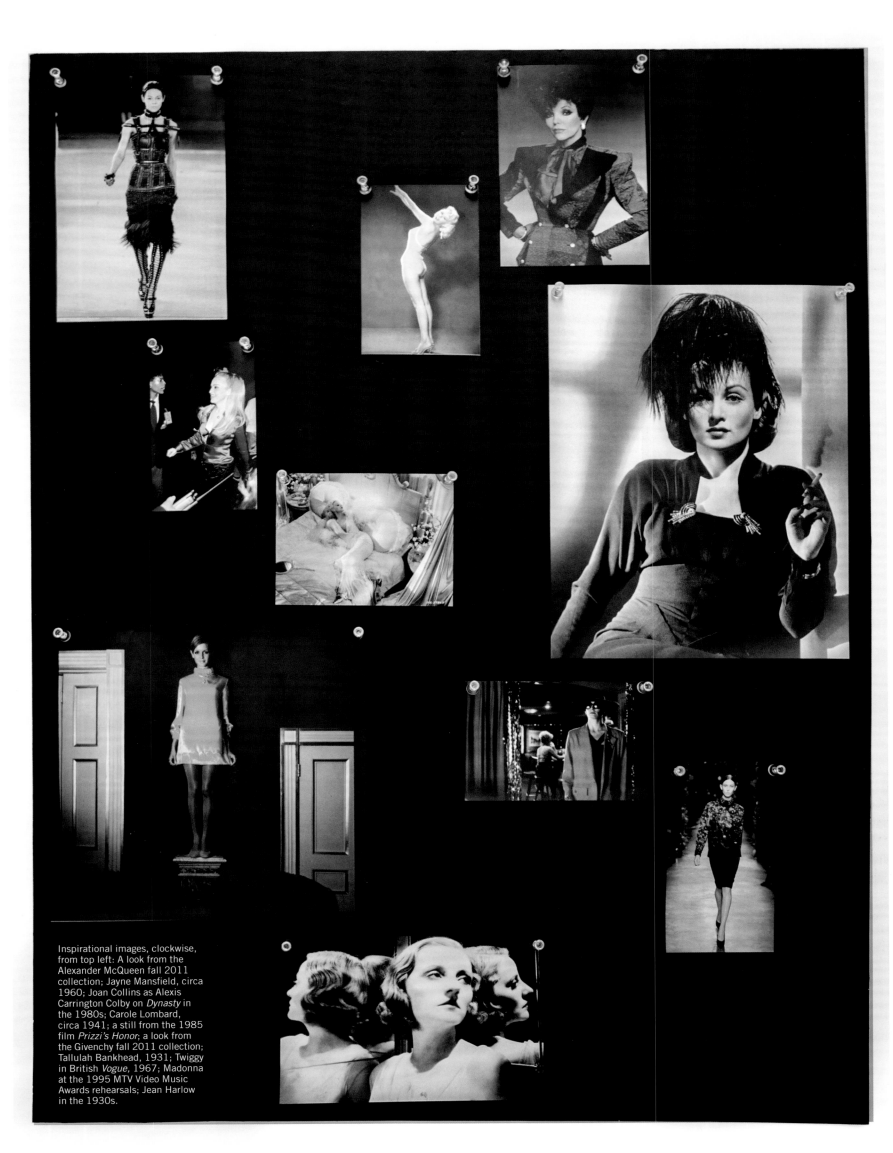

Inspirational images, clockwise, from top left: A look from the Alexander McQueen fall 2011 collection; Jayne Mansfield, circa 1960; Joan Collins as Alexis Carrington Colby on *Dynasty* in the 1980s; Carole Lombard, circa 1941; a still from the 1985 film *Prizzi's Honor*; a look from the Givenchy fall 2011 collection; Tallulah Bankhead, 1931; Twiggy in British *Vogue*, 1967; Madonna at the 1995 MTV Video Music Awards rehearsals; Jean Harlow in the 1930s.

ONE FOR THE AGES

THE MODEL AND ACTRESS AMBER VALLETTA TOOK A DECADE-BY-DECADE TRIP THROUGH THE CENTURY FOR THIS AGE-DEFYING TALE.

When I was first approached to model in this story, all I was told was that it would be about aging. Initially, I didn't quite understand the scope of it. I thought it was going to be about showing fashion through the years, but ultimately it was about so much more.

Steven Klein, the photographer, went on to explain that he wanted to age me from 30 years old all the way to 120. It was a bold idea on his part—not to mention *W*'s—and, for me, a leap of faith. Modeling is all about looking like the best version of one's self, and in this story we would be pushing the boundaries of what people normally consider beautiful. I had never done anything like this before, nor had I seen it done in a fashion magazine. But if anyone could do it—and do it well—it was Steven. There is such a twisted artistry to his work, and yet it's always sexy. I've worked with him for over 15 years, and I knew that, at the very least, the photos would be extremely interesting.

Preparations began weeks before the actual shoot, with a prosthetics fitting at Tinsley Studio in L.A., where they do makeup effects for film and TV. Dominie Till, who worked as the prosthetics supervisor on the *Lord of the Rings* trilogy, made a cast of my face and hands. First they cover your entire head—except for the nostrils—in a gooey gel. Then they put a layer of plaster on top of that, which takes 30 minutes to harden. It's slightly claustrophobic and scary, but I had been through it a couple of times—once for a TV pilot about vampires, and again for the film *What Lies Beneath*. For this shoot, they created several prosthetics for different parts of my face—the bags under my eyes, the jowls around my chin—and they built upon them to age me.

The shoot took place in New York at Highline Stages over the course of two days that started at 9 a.m. and went on until 2 or 3 in the morning. Many of those hours were spent in the makeup chair, and I fell asleep a couple of times while getting my hair and prosthetics done. But when you're enjoying something, it doesn't feel difficult, and this shoot was a lot of fun.

Instead of using film, Steven used a Red digital camera, which produces high-resolution video. So each setup was shot as a one-to-six-minute-long scene, making it a bit different from your average fashion shoot. I definitely approached it more as an actress than as a model. For the shot where I'm around 110 years old, we were playing very sad, ethereal music from the film *Mulholland Drive*. The story was that I had aged and my lover hadn't, and when he saw me he wasn't sure whether it was me or not. Things got very emotional, and I started to cry. The final scene, where I'm 120 years old and climbing a set of stairs—essentially, toward death—was all about transcendence and peace.

It's definitely odd seeing yourself as a much older person. But it's also fascinating to witness what you might look like down the road. Funnily enough, I actually really liked the way I looked at 120. In fact, I preferred the oldest versions of myself to the ones where I was about 70 or 80, when I looked as though I'd had plastic surgery. That felt unnatural. But there was something very calm and gentle about me at 120, and I found it sort of lovely. I was freaking everyone else out, though, especially when I started to dance around looking like a little old lady. That's the hardest thing about getting to a certain age: You feel the same on the inside as you always did—perhaps a little wiser and more secure—but on the outside you're very different. My grandmother used to say that aging isn't for cowards, and she was right. People stop looking at you, and you just sort of disappear, especially in our youth-obsessed culture.

I turned 40 this year, and I have mixed feelings about it. I know I still look relatively young, but I'm not fooling myself: I'm 40 looking at 60, not 20 looking at 40. And I'm doing everything I can to slow the process! I exercise and eat well. I'm into noninvasive treatments like facials and lasers. But I think what's most important is mental health. I'm a firm believer that how you feel on the inside is reflected on the outside. I meditate and take care of myself internally. Which is to say, I make sure that I'm peaceful and grateful. And this shoot definitely made me feel grateful to be the age I am.

PHOTOGRAPHED BY STEVEN KLEIN
STYLED BY EDWARD ENNINFUL
PUBLISHED IN SEPTEMBER 2011

To view the film inspired by this story, go to www.abramsbooks.com/wstories and enter access code wstories5films

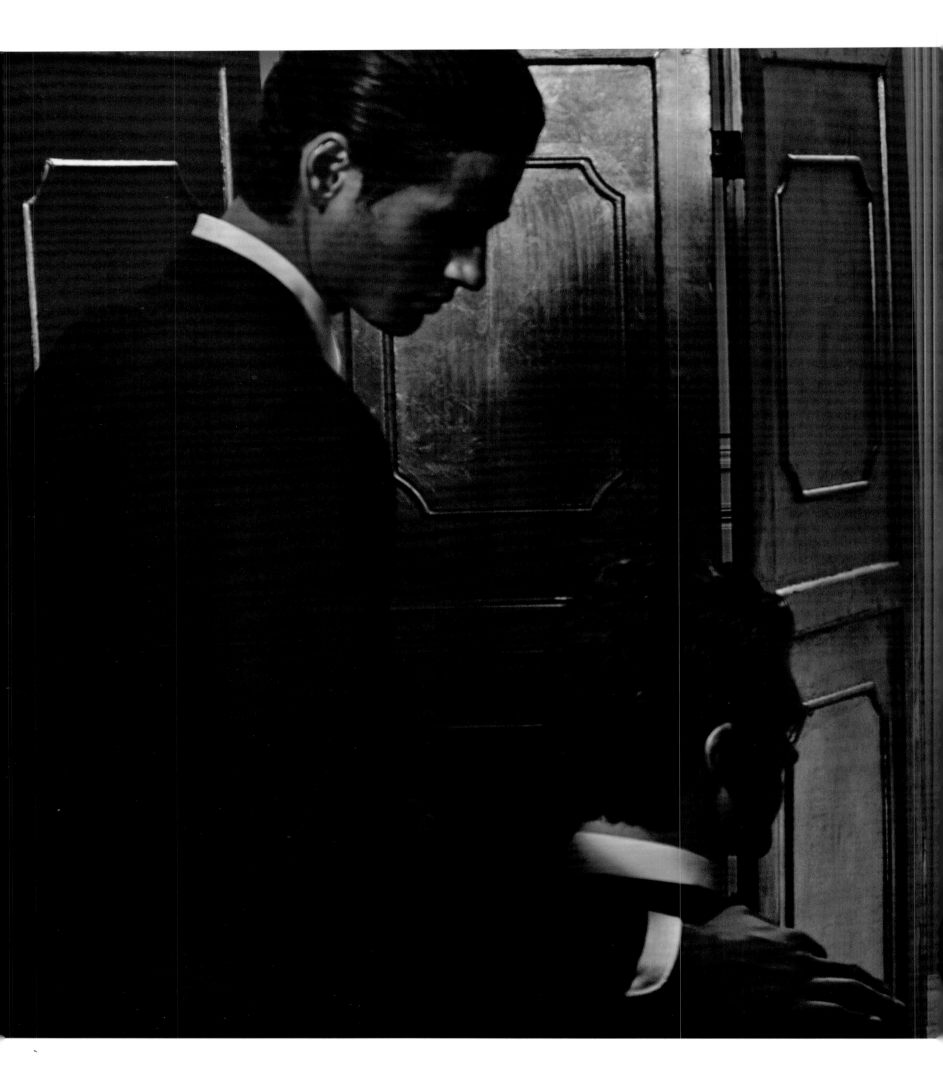

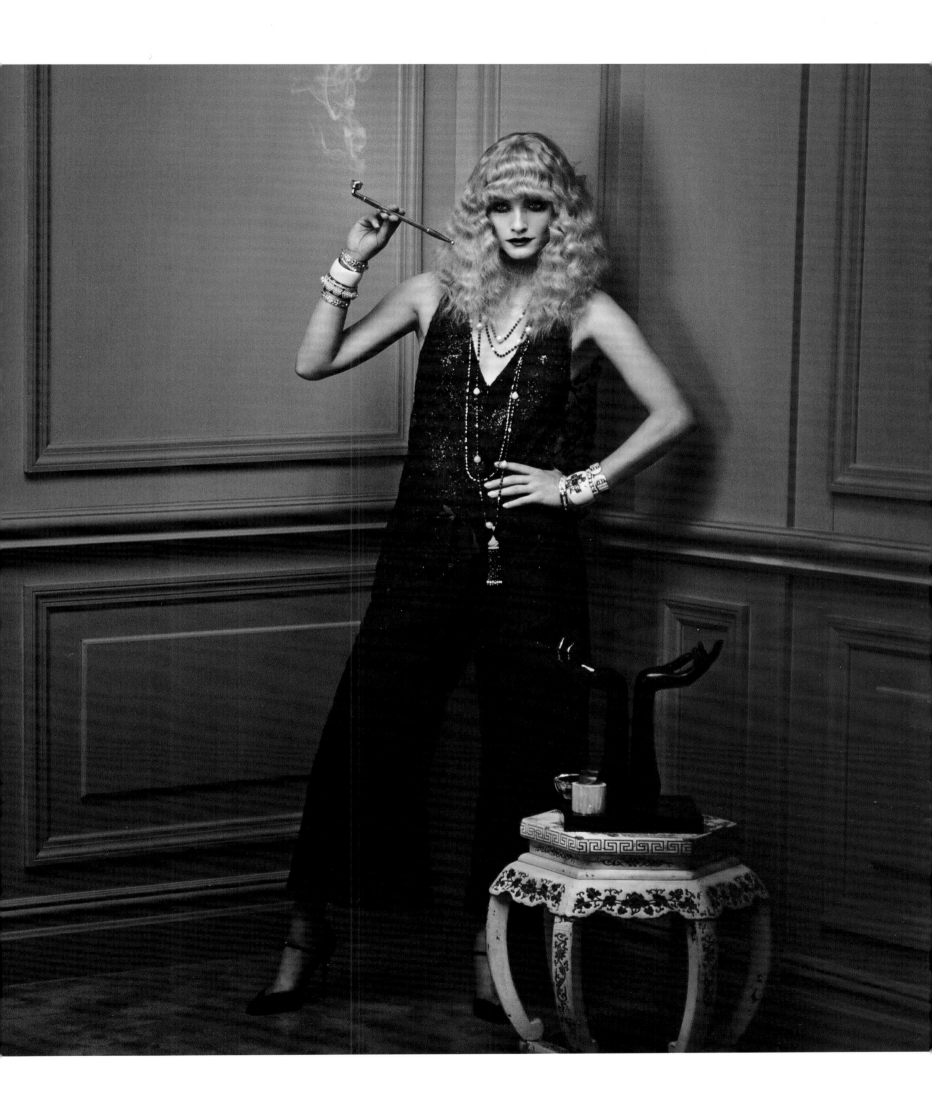

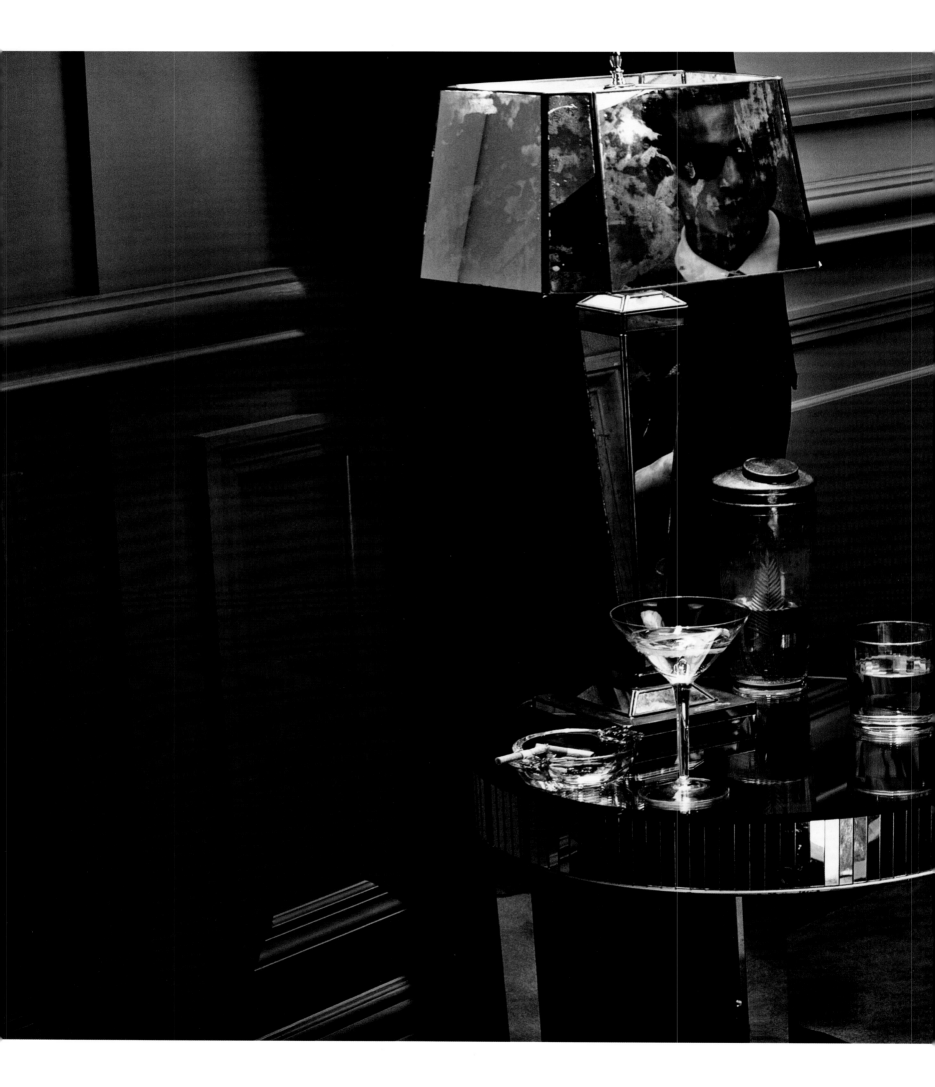

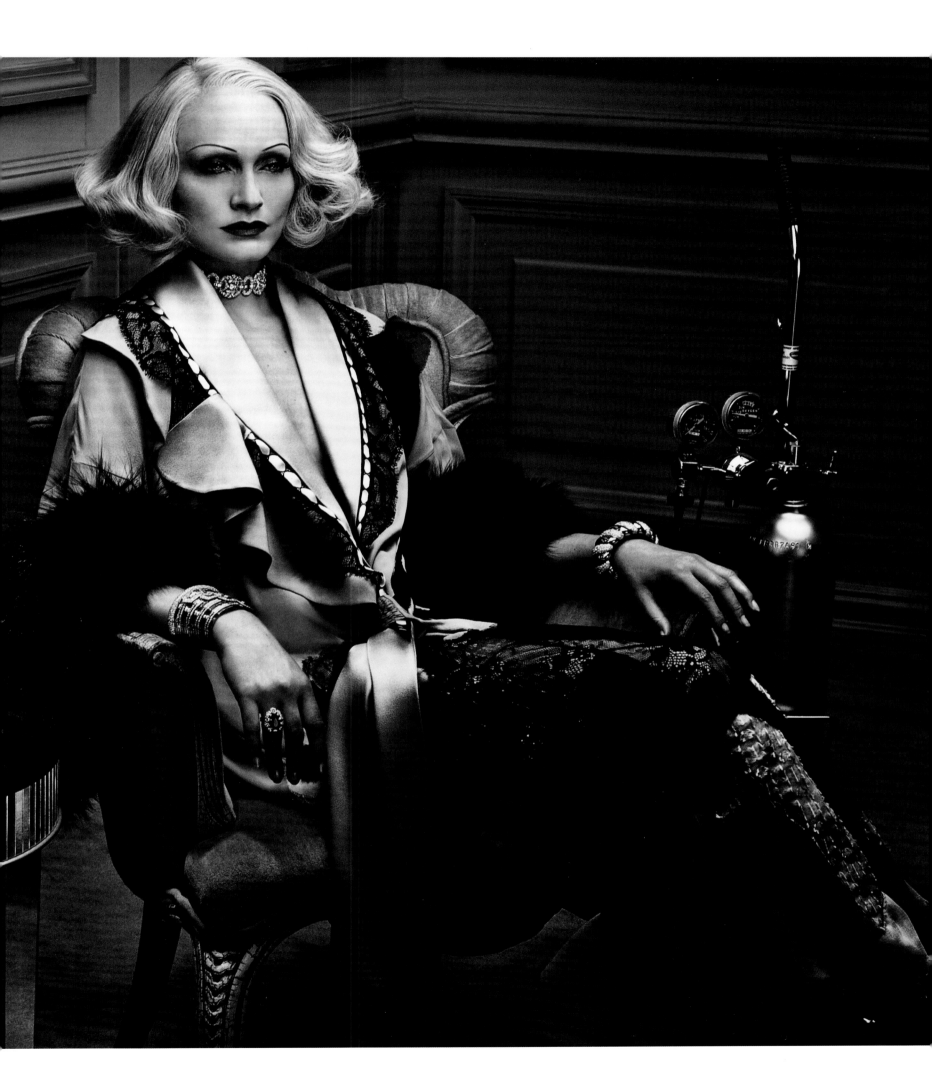

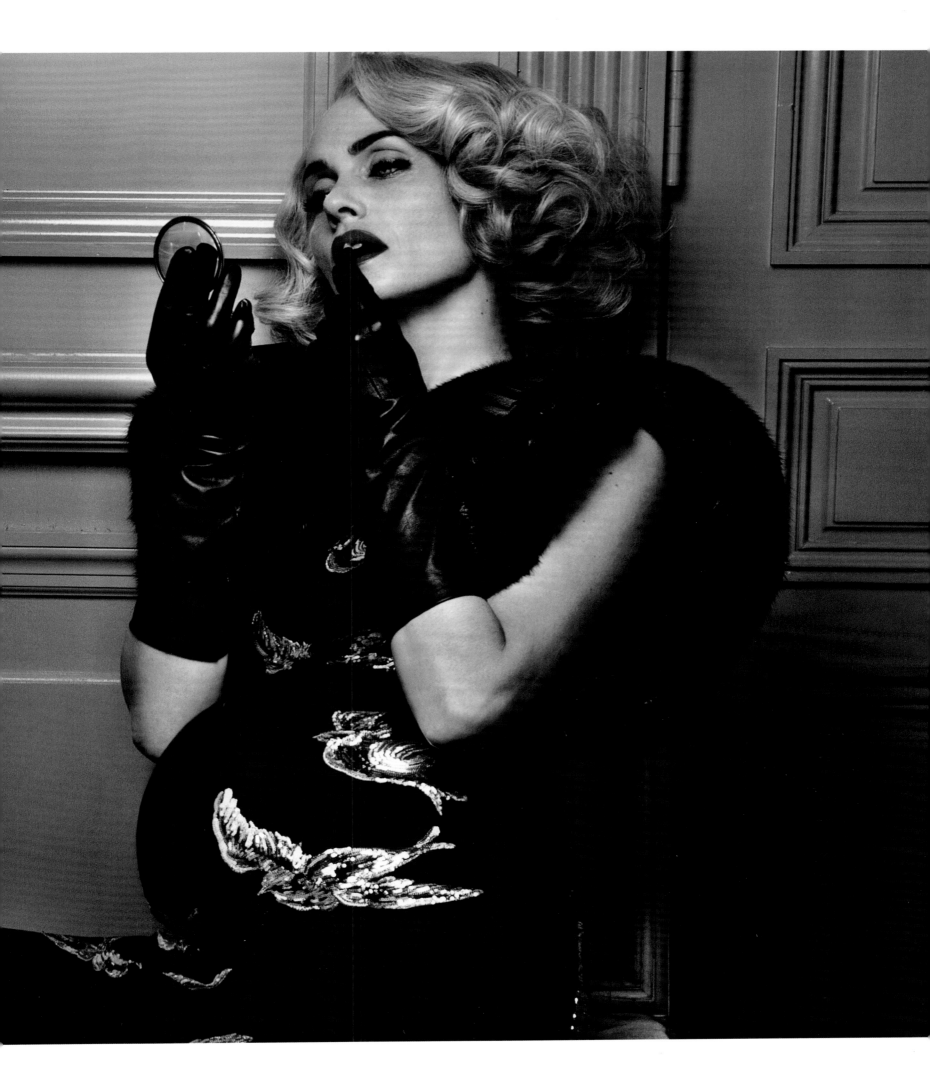

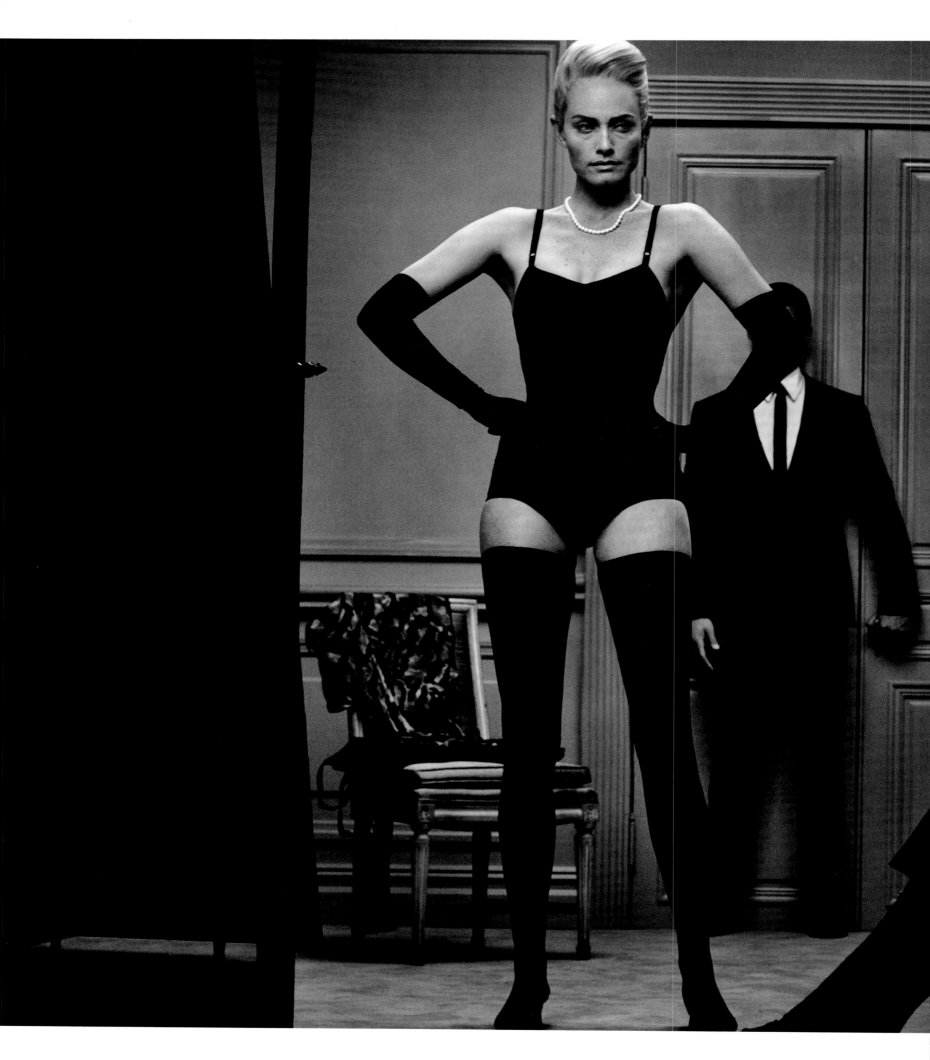

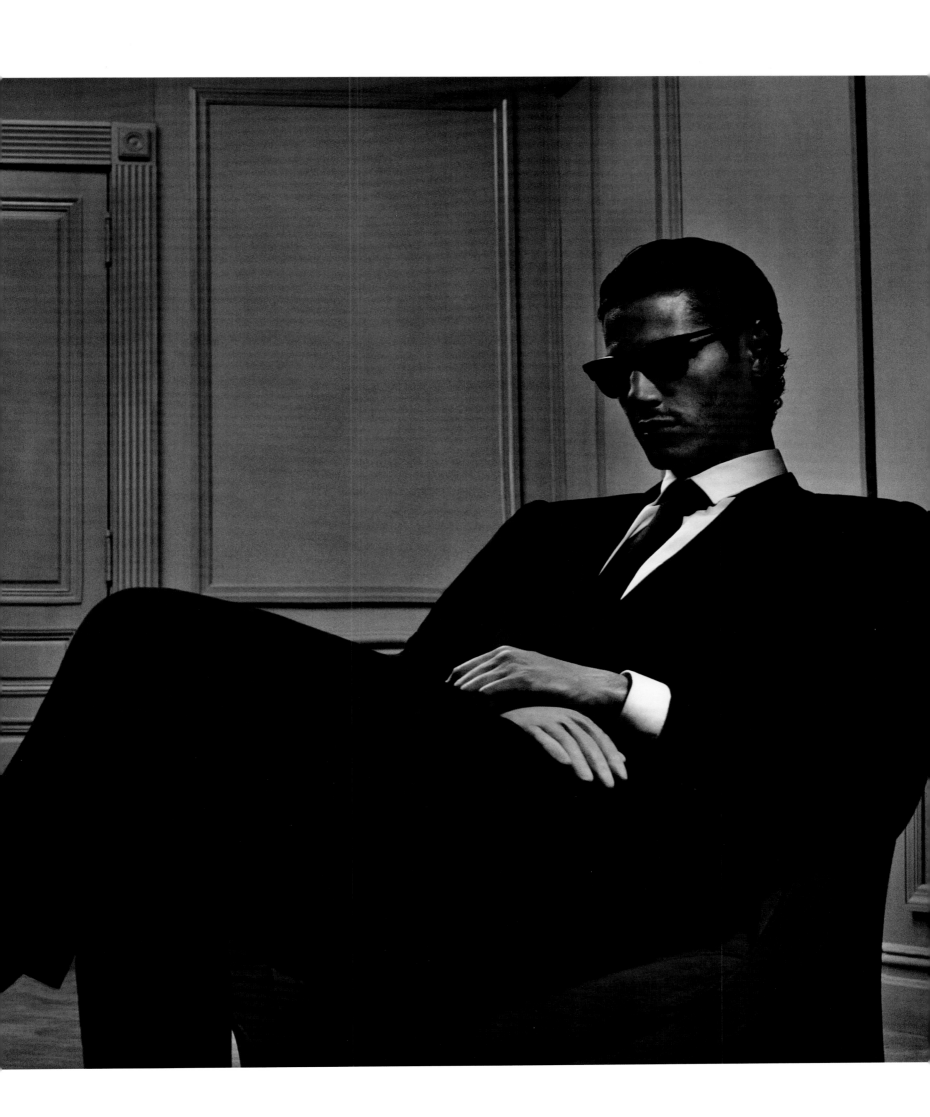

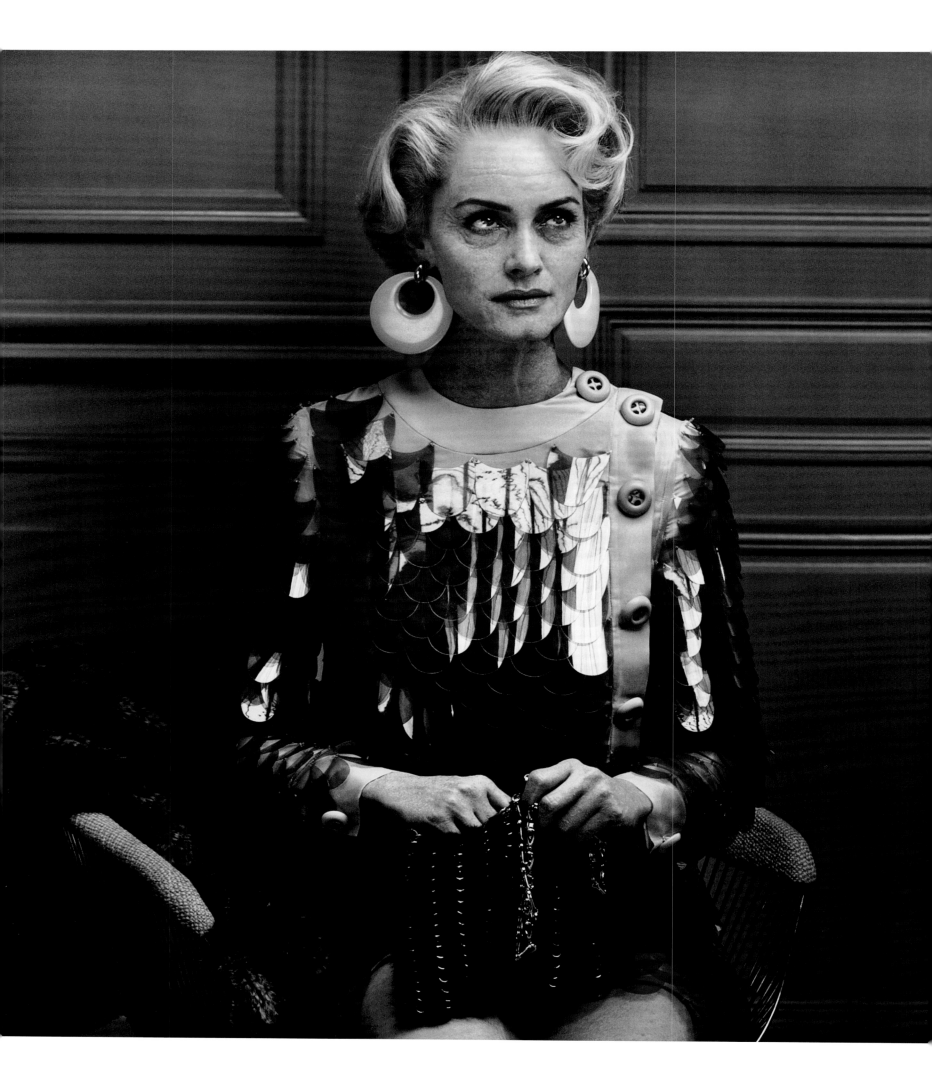

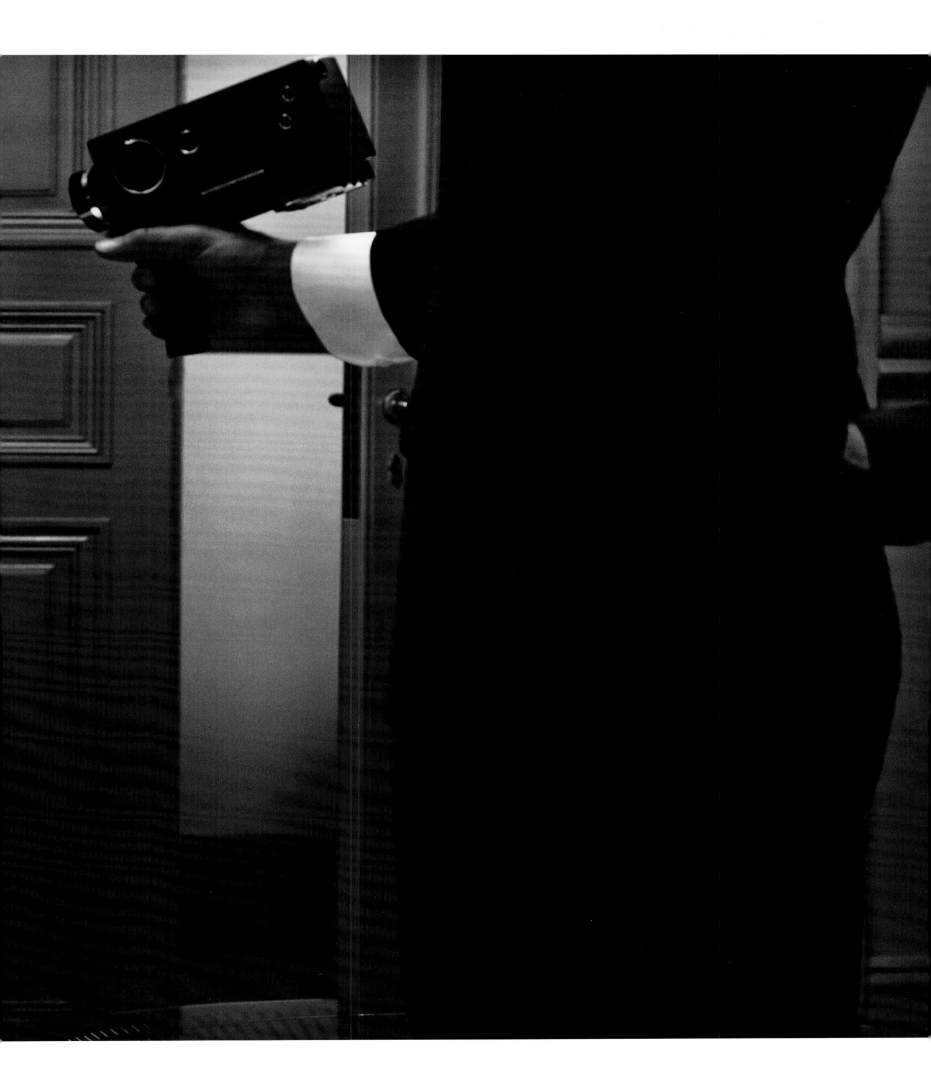

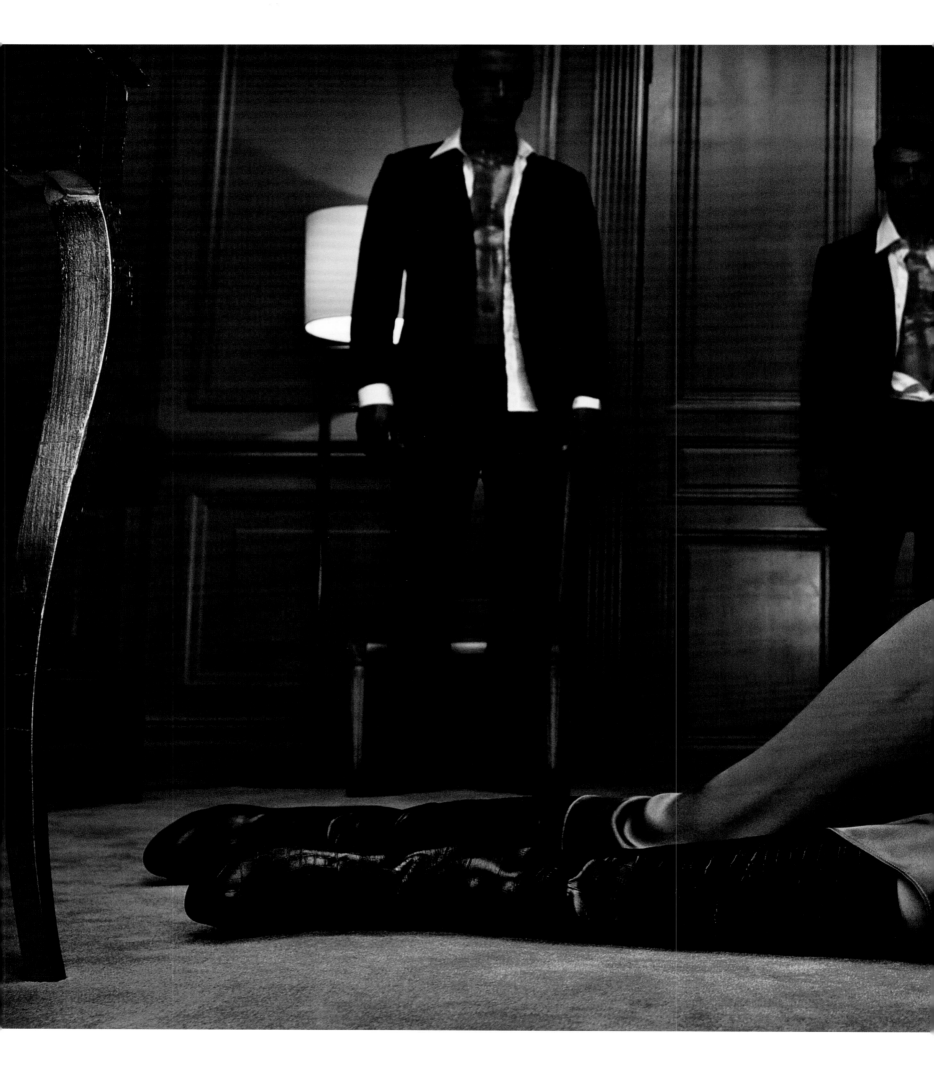

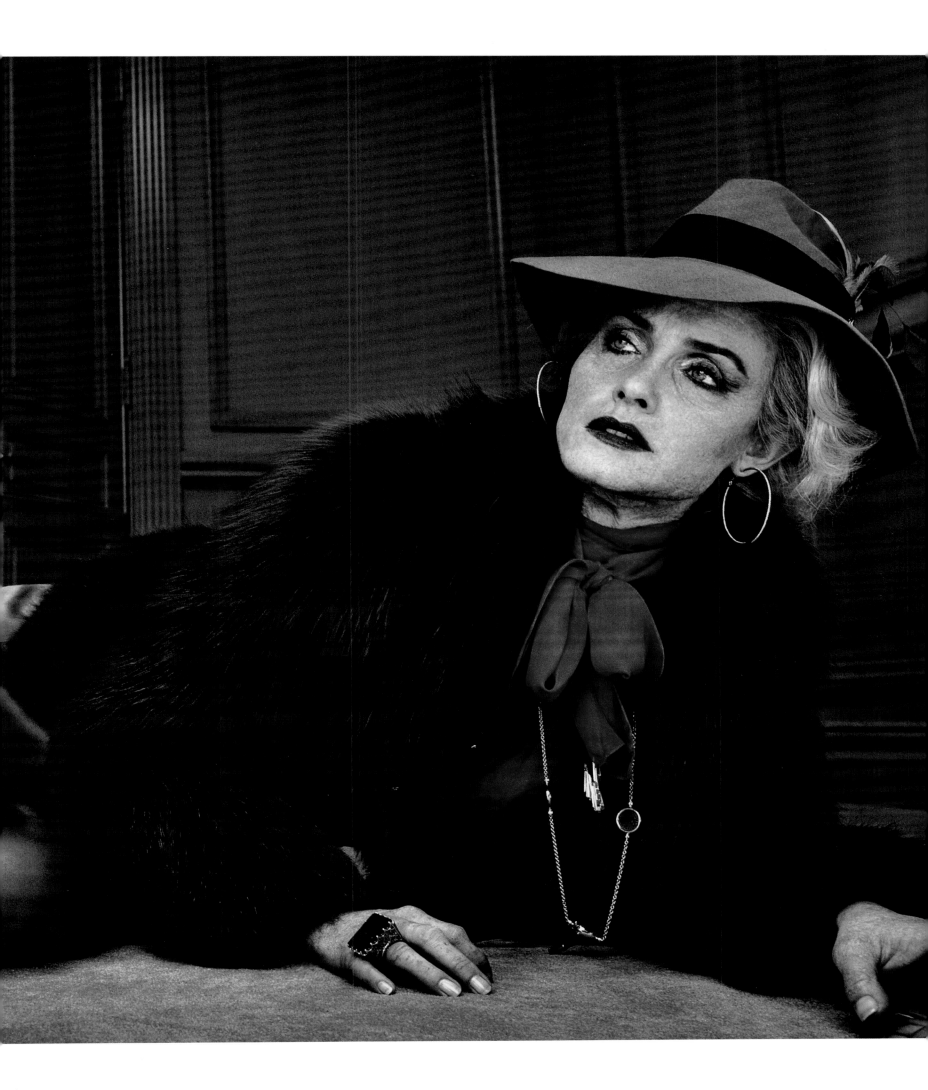

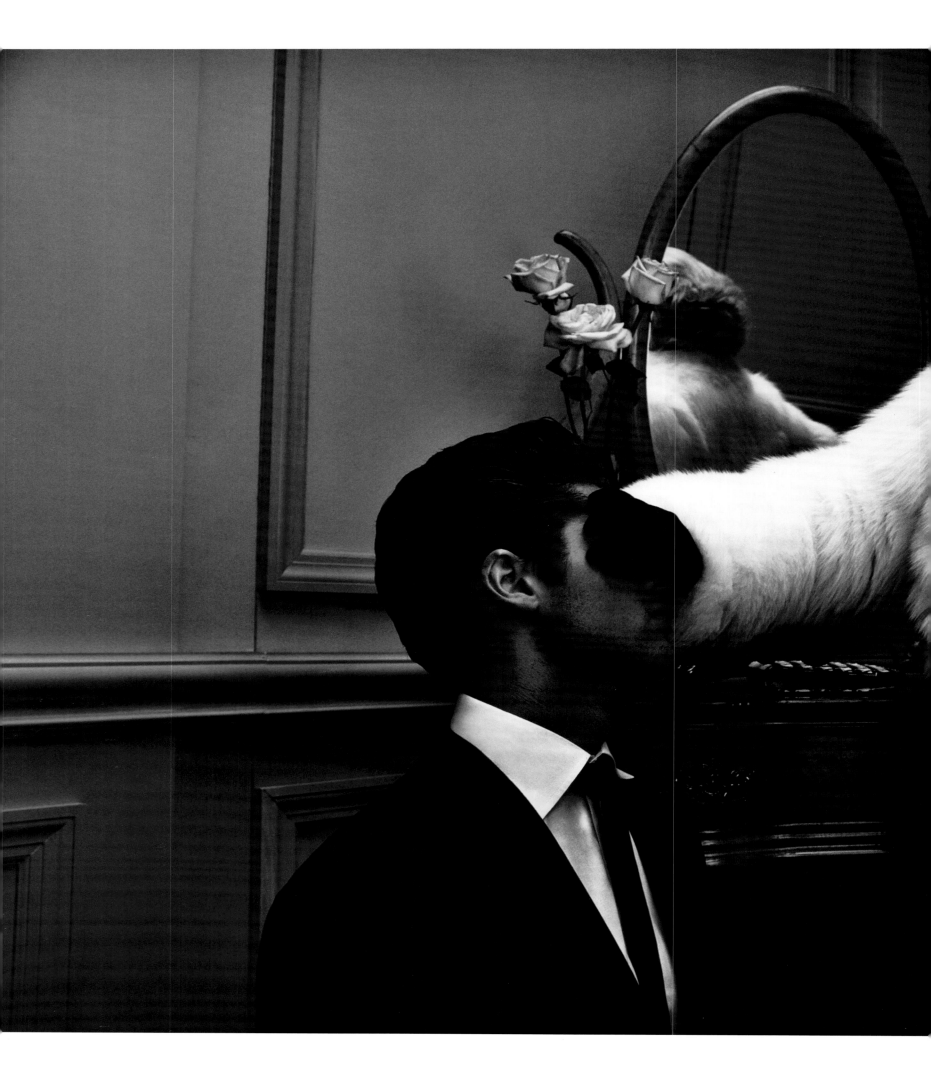

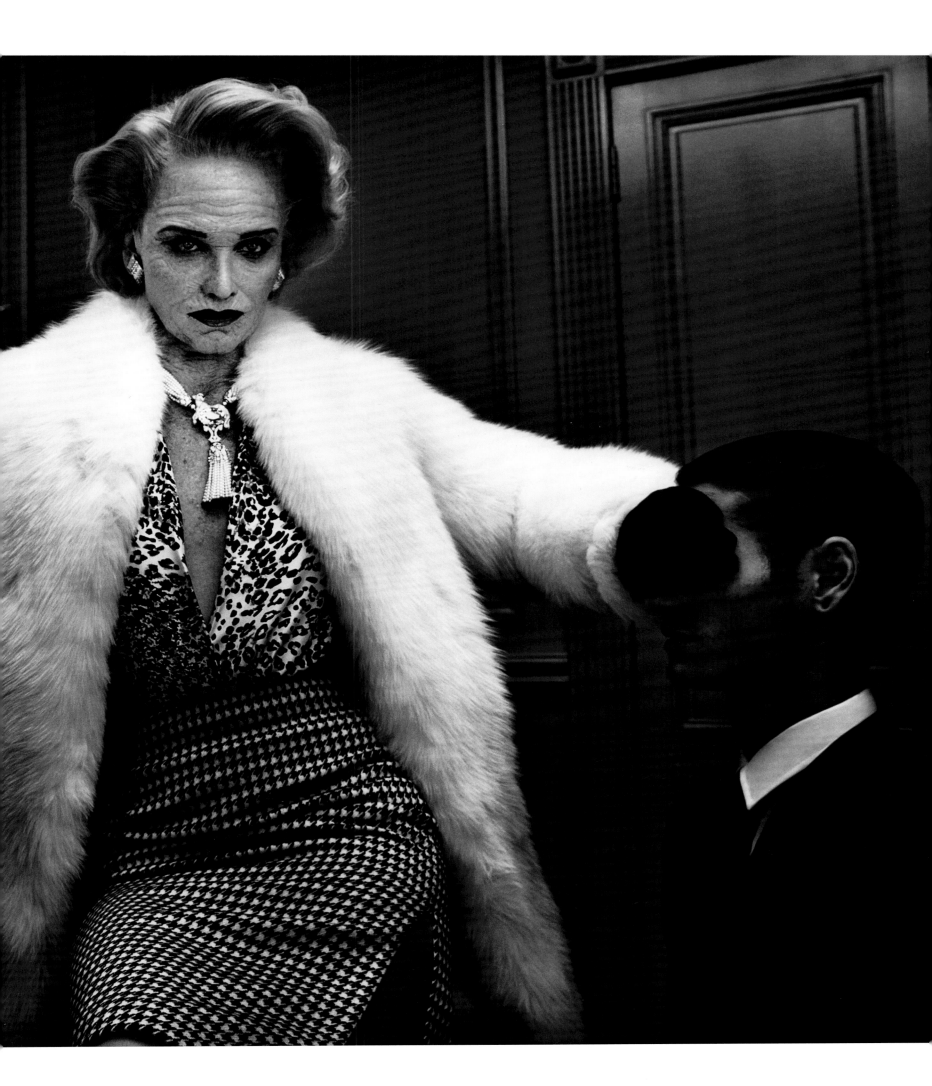

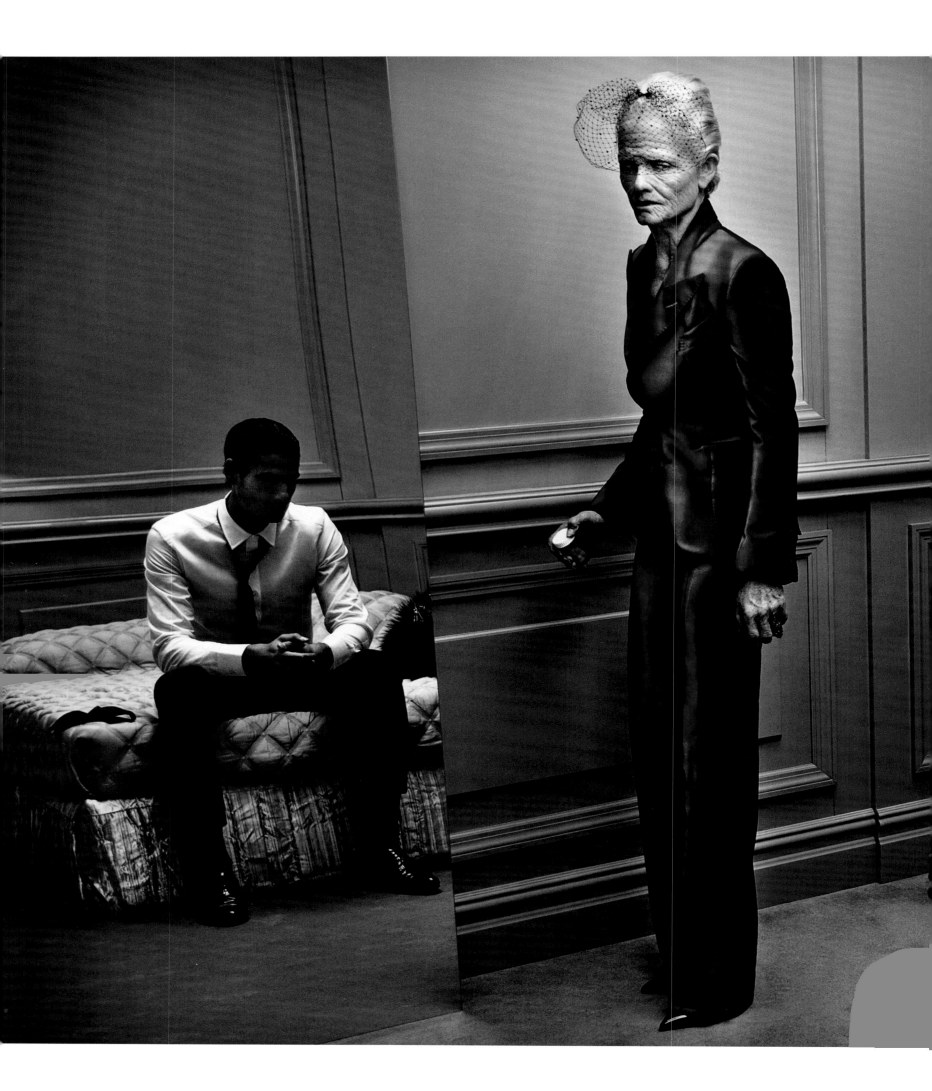

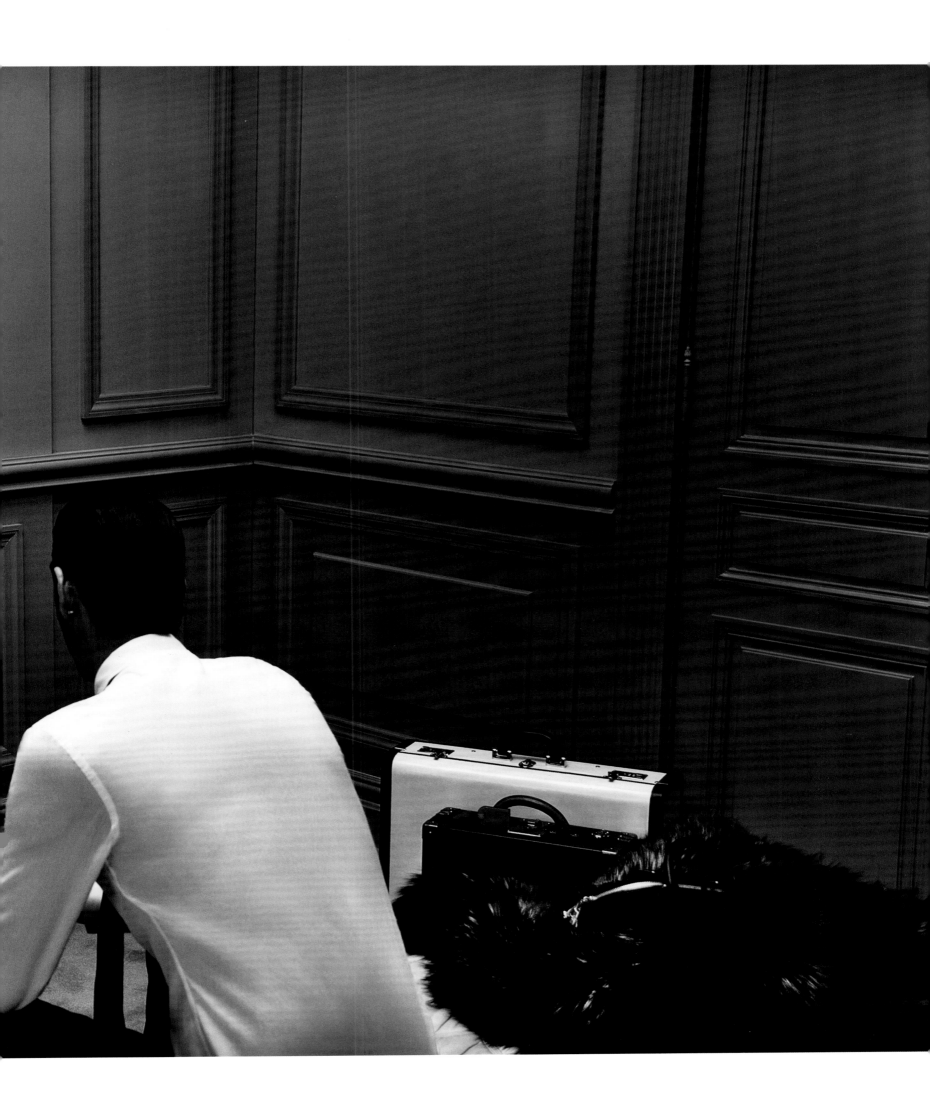

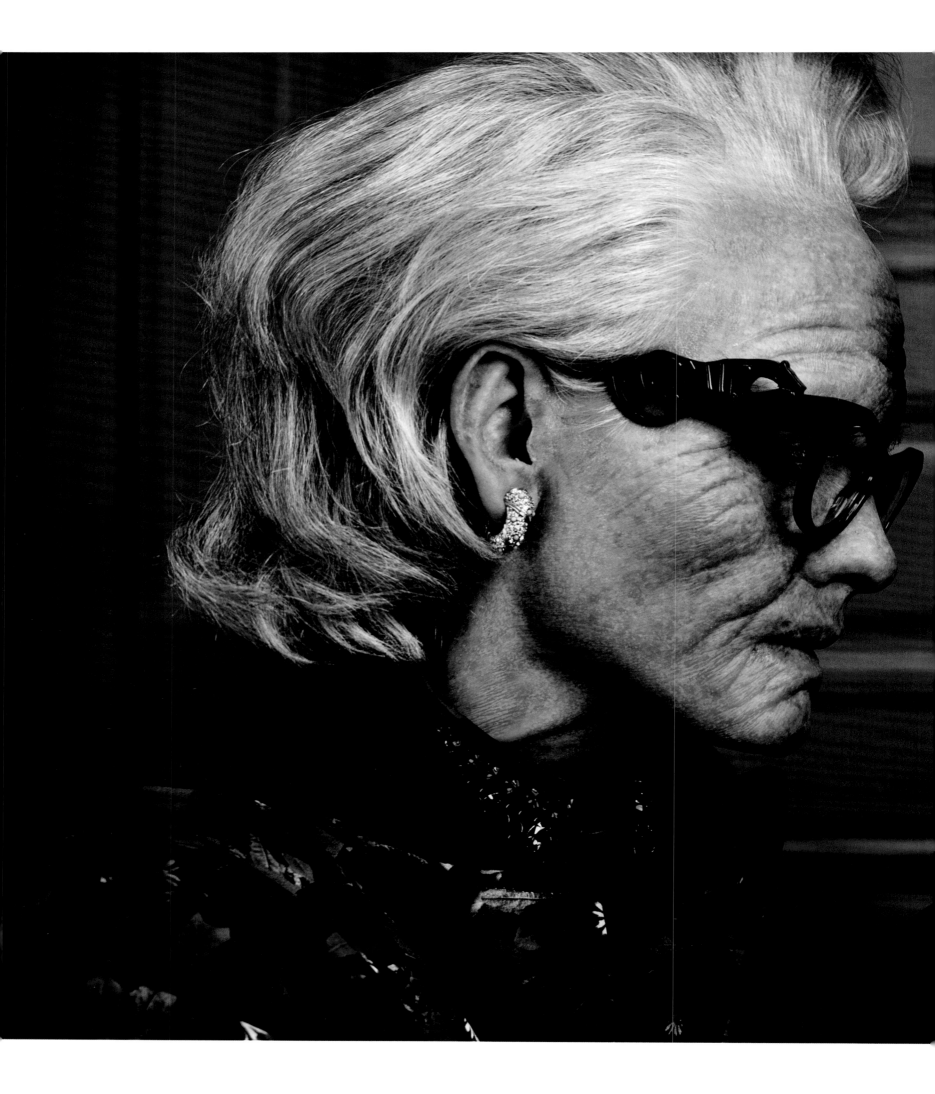

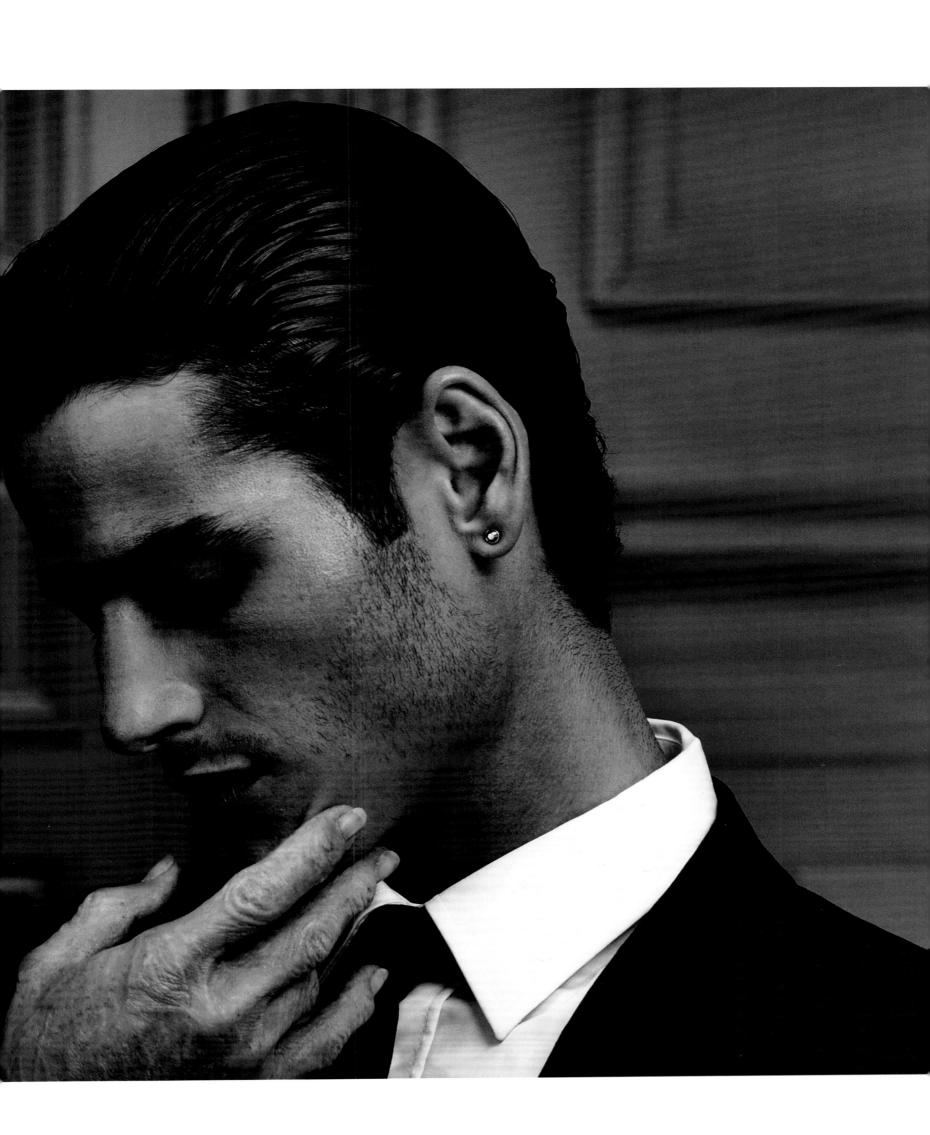

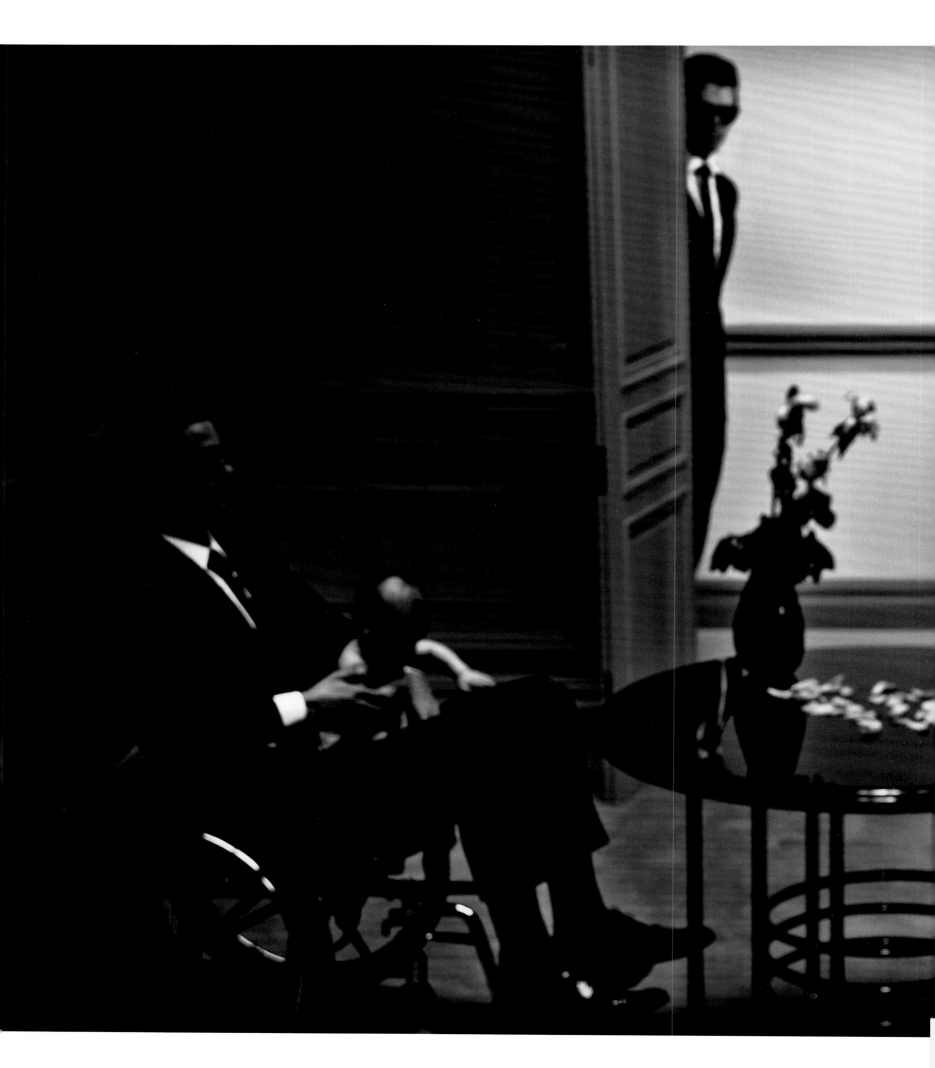

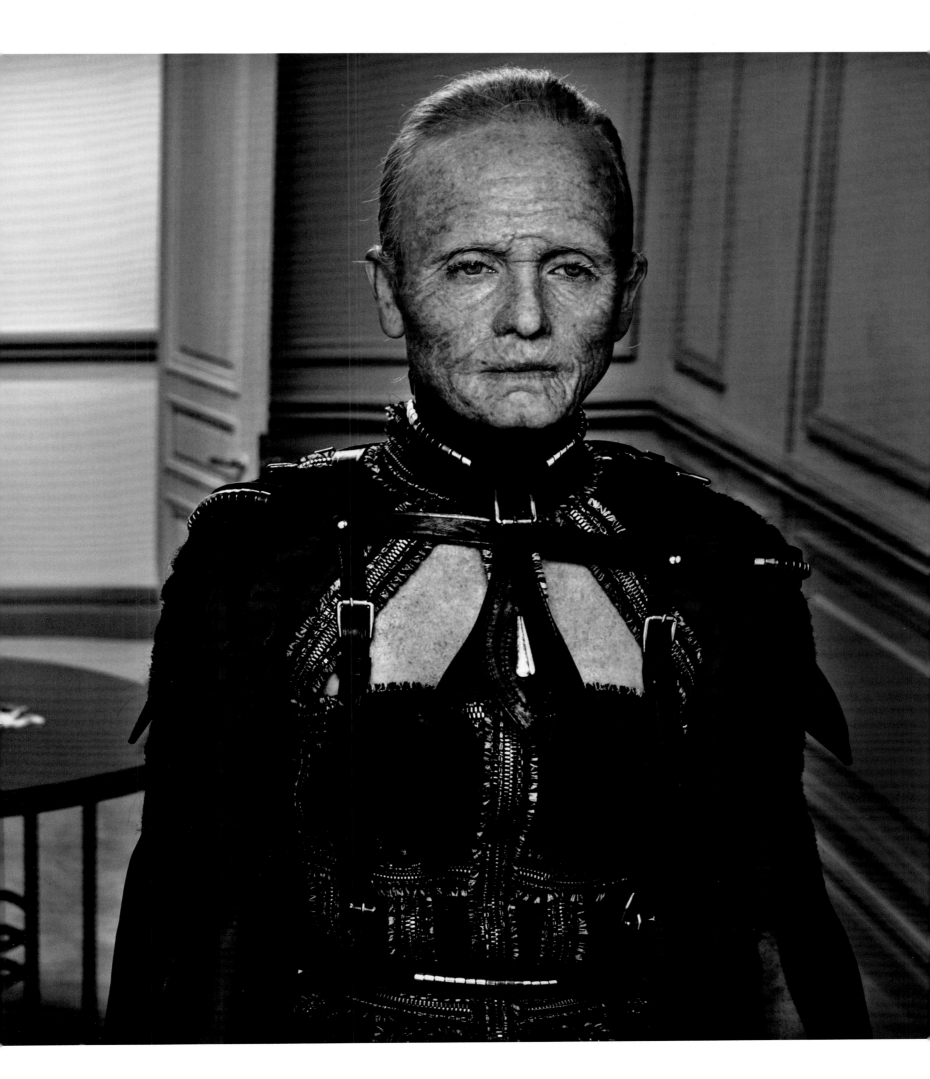

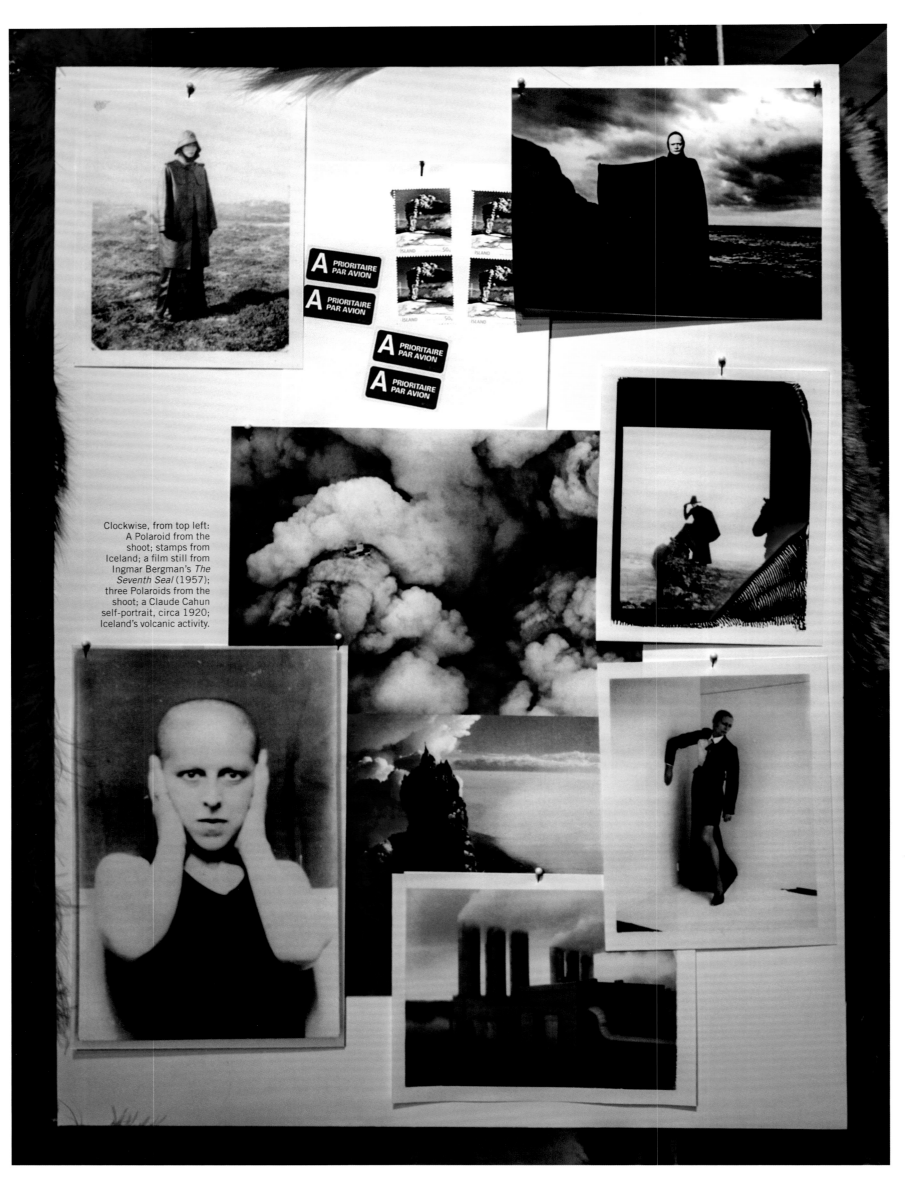

Clockwise, from top left: A Polaroid from the shoot; stamps from Iceland; a film still from Ingmar Bergman's *The Seventh Seal* (1957); three Polaroids from the shoot; a Claude Cahun self-portrait, circa 1920; Iceland's volcanic activity.

PLANET TILDA

ICELAND'S LUNARLIKE LANDSCAPE SETS
THE STAGE FOR AN OTHERWORLDLY ADVENTURE LED
BY THE ACTRESS TILDA SWINTON.

The photographer Tim Walker and I, along with our mutual friend the creative director Jerry Stafford, had been eager to make a story together for some time. After I filmed *The Beach*, I asked Jerry to introduce me to a few fashion designers; if I was to be photographed at events, I wanted to know who had made my clothes, so I could feel comfortable in them. Getting dressed for public appearances is a performance, and whether I'm working with Haider Ackermann, Phoebe Philo, Raf Simons, or Alber Elbaz, the designer is part of the narrative. But aside from red carpet events, Jerry and I work together on editorial stories, and we take them as seriously as if they were major pieces of work. We ask each other: *What's the story and location? What are the references?*

The idea of going to a wilderness intrigued all of us. We wanted to show a human character isolated in a nonhuman (even inhuman) sort of wilderness. Shooting in a Tesla coil was something Tim had long wanted to explore, and for a moment—until practicalities restricted us—it felt like we would do it. Then we thought of a remote desert like Marfa, Texas, with all that dry air and hallucinatory art. We kicked around this idea for a while, until somehow Iceland started to capture our imagination. And once it took hold, it proved irresistible.

I had never been to Iceland before, though I have several Icelandic friends and had heard them tell stories about their country. My impression was that it was a place of openness, warmth of human spirit, newness of ideas and landforms, flux, thermal activity, black sand, red rock, pale-blue milky water, steaming hillsides, tiny shaggy ponies, and fairies and elves. I wasn't off. For someone like me, who is devoted to life in the Scottish Highlands, Iceland is like home squared: Scotland on steroids. I found it nonstop inspiring and have been back several times.

It was not an easy terrain to be in—cheek-blasting from both the wind and the cold and, from time to time, pretty hot underfoot. Iceland is volcanic and in a state of constant renewal. Bubbling, scalding water springs from the center of the Earth, creating pools in an astonishing range of colors. We shot at a thermal-energy plant, so all the steam in the pictures is naturally produced; no smoke effects for us.

Jerry and I had made a mood board before the shoot, just the way I put one together for a film. It's a really useful way of tuning your aesthetic sense. Because the Icelandic countryside feels like a no-man's-land, we were drawn to the thought of portraying a dramatic character who seemed to have literally grown out of the ground, or who had fallen to Earth there and instantly taken to the landscape. Of course, David Bowie in the 1976 film *The Man Who Fell to Earth* was an influence. But we didn't want this story to feel reductive, so we also collated Arnold Genthe's portraits of Greta Garbo, stills from Ingmar Bergman's *The Seventh Seal*, and the work of the French artist and provocateur Claude Cahun, who is famous for her explorations of gender role play in the '20s. People talk about androgyny in all sorts of dull ways; Cahun looked at the limitlessness of an androgynous gesture, which is something that has always interested me. We wanted our pictures to show a new perspective, and also an ancient one—primal, even. Old footsteps, new eyes.

Our protagonist had to have a balance of robustness and angularity to survive in such a challenging/thrilling/inhospitable environment. She needed a kind of warrior attitude, but at the same time there had to be something vulnerable about her. Fashion-wise that translated into big shapes in monochromatic colors that felt like a kind of uniform. Bergman inspired the skull caps, and Cahun's images gave us the idea of making her bald, as well as of making her pale flesh gleam through a layer of Perspex, as if it were just out of reach—now you see it, now you don't. With her bare eyes and naked scalp, the character appeared somehow newborn, blinking in the light. To us, that made sense because Iceland is one of the newest landmasses on Earth, and the atmosphere we wanted to evoke was one of fresh arrival, of untapped and fluid possibilities.

PHOTOGRAPHED BY TIM WALKER
STYLED BY JACOB K
PUBLISHED IN AUGUST 2011

To view the film inspired by this story, go to www.abramsbooks.com/wstories and enter access code wstories5films

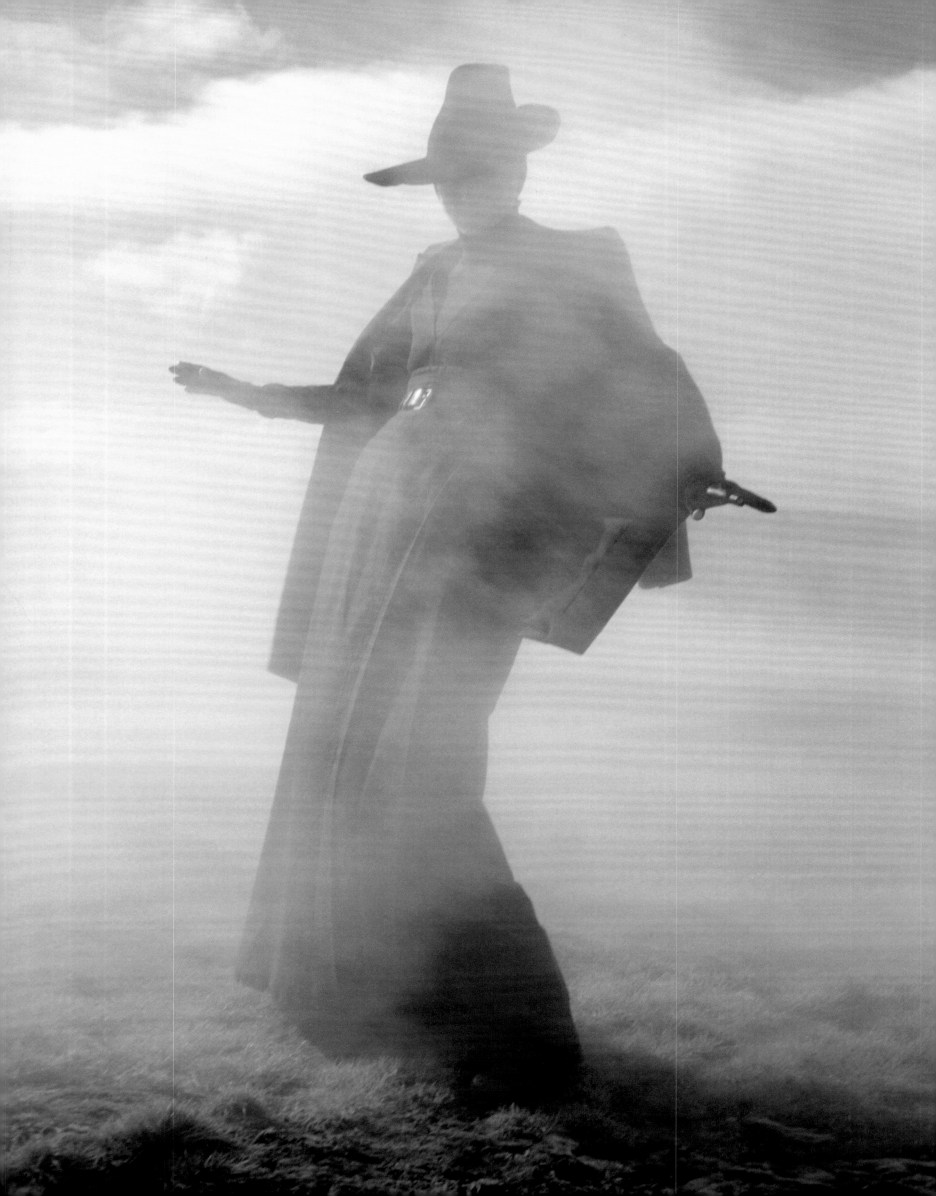

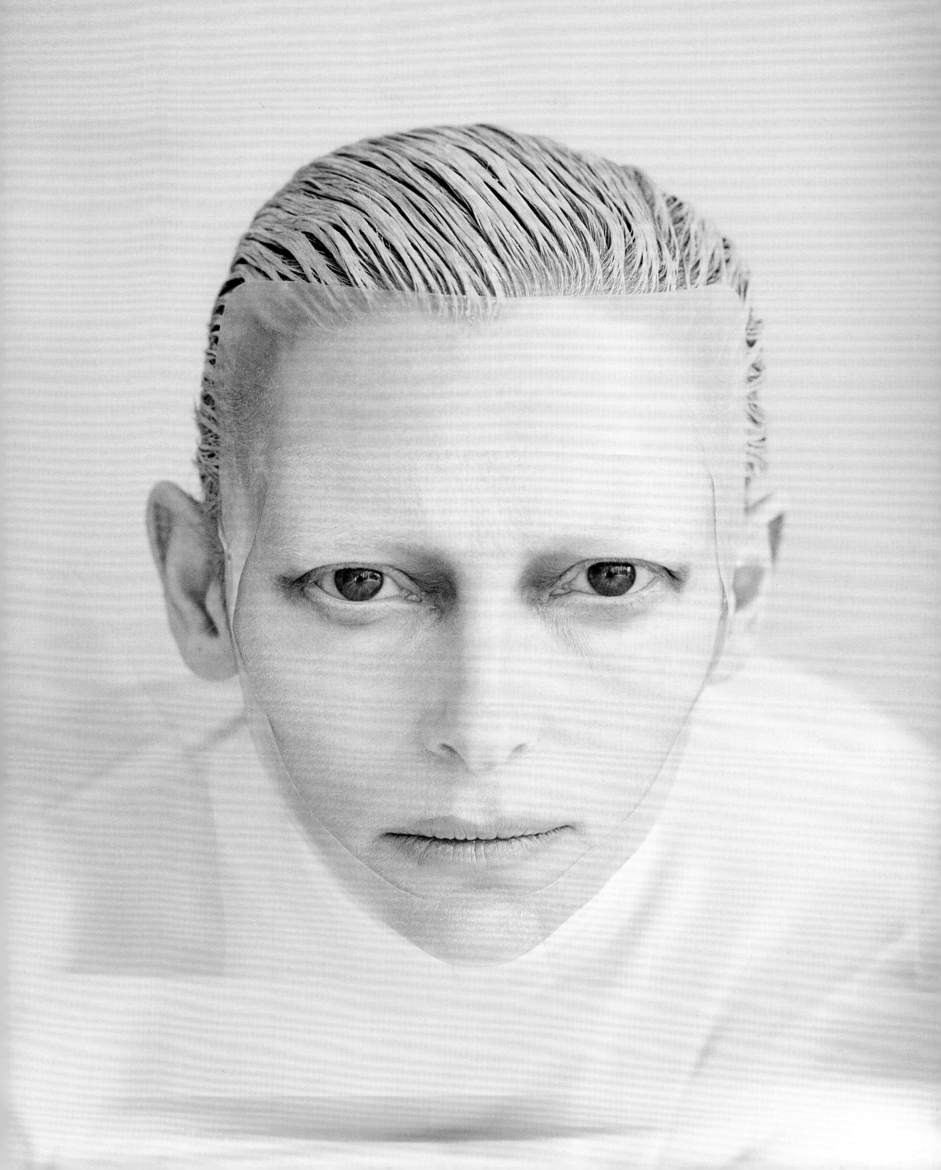

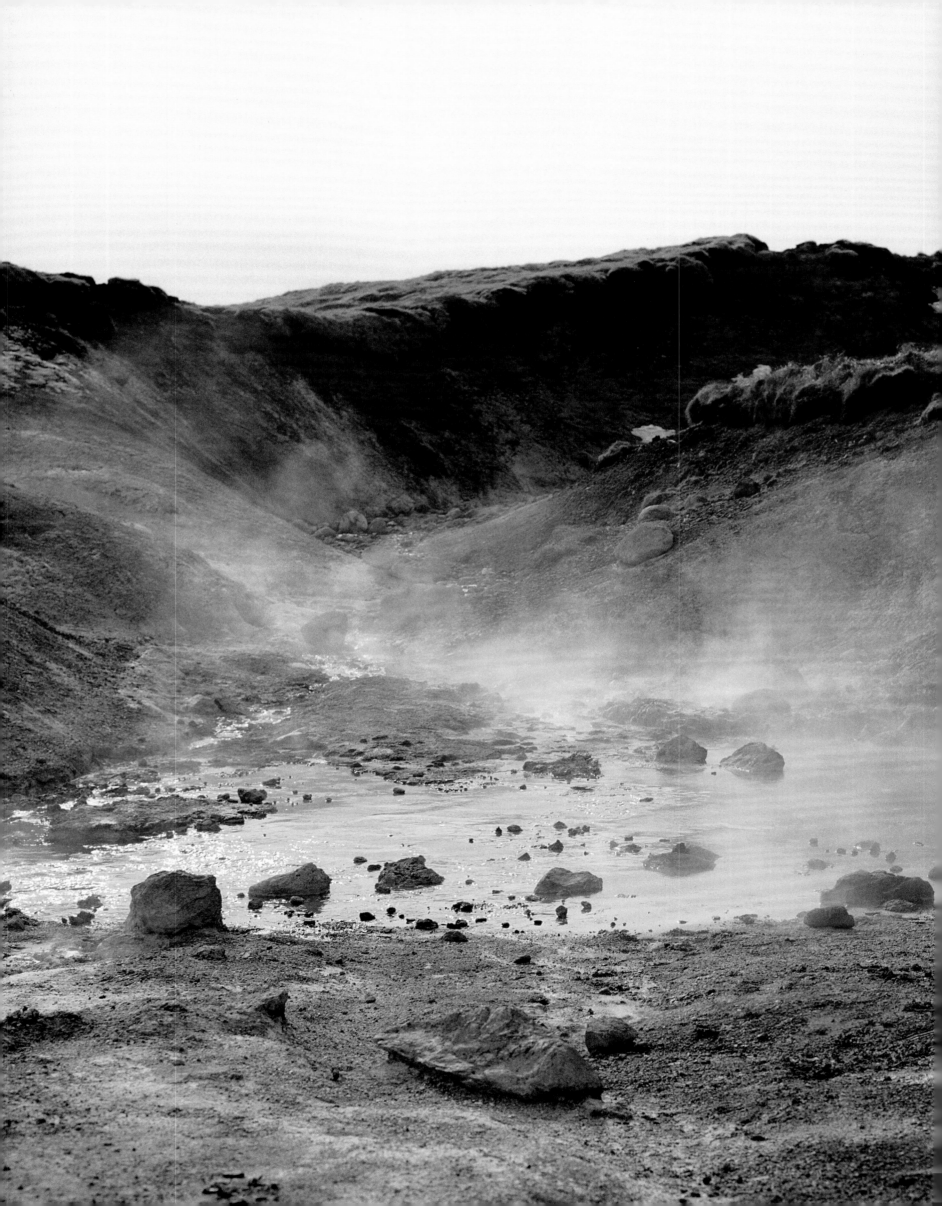

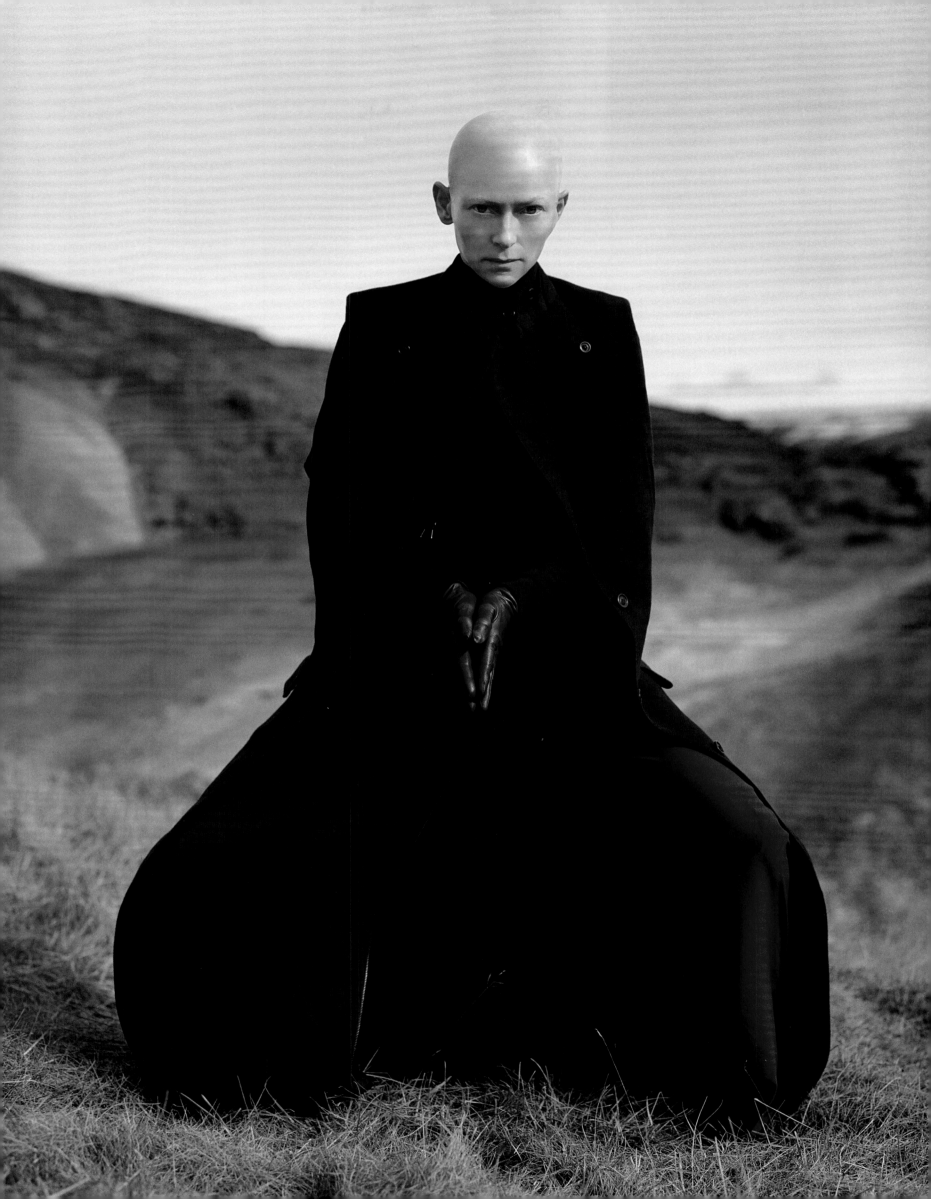

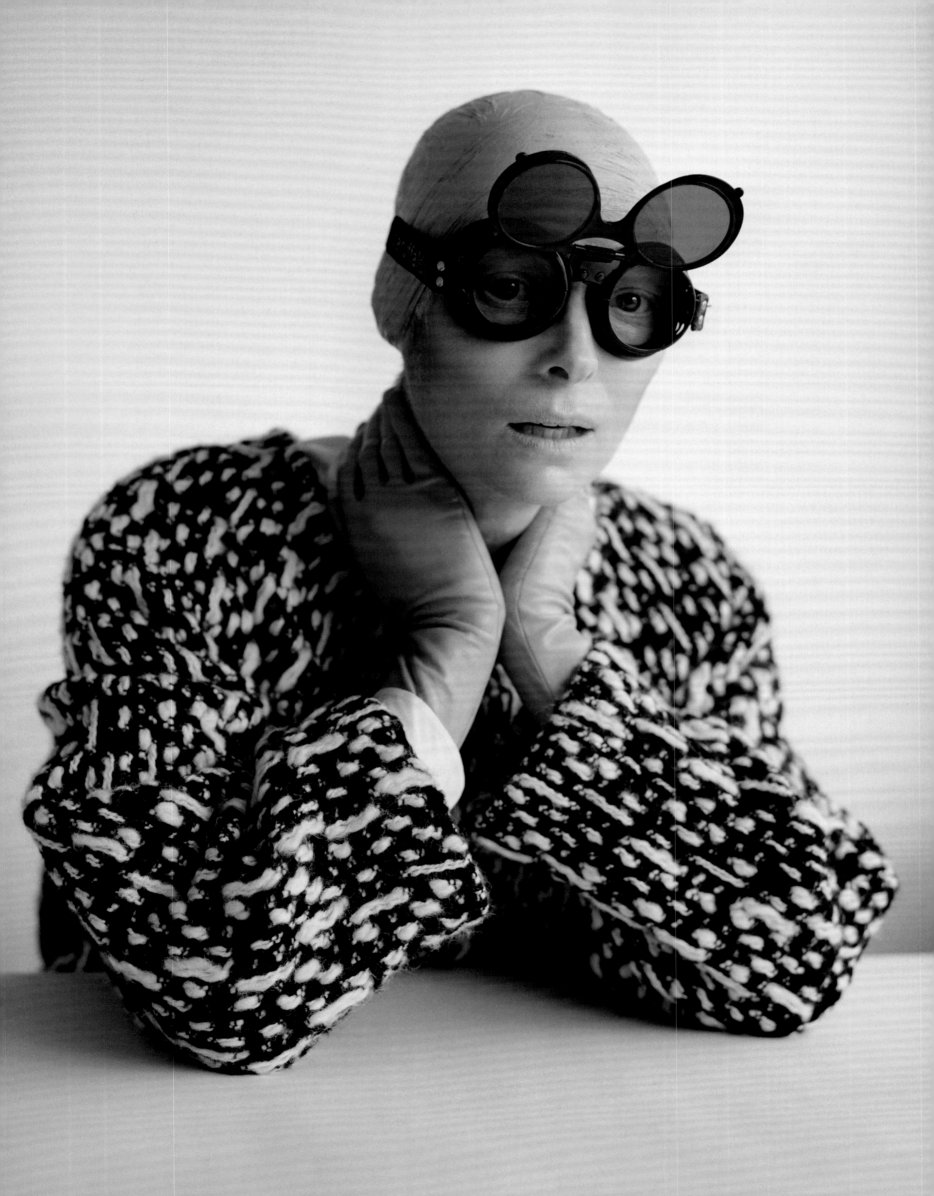

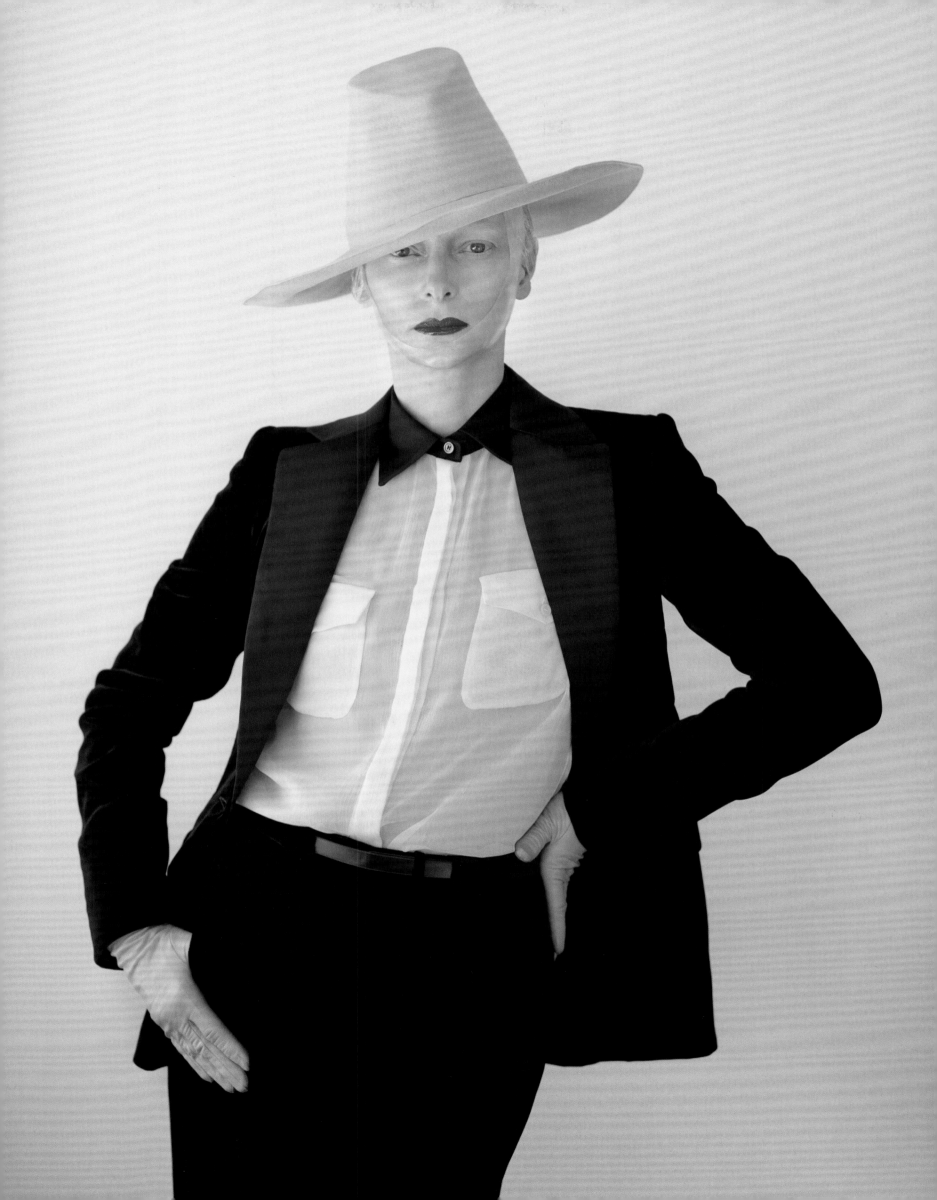

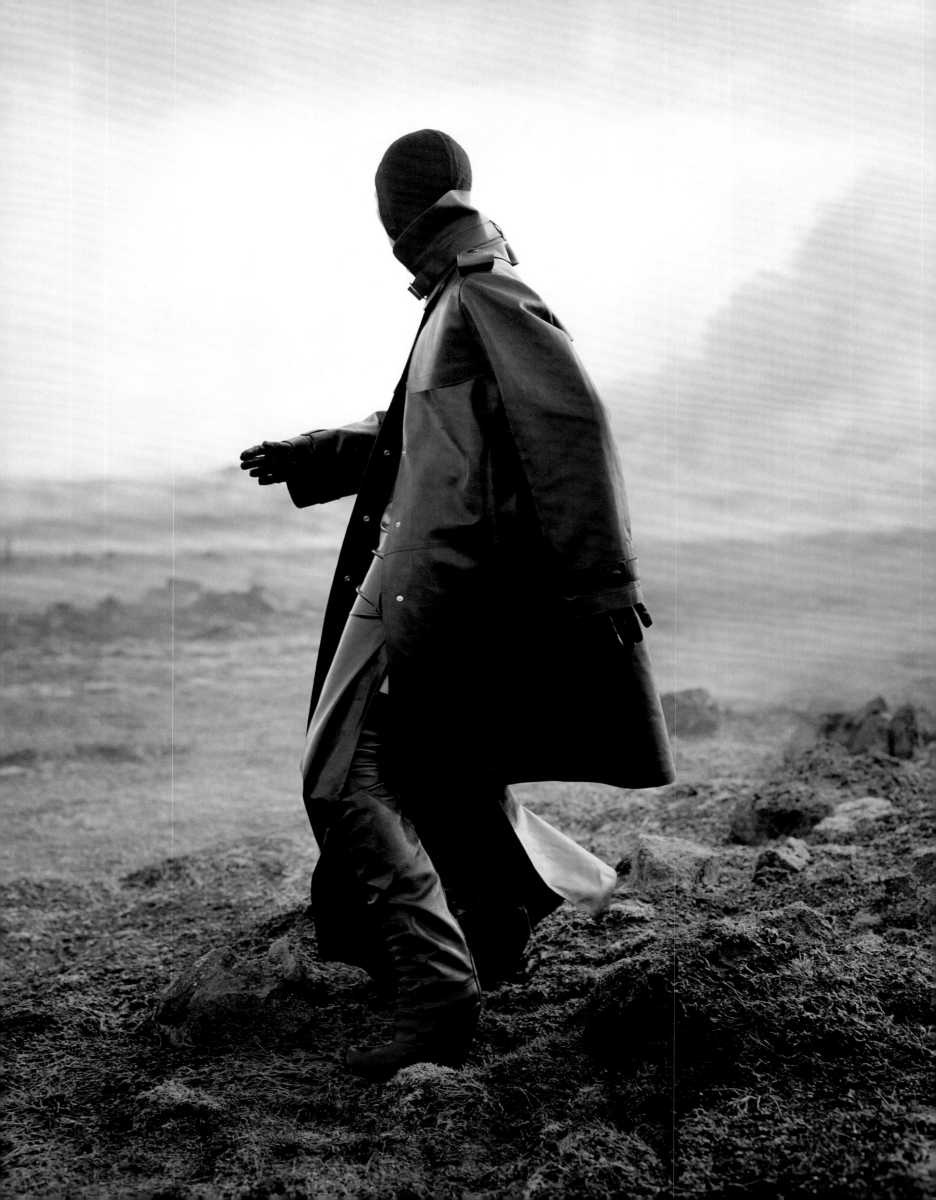

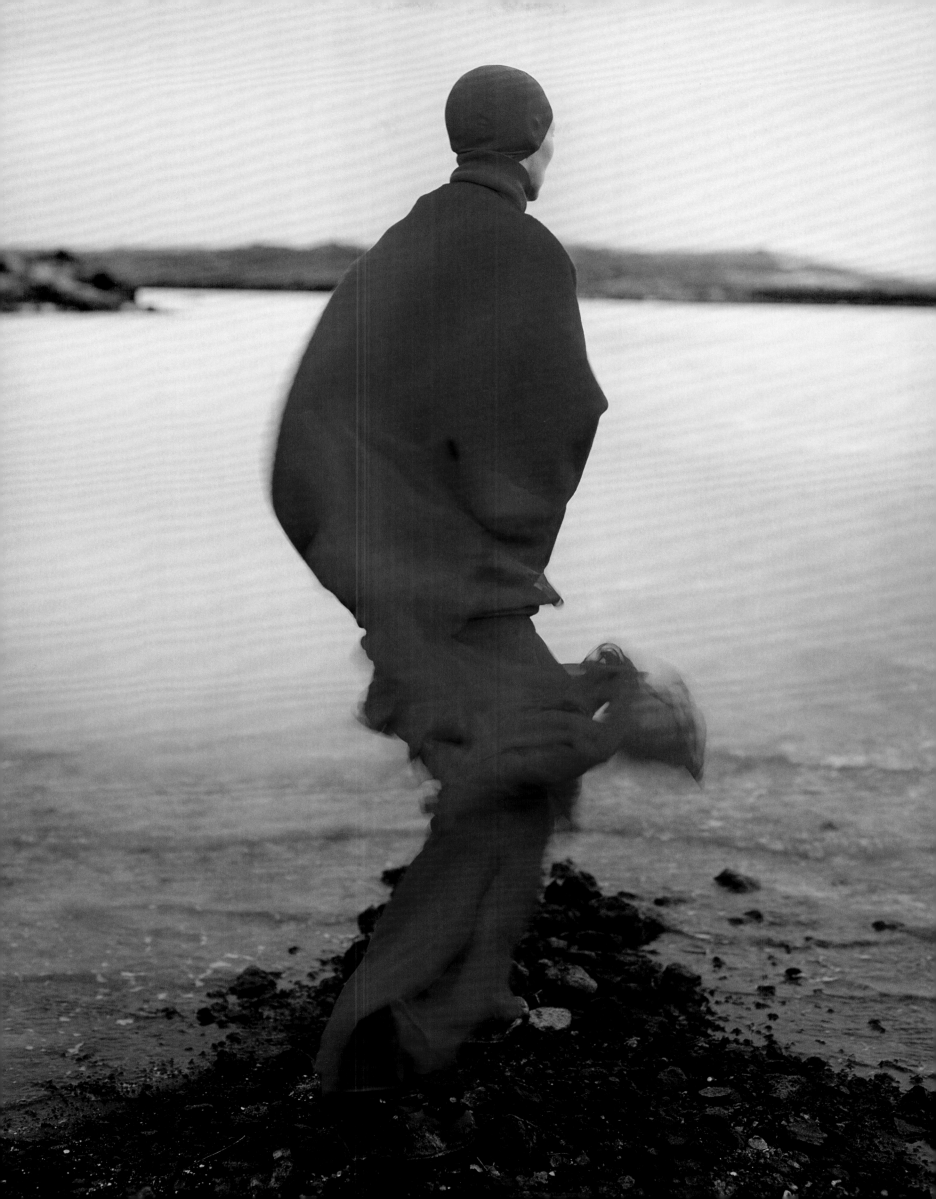

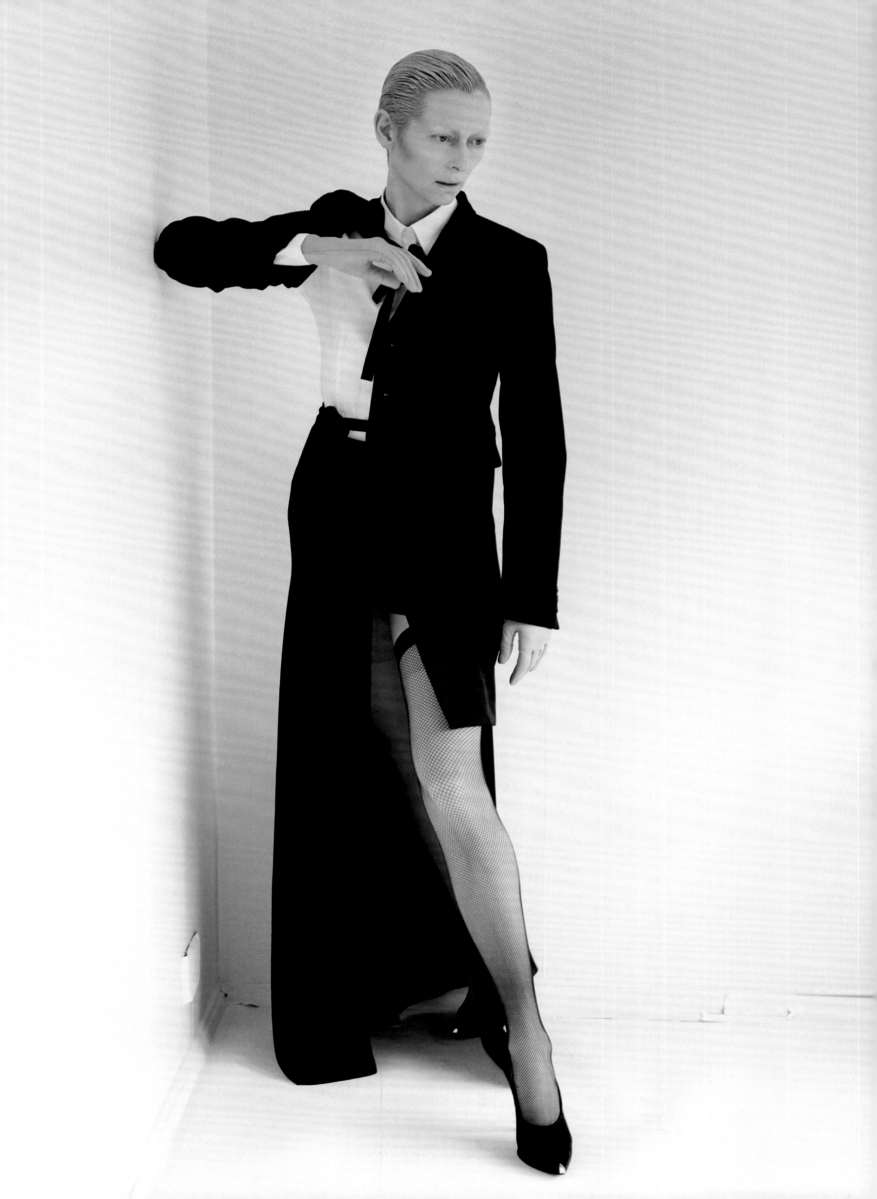

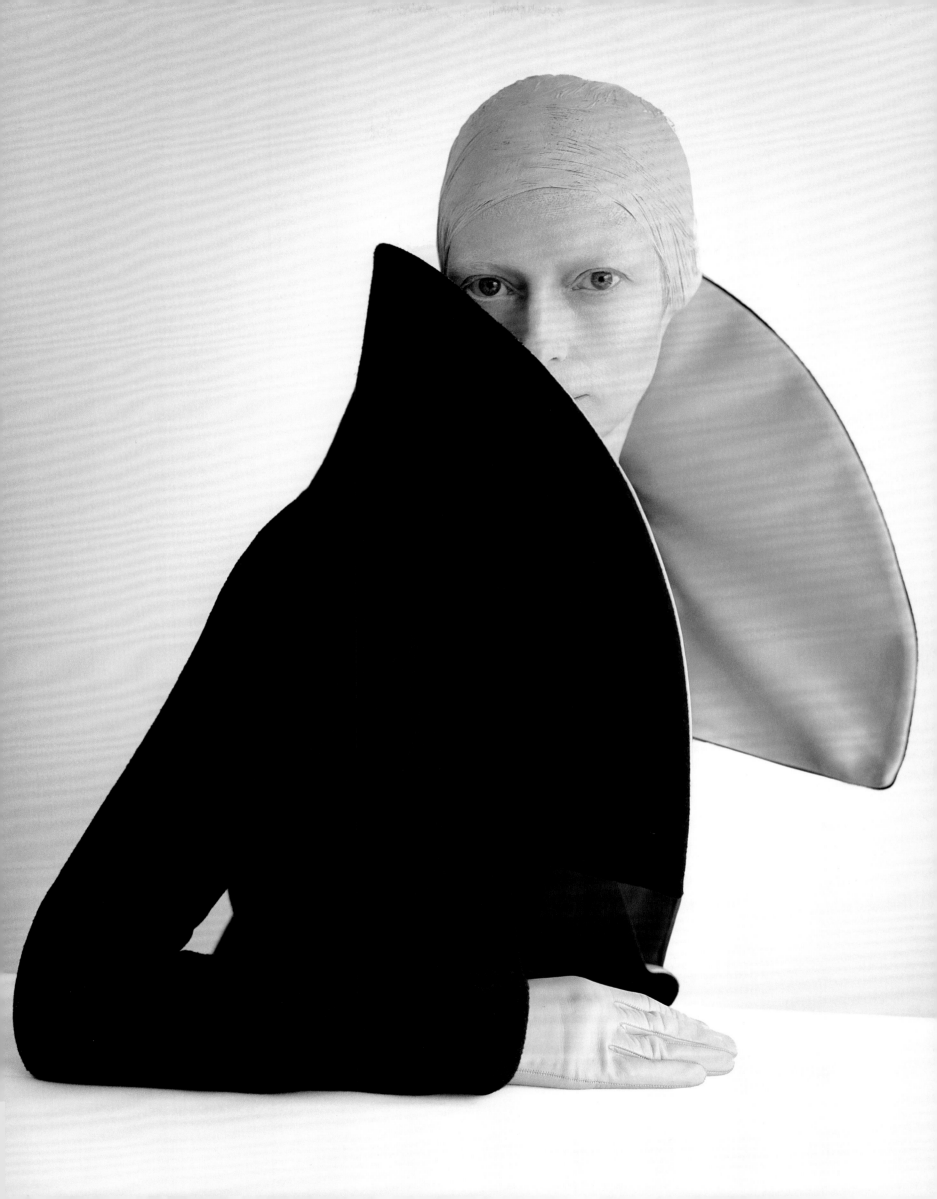

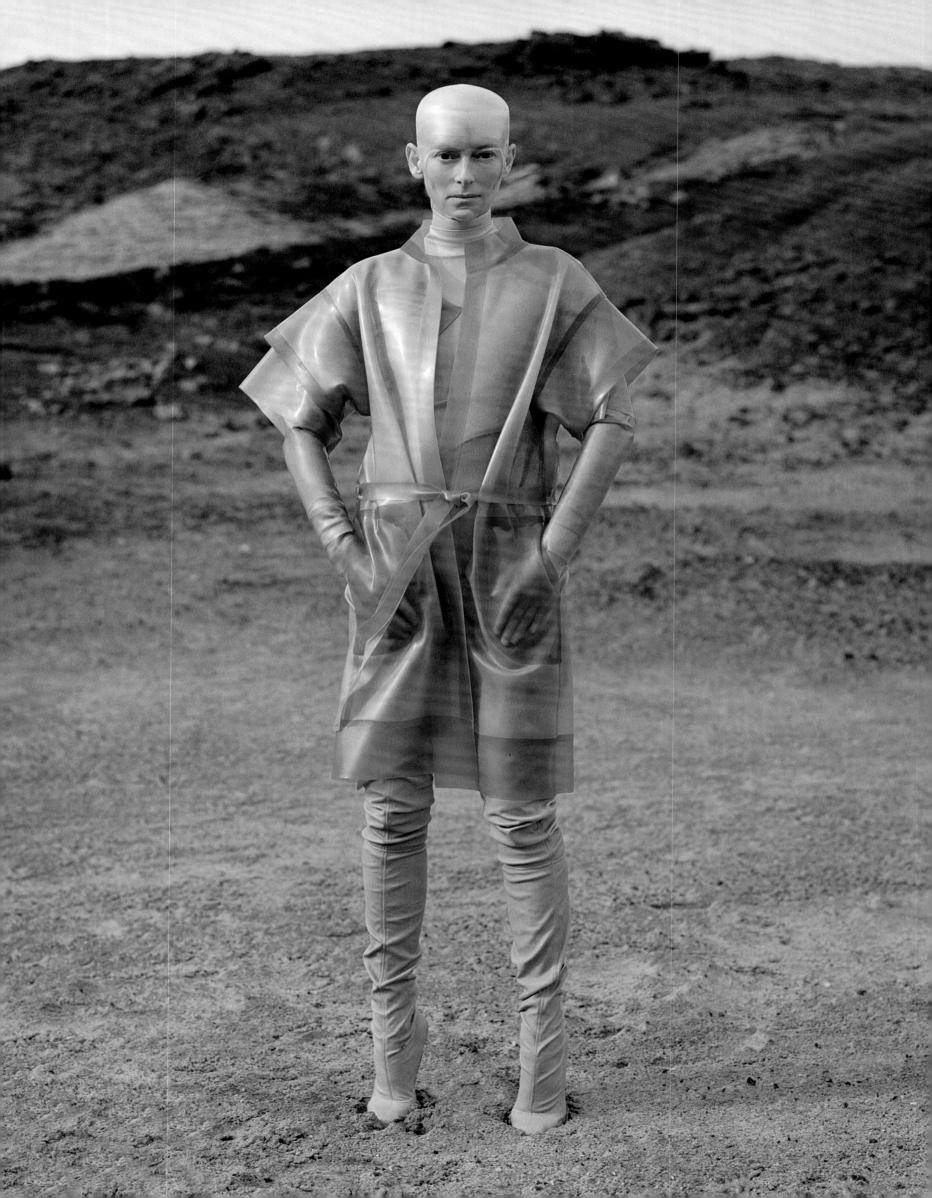

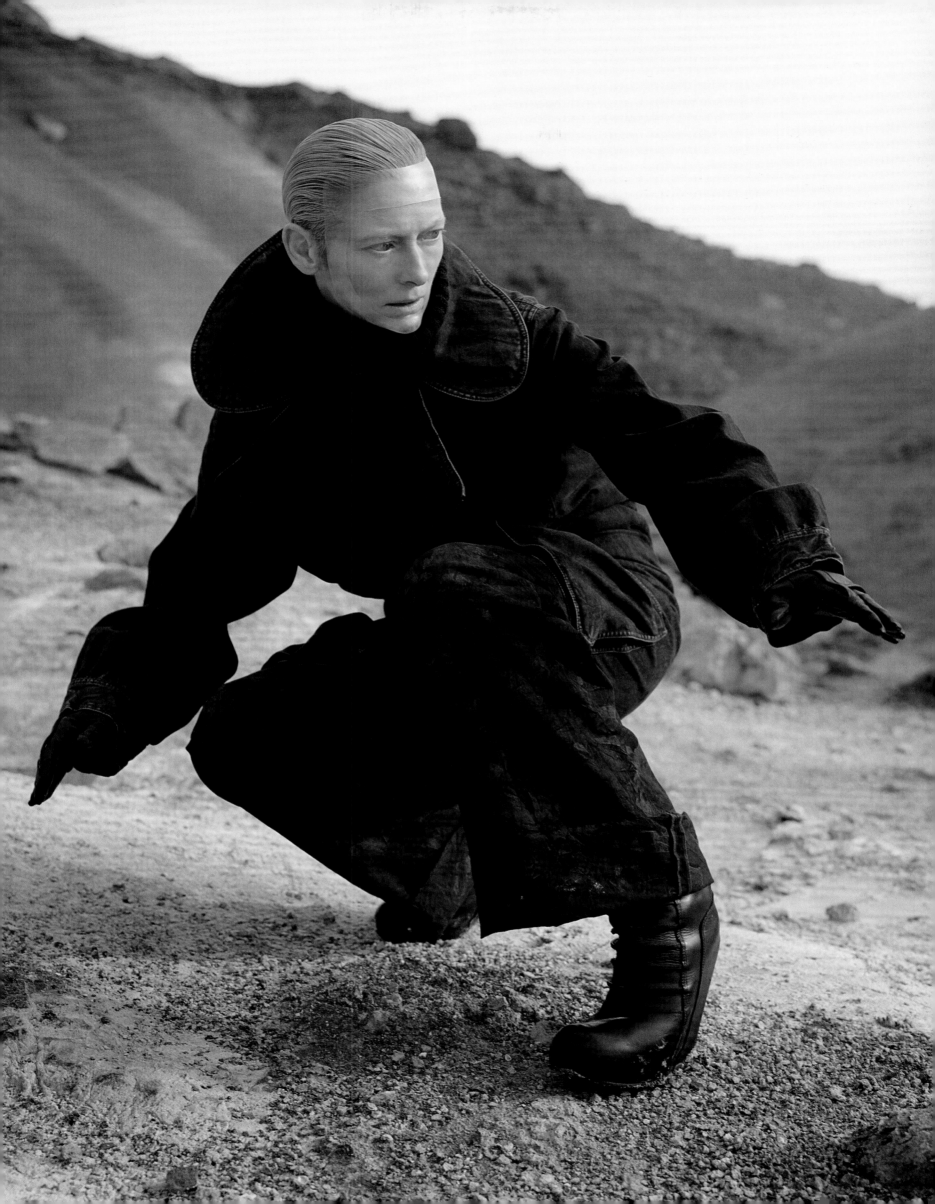

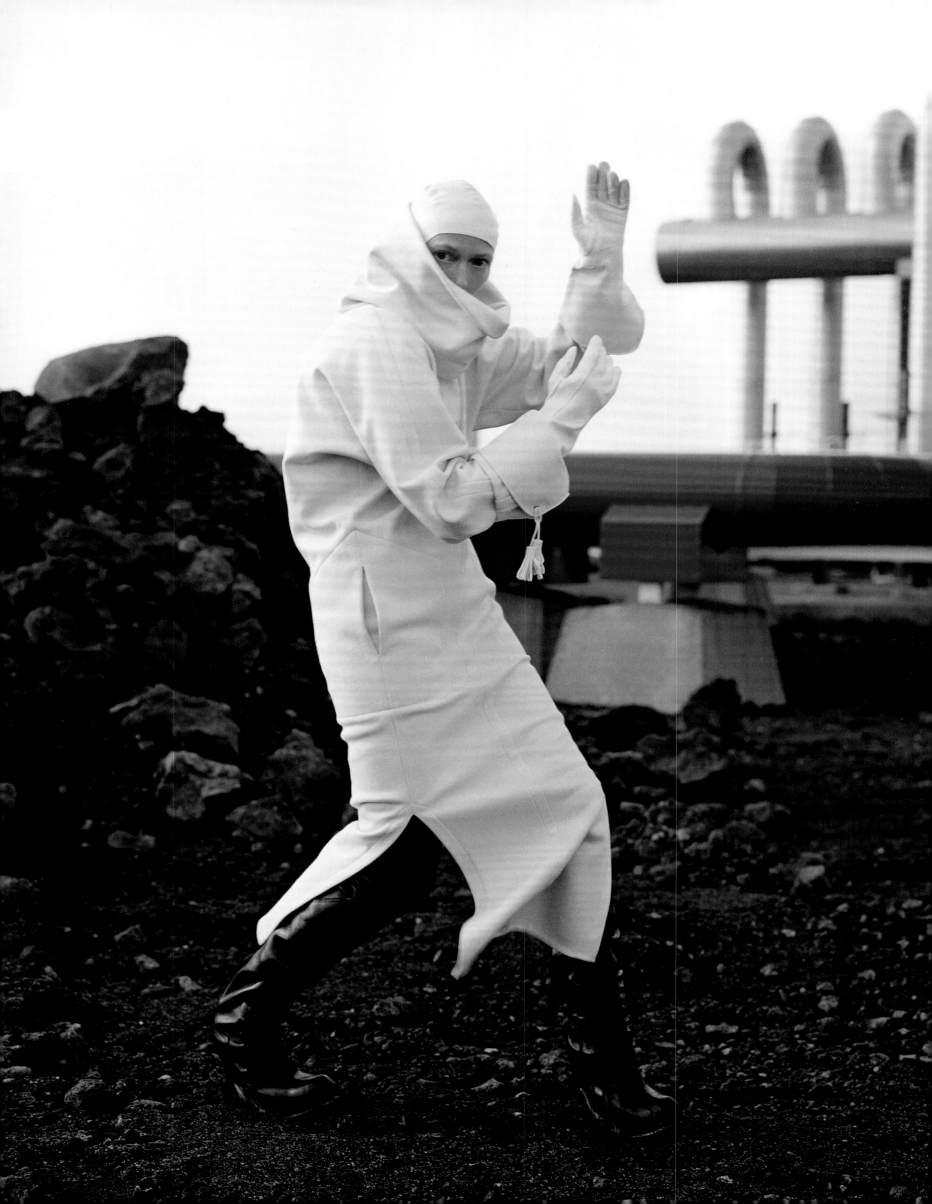

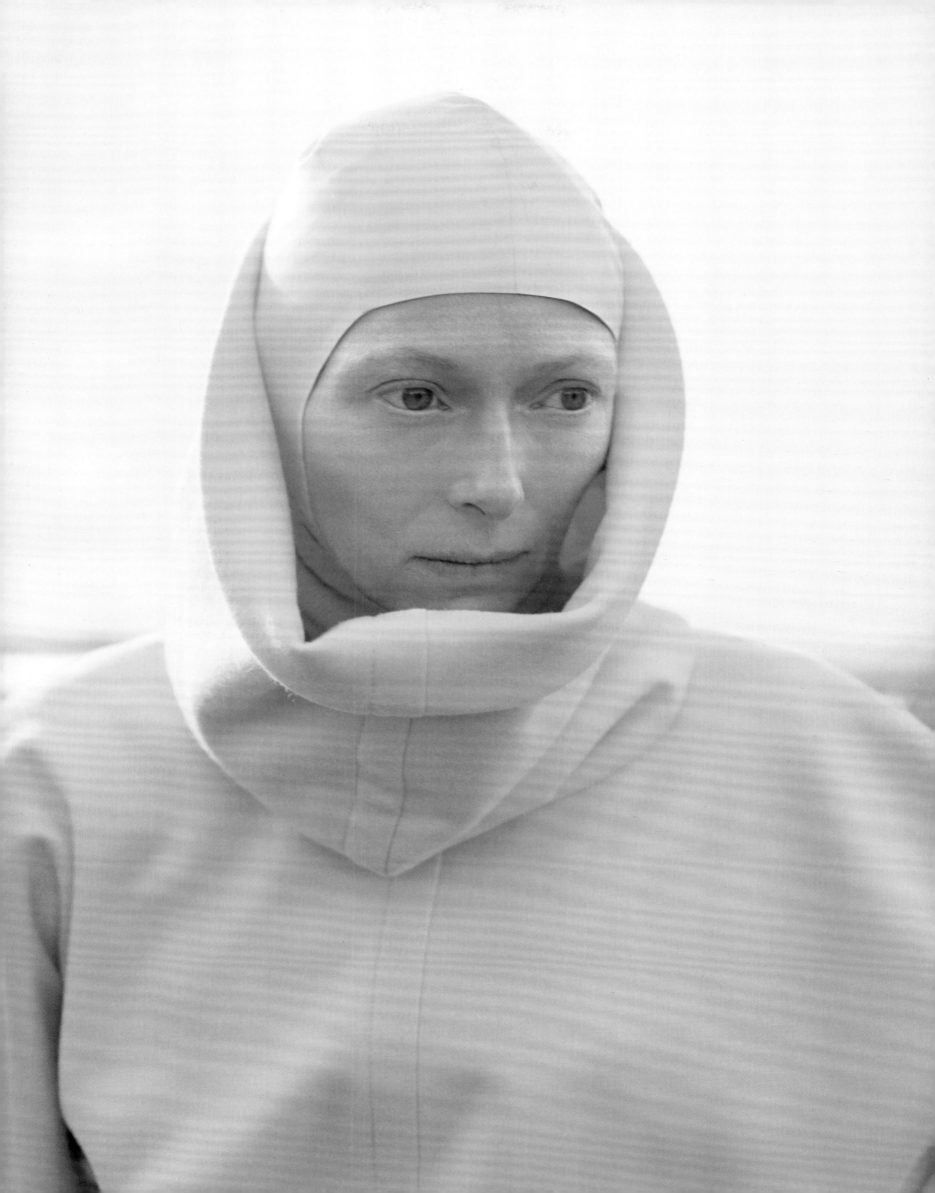

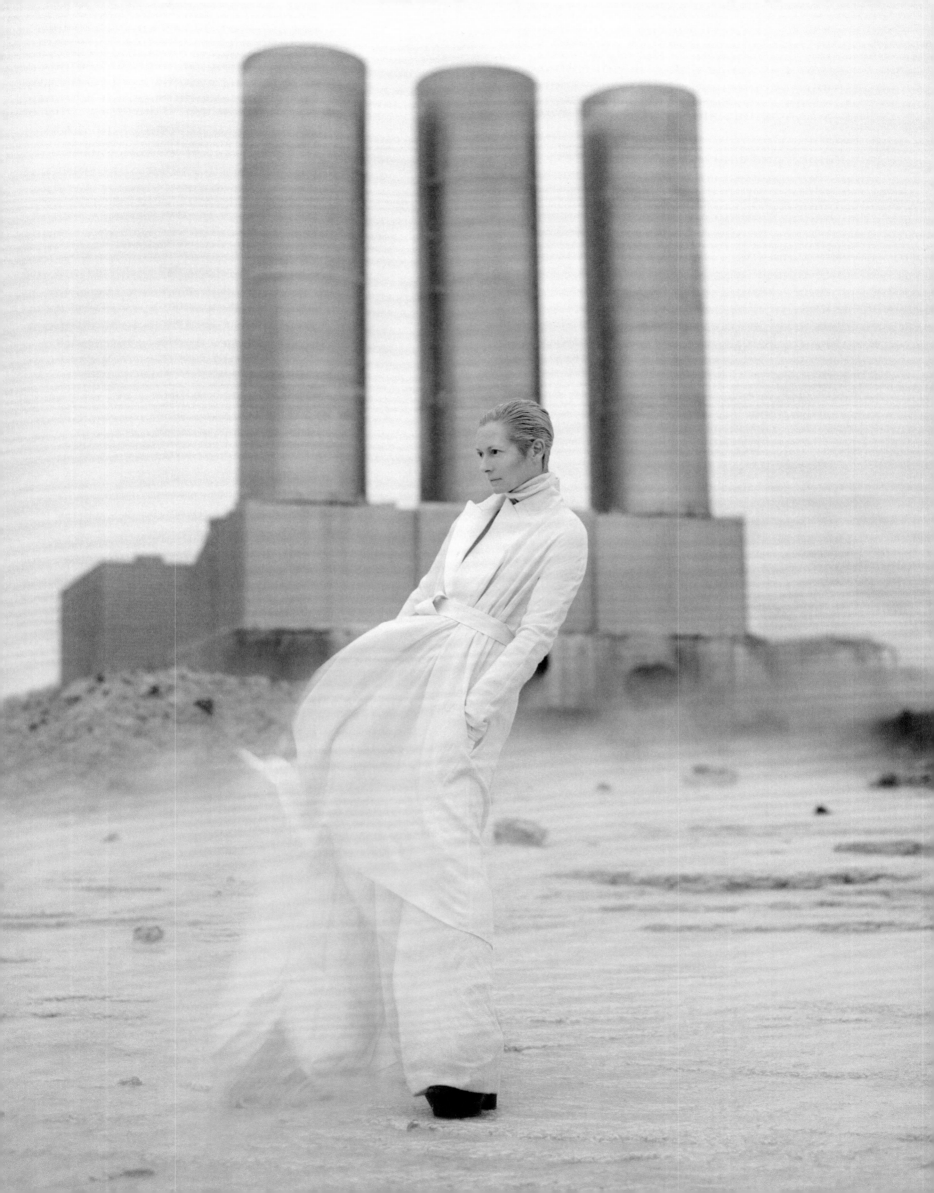

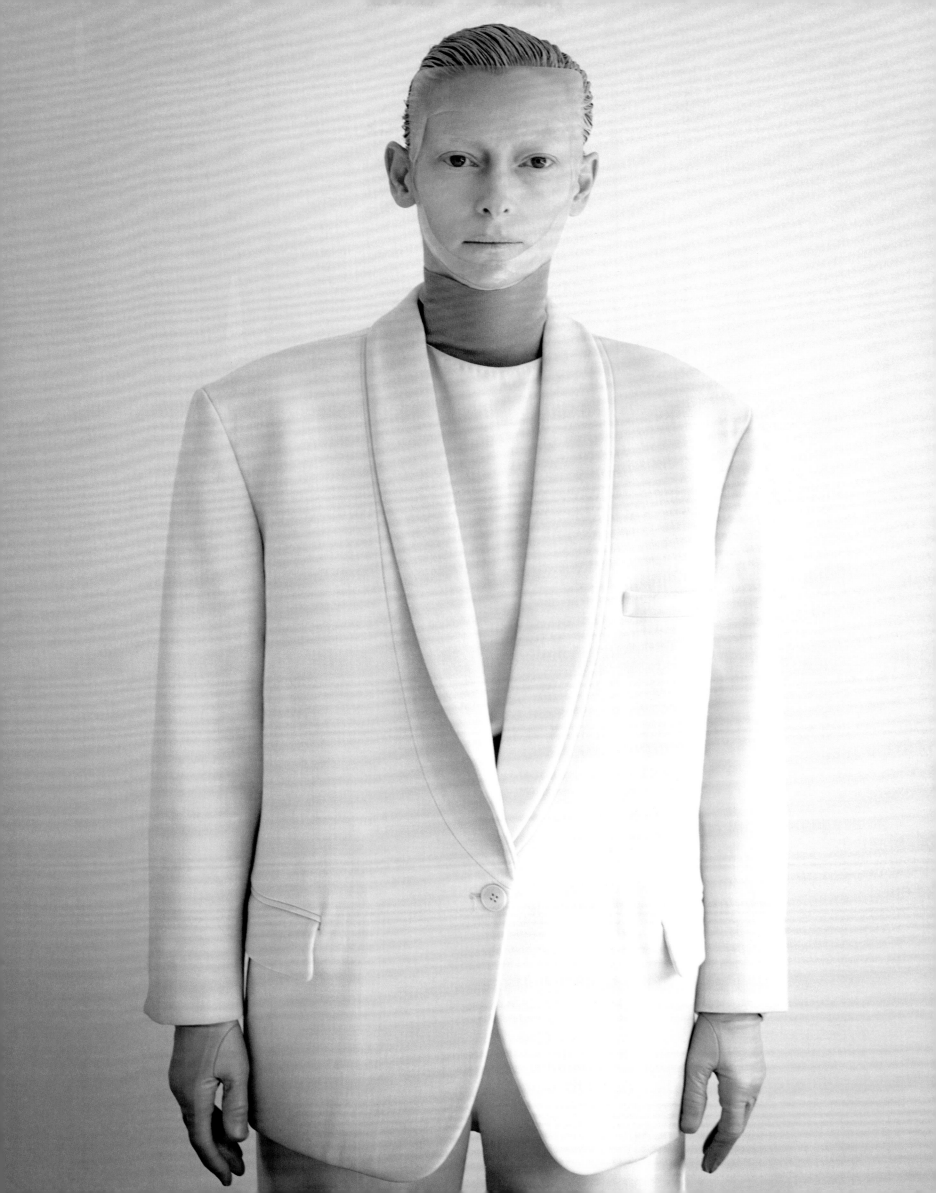

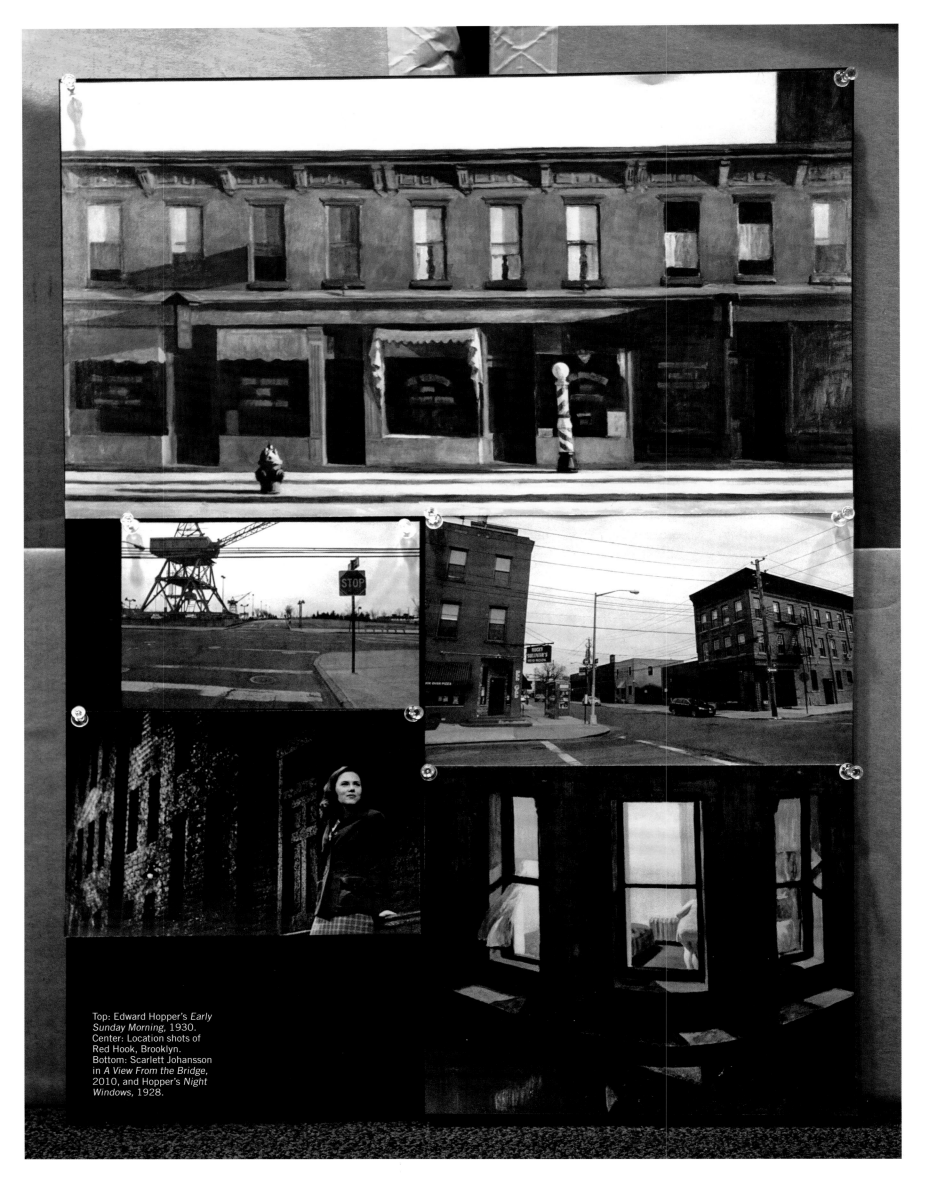

Top: Edward Hopper's *Early Sunday Morning*, 1930.
Center: Location shots of Red Hook, Brooklyn.
Bottom: Scarlett Johansson in *A View From the Bridge*, 2010, and Hopper's *Night Windows*, 1928.

LAST EXIT TO BROOKLYN

THE MOODY, WINDSWEPT WATERFRONT OF RED HOOK, BROOKLYN, PROVIDED A FITTING BACKDROP FOR FORMER *W* FASHION DIRECTOR ALEX WHITE'S VISION OF A YOUNG WOMAN IN THE THROES OF LOVE.

In January of 2010 I saw the Arthur Miller play *A View From the Bridge*, starring Scarlett Johansson and Liev Schreiber. Set in Red Hook, Brooklyn, in the 1950s, it tells the story of an Italian-American longshoreman and his family, and explores themes of love, betrayal, and jealousy. The narrative and the acting were incredibly inspiring—not to mention the setting.

I had recently moved to Brooklyn, and I found the neighborhood of Red Hook totally arresting, thanks to its big skies and desolate, Edward Hopper–esque street corners. Red Hook is tucked along an old industrial harbor, and something about the proximity to water gives the area a saturated light that's incredibly beautiful. I felt compelled to do a shoot there.

After seeing the fall collections a couple of months later—particularly those of Fendi, Prada, and Marc Jacobs—everything just seemed to come together. There were very retro clothes: rich tweeds, full skirts, and fur-trimmed coats in strange red and mustard colors that fit the mood perfectly. I knew that the photographers Mert Alas and Marcus Piggott would like the idea, and I also knew that they could capture that larger-than-life Red Hook sky in a spectacular way. Given the manner in which they manipulate colors, I had a feeling that the images would look almost surreal—and they did. When conceiving shoots with photographers, sometimes there's a lot of dialogue and back-and-forth; other times, not so much. When I work with Mert and Marcus, there is always a shared internal click. It's something I

have with only a handful of photographers. Often, words are not necessary.

I wandered around the streets of Red Hook looking for places and buildings that I felt were especially interesting. Then I asked John Hutchinson, a location scout who has a great eye, to fine-tune my selections and help me find the perfect spots.

It occurred to me to cast three girls to play a similar character to Johansson's Catherine in the Arthur Miller play—a young woman falling in love for the first time, her feelings exposed in the solitude and sun-dappled light of the empty Brooklyn street corners. I looked for models with nostalgic faces. Lindsey Wixson, Ginta Lapina, and Kirsi Pyrhonen embodied the spirit I had in mind.

Together with the hairstylist Paul Hanlon and the makeup artist Lucia Pieroni, we developed an intriguing look—dark lips and windswept updos. Mert and Marcus had the idea of playing with the palette of the clothing and the landscape in a parallel way. It was a very spontaneous project. They observed the neighborhood, developed a feeling for it, and shot according to that mood.

Looking back at the many stories I've done for *W*, this is still one that stands out for me. There's such a transporting quality to the pictures. I live nearby, and those streets are so familiar—yet they look like someplace else entirely in these images. It's as if we had shot in a small town in Idaho or Kansas. You can get lost in these photographs.

PHOTOGRAPHED BY MERT ALAS & MARCUS PIGGOTT
STYLED BY ALEX WHITE
PUBLISHED IN SEPTEMBER 2010

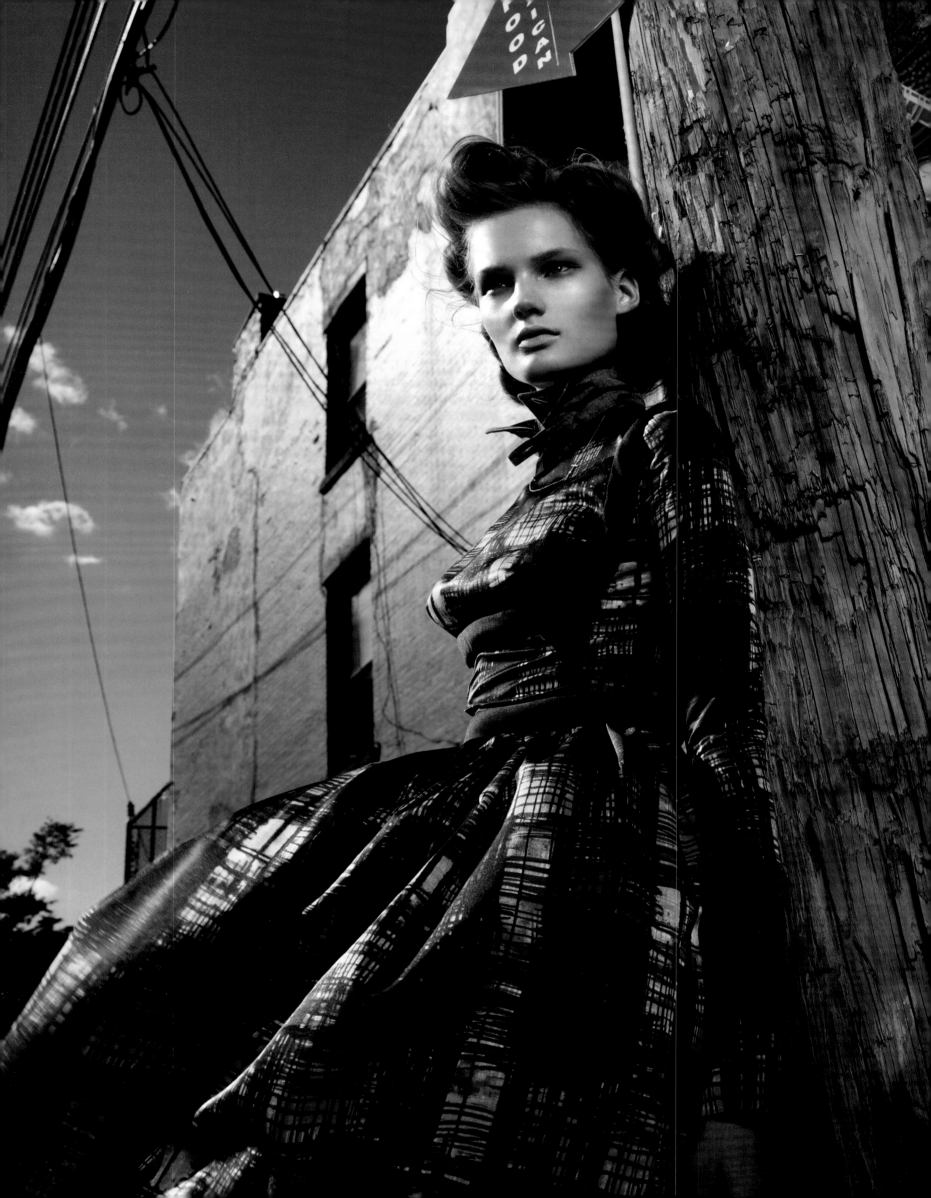

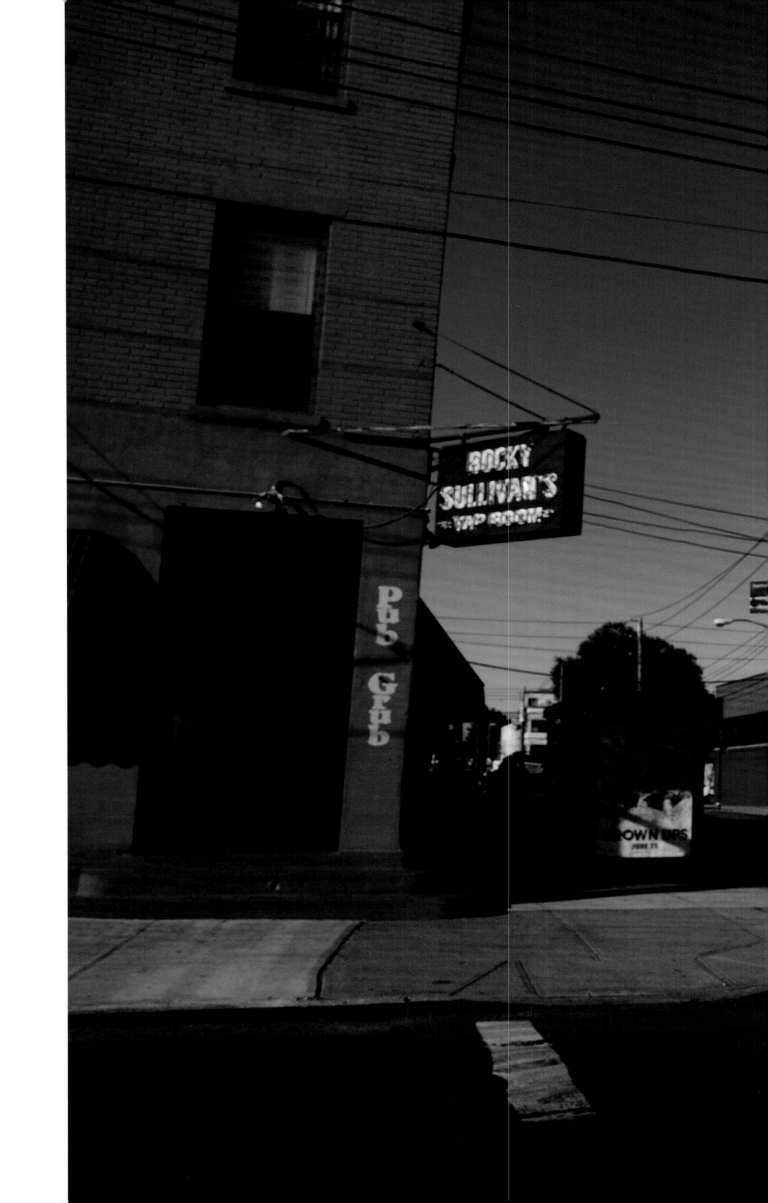

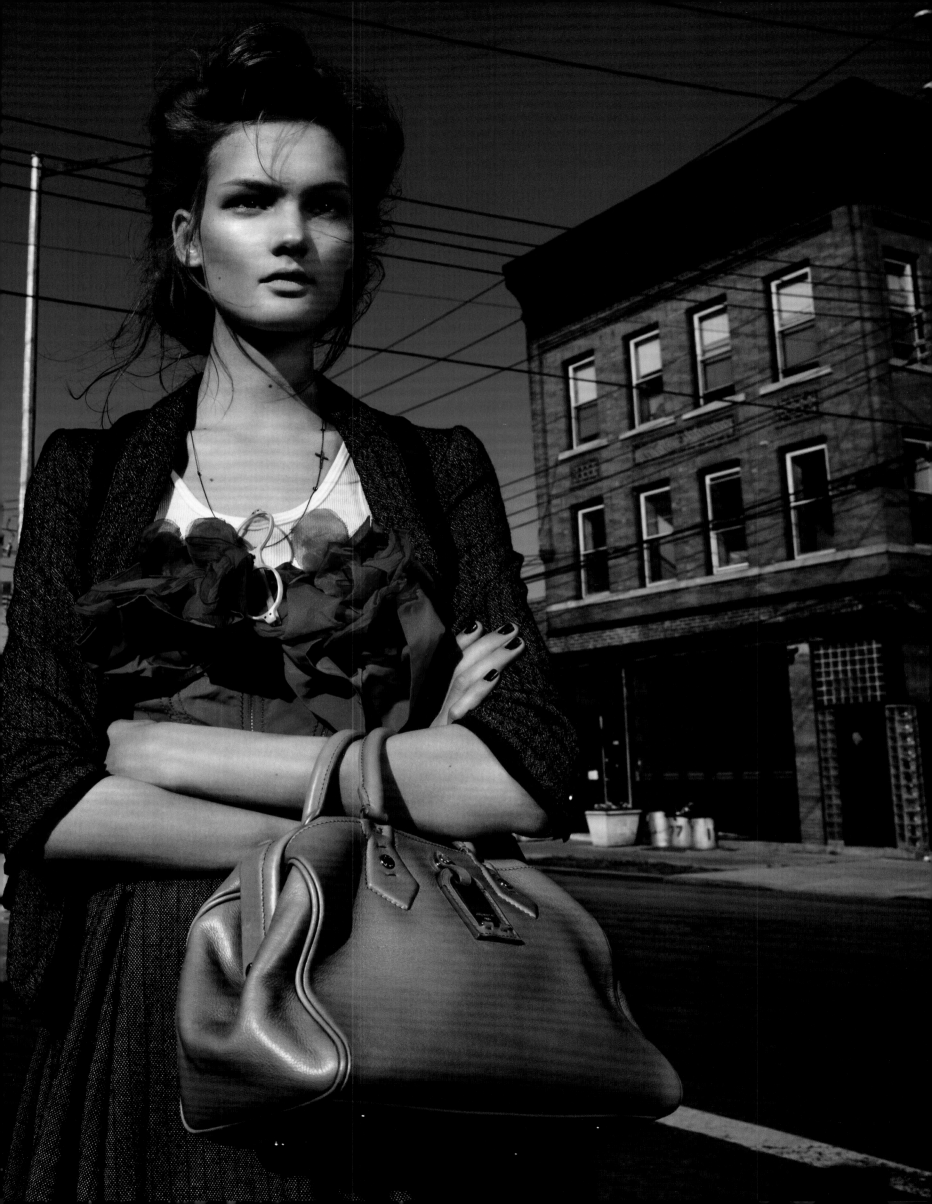

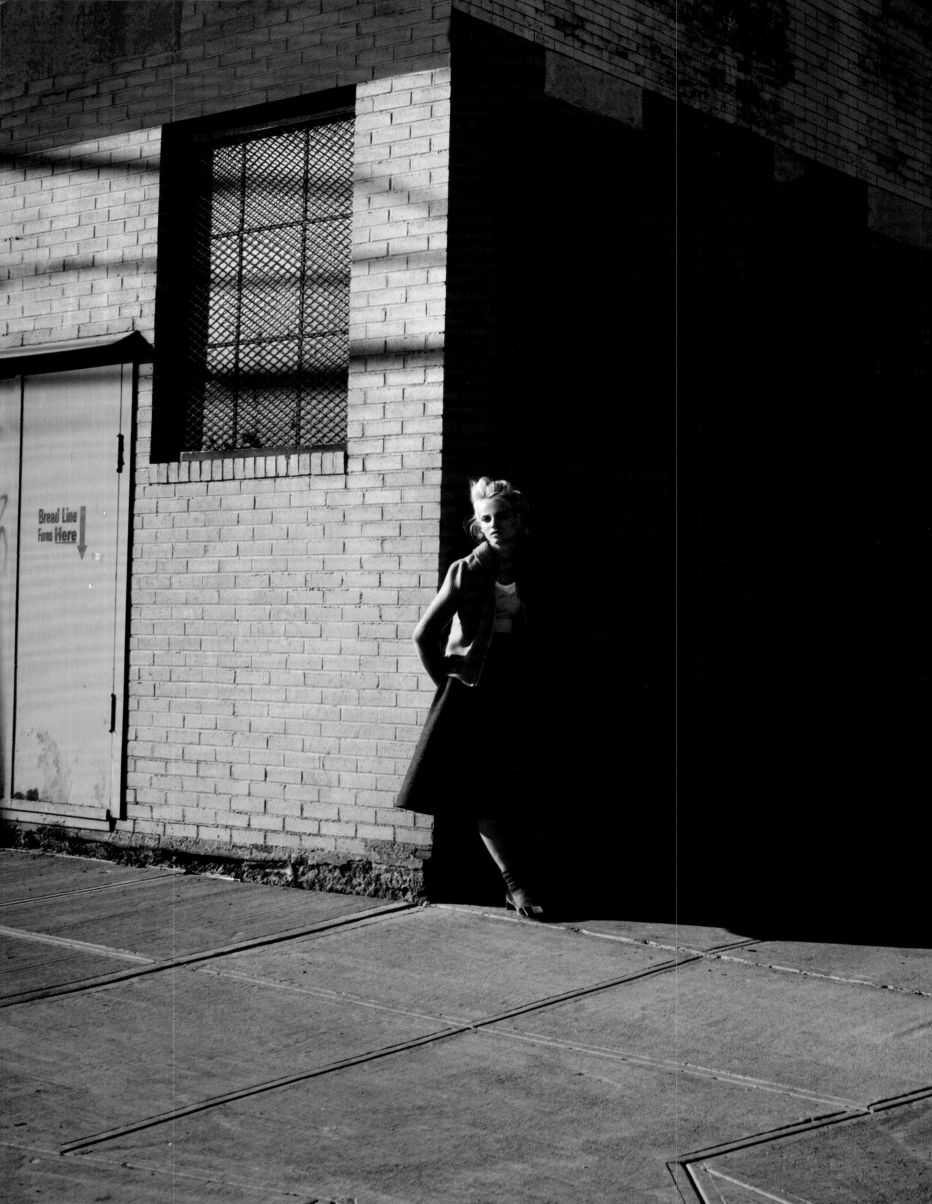

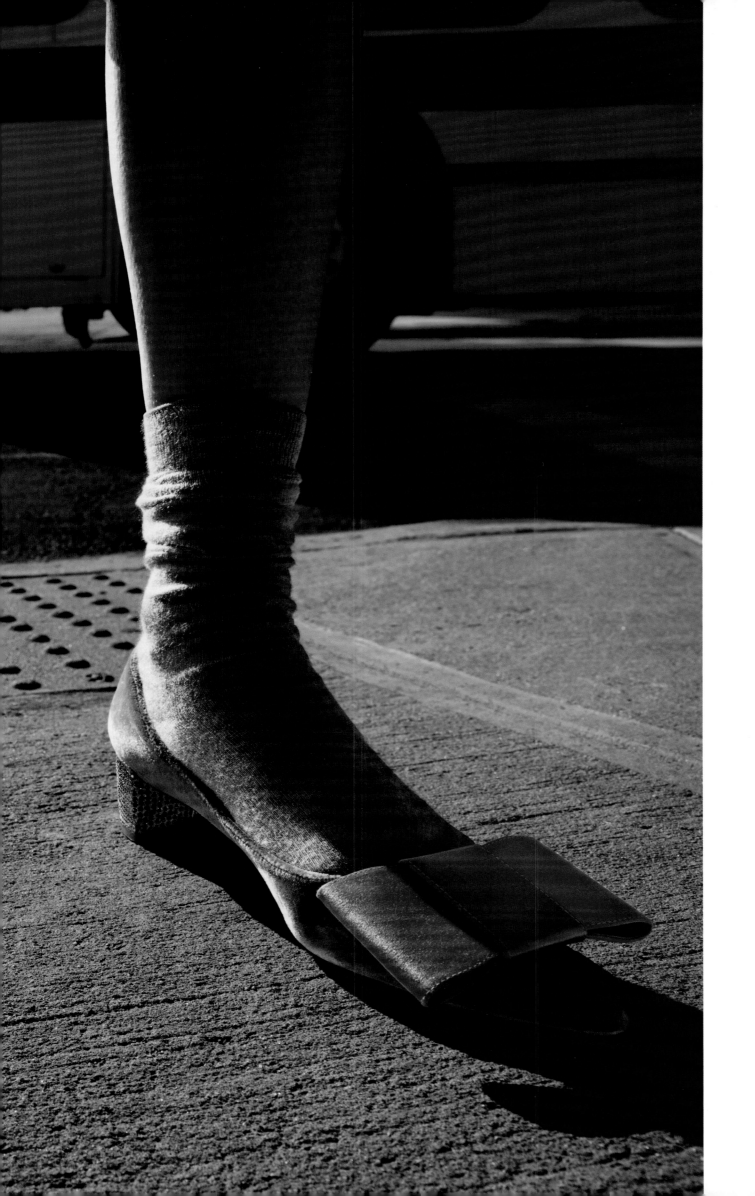

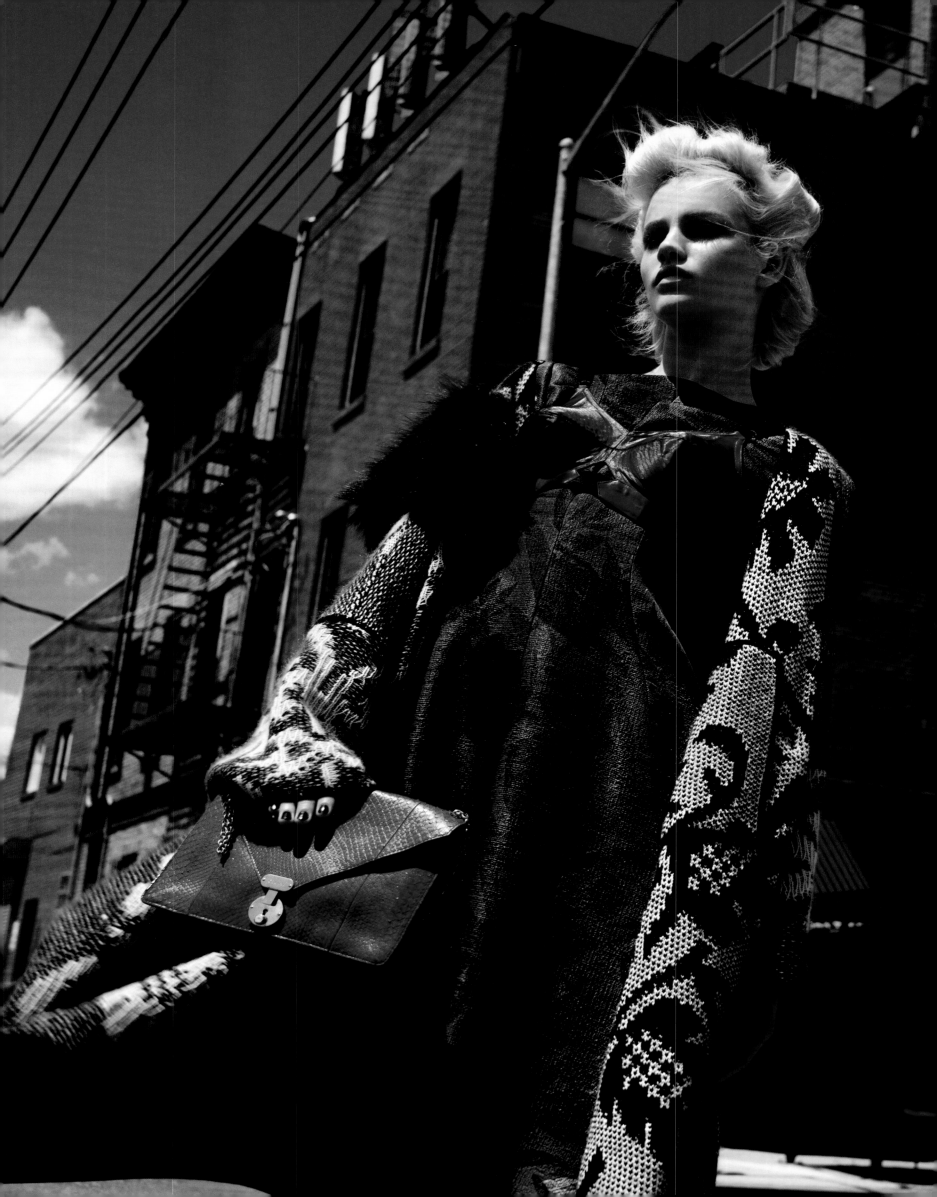

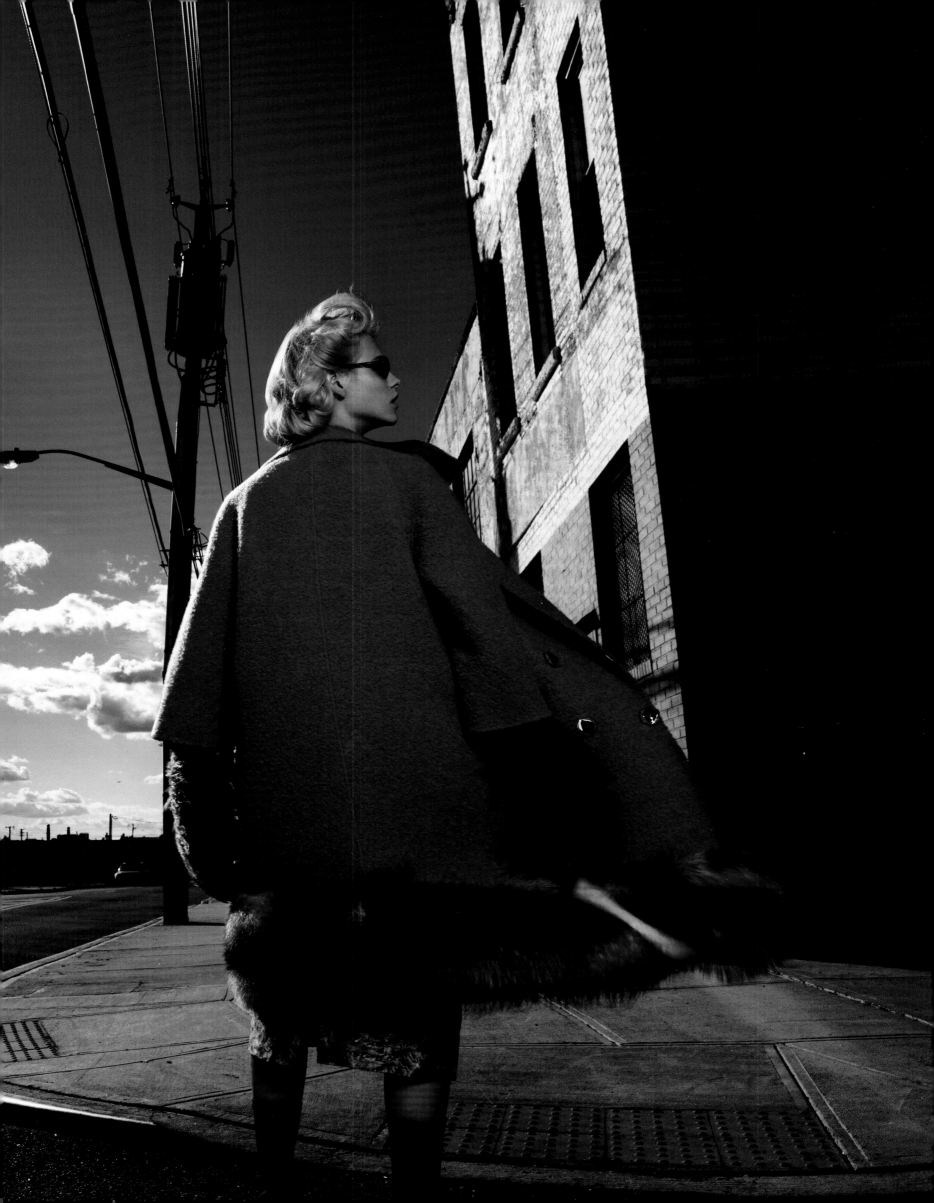

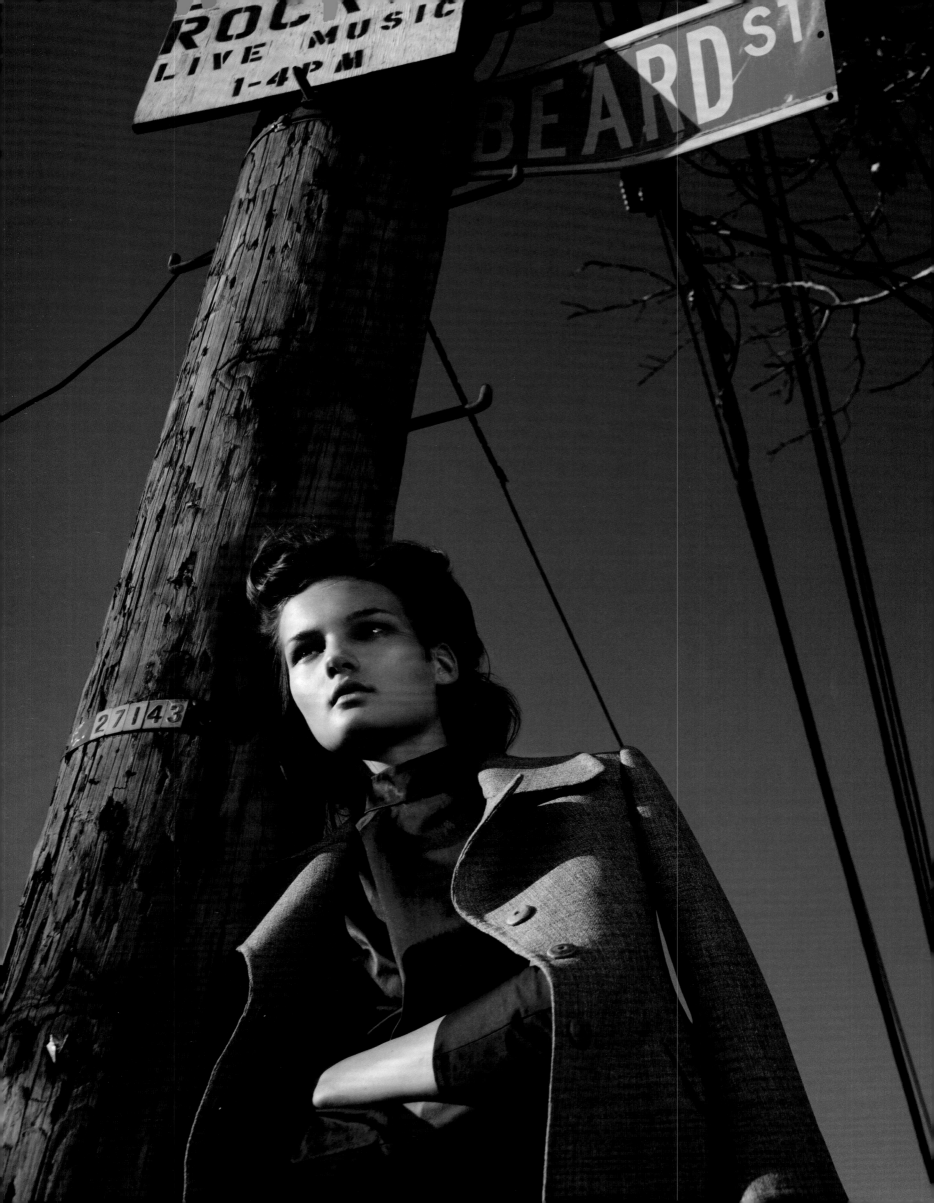

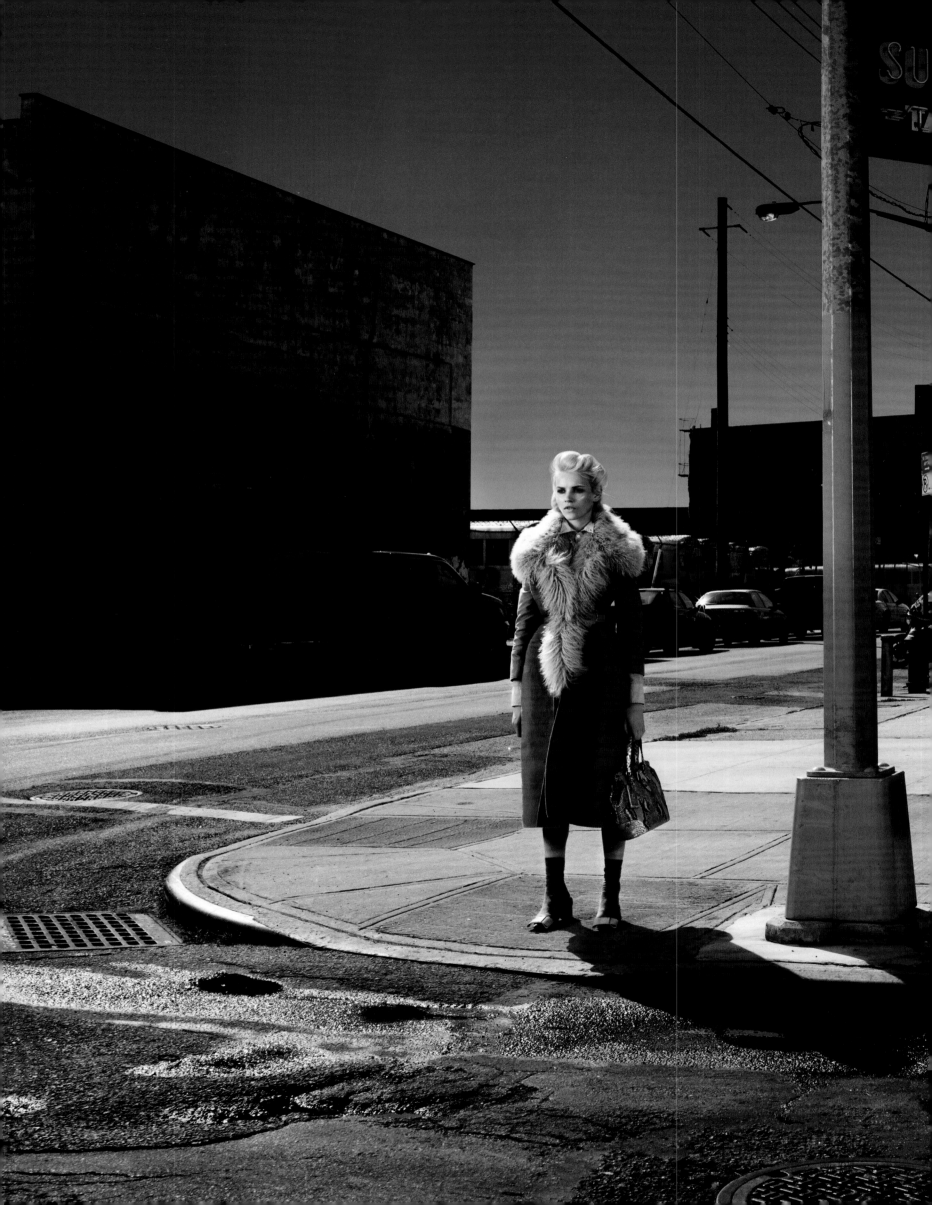

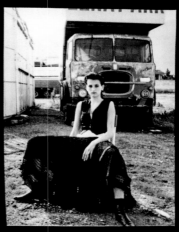
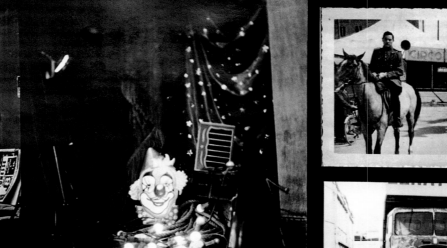

Clockwise, from top left: An Italian family circus like the one that inspired Paolo Roversi; Roversi's studio; a circus; an outtake from the shoot in Palermo; two images from Roversi's studio; a circus; two outtakes from Palermo; set designer Jean-Hugues de Chatillon with the snake from the shoot; the Palermo landscape; Roversi's studio.

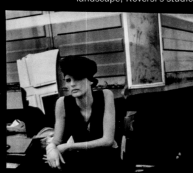
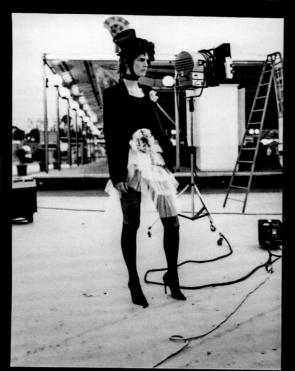
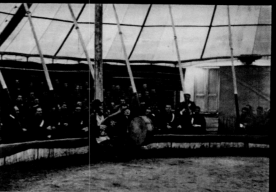

CARNEVALE

THE CHANCE DISCOVERY OF A CIRCUS IN PALERMO WAS PHOTOGRAPHER PAOLO ROVERSI'S STARTING POINT FOR THIS VISUAL EXTRAVAGANZA.

People describe my work as ethereal. I try to find something deeper, more interesting—the soul of the subject. I think it stems from my childhood in Italy. When I was young, I was very involved with literature, theater, and poetry. And I was surrounded by religious and Renaissance art—all the Italian iconography. I got into photography by chance. When I was 17 or 18, I went on a family trip to Spain and took some pictures. I enjoyed it, and when I returned home I learned that the postman was also interested in photography. He asked if I had space to build a darkroom, and the two of us made one in my basement. I spent a lot of time there making prints.

Later, I met the art director Peter Knapp at a dinner. I showed him some of my pictures—at the time I was doing portraits and a little bit of reportage. He said I should come to Paris. He thought it would be interesting for me. So in 1973 I moved to Paris, where I still live. There I discovered the fashion world, and Guy Bourdin and Helmut Newton—the masters. I was immediately attracted to that type of photography.

I believe you create from what you have inside. As such, there are a lot of memories in my work, mixed with dreams. And I remember being enthralled by the circus when I was a boy. Growing up in a small town, it was a big thing when the circus arrived. It would happen maybe once or twice a year, and there would be all these animals—lions, tigers, monkeys! For a child, the circus is a big engine for dreams and imagination, fears, and fantasies. It's a very emotional thing.

With this shoot, we didn't set out to do a circus story—in fact, it started quite differently. The stylist Alex White and I wanted to do photographs about Sicily—its landscape and strong light. We cast a very young model to play a rough, wild woman, and we spent a day shooting. But it just wasn't working. We were having difficulty capturing that Sicilian mood with this little girl. So we called Stella Tennant to see if she could fly from London the following day. She jumped on a plane to Sicily, and the young girl jumped on a plane home.

I first started working with Stella when she was a 17-year-old punk with a ring in her nose. I immediately fell under her spell. She's been a big muse in my work—probably one of the biggest—because she can look street, tough, wise, feminine, masculine, or aristocratic. You put a piece of clothing on her and she interprets it in her own way. For me, a true model isn't just a nice girl in front of the camera. She's an artist and a performer.

So here we were, in Palermo, and by chance we discovered that a little circus was happening there. We took a couple of pictures—for instance, the black and white shot of Stella with the little dog, and the one opposite it, with the big flower in her hair. It was a nice setup, but we ended up going back to Paris, getting more clothes, creating a carnival set in my studio, and finishing the shoot there. You didn't think I'd say that, did you? The snake and the monkey shots were both done in my studio—and that monkey was crazy! It got loose just before I took that picture and was jumping and screaming, hanging from the curtains. Finally its handler caught it and put it on Stella's shoulder, but it kept pushing her hat over. I use an 8-by-10 Polaroid camera, so you can take just one picture every three or four minutes—it's not like *click, click, click*—and that makes it very hard to do these kinds of shots. I couldn't tell the monkey "Don't move!" By comparison, the snake was much easier to shoot.

At the time, I hadn't been thinking about Federico Fellini and his films. But he's from the same part of Italy as I am, so I'm very close to his world and his sensibility and poetry. He is always in my heart and blood, and I think maybe a bit of him and his sense of fantasy came out in this story. But nothing is ever rational in my world. It's always the opposite of that.

**PHOTOGRAPHED BY PAOLO ROVERSI
STYLED BY ALEX WHITE
PUBLISHED IN MARCH 2002**

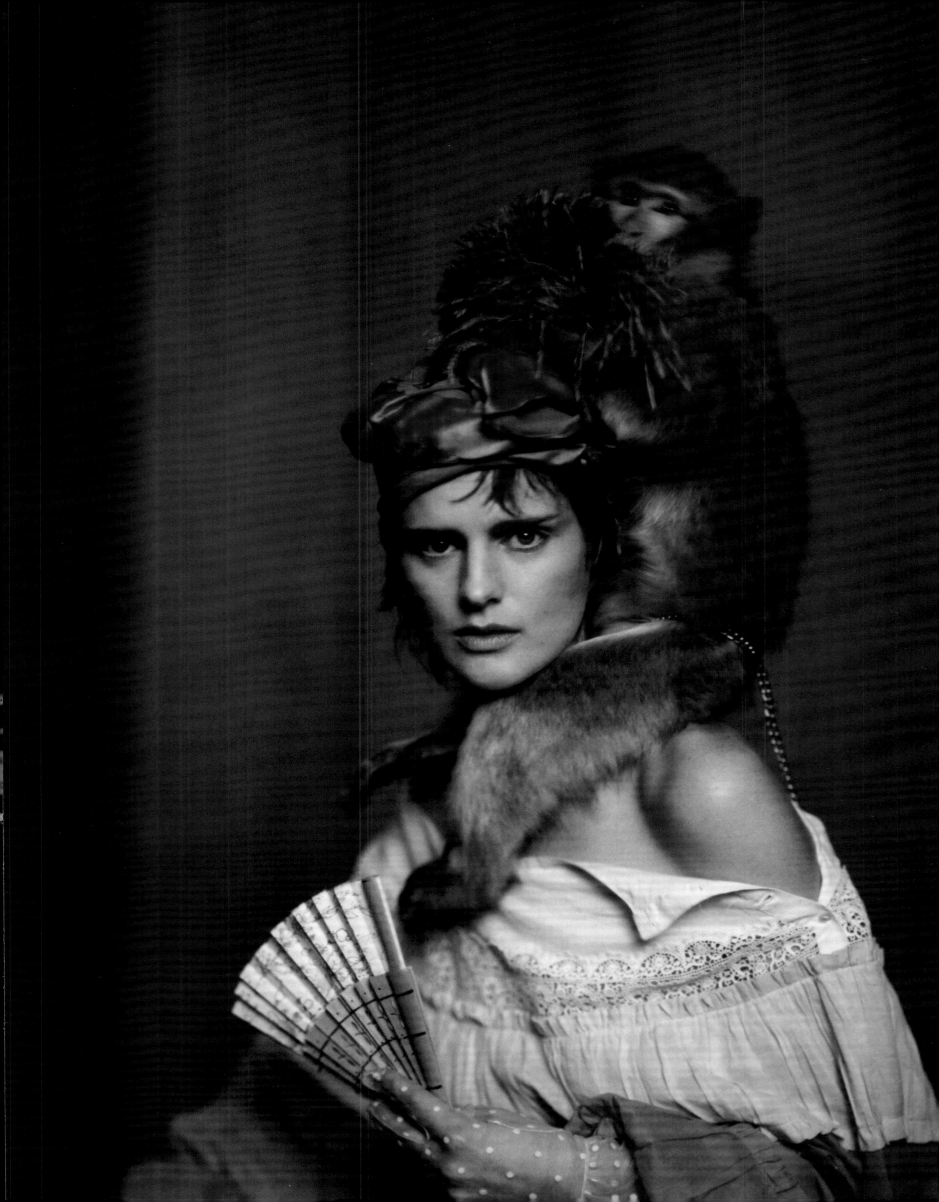

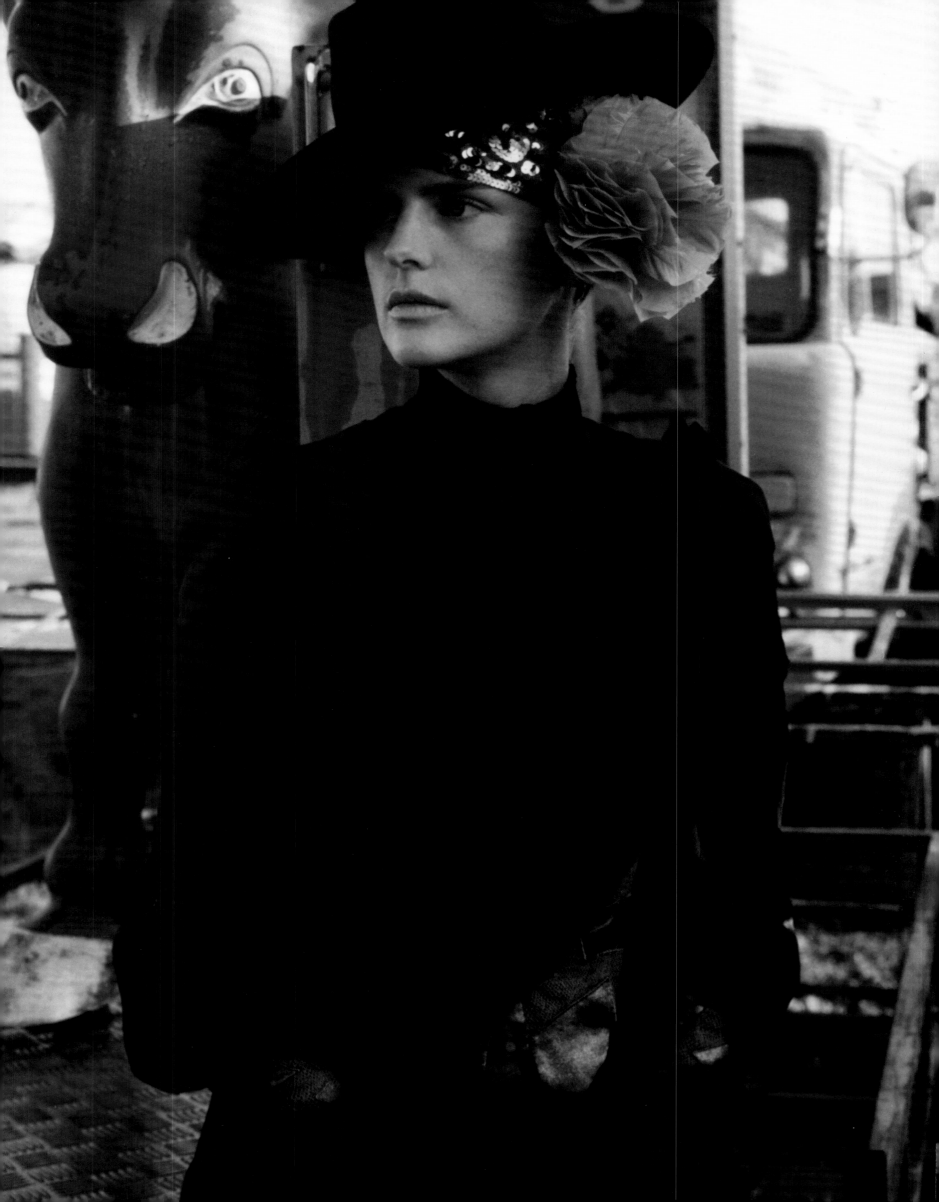

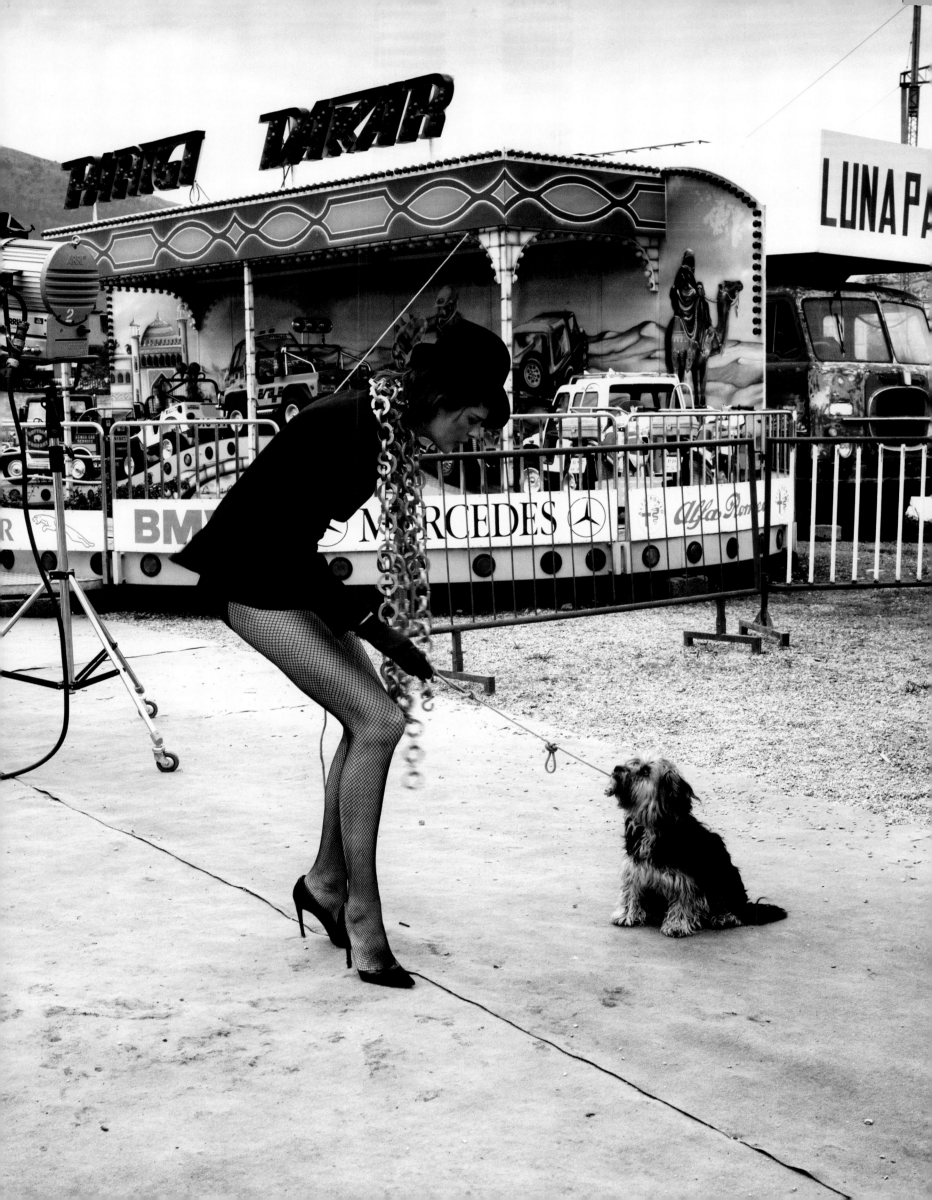

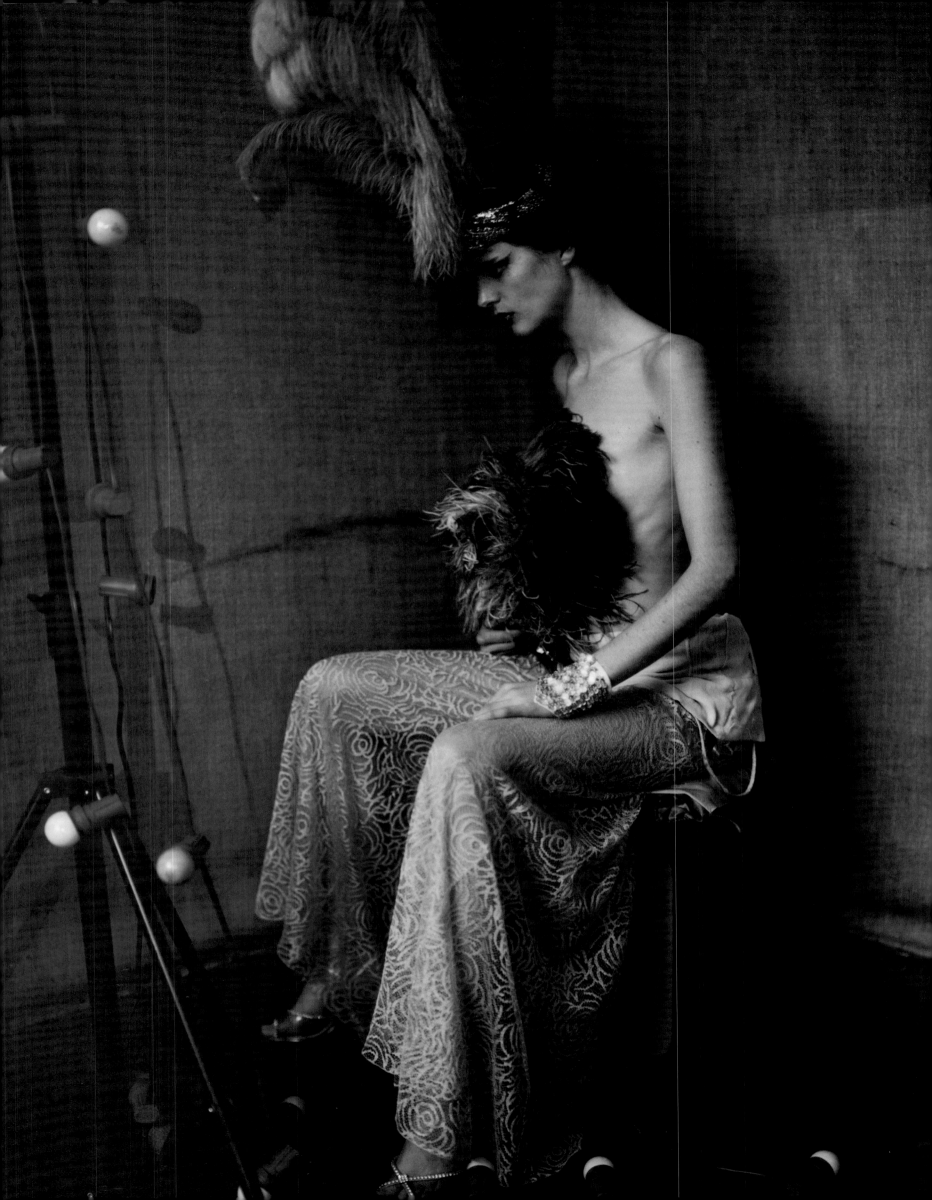

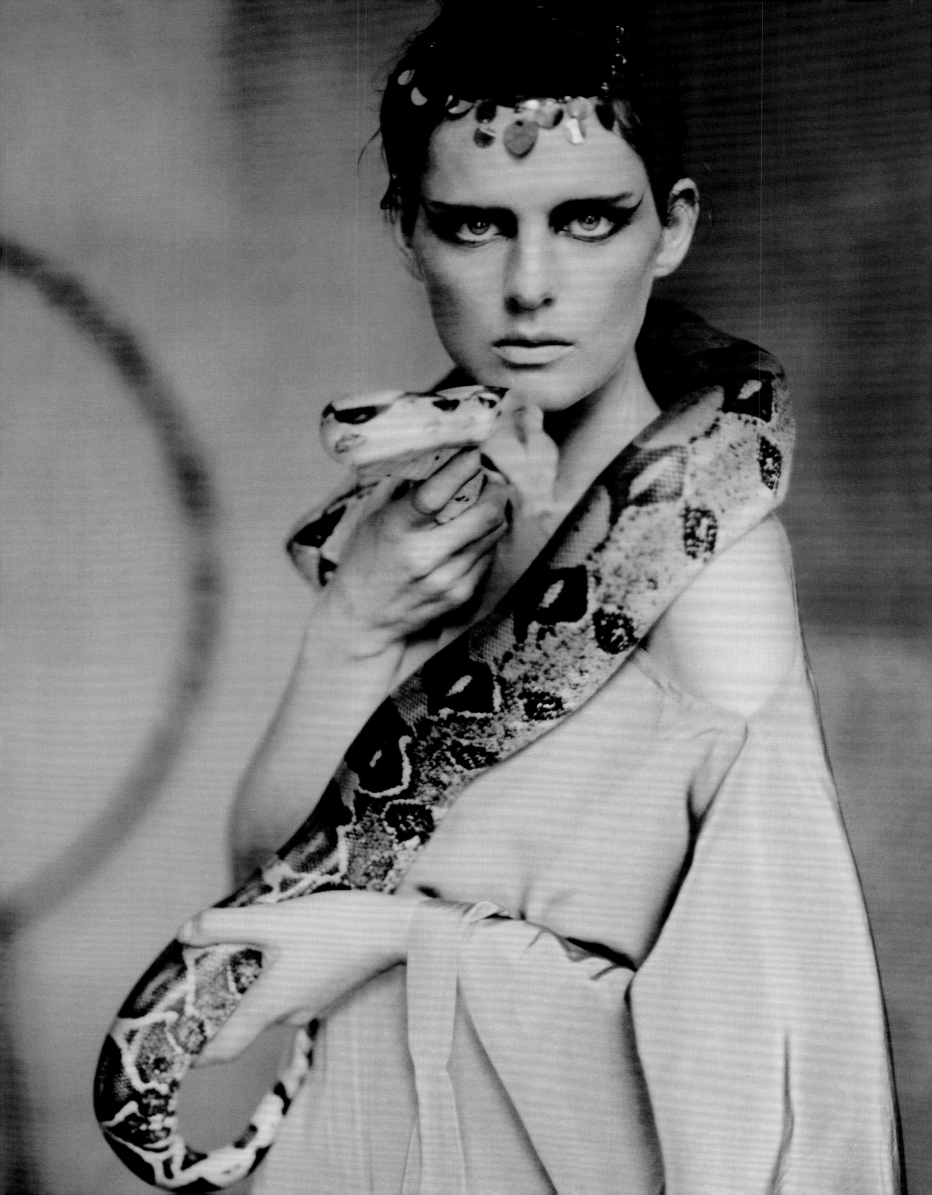

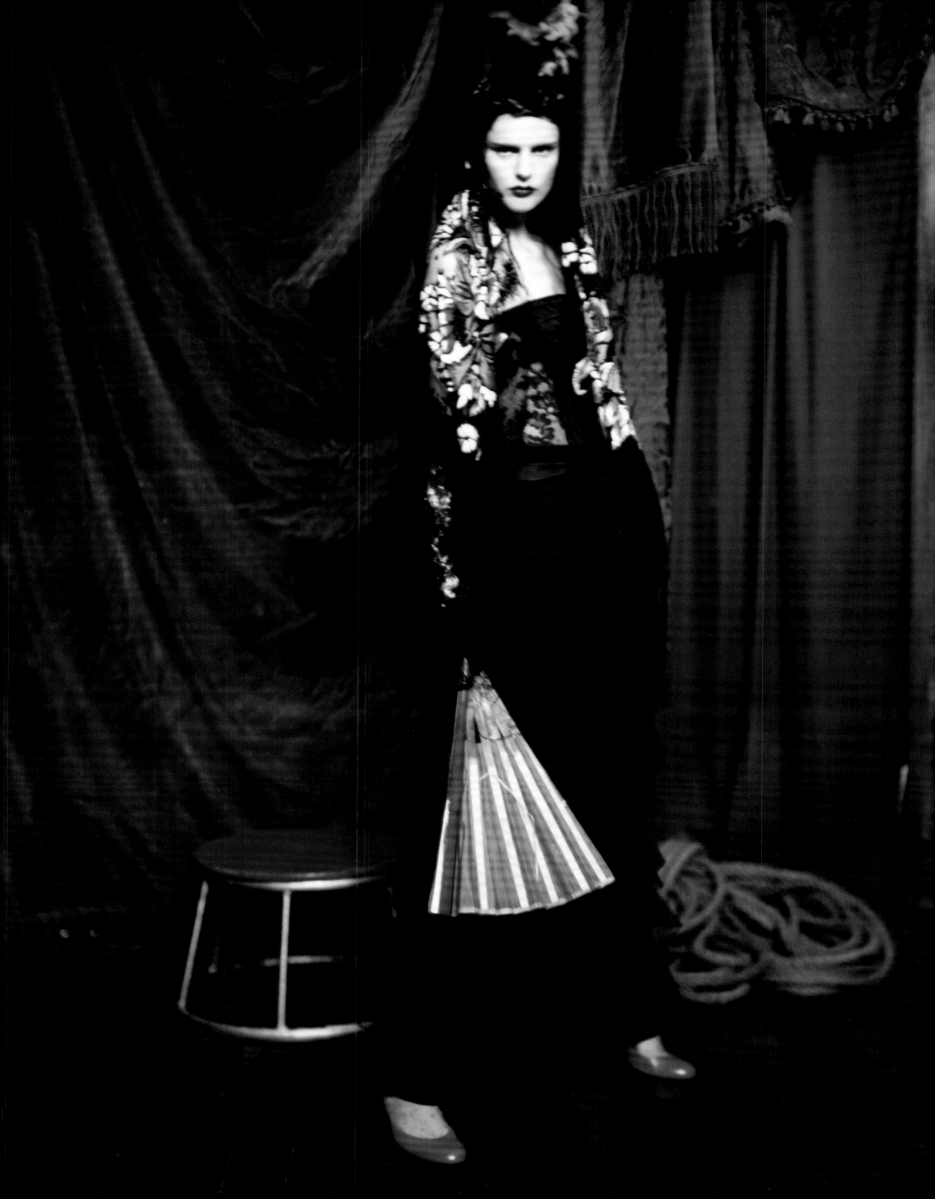

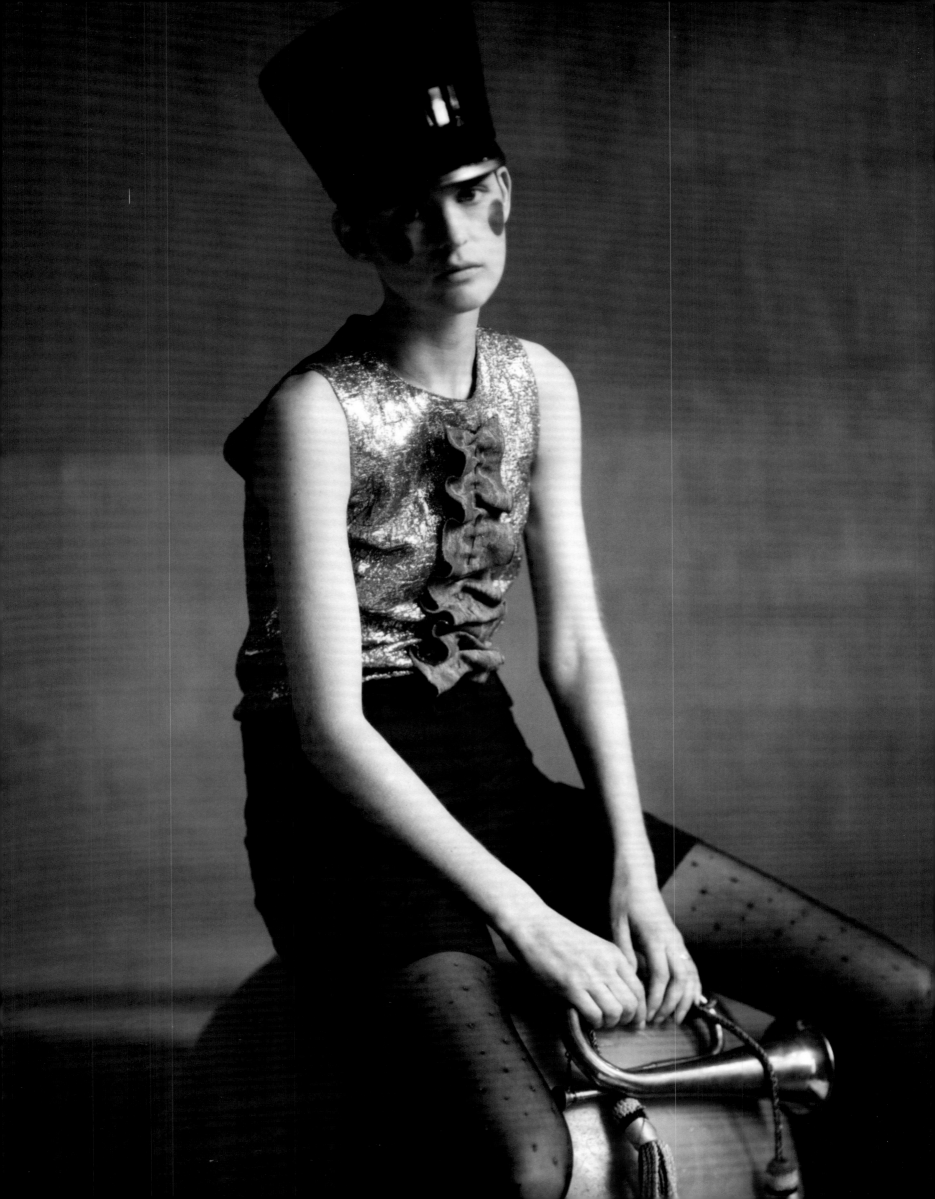

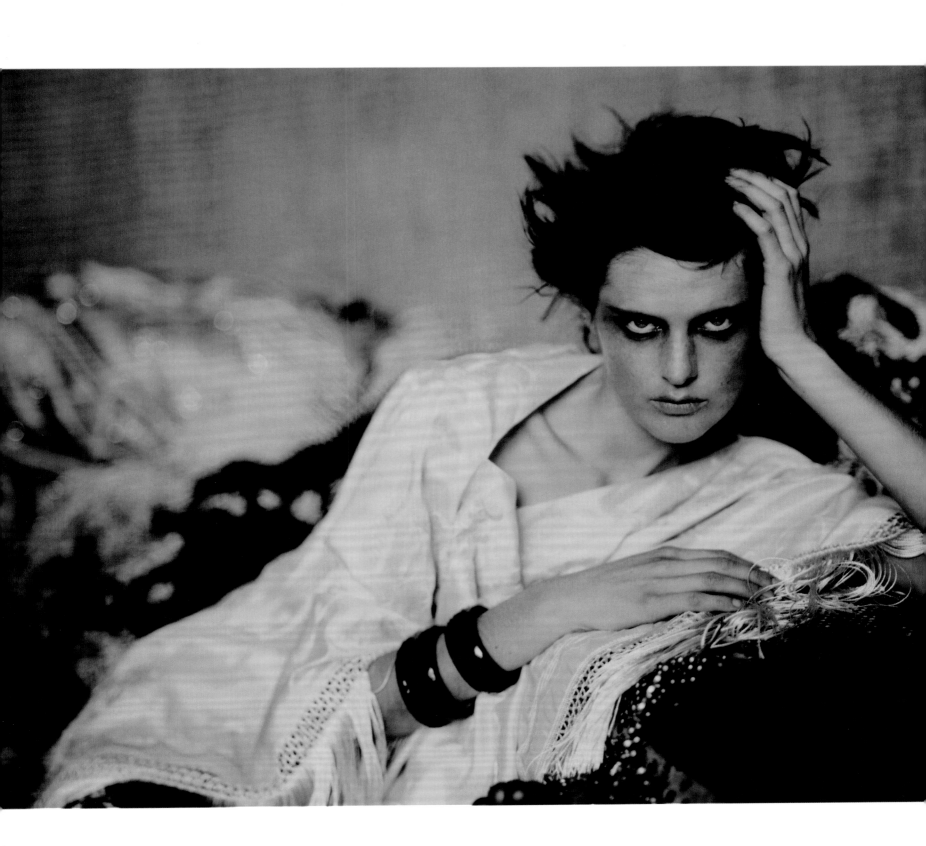

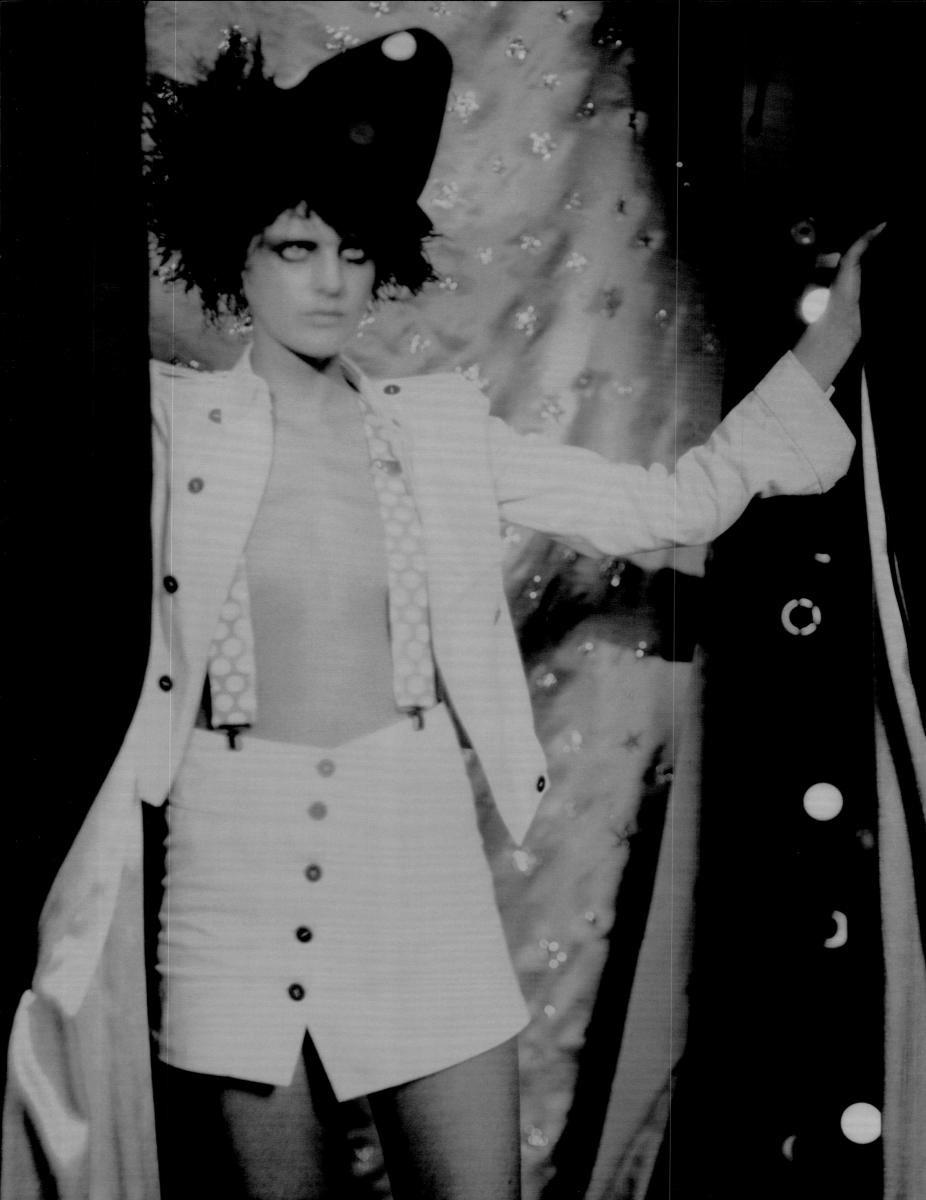

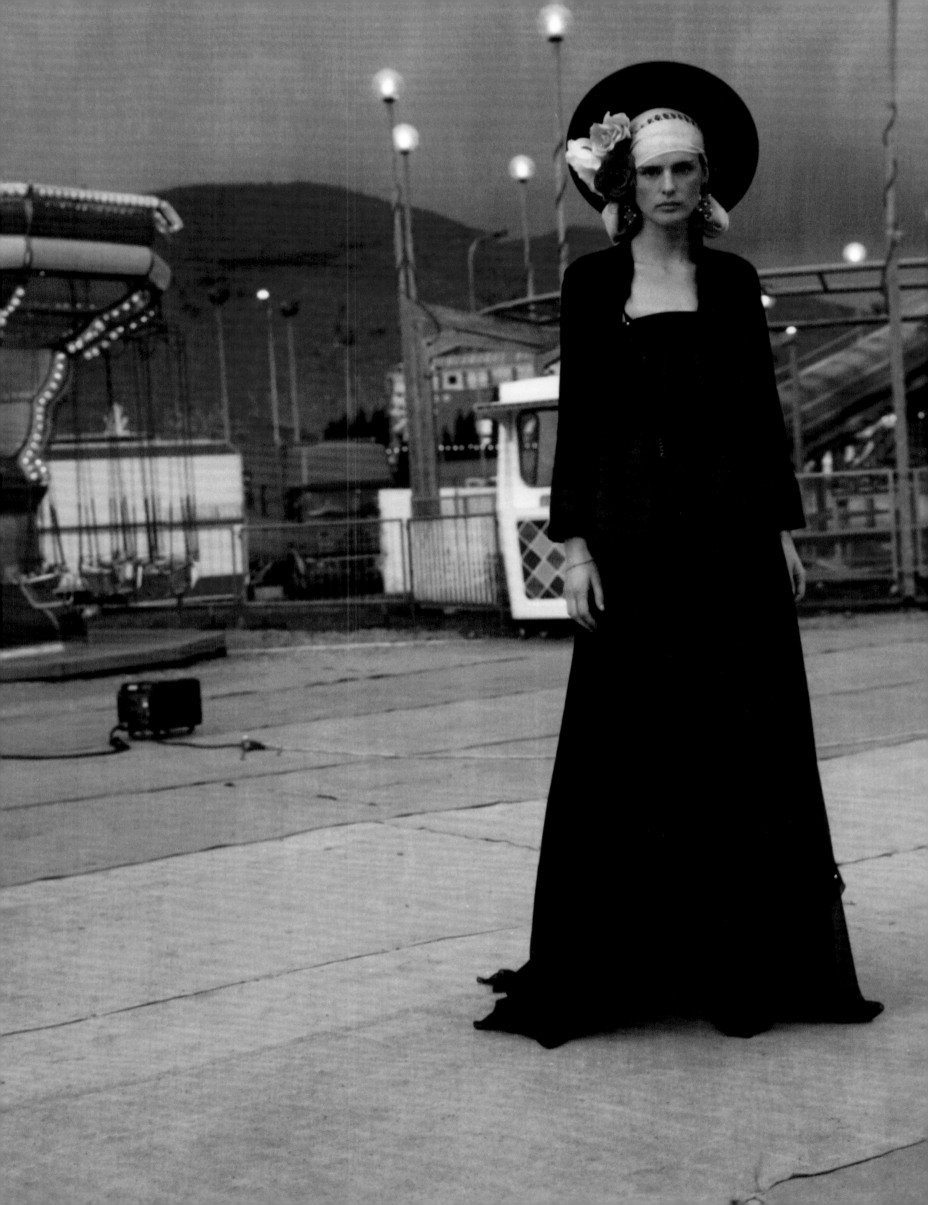

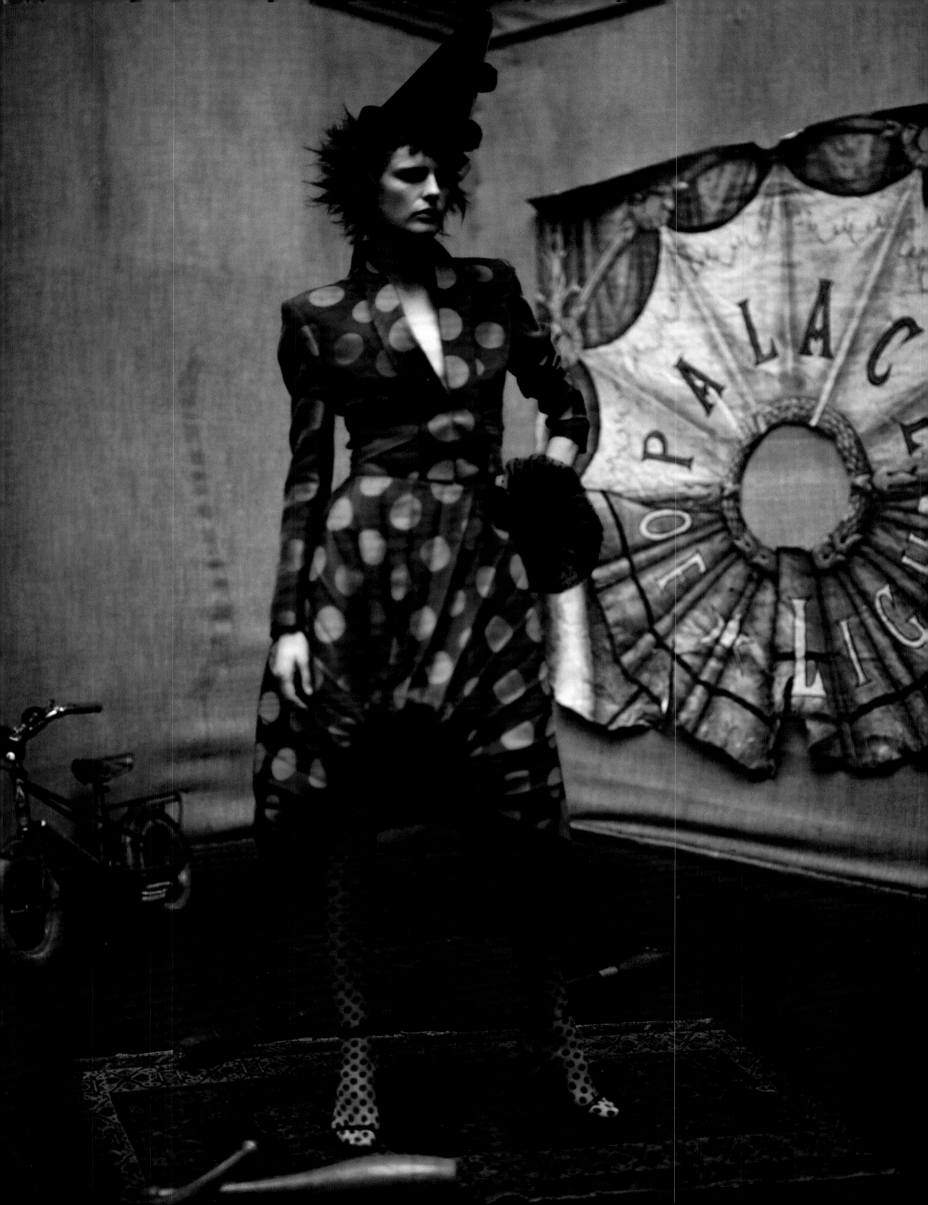

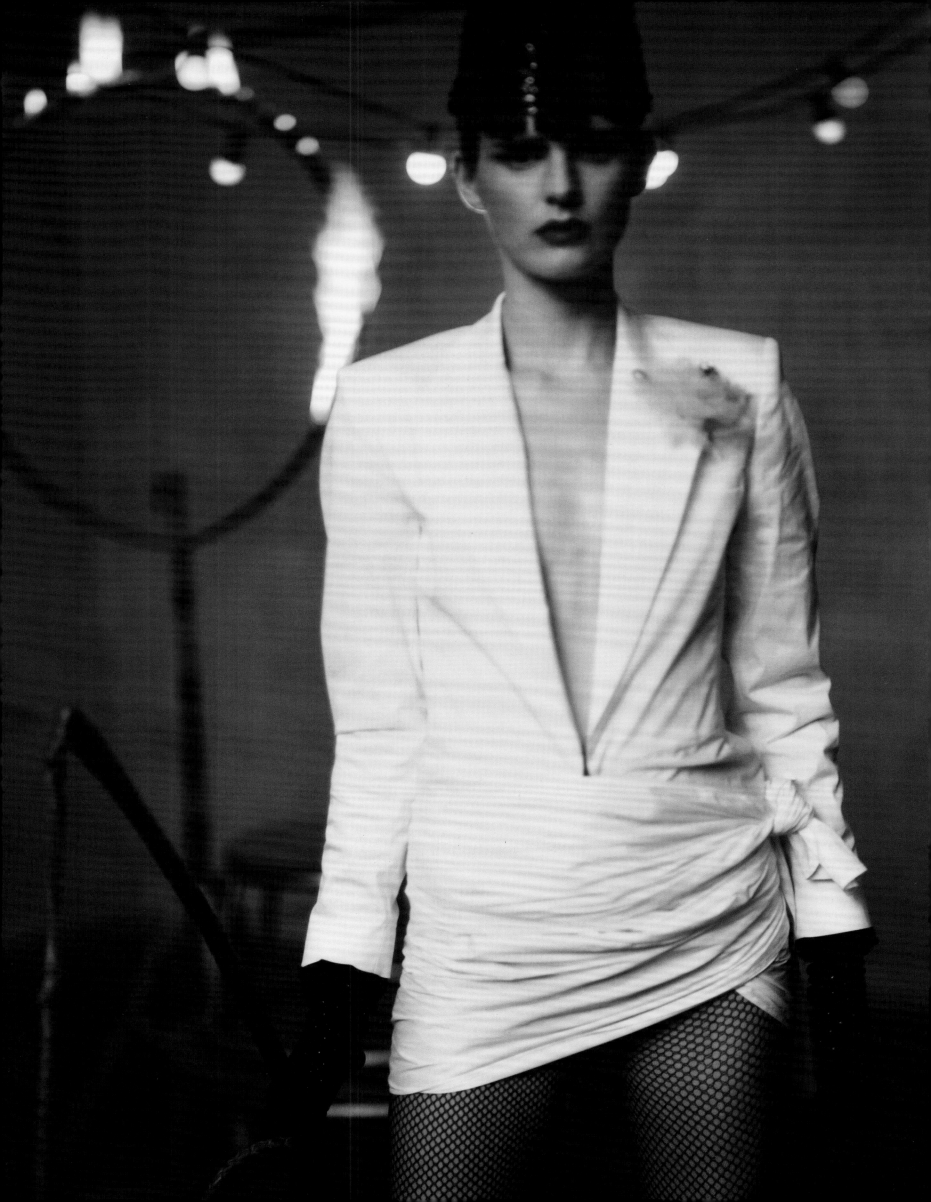

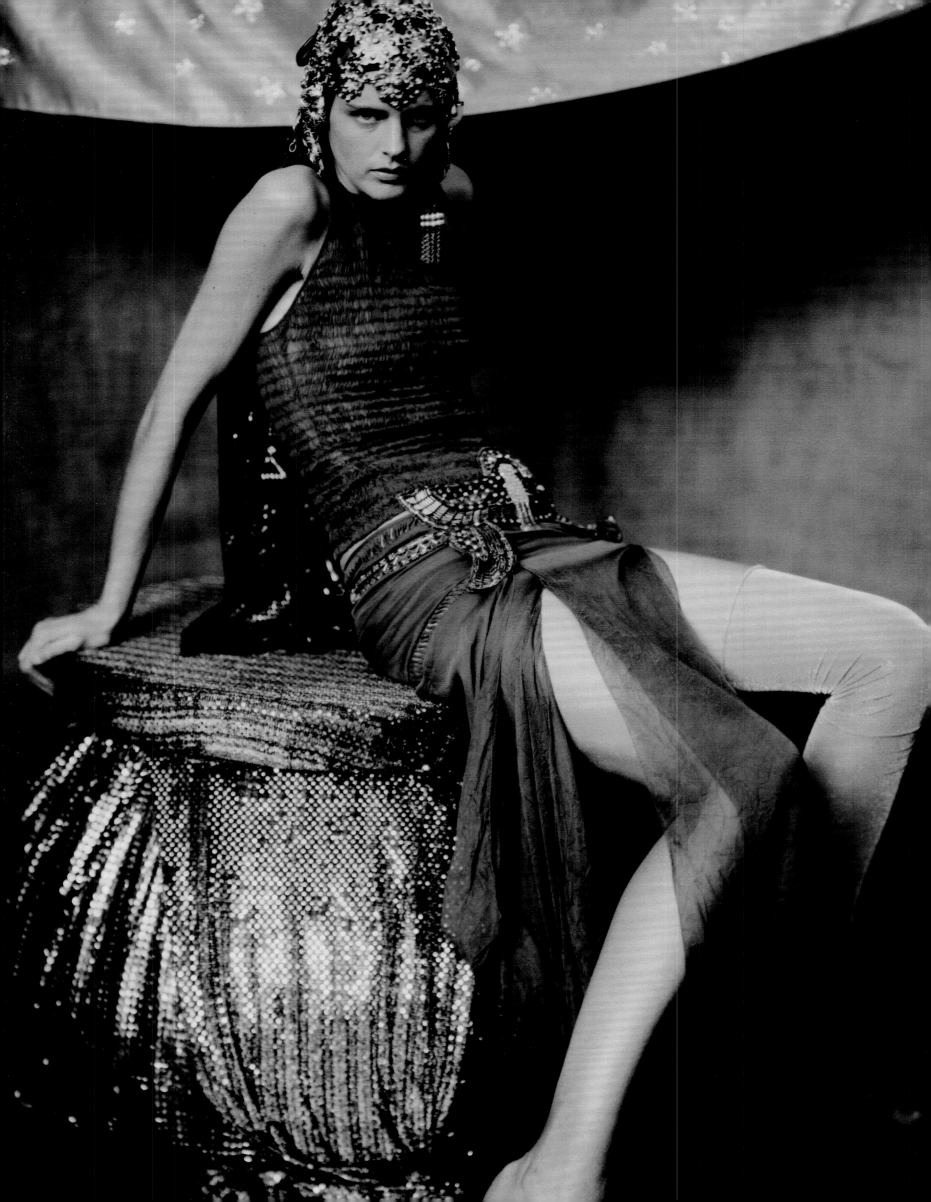

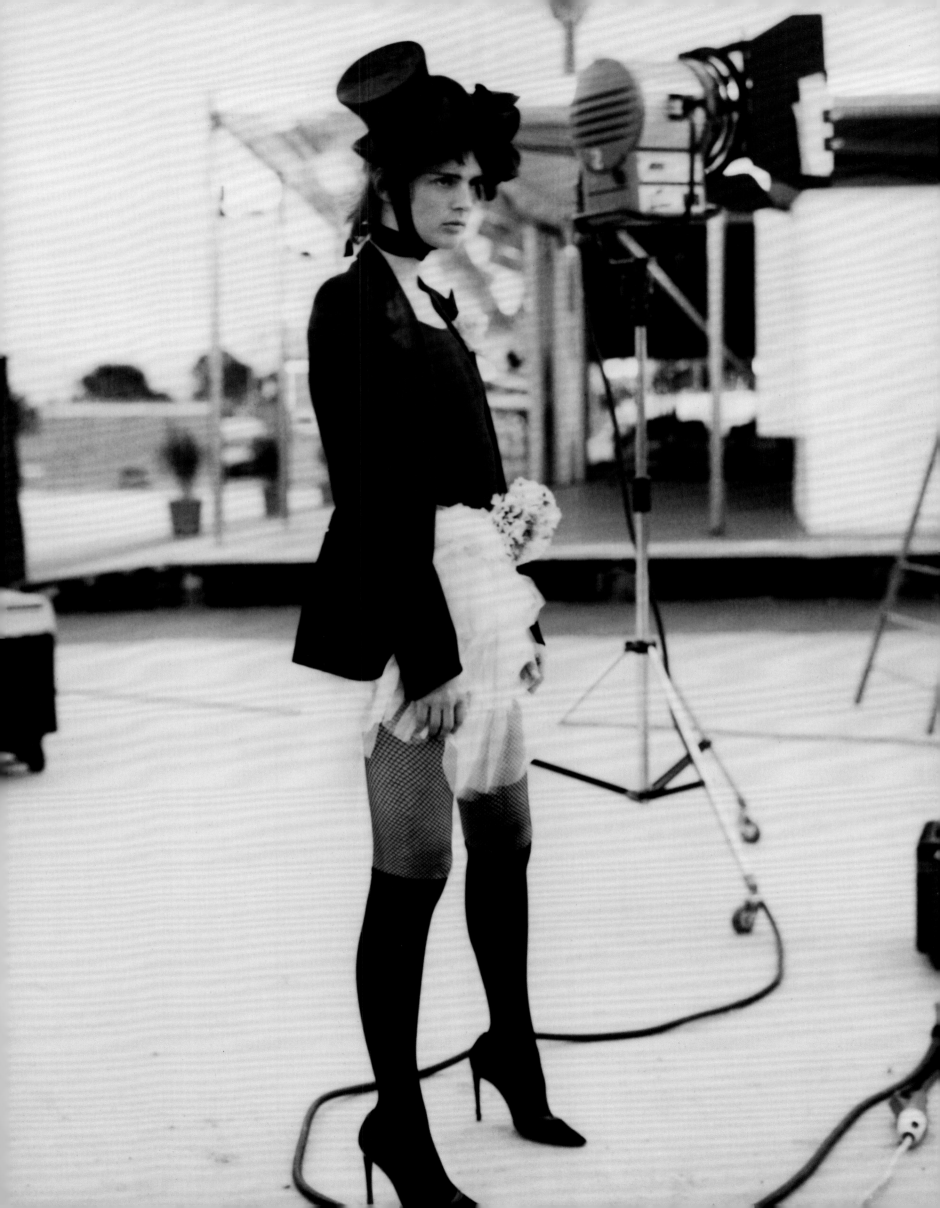

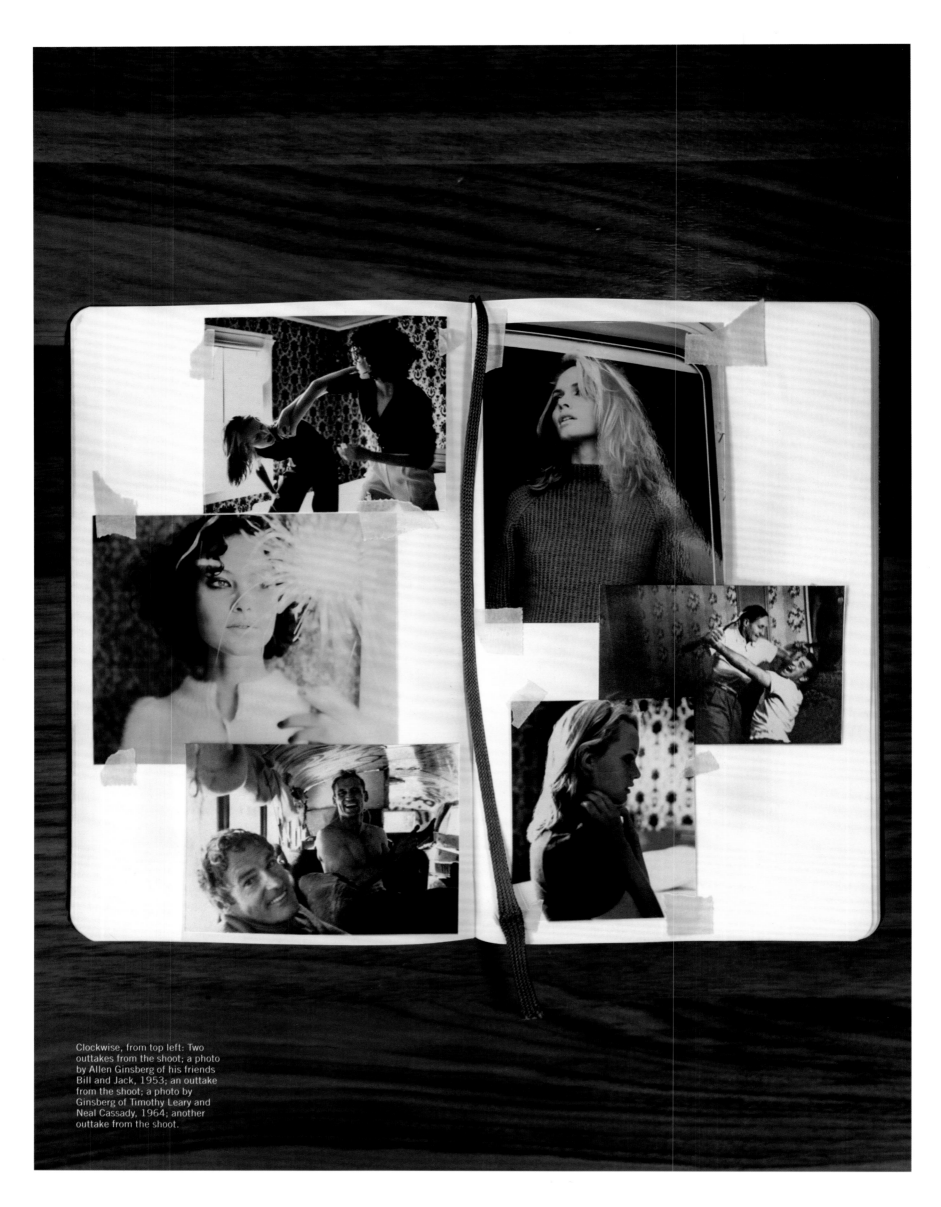

Clockwise, from top left: Two outtakes from the shoot; a photo by Allen Ginsberg of his friends Bill and Jack, 1953; an outtake from the shoot; a photo by Ginsberg of Timothy Leary and Neal Cassady, 1964; another outtake from the shoot.

BEAT DWELLERS

THE PHOTOGRAPHER CRAIG McDEAN HIT THE ROAD IN SAN FRANCISCO FOR THIS SPIRITED TRIBUTE TO JACK KEROUAC AND HIS CREW.

People can't help but be influenced by their background. I'm from Manchester, England, so music has always been a big part of my life and work. Growing up, I loved the Clash and New Order. And I would pore over beatnik stories—*On the Road* and *Howl*. Before this shoot, I had been rereading that old literature, and I was looking again at all those great pictures from the era of Jack Kerouac and Allen Ginsberg and their crew. I love that time period—and I love San Francisco. It's always been one of my favorite places on the West Coast, and I was eager to go back there and do this story.

Shalom Harlow and Amber Valletta had been each other's best friends for a long time, and to me they were quite beatnik in their own way—very free-spirited girls. That's what I loved about them, and why they were the perfect models for this shoot. They could just be themselves.

It was 1995, which now feels like the good old days, when all the magazines had lots of money and we could afford to spend four luxurious days there, three of them shooting. It was the first story that Alex White, then *W*'s Contributing Fashion Editor, and I shot together for the magazine, and we spent the first day scouting locations. I wanted to use the kind of simple, rundown places where students live, and we found a few downtown. But a lot of the story was done on the street. We rented a '60s Cadillac, with room for me in the front and them in back, and rode around taking pictures, jumping in and out of the car. The only way to capture the spirit of the Beat generation was to just put the girls in different situations and click away—very guerrilla-style. It was almost like a road trip, except we weren't traveling far.

As a kid, I wanted to be a motocross pro, and I used to take pictures of bikes and the races at a track near my family's house. My first book, published in 1999, was called *I Love Fast Cars*, and it was an homage to muscle cars and the world of drag racing. So even though I do a lot of studio portraits, I've always had a natural inclination toward a freewheelin' kind of photography.

Which is not to say this story wasn't a major production—there was hair and makeup and styling, and months of research. It only appears as though we just turned up in San Francisco.

Ever since I started taking fashion pictures for *i-D*, at the age of 16, my work has been guided by the models I'm shooting. You build a rapport with them and create from that a certain level of comfort. That's how many of these images came about—Amber and Shalom just messing around. There's one image of them playing on the bed, grabbing each other's hair. I shot it because I loved it, and it was a great moment, but it wasn't intended to run in the magazine. The photo of Amber shaking her hair on the beach—she gave me that gift. We went down to the ocean, and it was freezing. She was shaking because she was cold; it wasn't planned. I only snapped one frame of her doing that. We had a couple of lawn chairs that we just plopped on the grass, and I got that picture of them in their matching Gucci outfits. It was as simple as that.

The Gucci clothes in the story were from Tom Ford's first show for the house. The collection was very '70s, with lots of silk shirts and velvet trousers, but somehow the clothes worked really well. In retrospect, I find it funny that we shot the same look on both girls—most photographers wouldn't do that today. Aside from that one image, high fashion wasn't an integral part of what we were doing—or at least it wasn't for me. Everything they wore was very simple, just turtlenecks and button-down shirts. I remember we took a lot of black jumpers. It was an era when you didn't have to have a handbag in every shot—you could just throw some clothes on the girls and go.

PHOTOGRAPHED BY CRAIG McDEAN
STYLED BY ALEX WHITE
PUBLISHED IN SEPTEMBER 1995

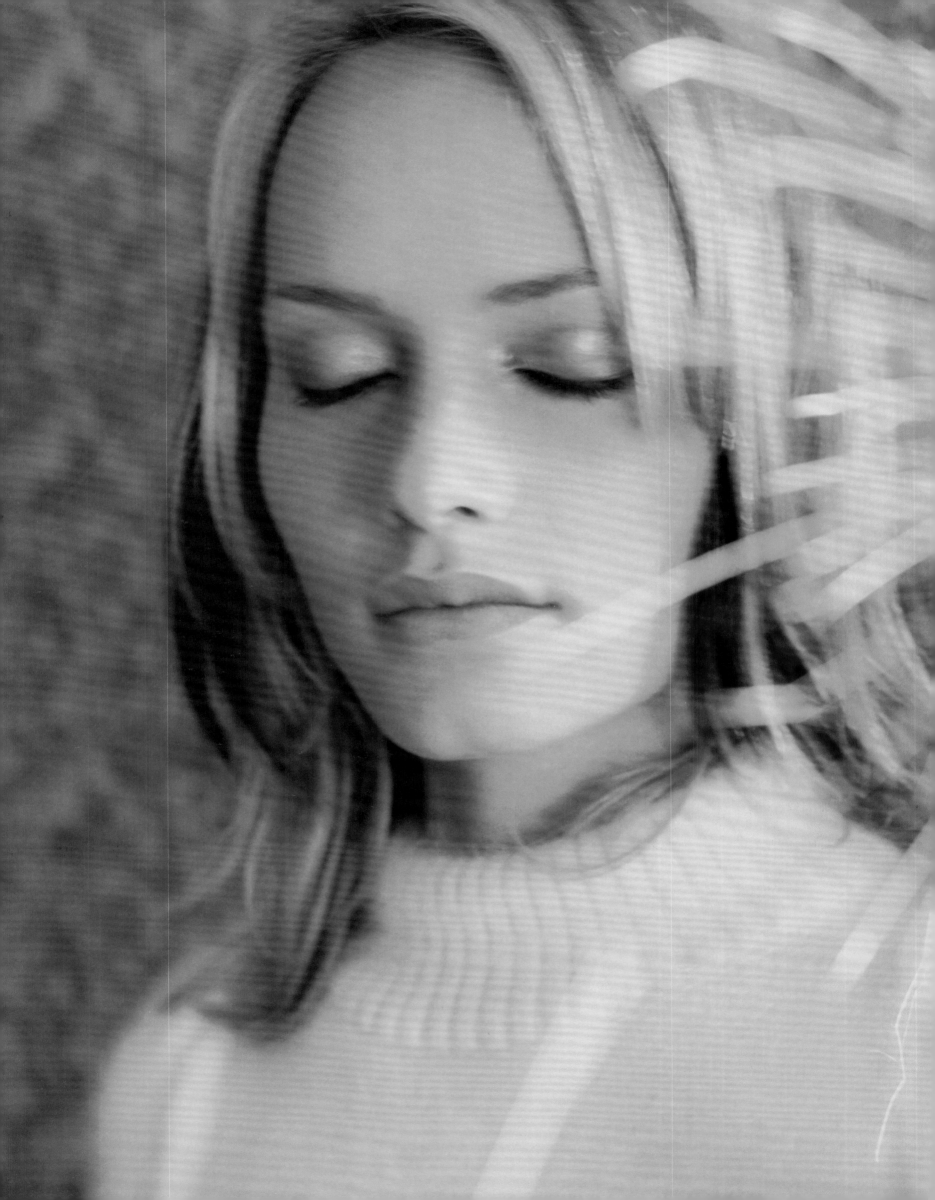

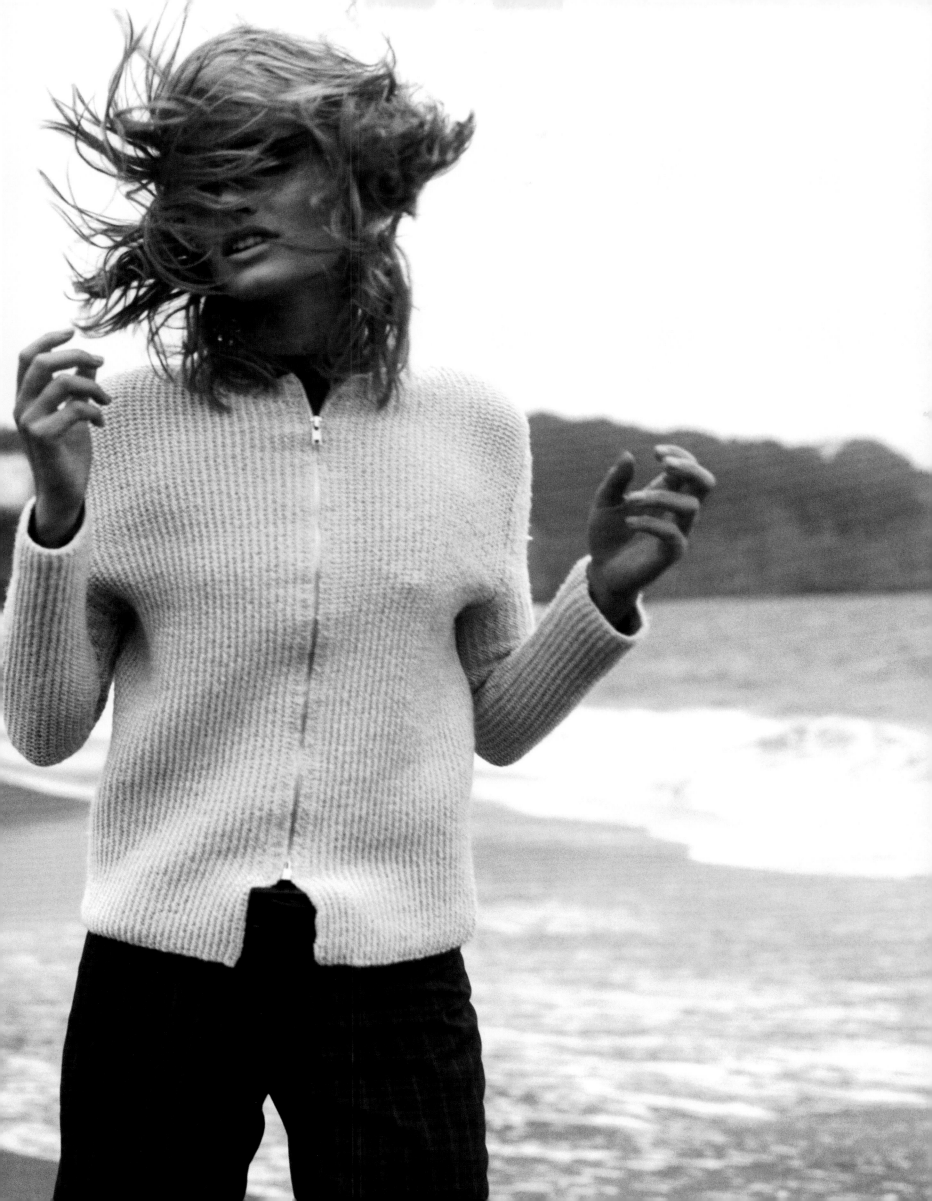

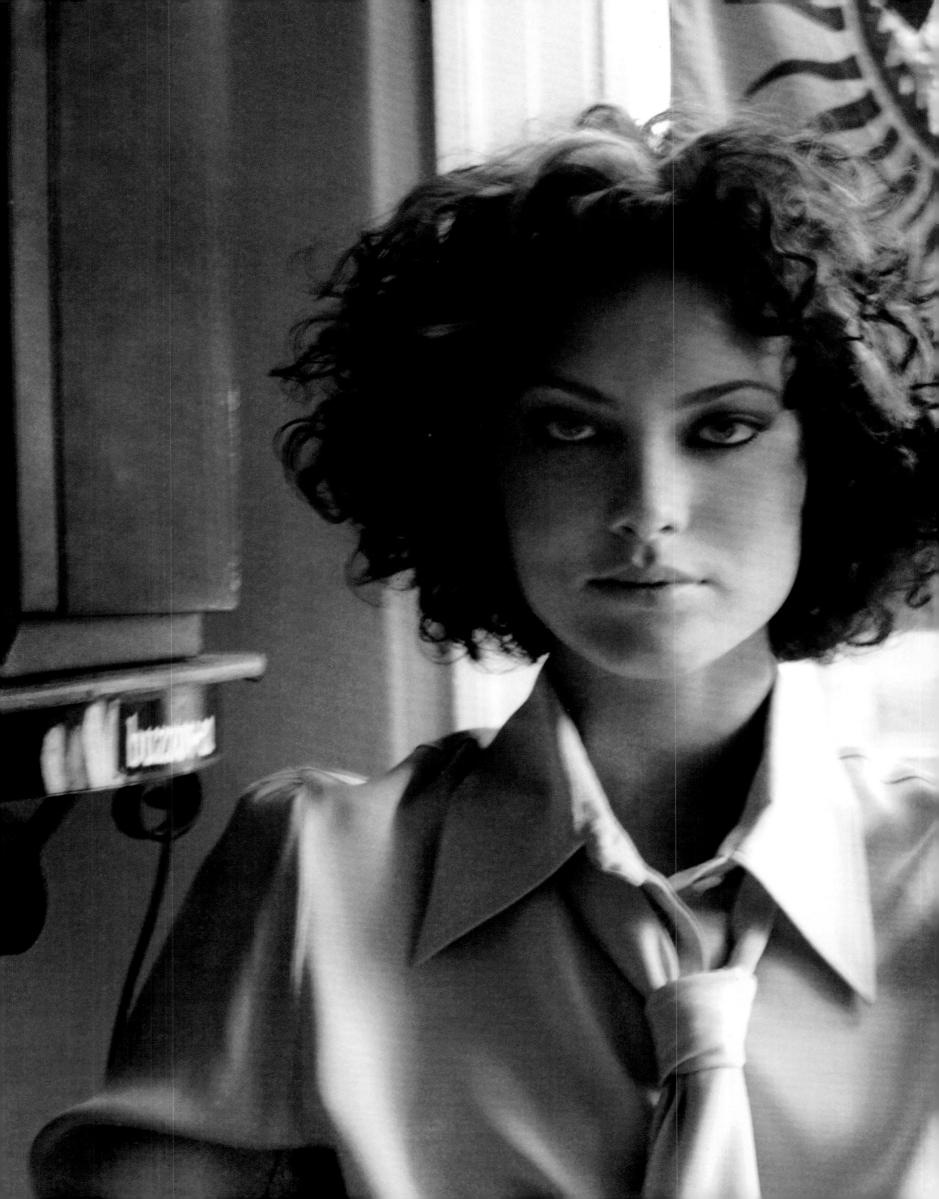

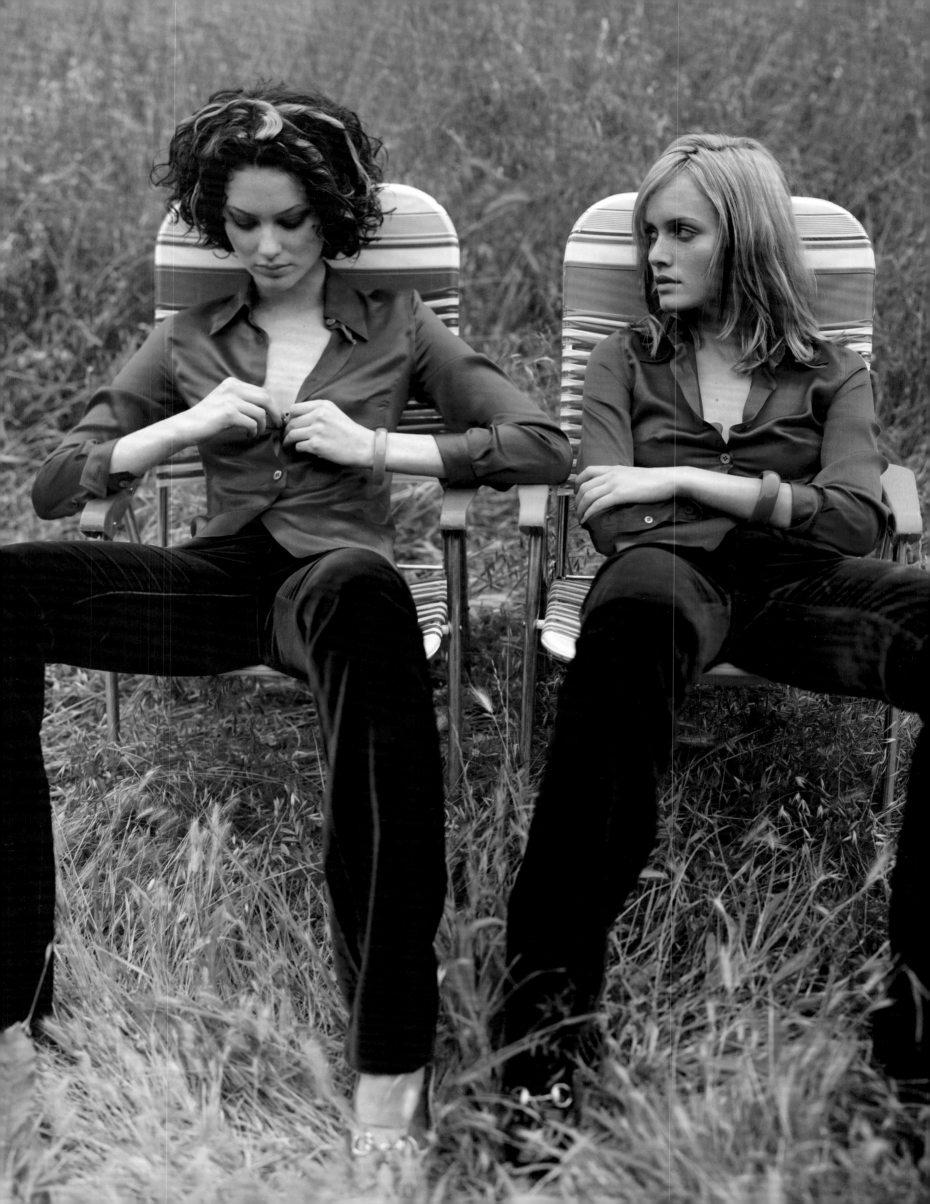

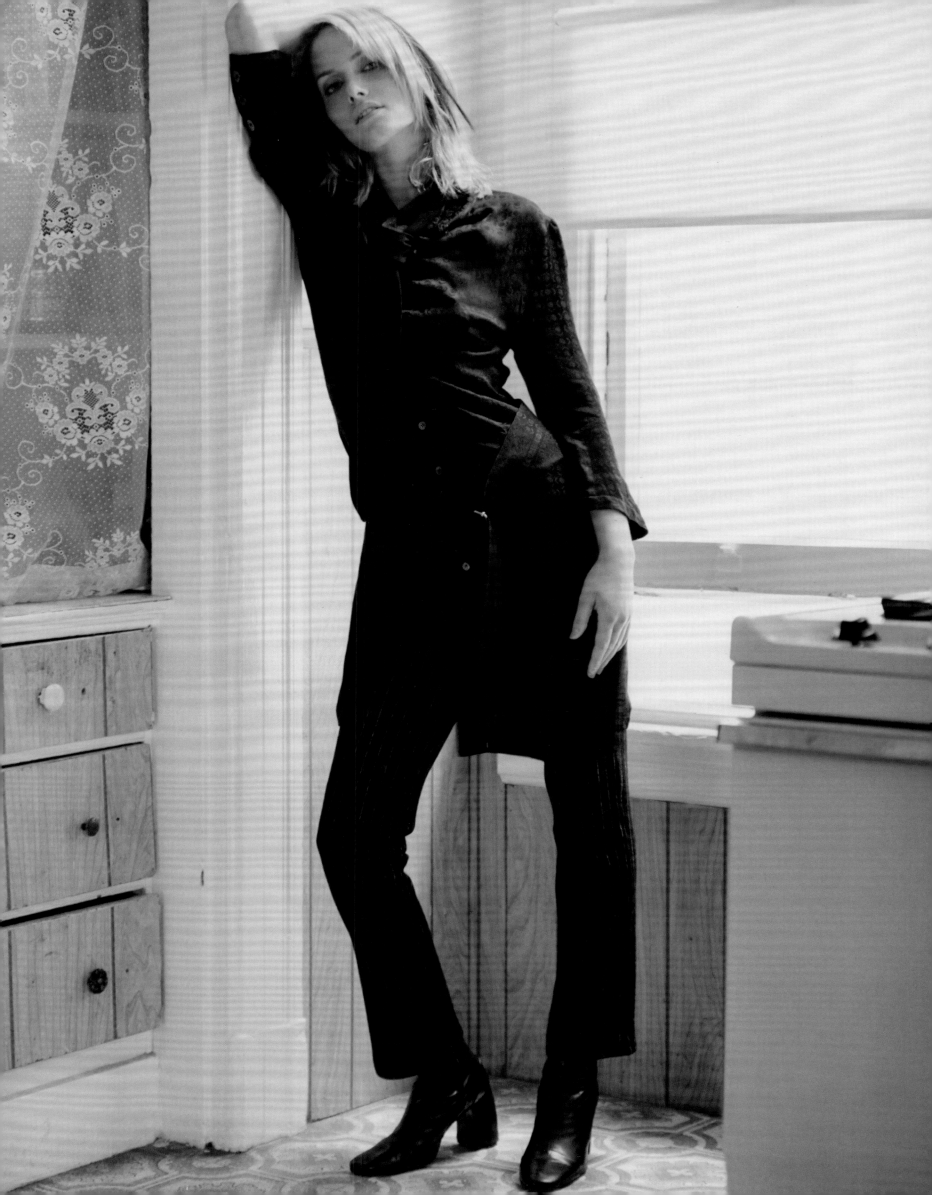

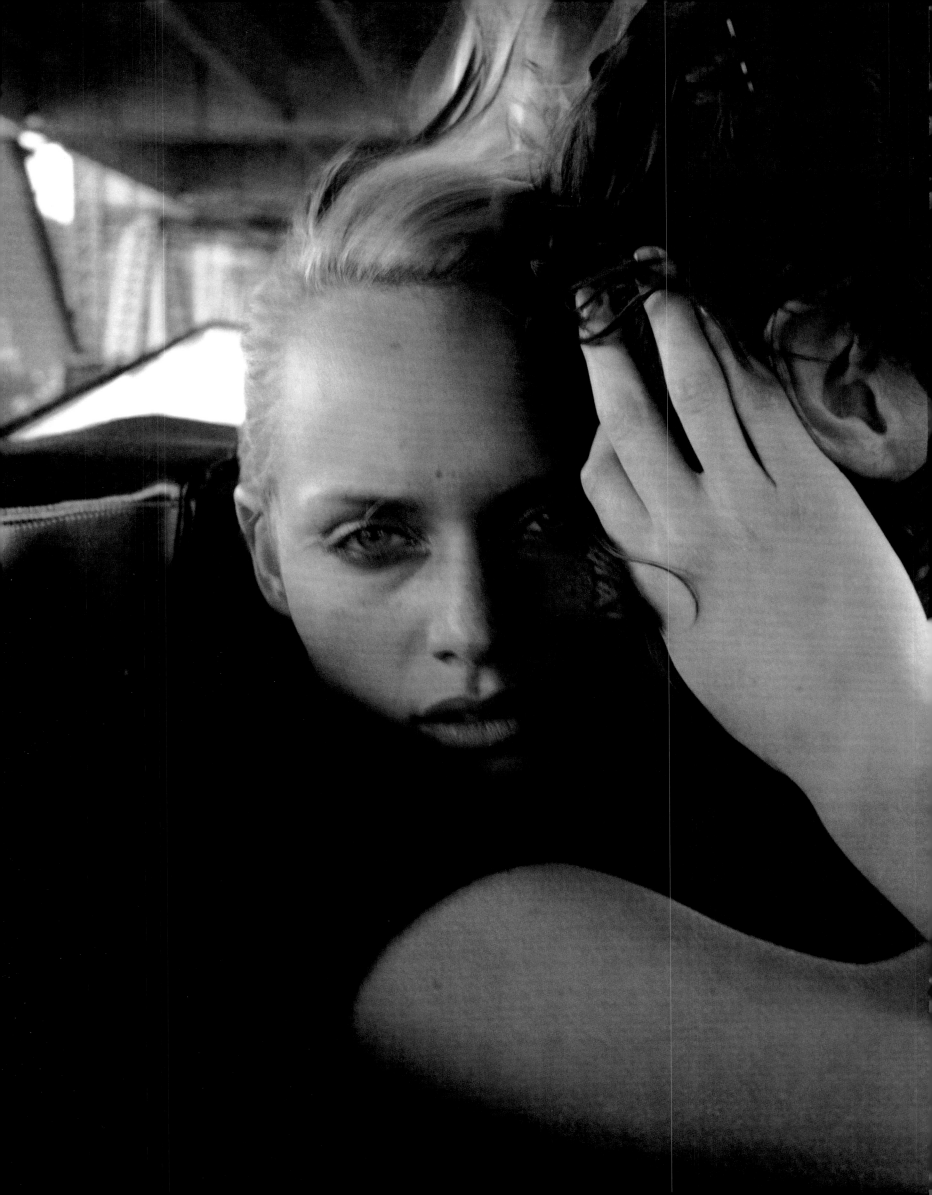

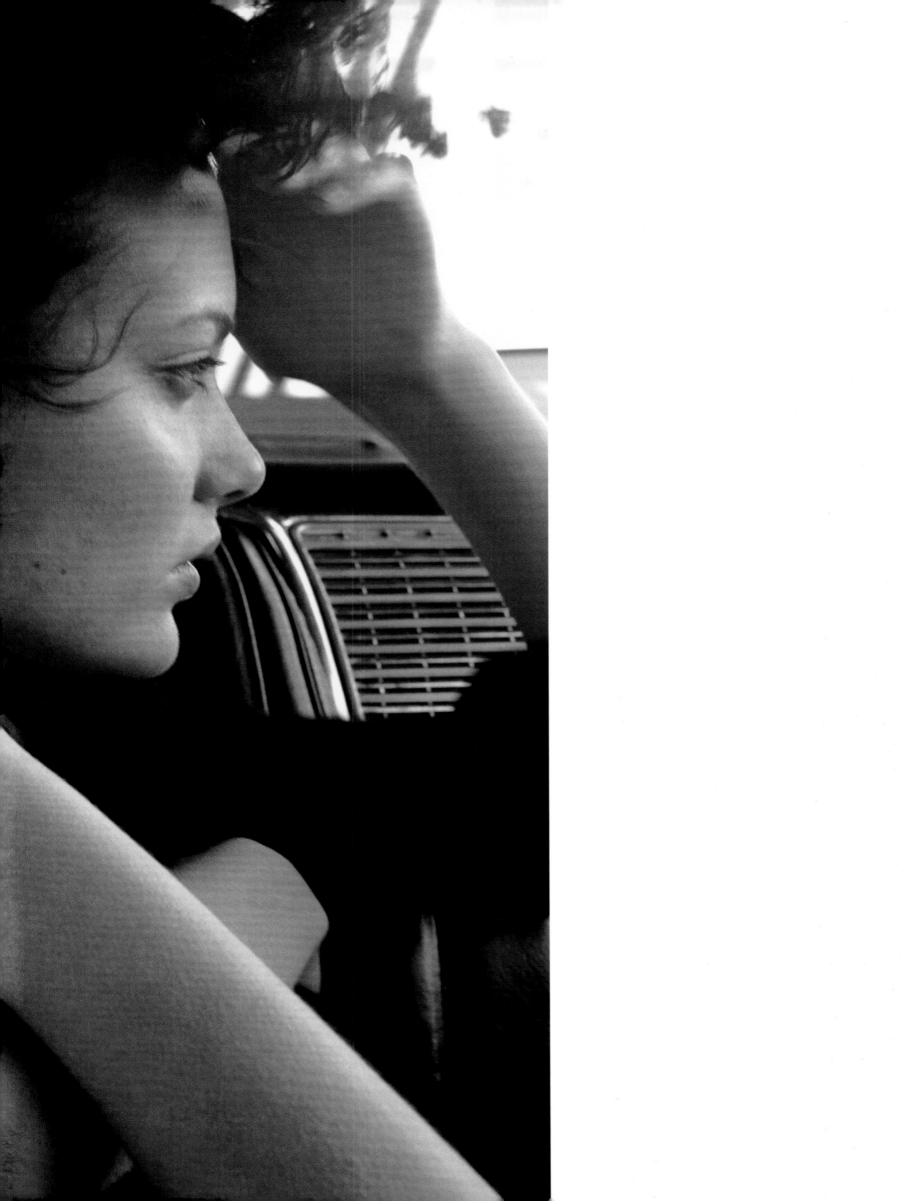

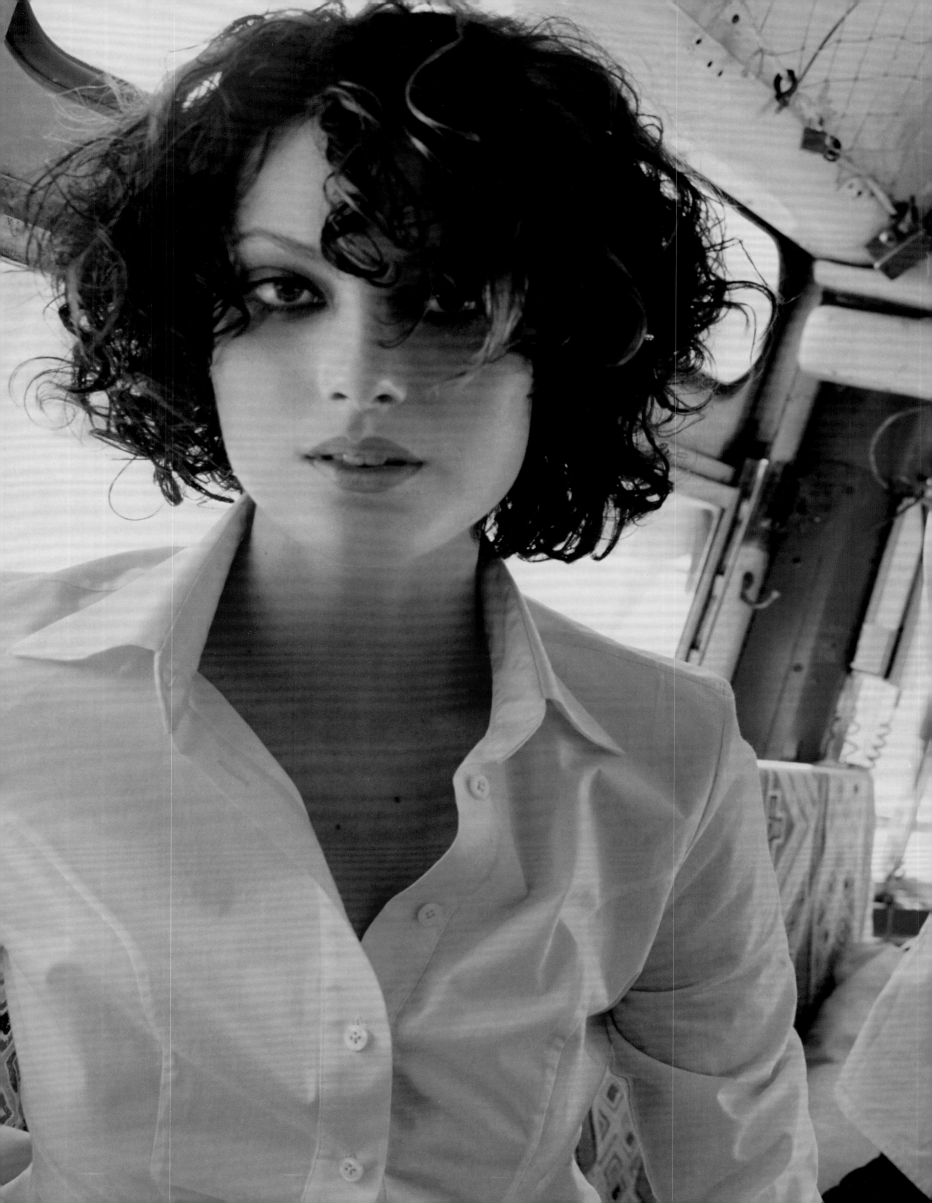

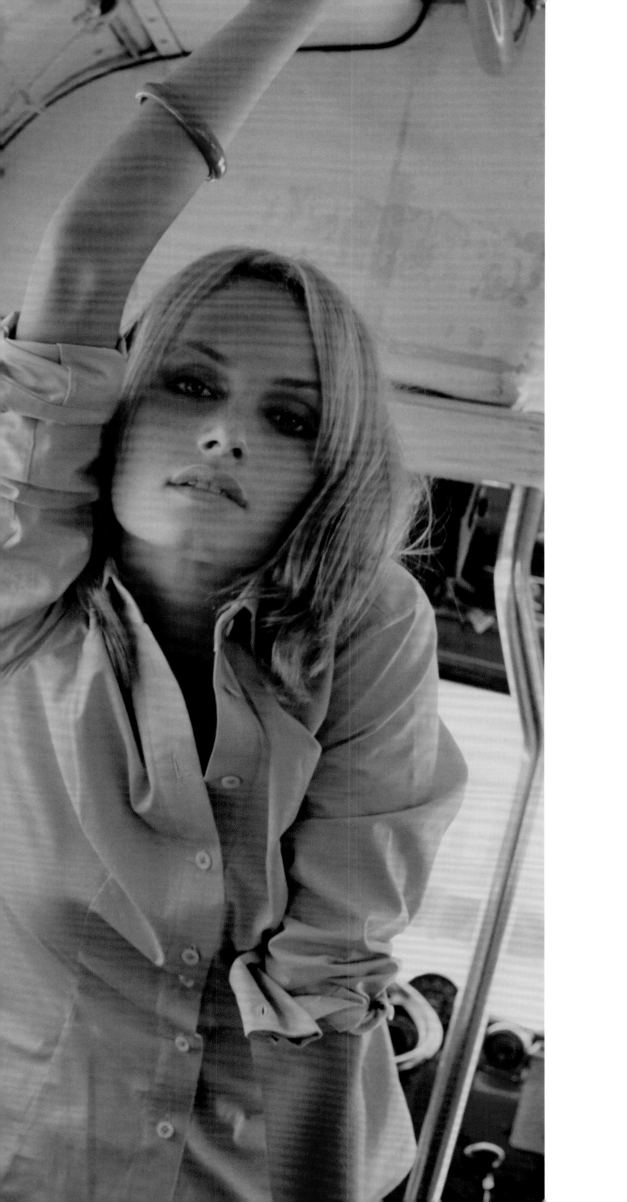

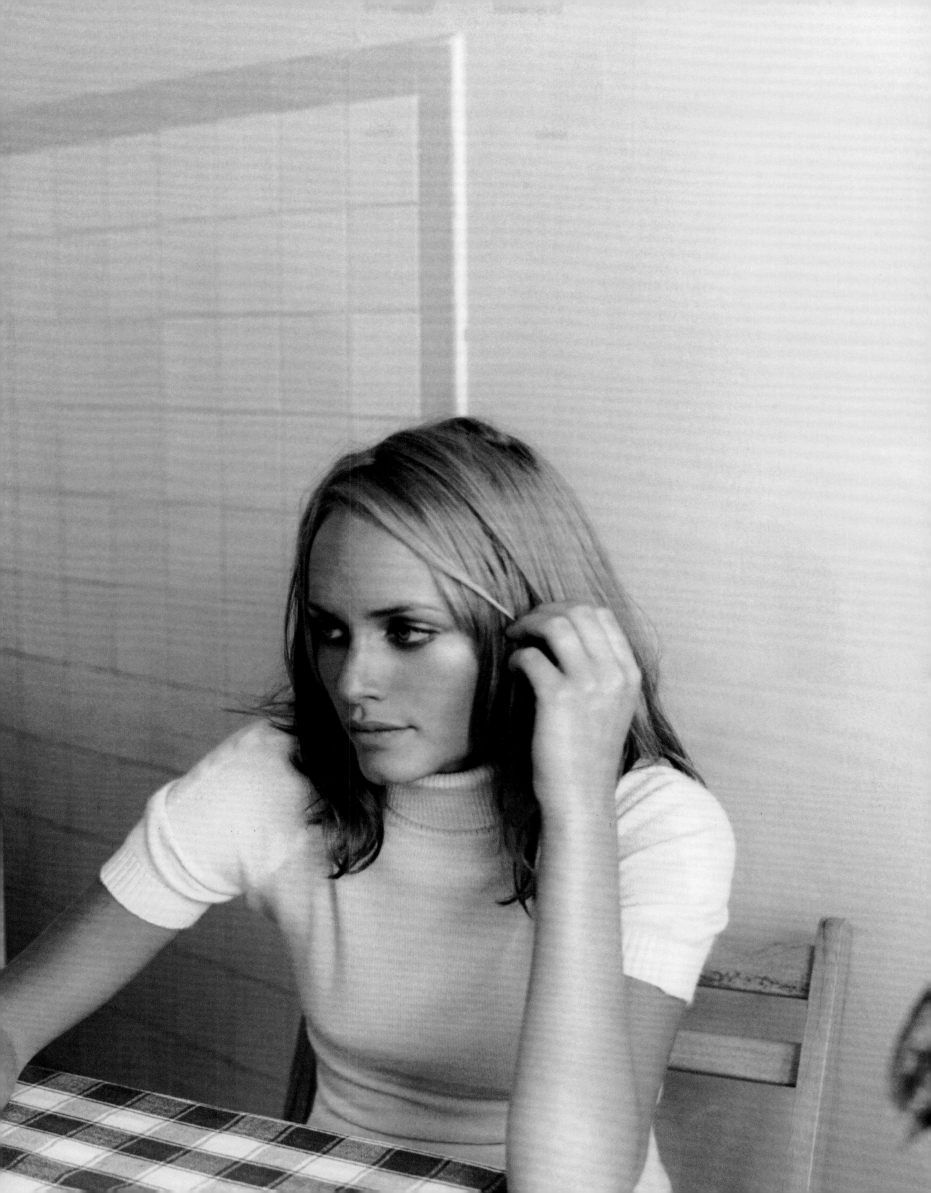

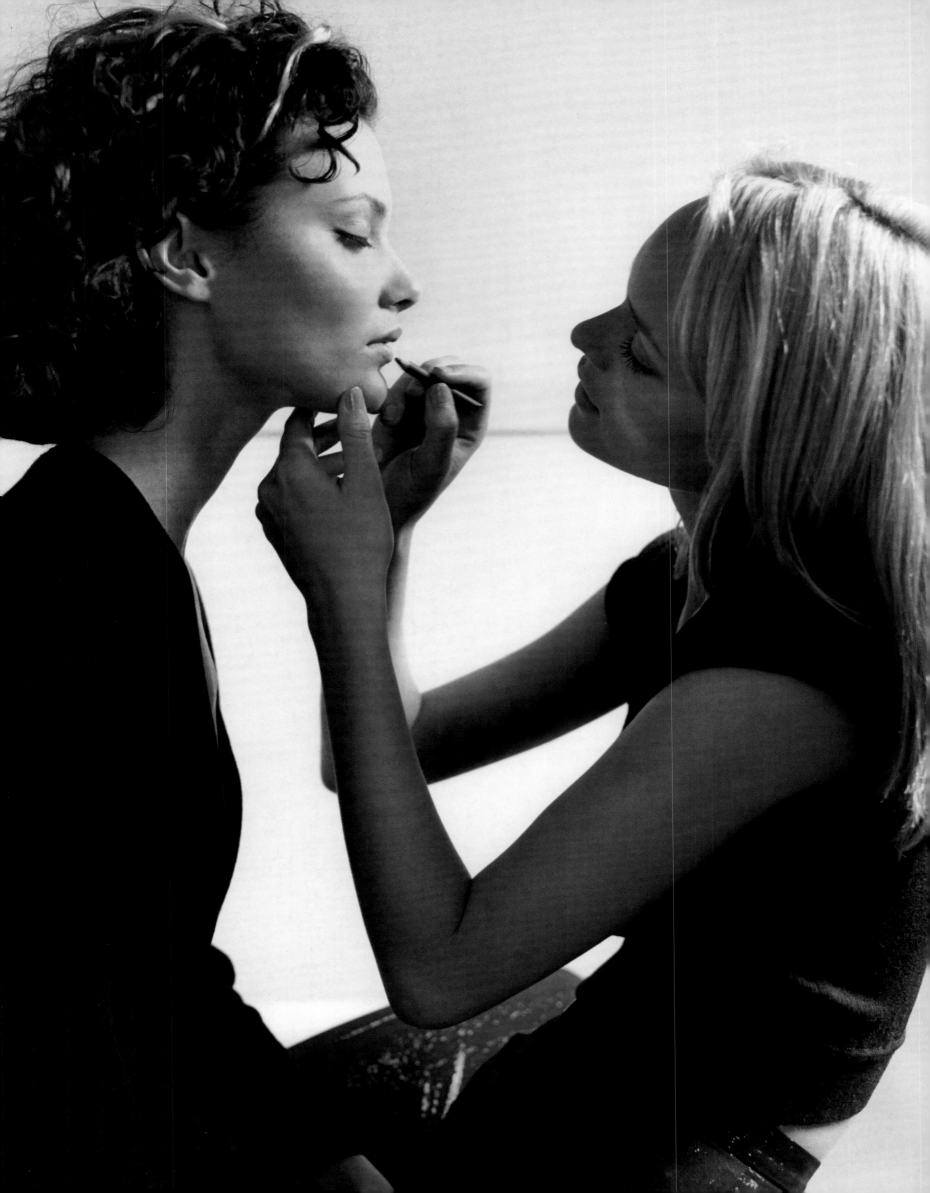

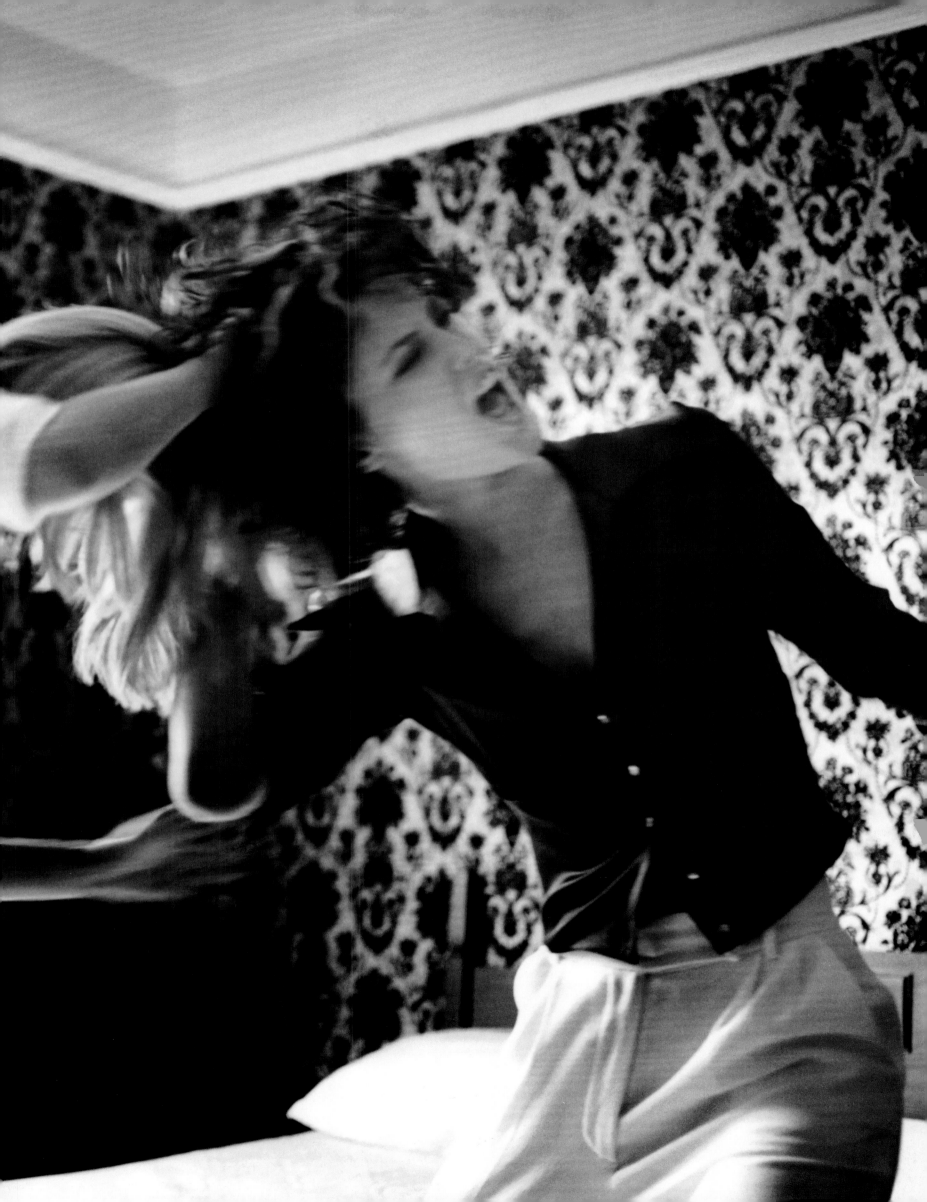

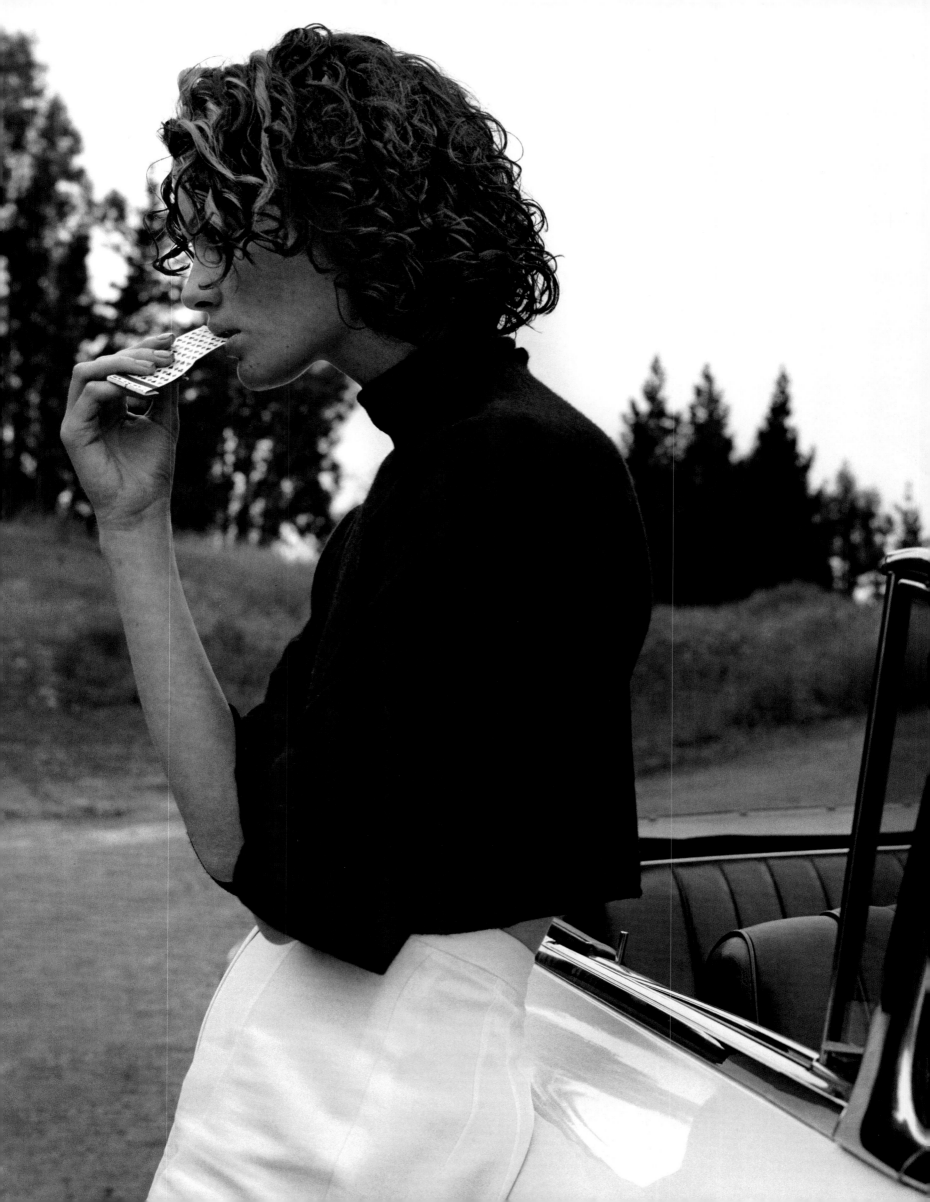

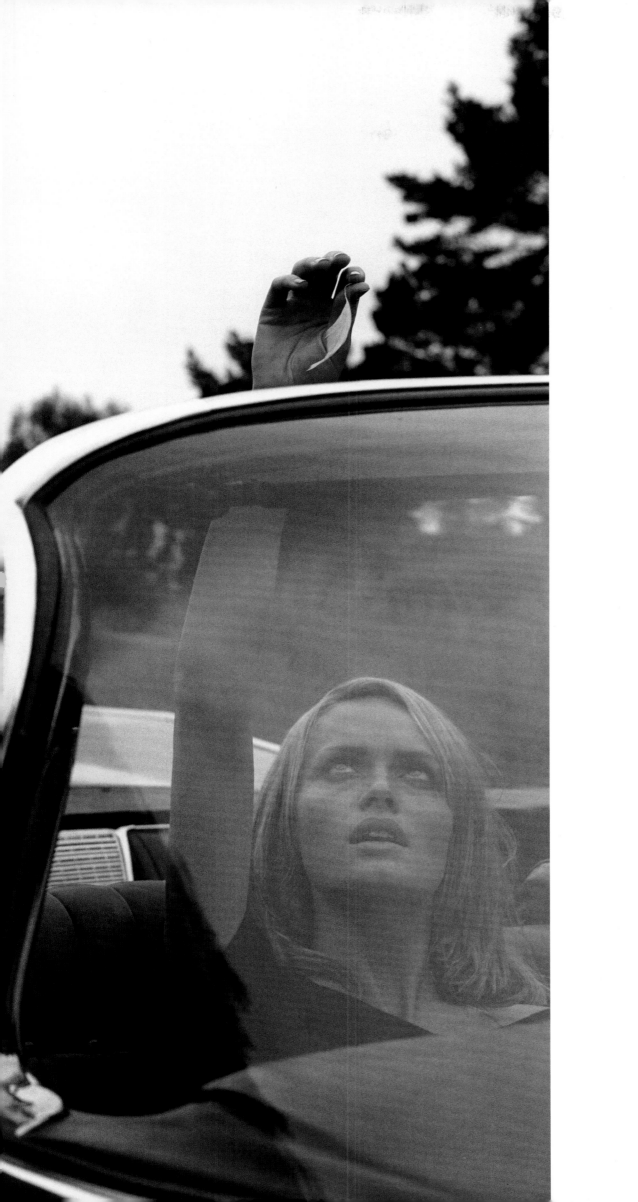

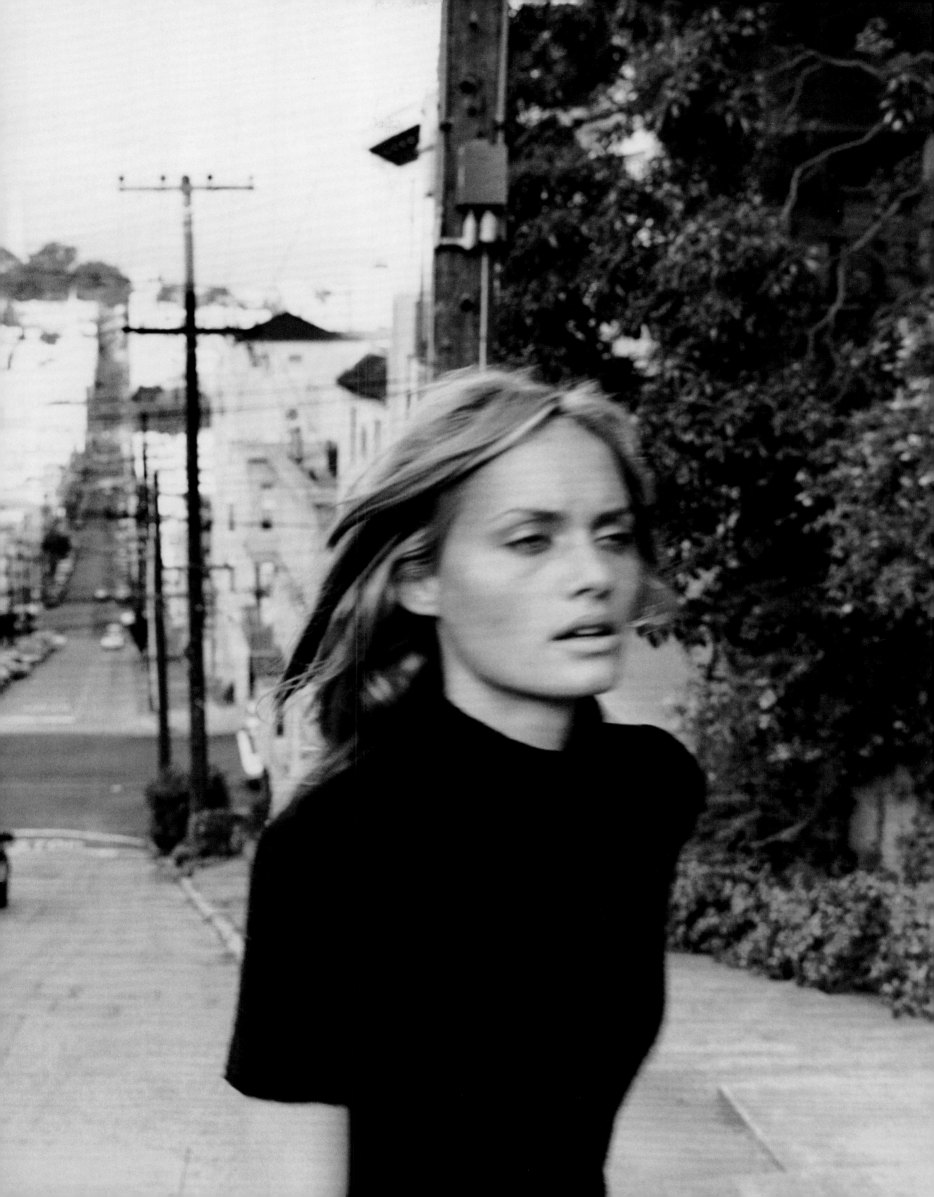

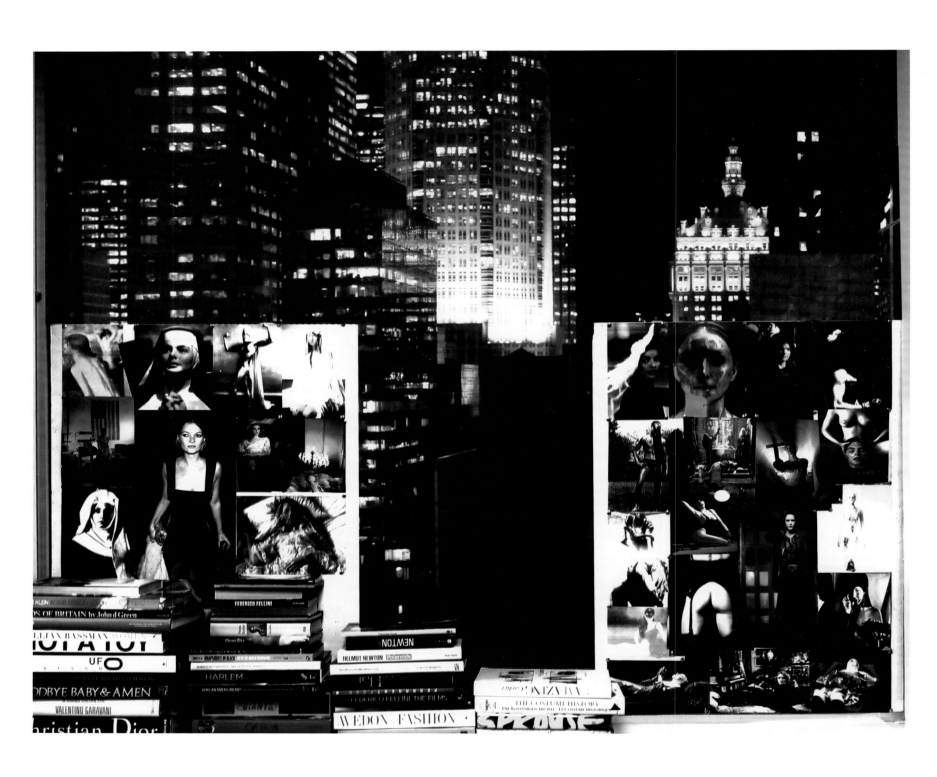

Edward Enninful's mood boards, in preparation
for the two–sides–of–Kate Moss shoot.

GOOD KATE, BAD KATE

FOR OUR DOUBLE-COVER STORY FEATURING KATE MOSS, WE ASKED THE BRITISH AUTHOR WILL SELF TO COMMENT ON FASHION'S QUINTESSENTIAL SILENT MUSE.

When I pore over these wonderful images of the model, designer, and eternal waif Kate Moss, firefly thoughts flit in and out of the dark halls of my mind. I think first of Dorian Gray in Oscar Wilde's amorality tale, who looks upon the portrait of himself in the fullest fruition of youth and wishes that it would age in his stead. Kate Moss seems to have always been with us—and to have always been as she is. Yet the truth is that she's twice married and a mother. Her life has been a slalom through the toxicities of fame and success.

I look back to photos of Moss at the outset of her career, and I see the full and terrifying extent of her juvenescence: how much younger she seemed than she actually was. At 19, the revered and reviled face of "heroin chic," Moss appeared to be in her Lolita teens. In her early 20s, she had the dégagé pout of a girl who has the right to vote but wouldn't enter a polling booth unless you dropped it over her head. In catwalk footage from later on, Moss's face had become streamlined, grown more feline, so that when emulating the swivel-hipped stride of her towering colleagues, she powered along the runway like a gilded hood ornament: inescapably British, the Rolls-Royce Spirit of Ecstasy gene-spliced—perhaps by some model-agent Dr. Moreau—with the iconic Jaguar.

Moss has aged and continues to age—not gracefully, for she's a suburban hellion from the outer limits of Cockneydom, but beguilingly. The images seen here delight in the platinum and pearliness of her slightly skew-whiff teeth. I lose myself in the cold reactor shutdown of her brown-to-black eyes. As for that ever-feted bone structure? Well, what to do but wax poetic about that perfect geometry: Moss's mouth no rosebud but a crushed carnation, her cheekbones somehow performing the alien accomplishment of curving down to below its petals.

Dark Moss and Light Moss. Bad Kate and Good Little Katie—simple dichotomizing is not what this dyad deserves. I look at the pictures of Moss dressed in black and think perhaps they're of a great beauty meditating upon her own inner ugliness. I try to divine the precise symbolism of the tattoo on her wrist. Is it piratical anchor or Coptic cross or some strange merging of the two? I think of Baudelairean decadence, and I'm hammered back into Dorian Gray's gilt frame.

But then, the images of Moss in white are hardly a counterpoint to the ones where she's in black: The lacy swathing is too opulent, the blonde hair is too blonde, the skin has both the pallor of an ice age and the sun's queasy burnish. Moss, neither the most adroit of catwalk queens nor a fluid component of moving pictures, has always excelled at presenting herself in such static and iconic formats.

In the past few years, with scandal heaped upon bathos, her once legendary media *froideur*—no interviews, no comments—has been fractured in ways so prosaic that far from shattering her visual image, it has left it mysteriously shellacked. With each dull revelation, the glaze on those features becomes thicker and her essential self becomes even more enigmatic. She remains like a great silent screen heroine who's animated and reanimated and then reanimated again by the fizzing jolt of the kliegs. Long may it continue.

**PHOTOGRAPHED BY STEVEN KLEIN
STYLED BY EDWARD ENNINFUL
PUBLISHED IN MARCH 2012**

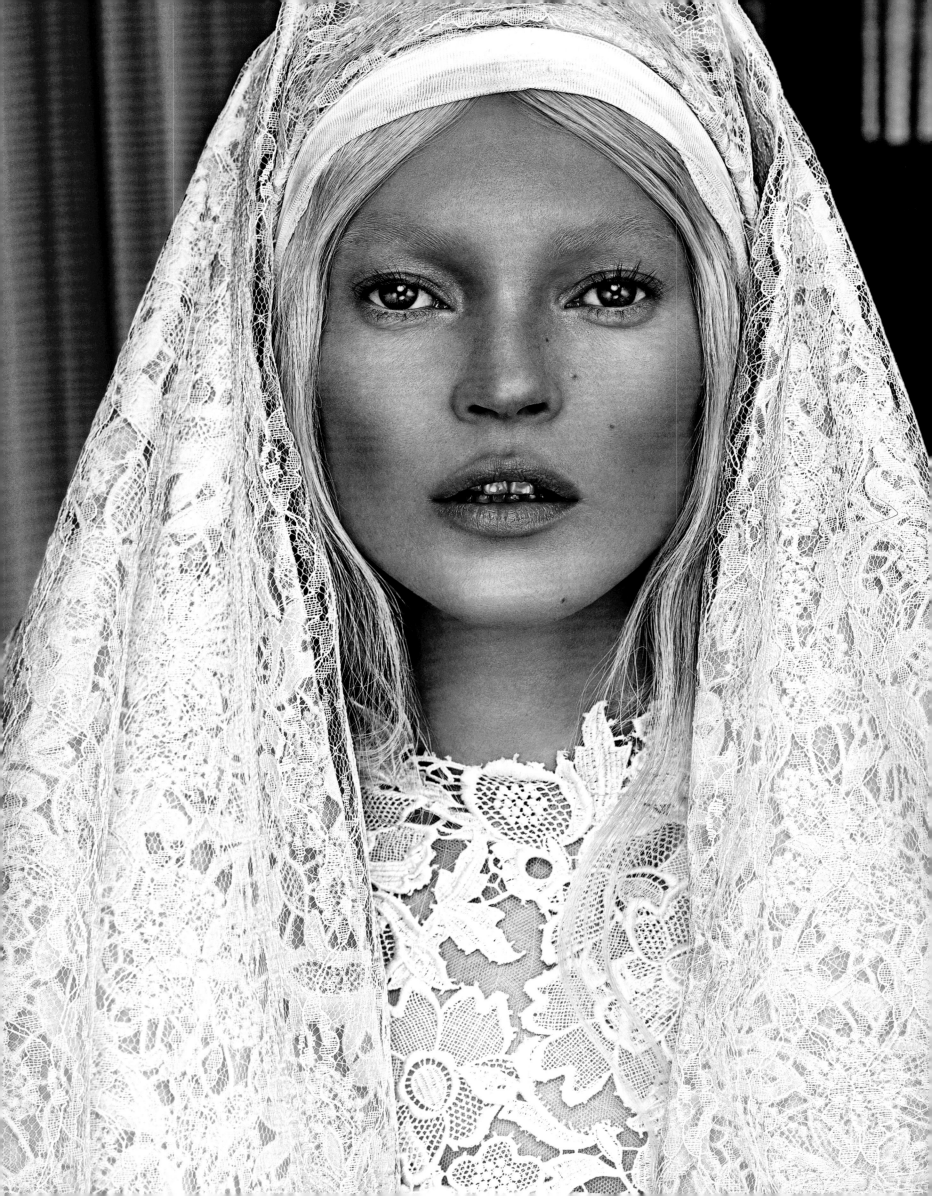

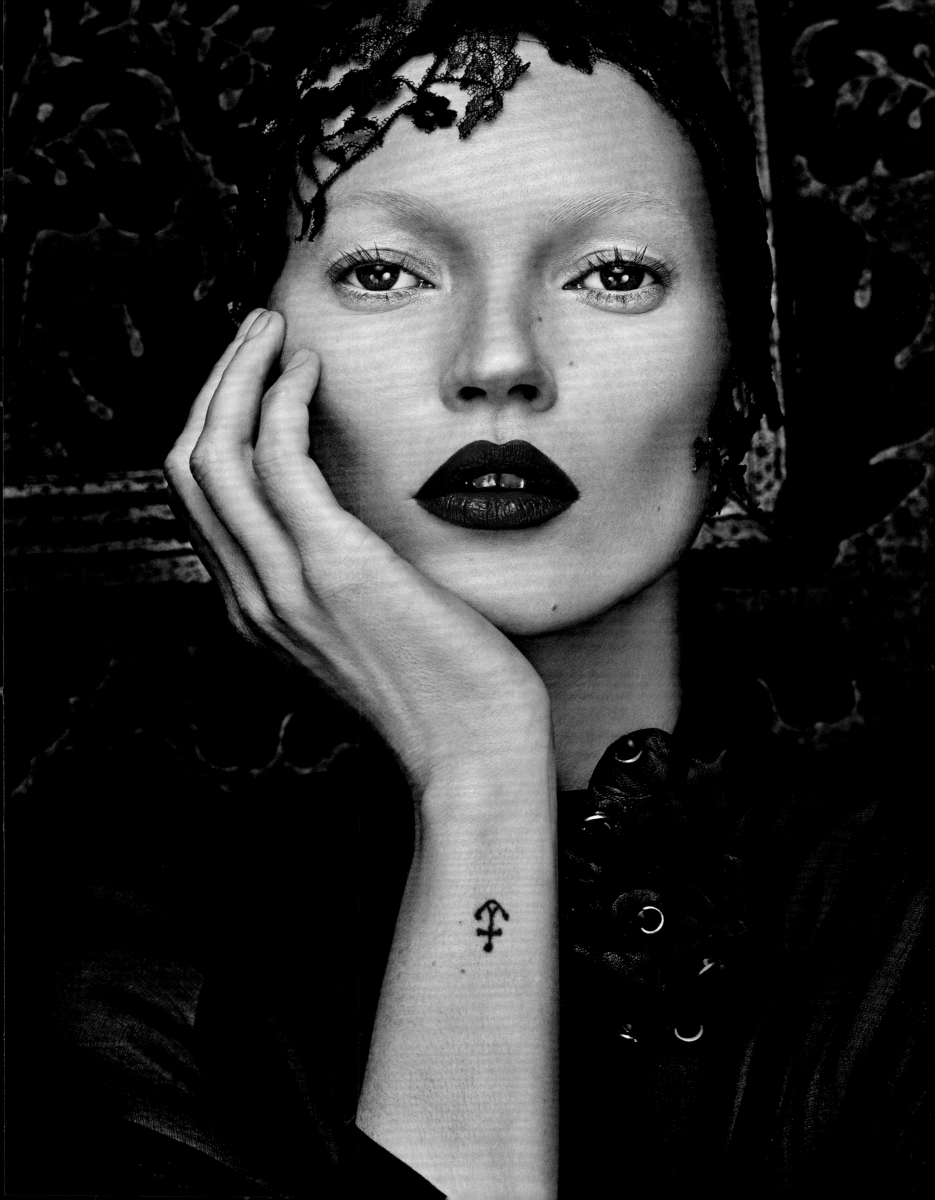

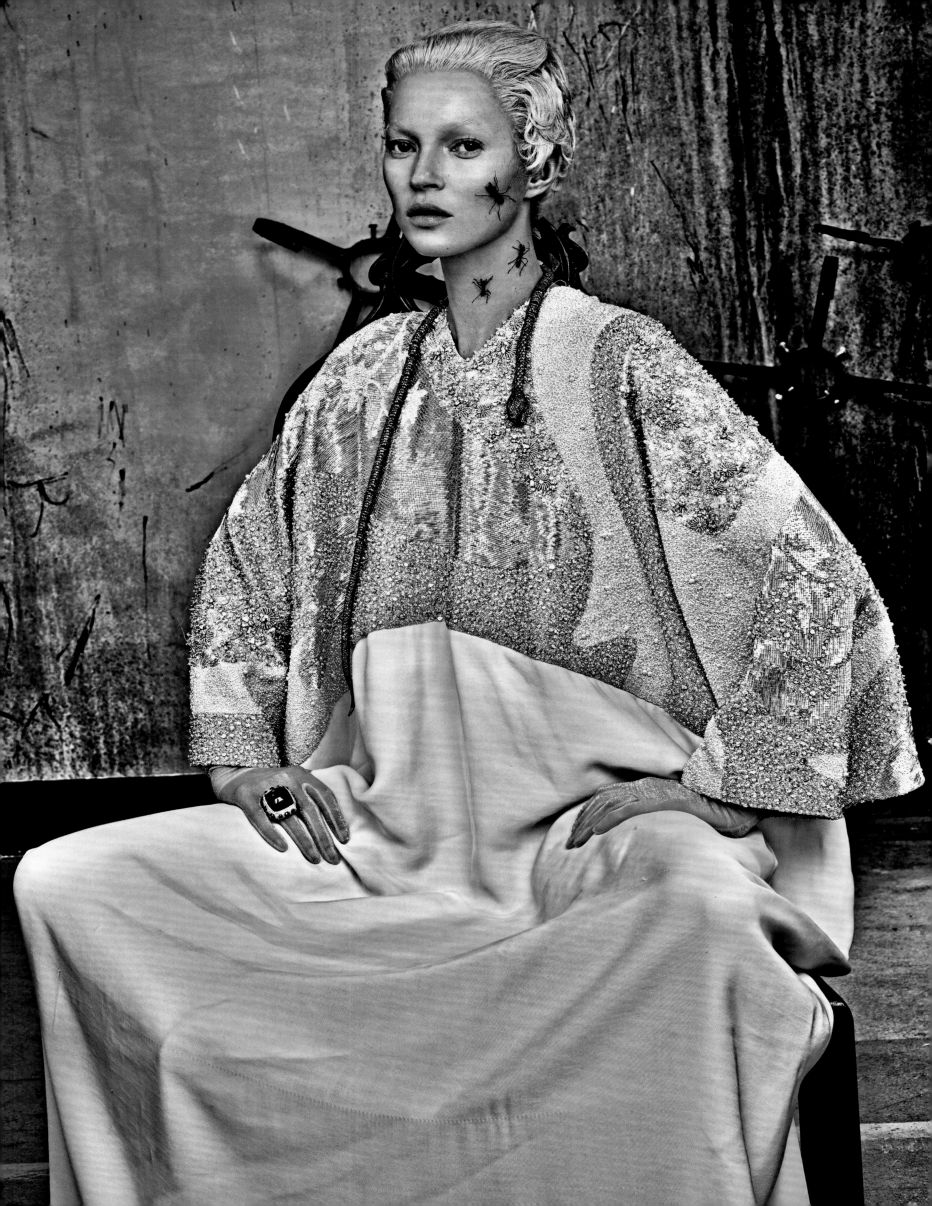

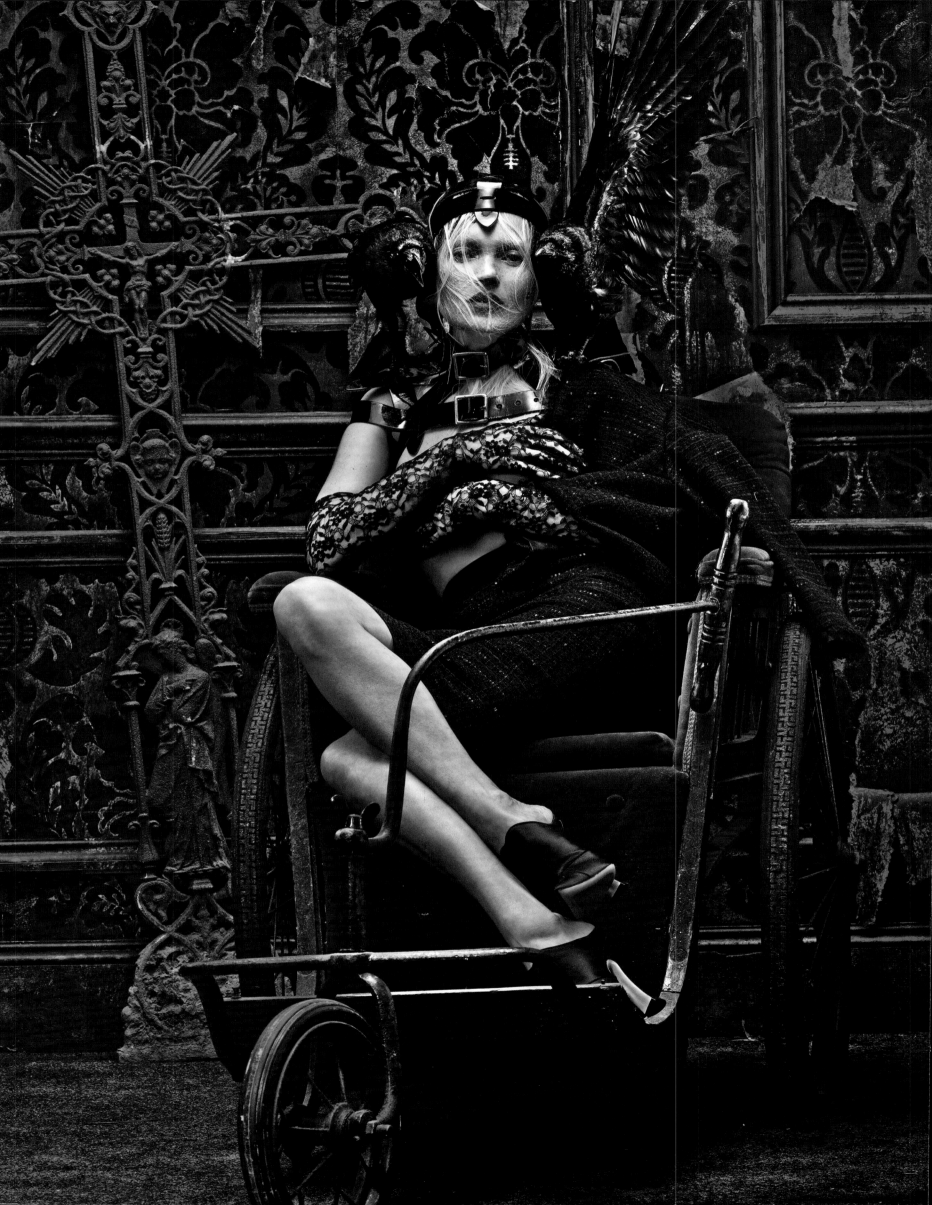

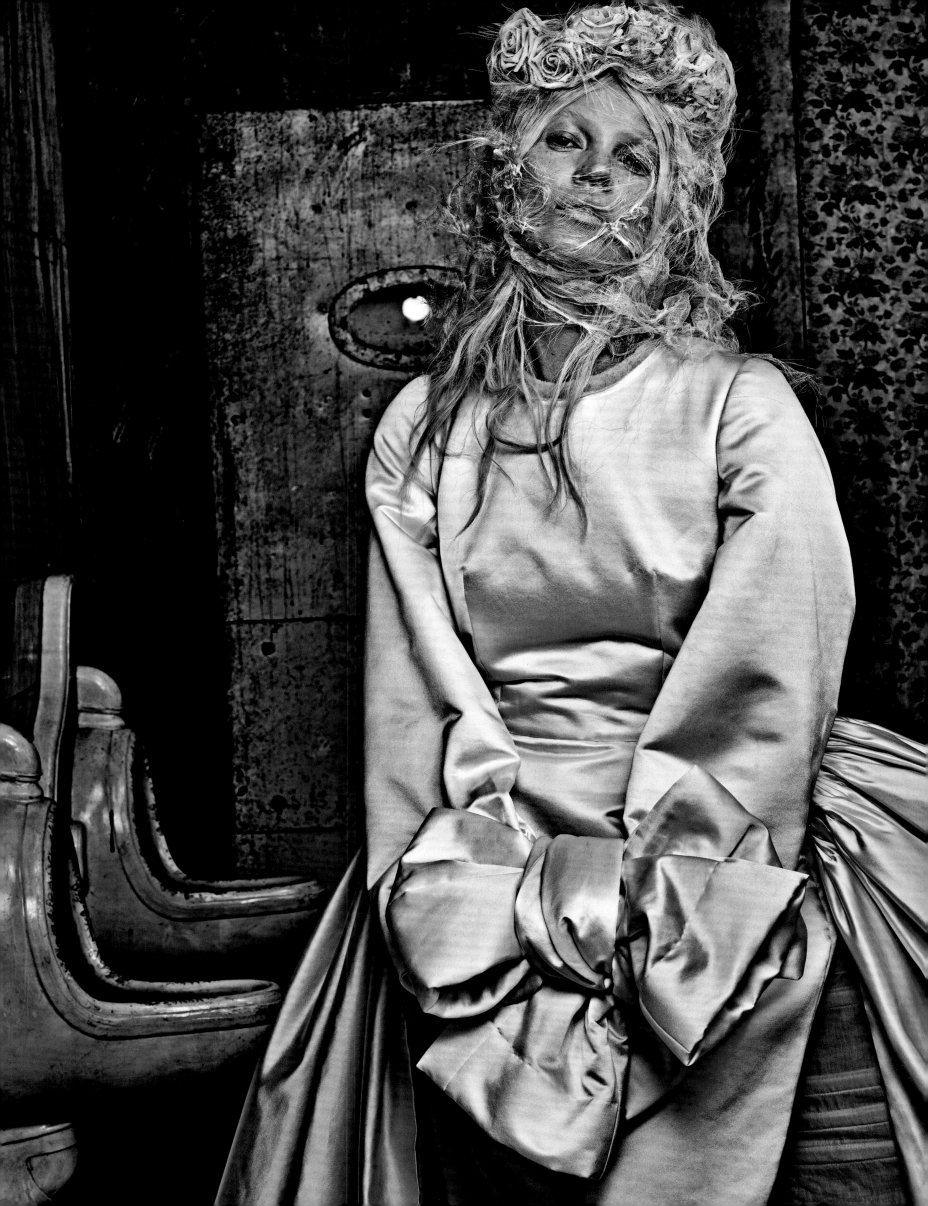

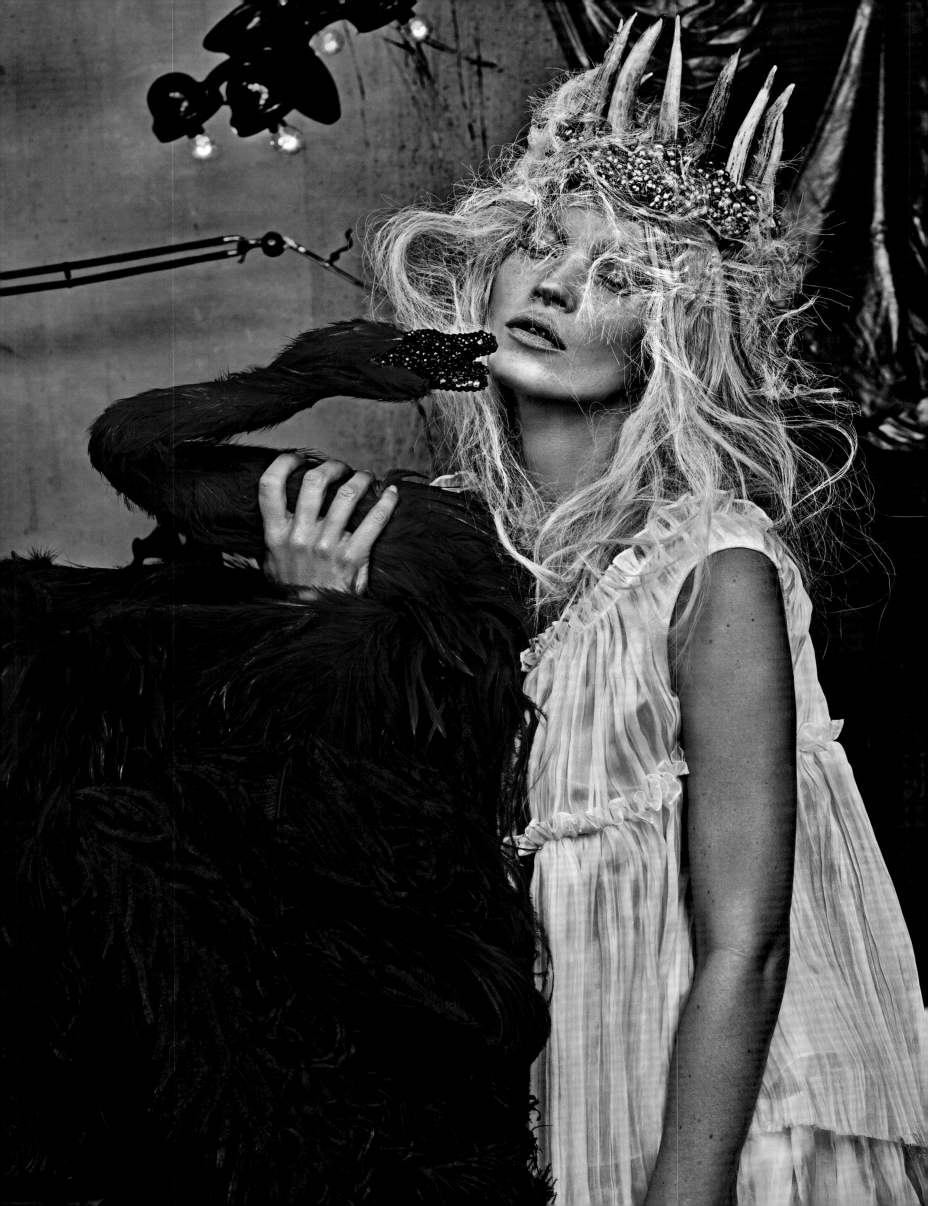

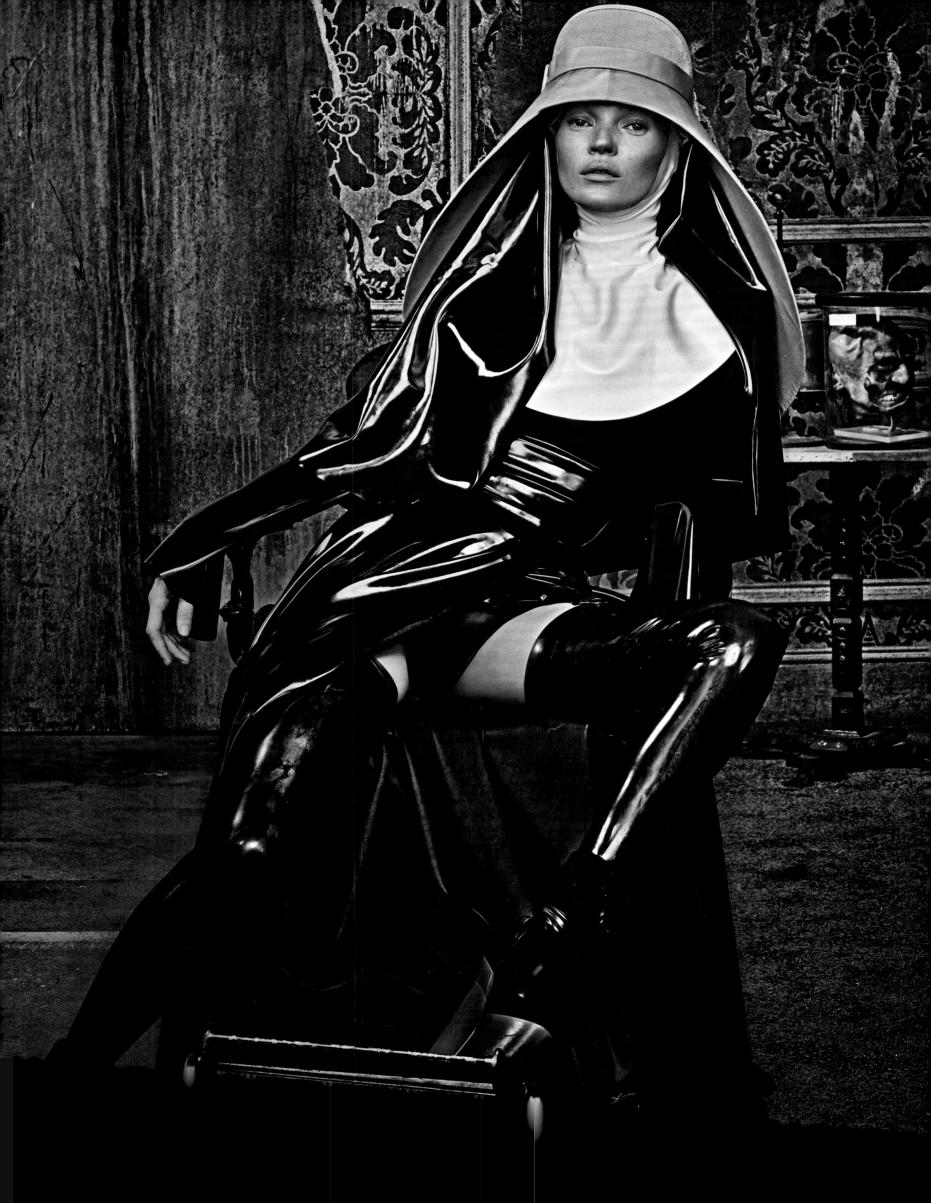

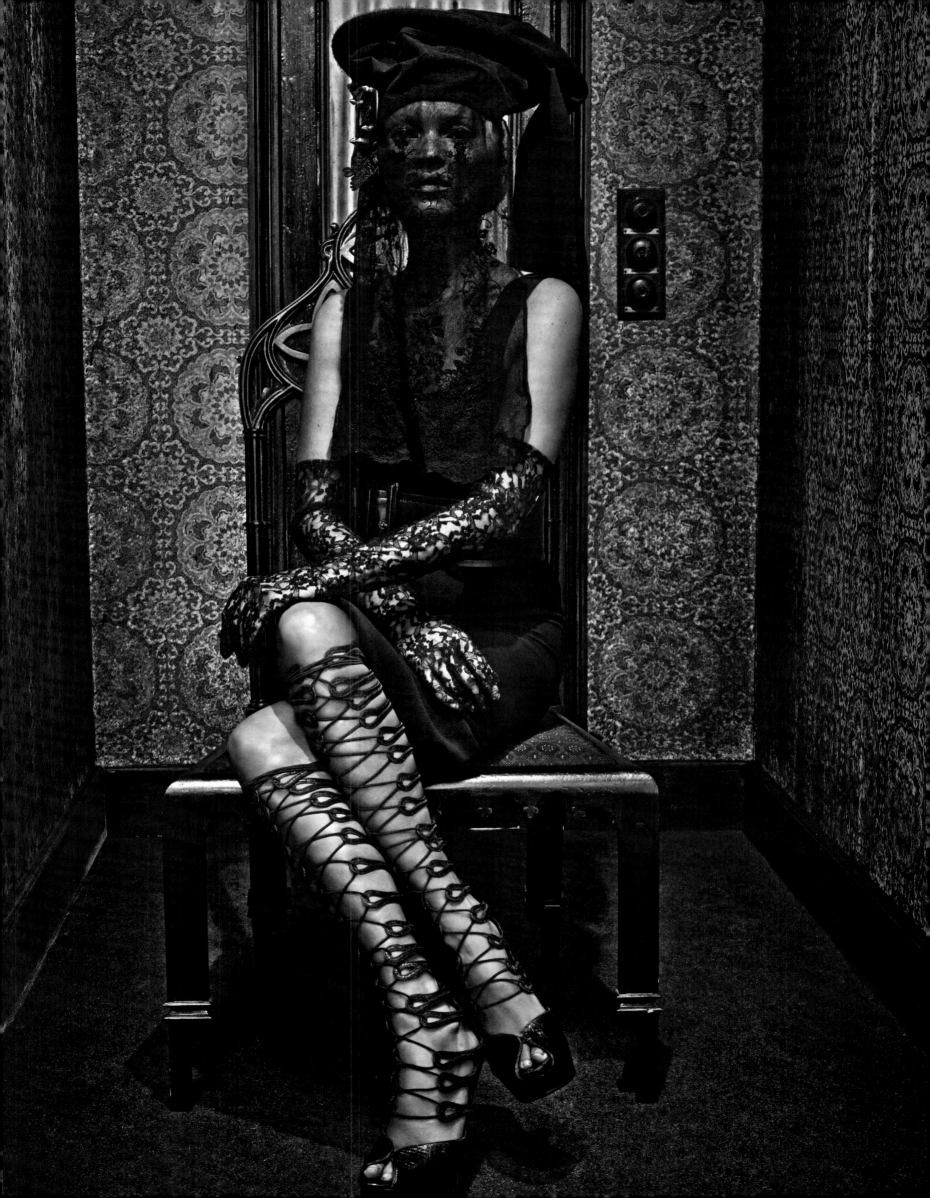

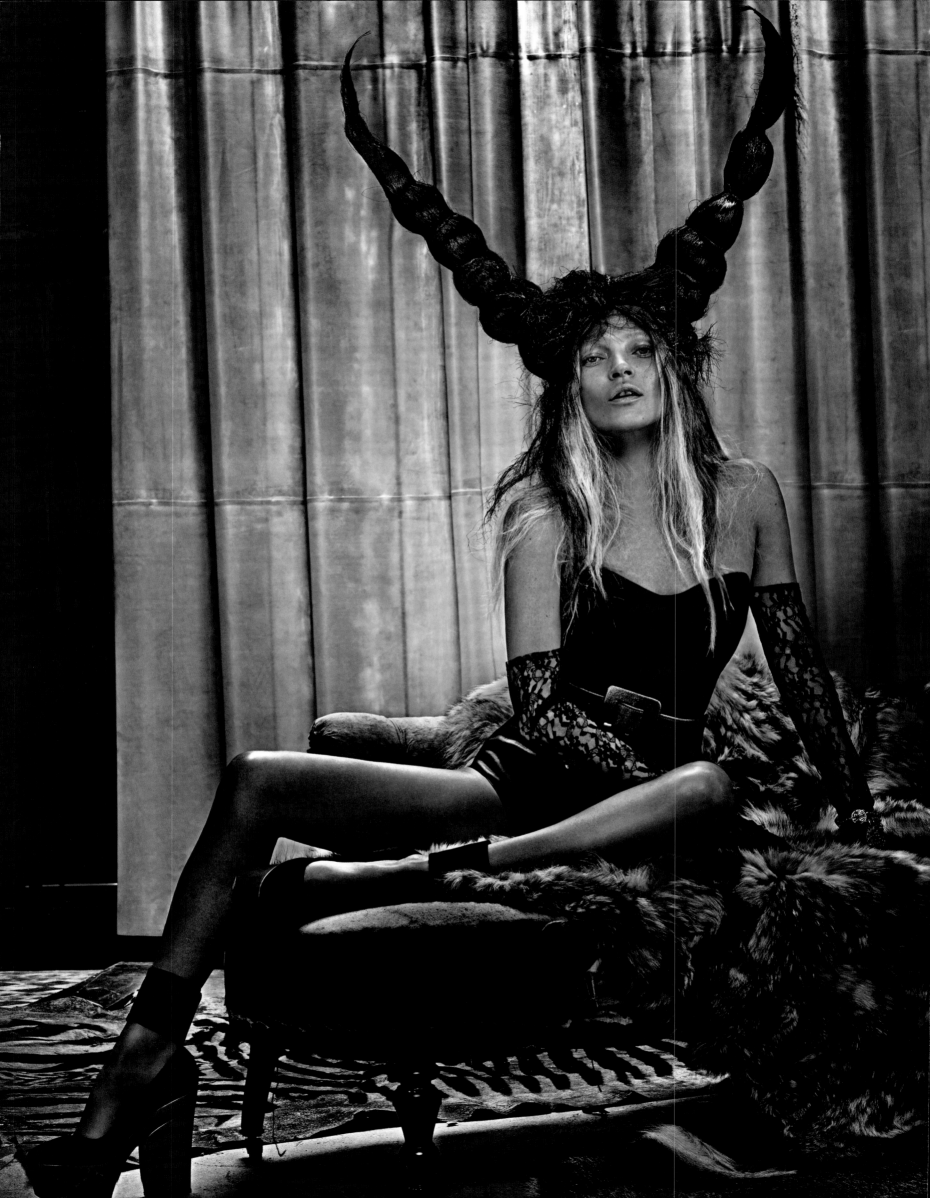

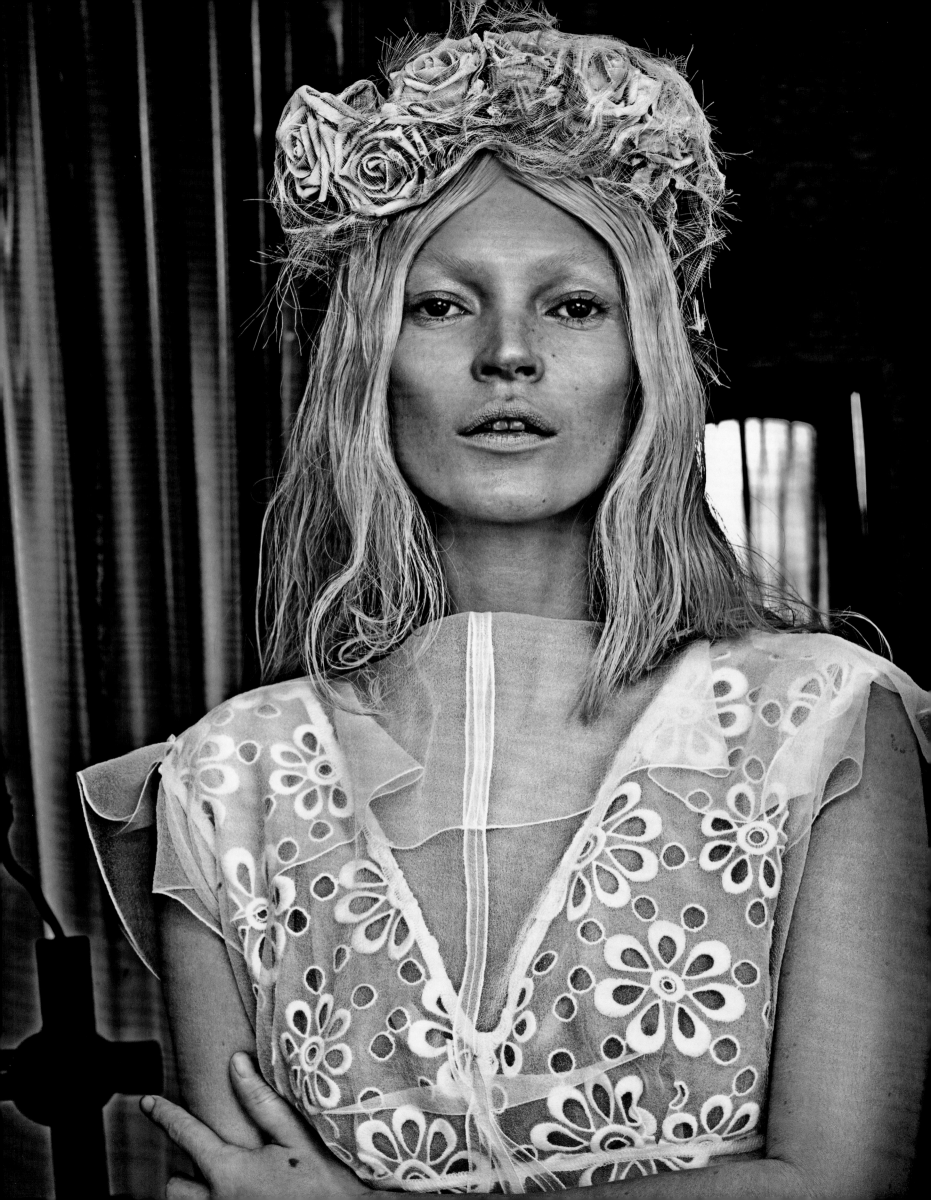

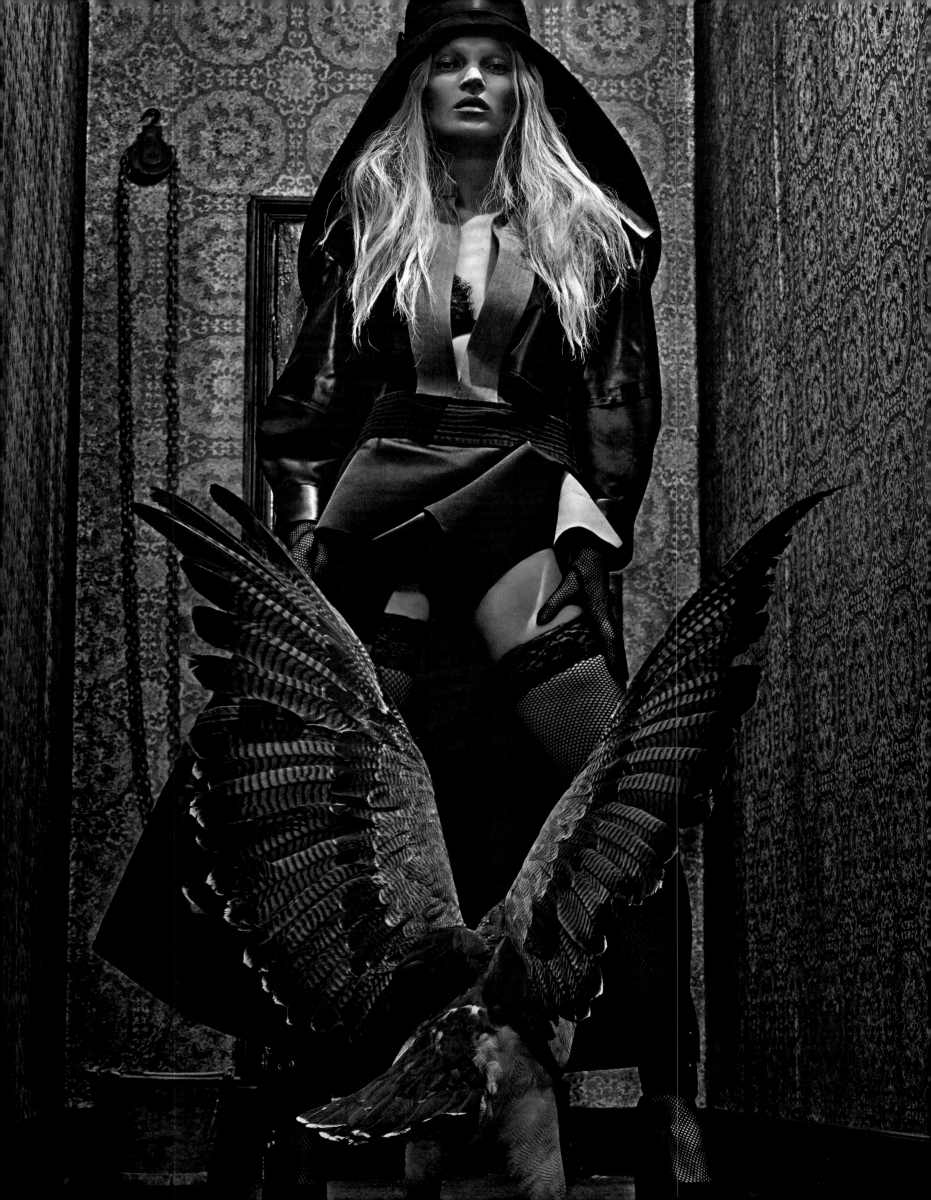

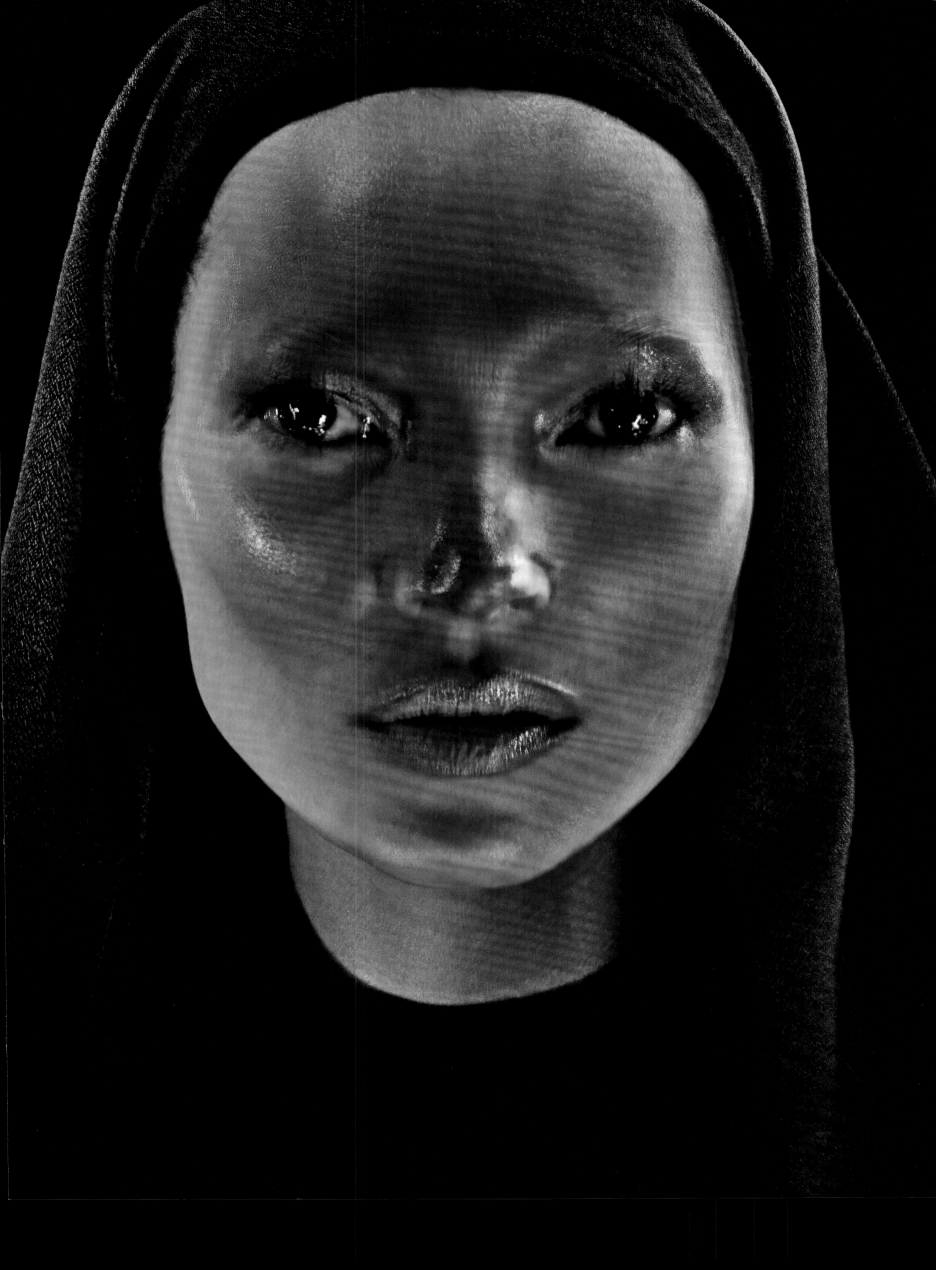

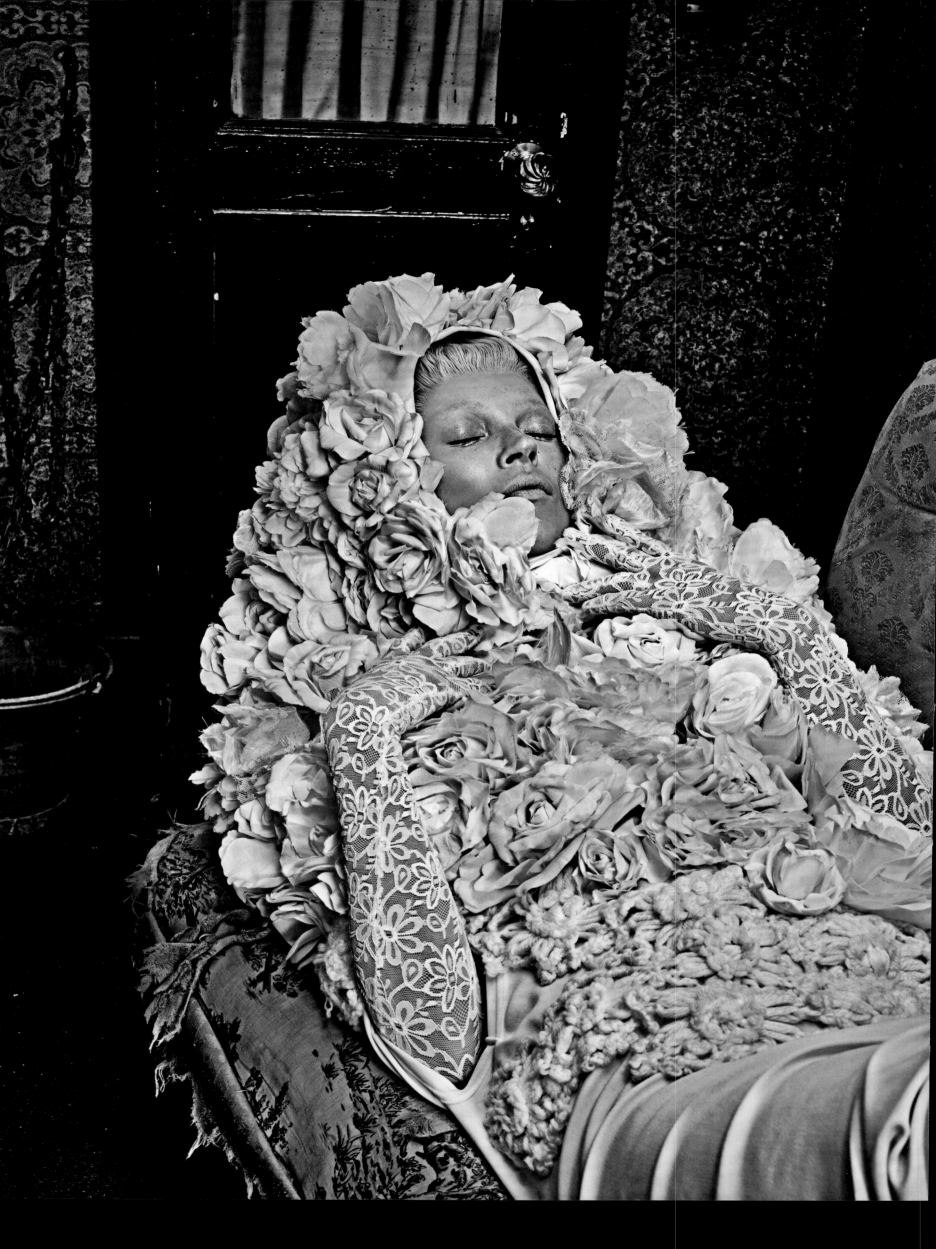

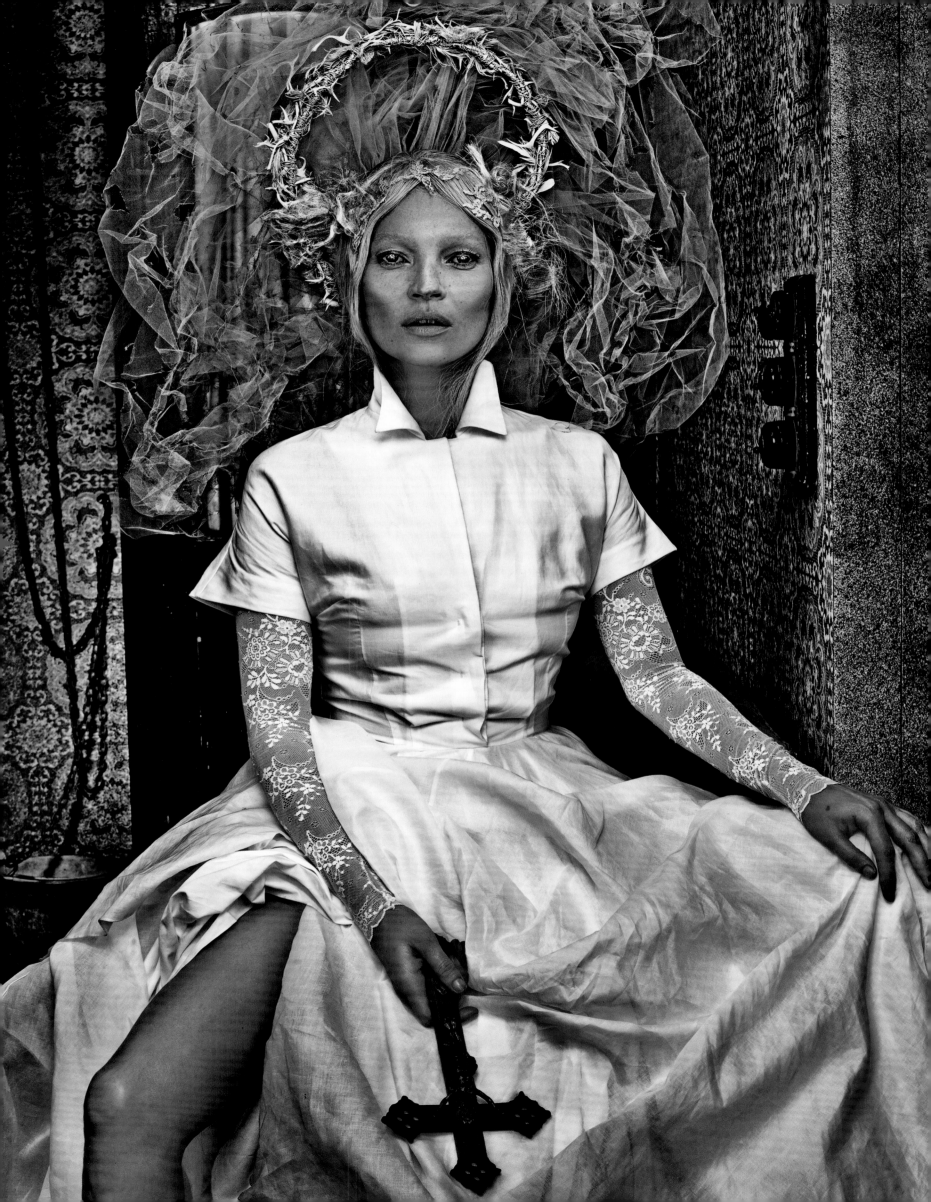

☆ ☆
CROWD SHOTS

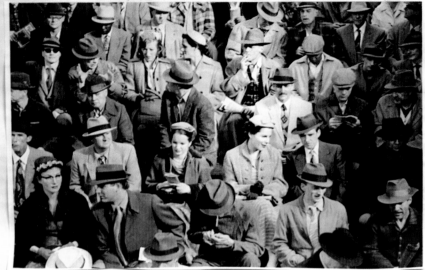

waiting
subtle ↗

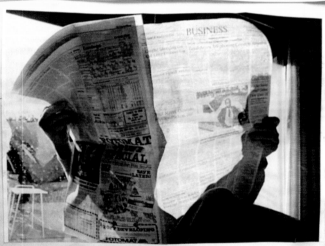

newspaper
only hands
watch,
ring
showing

CLOSEUP/MEDIUM SHOTS

Liza – yellow ese
man blowing cigar
smoke in woman's
face – covering her
face
only see lips clearly
(RED)

standing girl
winby haired
close up

Liza – Polkadots

y girl
eup, / medium shot,
high long shot

Balenciaga blue

↑ left half
100 mb

Clockwise, from top left: A page
from Prager's notebook, with
images from Stan Douglas and
Larry Sultan (from top); *You Are the
Star,* by Thomas Suriya; another
page from Prager's notebook, with
images from Haywood Magee, Jack
Cardiff, and Al Fenn (from top); a
contact sheet from the shoot.

SPELLBOUND

EMPLOYING AN ECCENTRIC CAST OF CHARACTERS, THE ART PHOTOGRAPHER ALEX PRAGER REENACTED A THRILLING DAY AT THE HORSE RACES.

I knew I wanted to be a photographer at 21, when I saw a William Eggleston exhibit. His ability to elicit profound emotion from such ordinary subject matter intrigued me. I bought my camera and darkroom equipment that same week and started taking pictures, inspired by the color and composition of Eggleston's work. That's really how my cinematic point of view developed. I wasn't tuned in to what anyone else was doing or what was considered cool or contemporary at the time. Add to that the fact that I grew up in L.A., where the landscape has an inherent drama to it, and you can understand where my aesthetic comes from.

Before this *W* story came about, I had shot only individual portraits, and maybe a couple of groups, with five or so people. For a while, I had wanted to do a big crowd picture, but it required substantial production—lots of people, costumes, the right lighting—which was hard for me to arrange. This assignment gave me the tools to create what I had imagined. The inspiration was a Stan Douglas photo called *Hastings Park, 16 July 1955* (2008), which depicts spectators at the horse races in the 1950s. I wanted to take that retro sporting aspect and give it an over-the-top, comical twist like that of *You Are the Star*, the mural of actors by Thomas Suriya on Hollywood Boulevard that I drove by every day.

I think the team at *W* was skeptical at first about the number of people I wanted to photograph, but once I sent over some sketches everyone was totally into it. I really wanted an assortment of characters, so I used a casting agency to find extras, and then combined them with friends and family. My sister Vanessa is the one in the baby blue jacket and platinum-blonde wig. I always put her in my crowd pictures now—she's become my *Where's Waldo?* I also included the musicians Binki Shapiro and Liza Thorn, and the actress Jessica Joffe. I like the energy that develops when I mix total strangers with people I know. It creates a connected/disconnected dichotomy.

Maybe that's why I'm so interested in shooting crowds. They're so complex and have so many things going on. I always try to have my photographs tell some kind of narrative, and in a crowd you can always find a million stories. Additionally, I think that the proliferation of technology has altered the way we communicate in a very interesting way. How we connect with one another is very different than it once was—and can often feel insubstantial. I want to explore the notion that you can be isolated even if you're constantly surrounded by people.

We completed the story in one day at a high school in Van Nuys. I had an important requirement for the clothes: that they be colorful. They needed to pop. But this was not the average fashion shoot: It was focused more on the people and who they were and where they were than what they were wearing. Of course, Photoshop is very important in my work. I want my pictures to have a slightly surreal quality, to be a bit off, so I'll alter body parts or move whole characters around to achieve that effect. For this story, I also digitally added a couple of birds—although one of the ones flying above Jessica Joffe is real.

When photographing crowds, there's only so much directing you can do. I'll look over everyone's outfits and check all their makeup, and then I'll put them into position and give them characters to play. But when I'm taking the actual pictures, I can't see everyone at once. That's where the surprises come in—you never know what you're going to get, which is why I approached this assignment as an art project. Thankfully, *W* agreed to that, and I think the risk paid off. Work from the shoot ended up in the 2010 *New Photography* show at the Museum of Modern Art in New York.

At that time, I had just completed my first short, called *Despair*, and I was obsessed with moving images. So after we were done with the pictures, I made a little film. I had 30 minutes to do it, and two of the models had to change their flights to accommodate me, but I couldn't resist. I had this amazingly lush setup, and I wanted to get everything I could out of it. I haven't worked with such a high level of production since then.

PHOTOGRAPHED BY ALEX PRAGER
STYLED BY CAROLYN TATE ANGEL
PUBLISHED IN NOVEMBER 2010

To view the film inspired by this story, go to www.abramsbooks.com/wstories and enter access code wstories5films

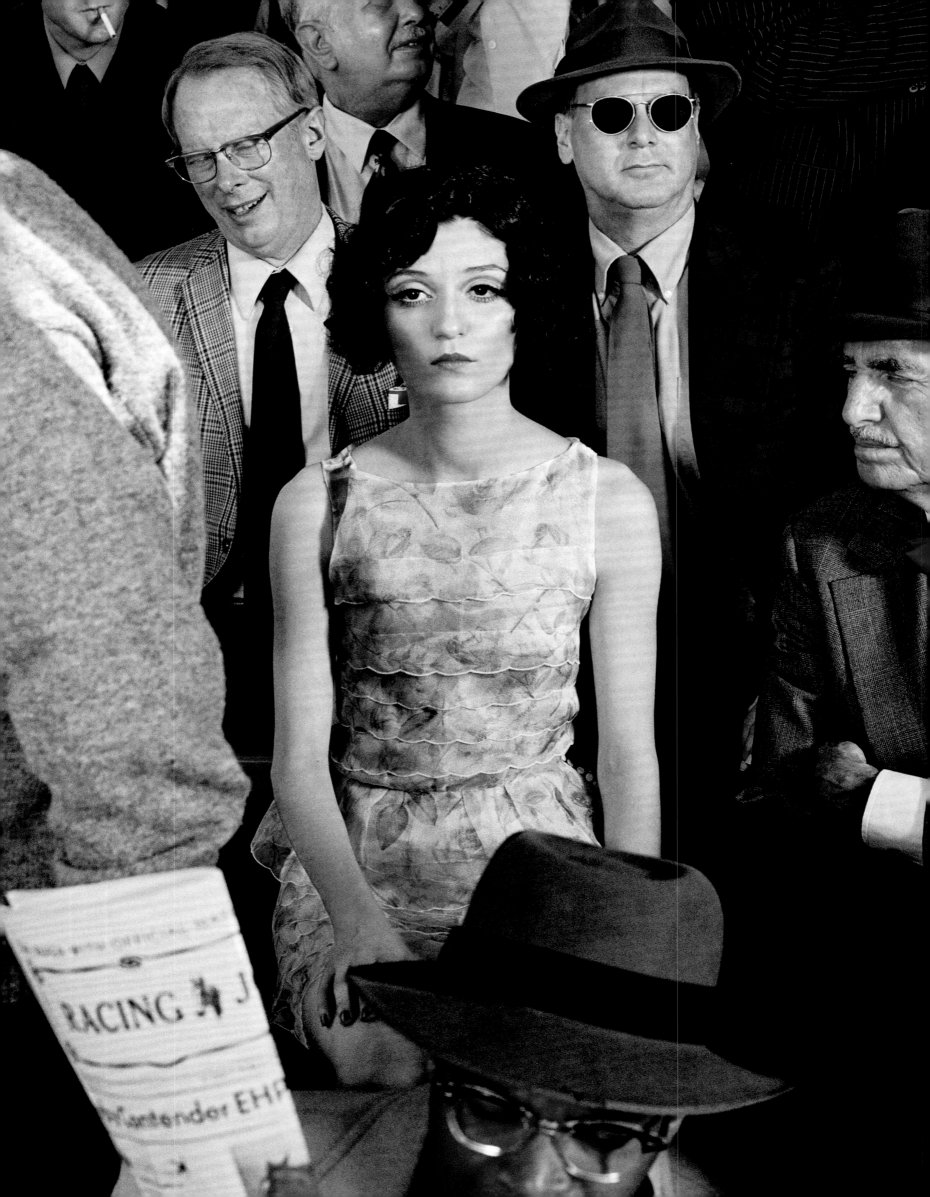

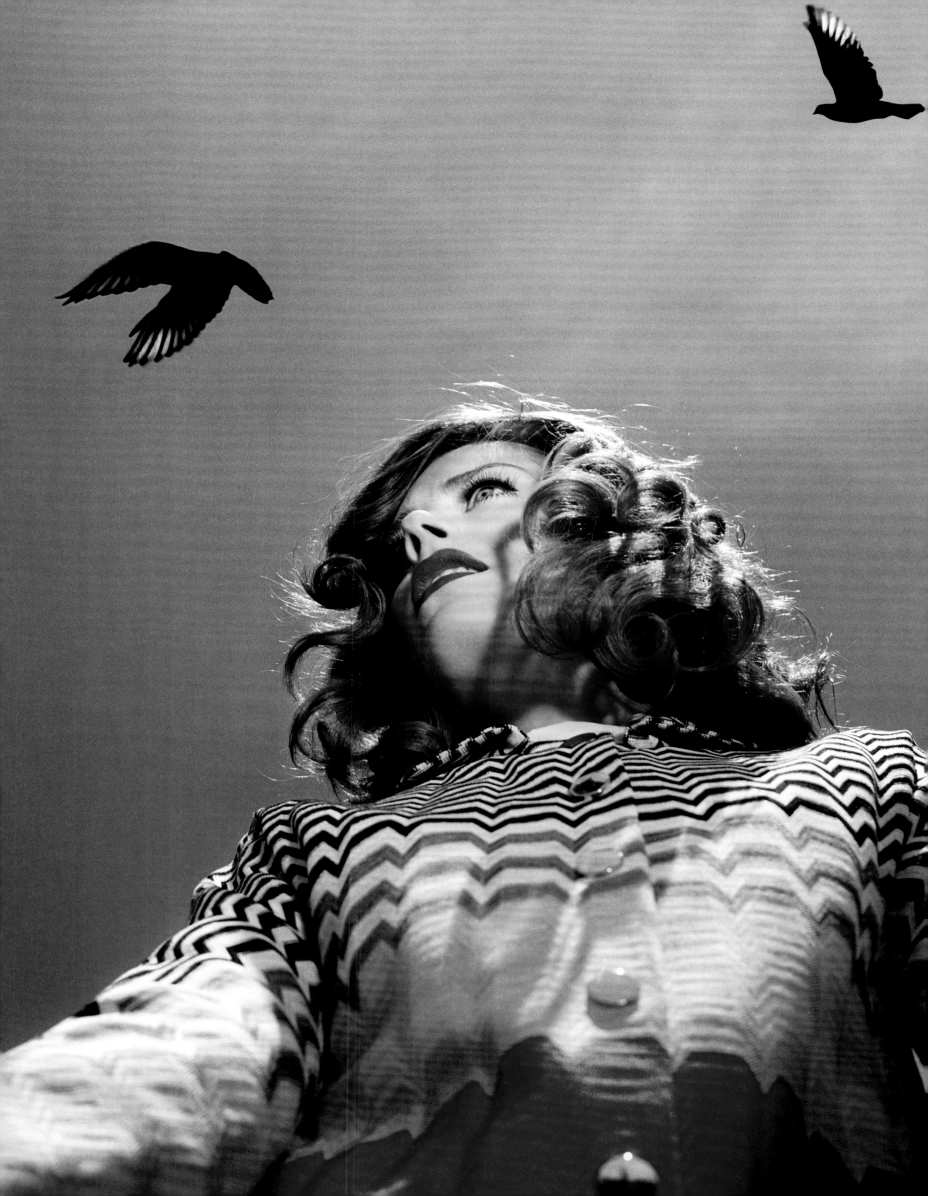

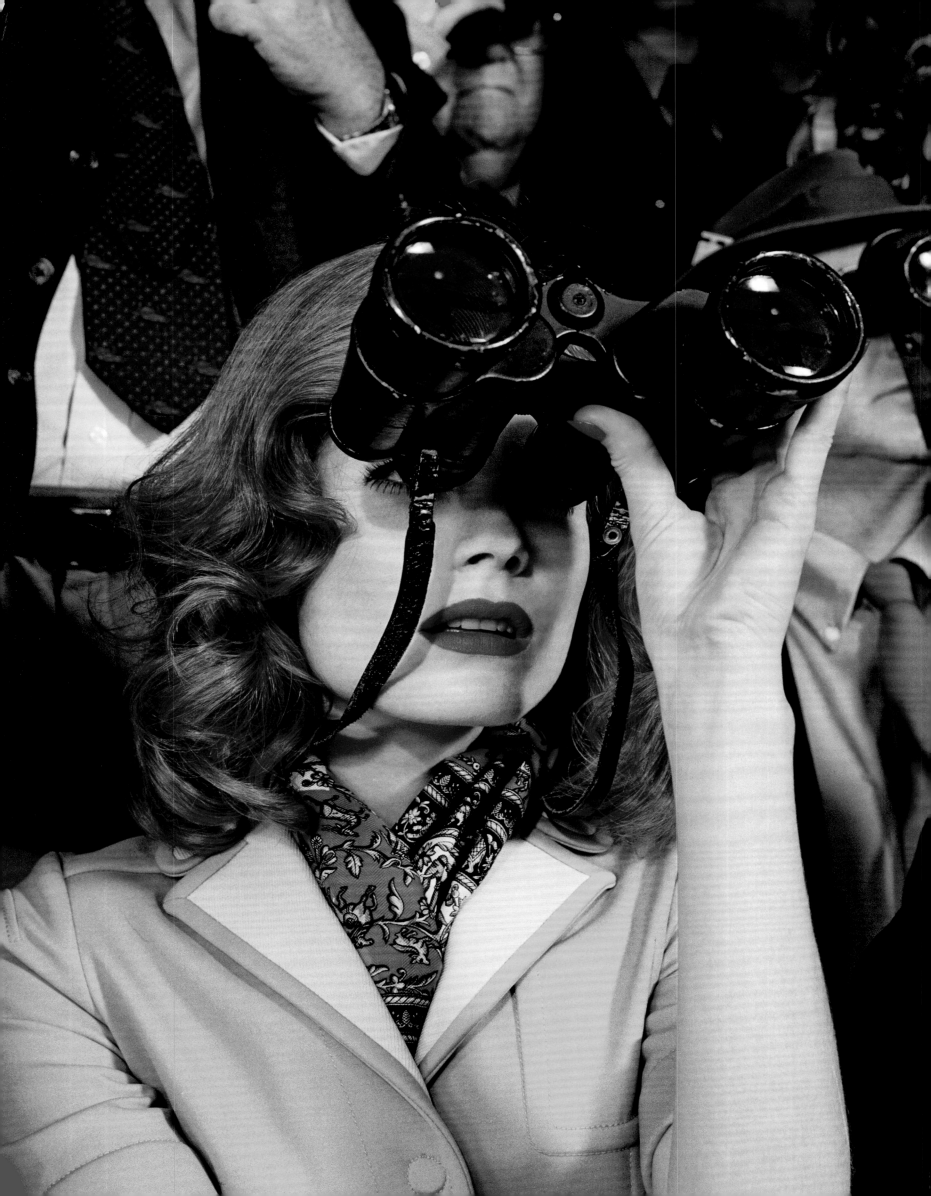

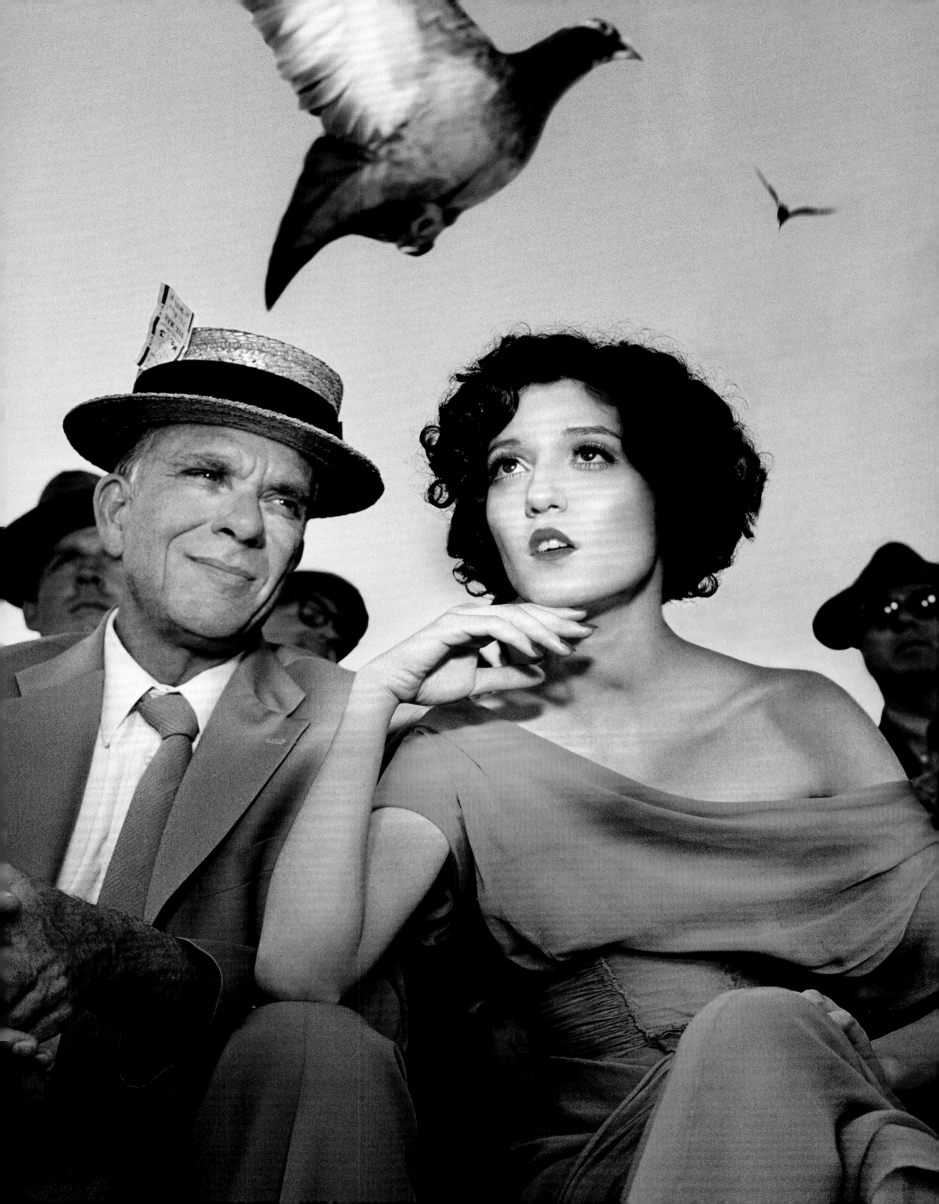

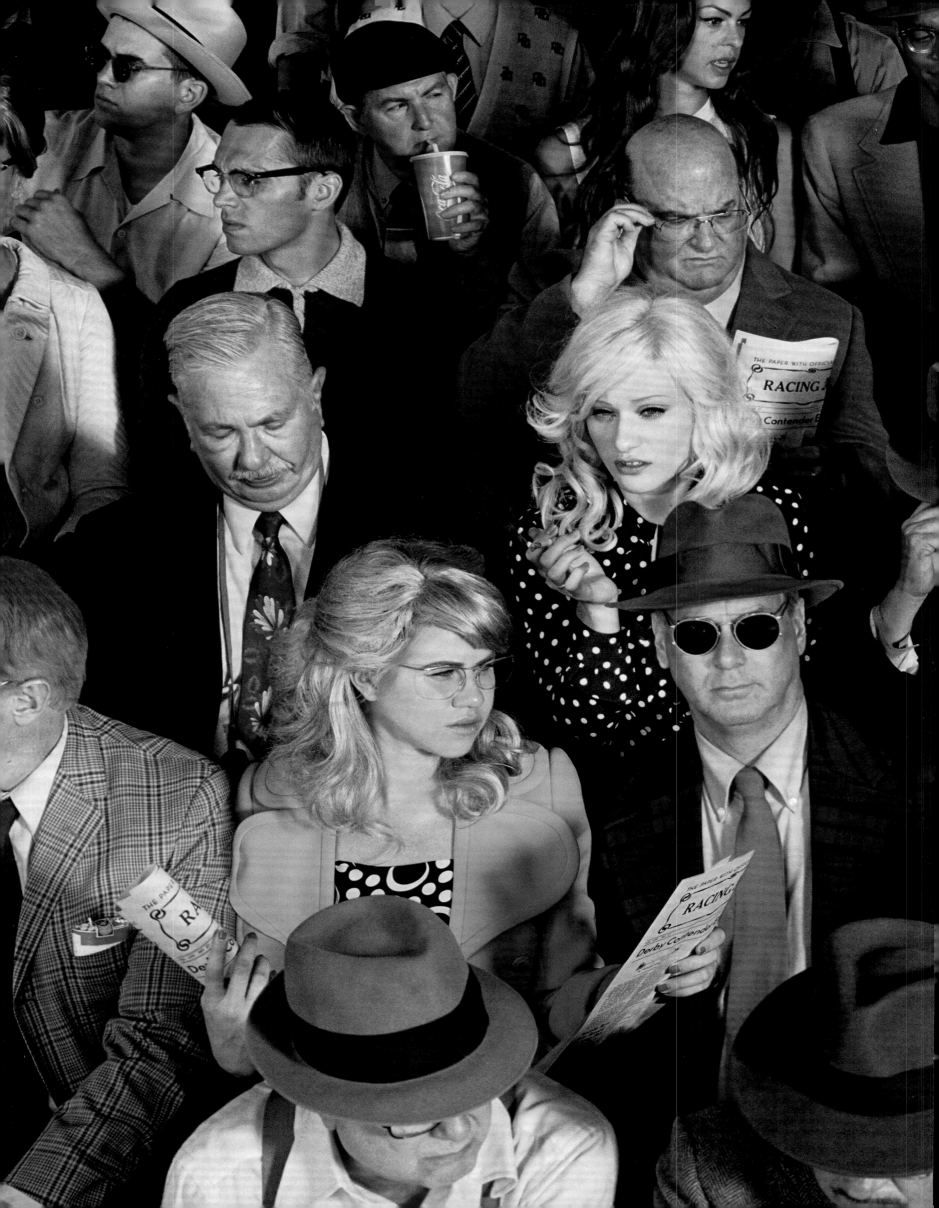

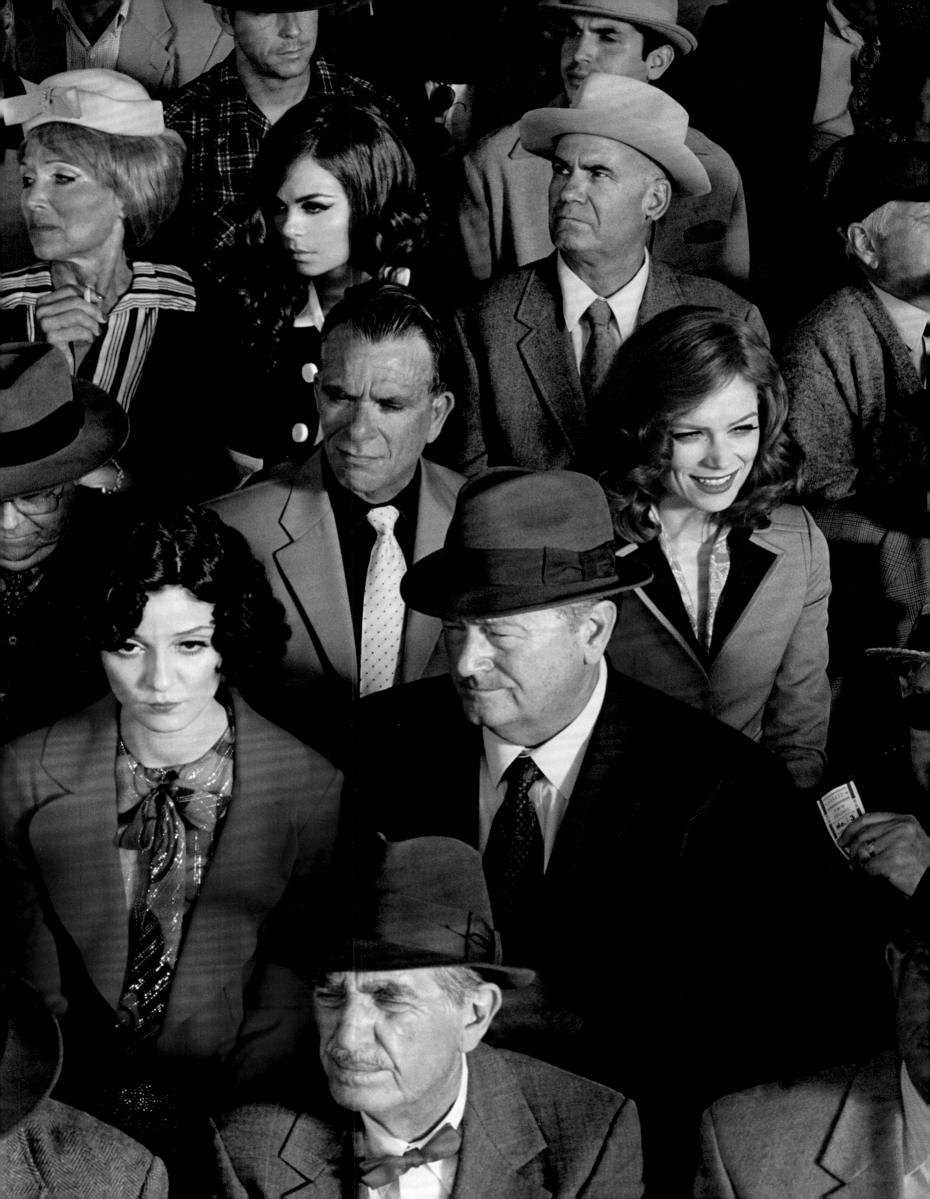

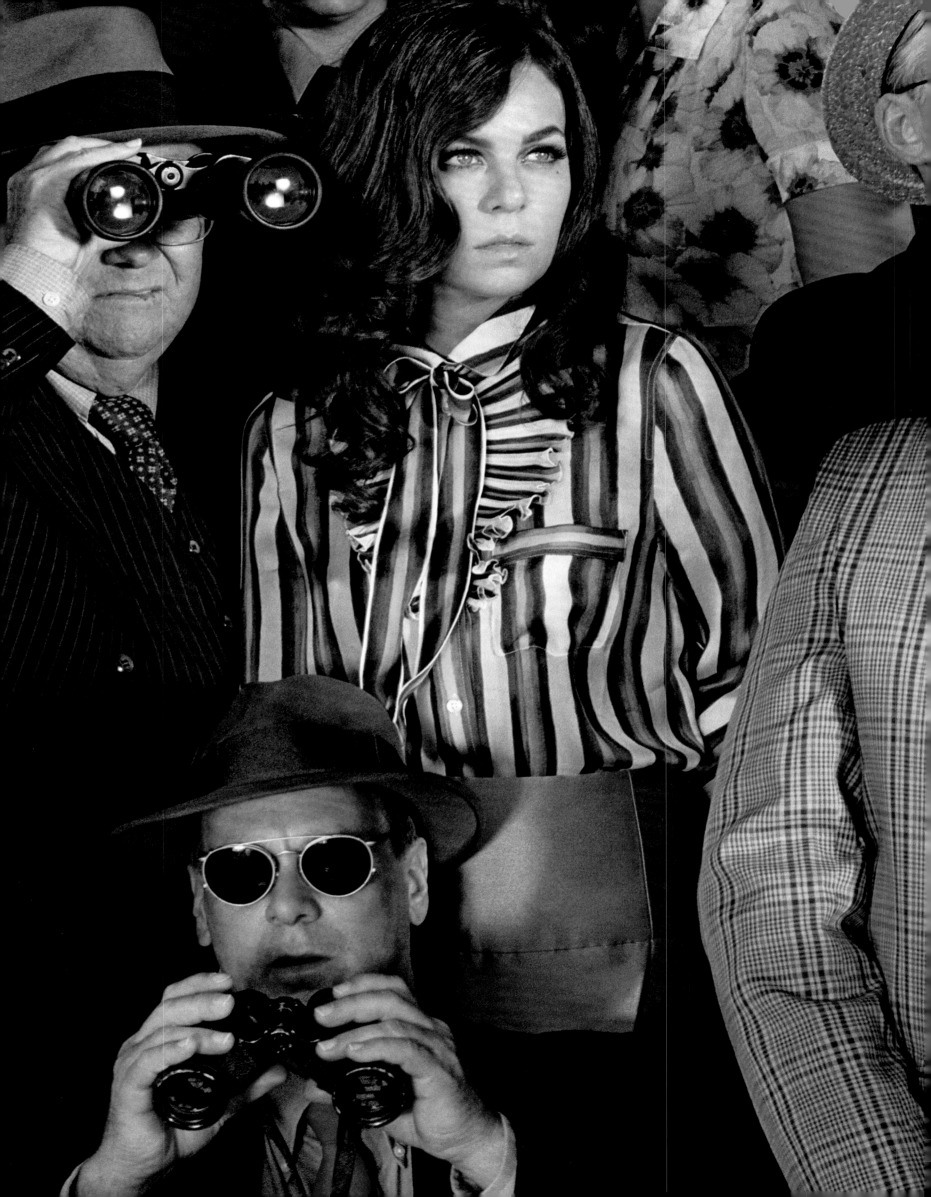

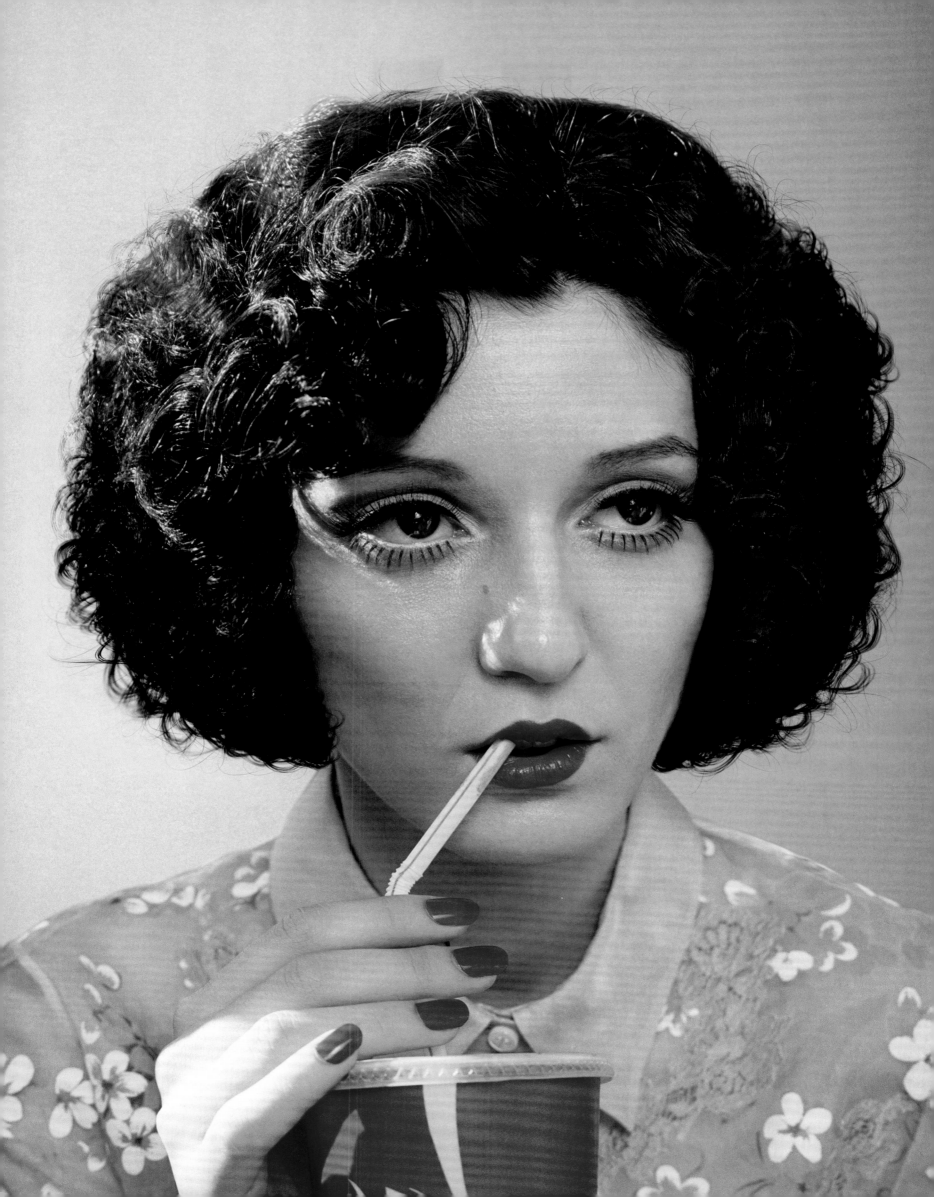

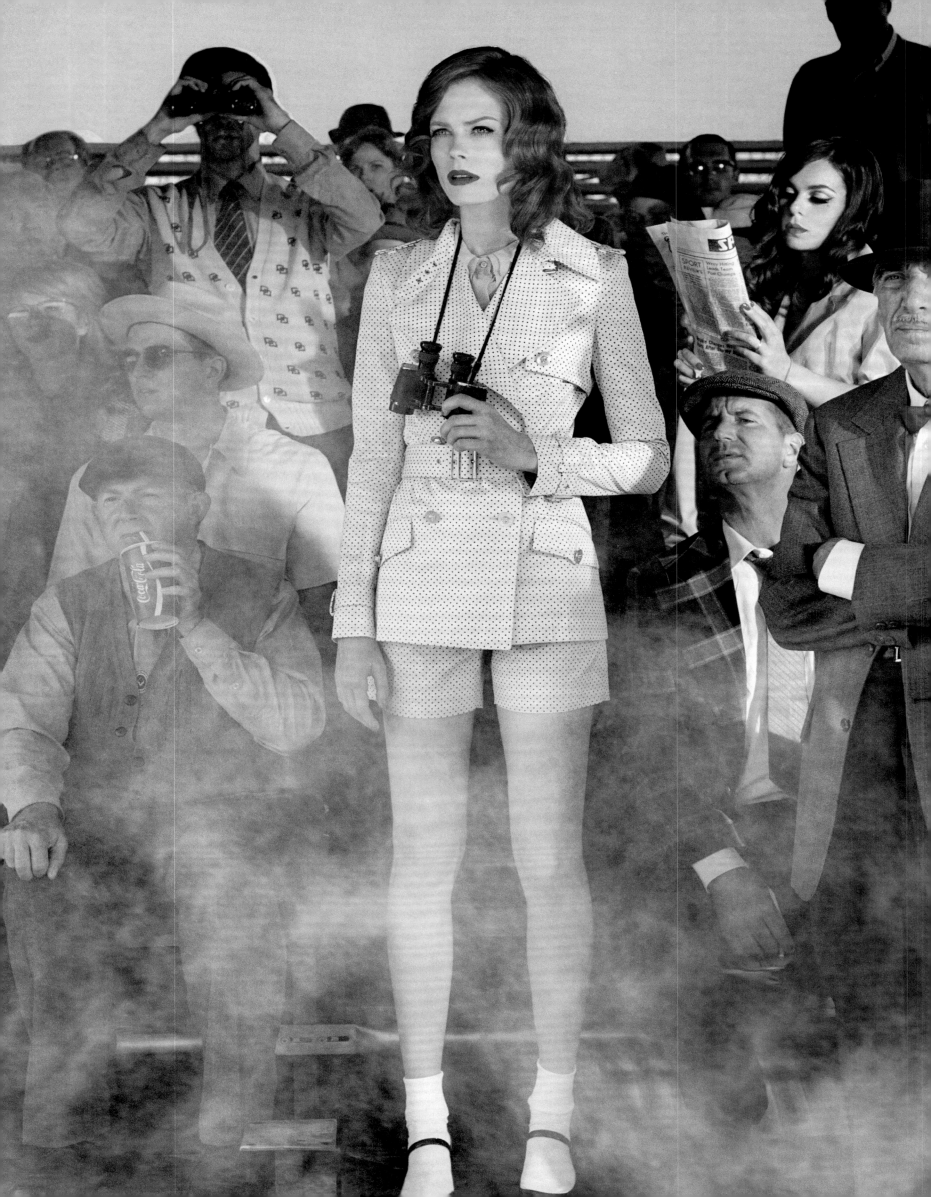

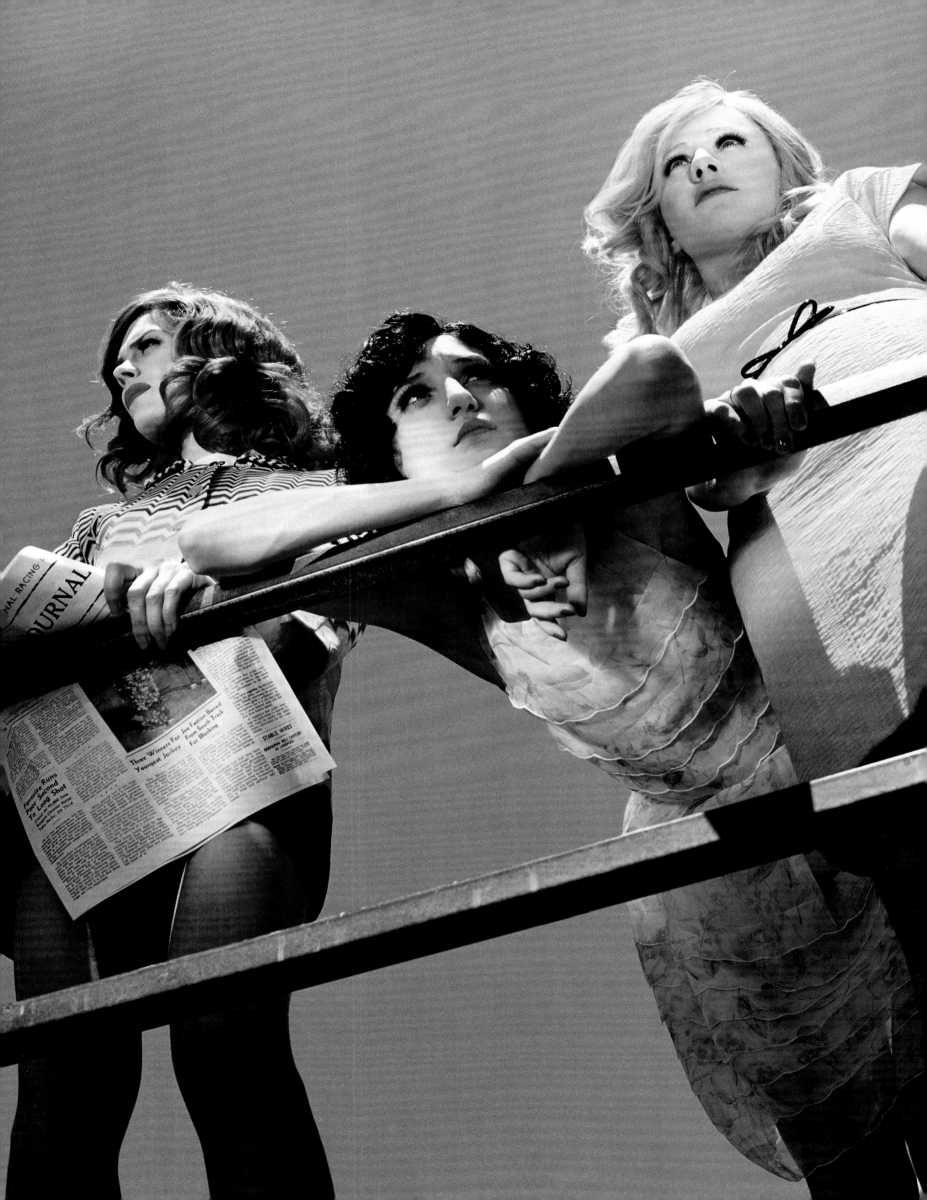

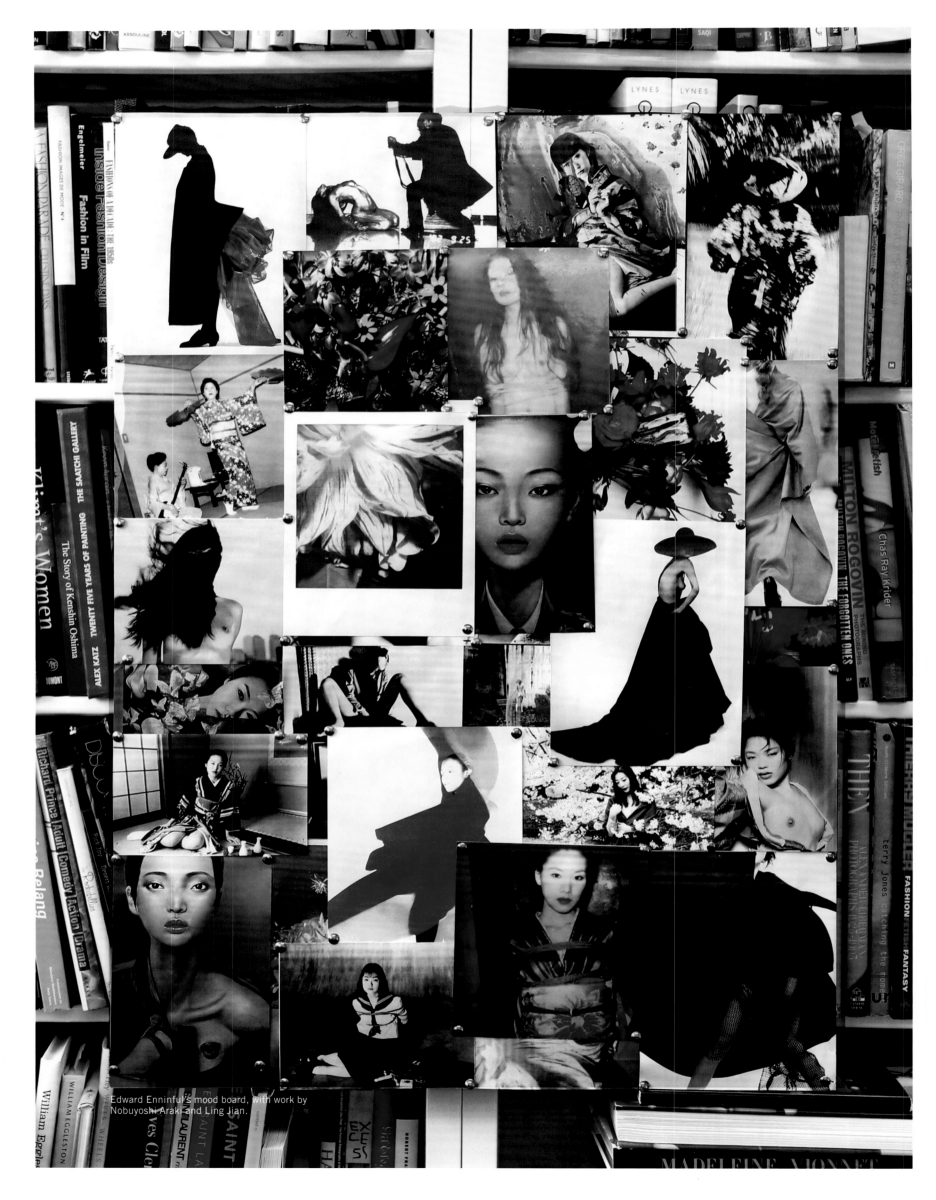

Edward Enninful's mood board, with work by
Nobuyoshi Araki and Ling Jian.

EAST OF EDEN

USING A RANGE OF CULTURAL REFERENCES, *W* FASHION AND STYLE DIRECTOR EDWARD ENNINFUL PUSHED JAPANESE TRADITION TO A RADICAL NEW EXTREME.

The initial spark for this story came from the spring 2013 collections: Prada, Haider Ackermann, Alexander Mc-Queen, Emilio Pucci, and others had lots of Asian references, which I found interesting. That got me thinking about the Japanese designers from the '80s whom I love, like Yohji Yamamoto and Comme des Garçons. From there, I started looking at the work of Nobuyoshi Araki, who's one of Japan's most prolific contemporary artists and photographers. I wanted the story to acknowledge the past but still feel new; you never want fashion to look like costumes with no current relevance.

There's a lot of research and time that goes into my shoots. I spend weeks on them, even for one picture. You have to go to the recesses of your mind and recall every movie you've watched, every book you've read. I always think of Tom Cruise in *Minority Report*—just grabbing every bit of information. You never know where inspiration is going to come from.

Using old Yohji ads, Araki photos, and other images, I created a mood board, which is what I do before every shoot. It allows me to fully develop the character. I'll kick around ideas with the photographers—in this case, Mert Alas and Marcus Piggott—and together we flesh everything out. *Who is the woman? Is she Chinese? Japanese? How old is she? Does she have bleached-blonde hair?* We approach the project as if it were a play. The next step is, *Where does she live? Where does she hang out?* That's when we brainstorm about location. Maybe she's in a castle, maybe a studio. The clothes are the third layer: Once we have the character and know where she is, the fashion just falls into place. I may be obsessed with a certain red dress, but if it doesn't work on the character, then it's out. I envy those stylists who can just take an outfit from the runway and photograph it. It's so much less torturous than the way I go about it.

It was important to have Asian models, since the story was about Asian-inspired fashion. So we cast Yumi Lambert, who's part Japanese, part Belgian; and Xiao Wen Ju, who's Chinese. Then there was Ondria Hardin, who's American but has a manga look, with her big eyes. There were a bunch of girls that season who had a similar aesthetic—I call them the children of Gemma Ward. It was Mert and Marcus who suggested we use them; originally, I had imagined girls with really round faces. We also cast Saskia de Brauw, who is one of the most iconic models today. When you do a story with many models, you need someone to ground it, and for me that was Saskia. For the cover, we chose three of the biggest names in modeling—Kate Moss, Lara Stone, and Natalia Vodianova.

We shot for two days in a huge Gothic country estate in England with beautiful grounds. We brought in sets and built amazing Asian-inspired rooms. But ultimately we decided not to use the pictures, because they felt too heavy-handed. We realized that the idea was so strong it didn't need such an extravagant location—the girls were getting lost in the background. We thought the focus needed to be on them and the clothes, so we re-shot in a studio in London for three days, using some of the set pieces we had created for the first shoot. A Japanese screen on the ground suggested Asia, and that was enough. We didn't need to hammer home the point.

Mert and Marcus are very good at directing the girls on-set. They really know about dance and movement, and they choreographed the pictures of Saskia with her hands positioned just so. We also had an expert who came to the studio to make sure that the hairdos were authentic and the obis were tied properly. We wanted to remain true to tradition.

It was an intense shoot—probably one of the most demanding I've ever experienced. Working with Mert and Marcus is always challenging, but that's what I love about them. Everyone is very focused, and if the images don't reach a certain level of excellence, they'll simply redo them. And I thank God we did. It turned out to be one of my favorite stories ever—it just felt so magical. Plus, I love the title: "East of Eden." It has such scope; your imagination can just run wild.

PHOTOGRAPHED BY MERT ALAS & MARCUS PIGGOTT
STYLED BY EDWARD ENNINFUL
PUBLISHED IN MARCH 2013

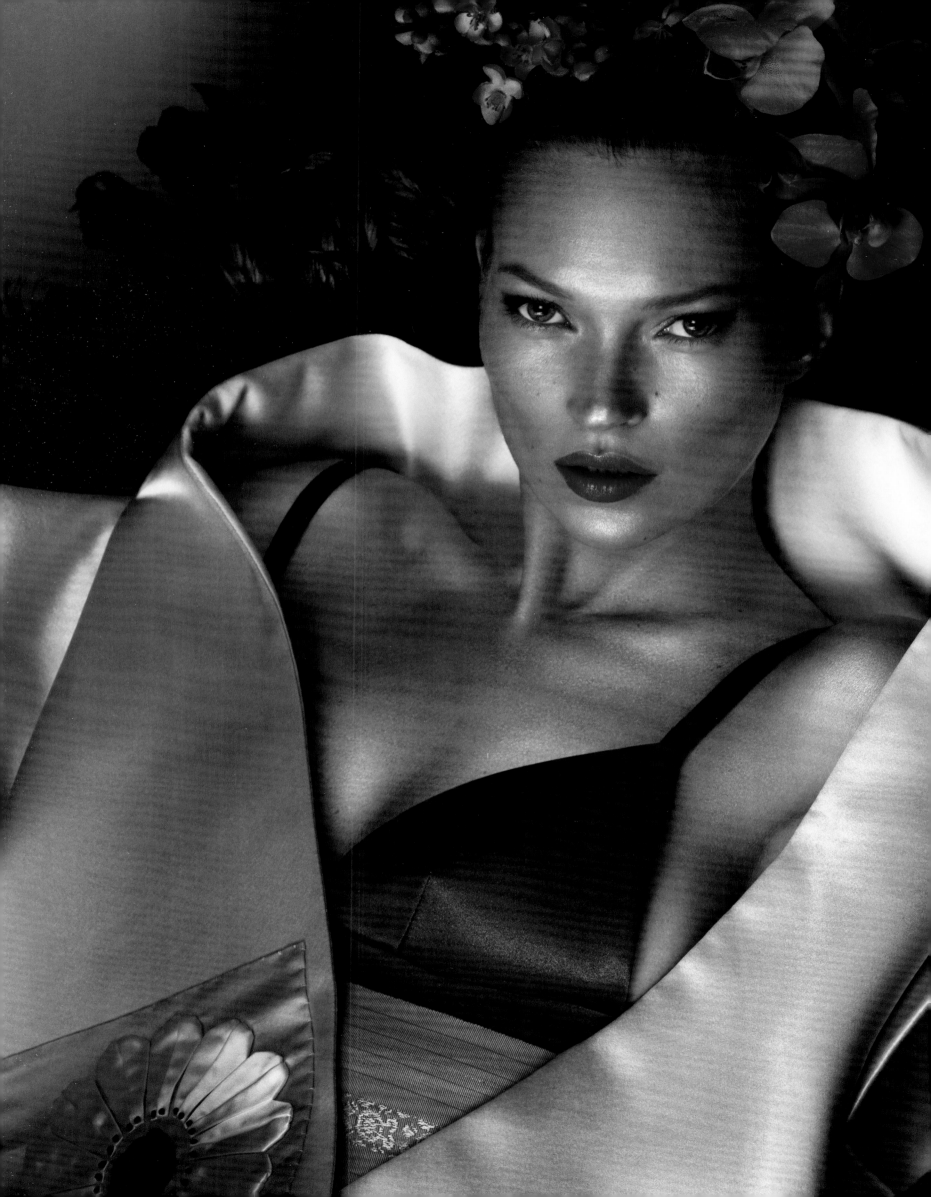

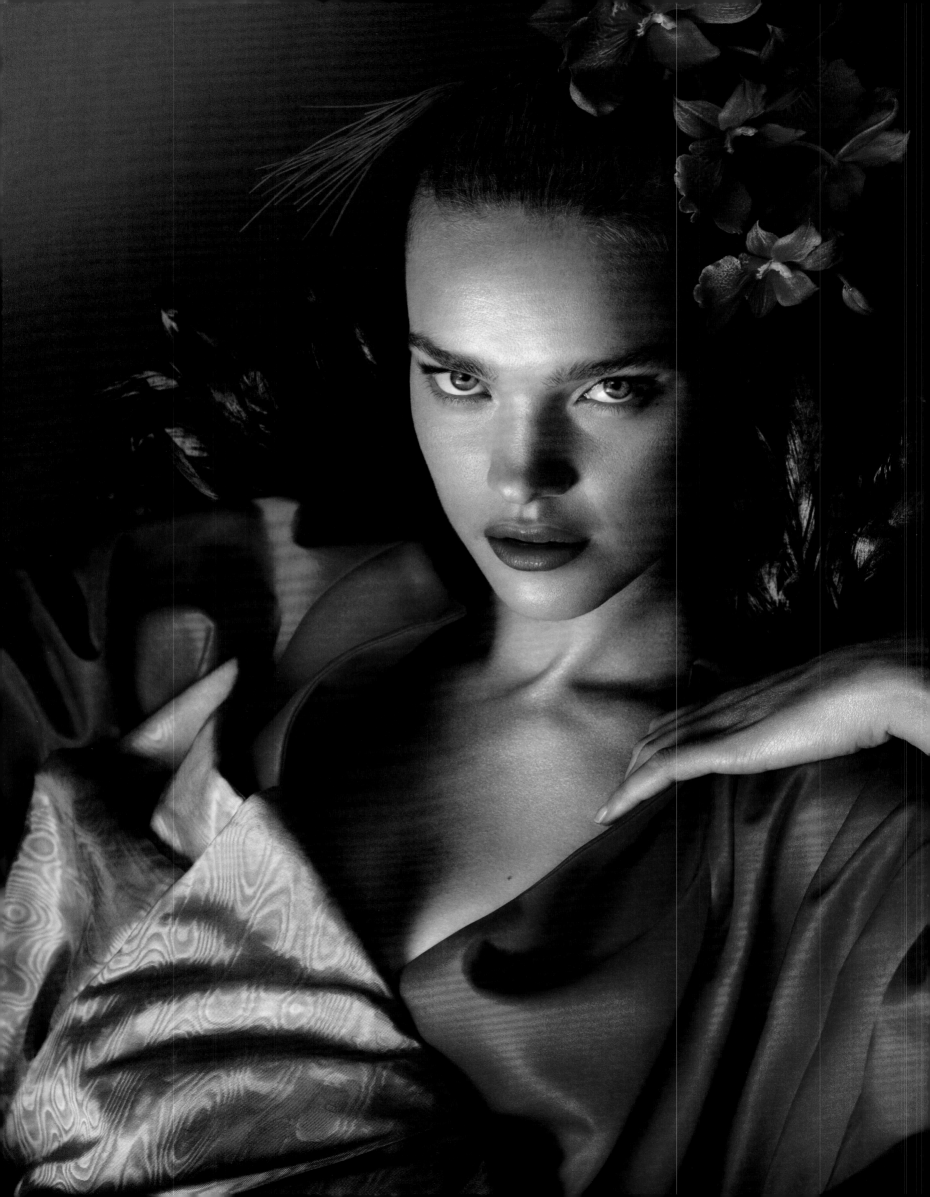

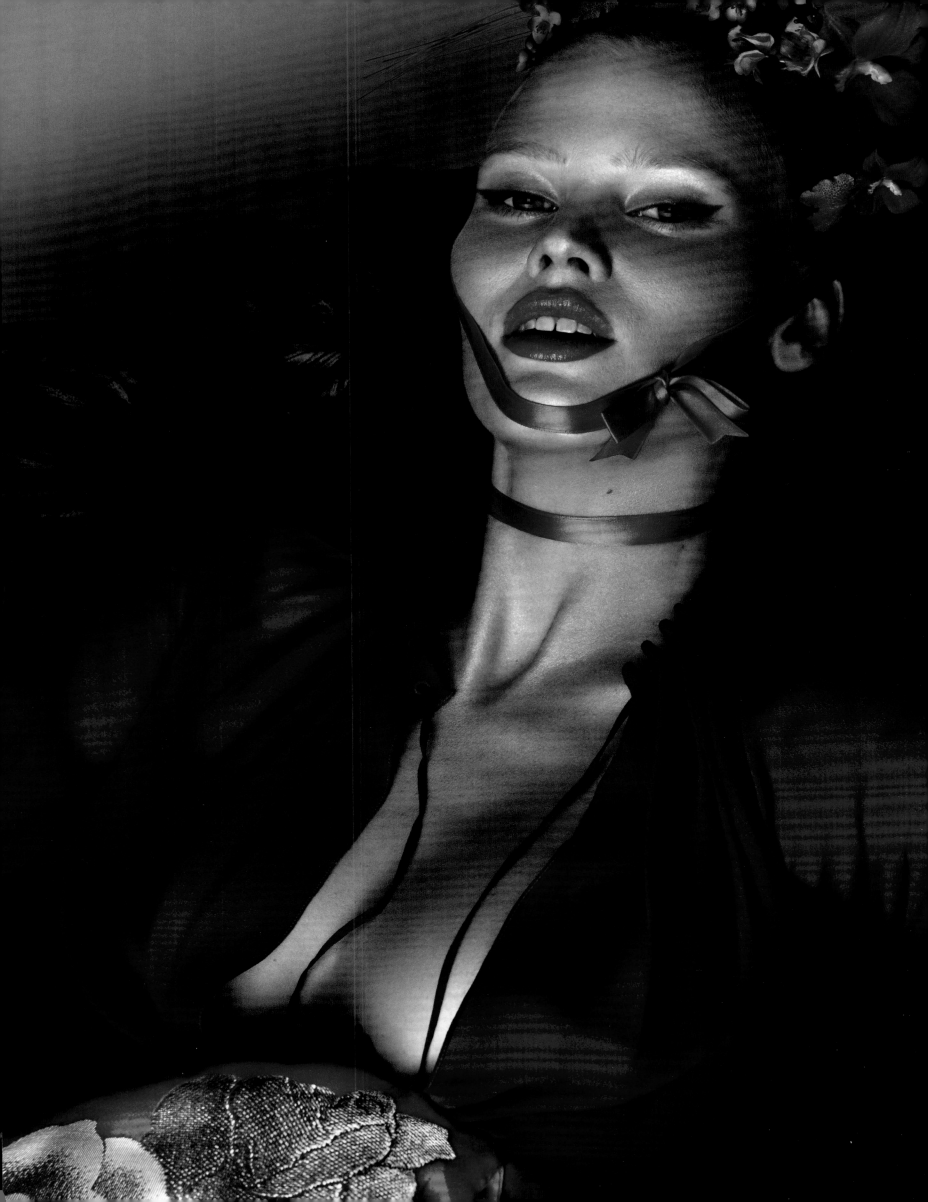

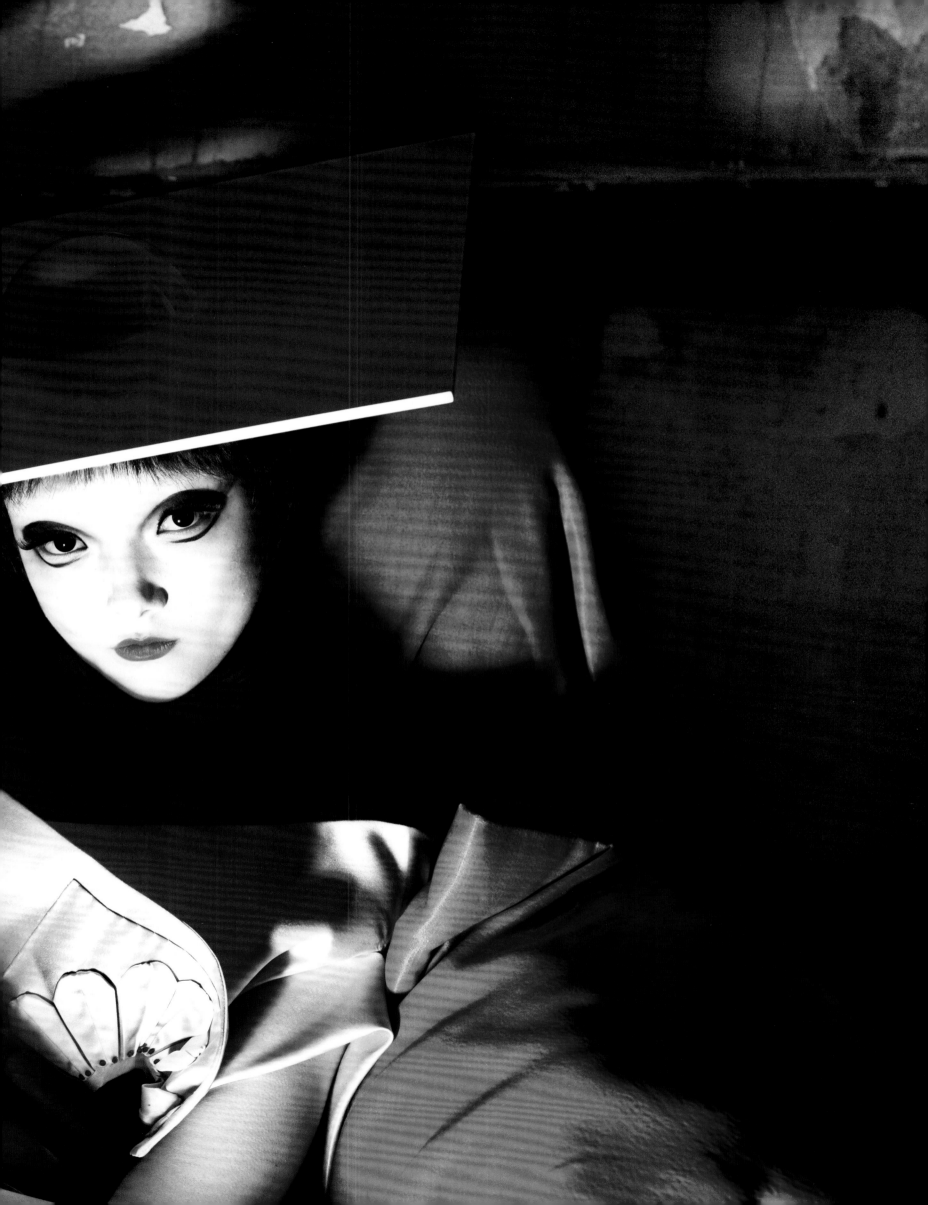

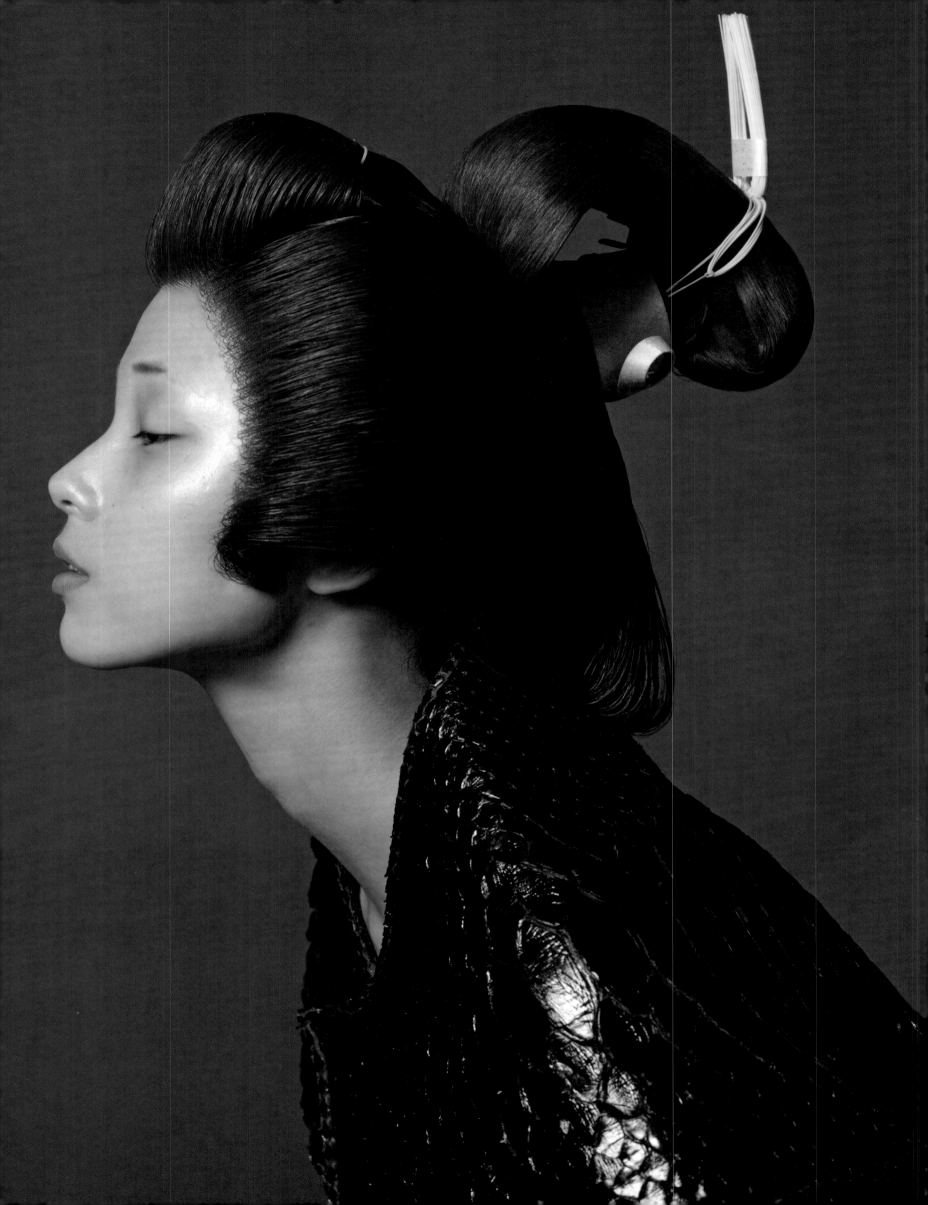

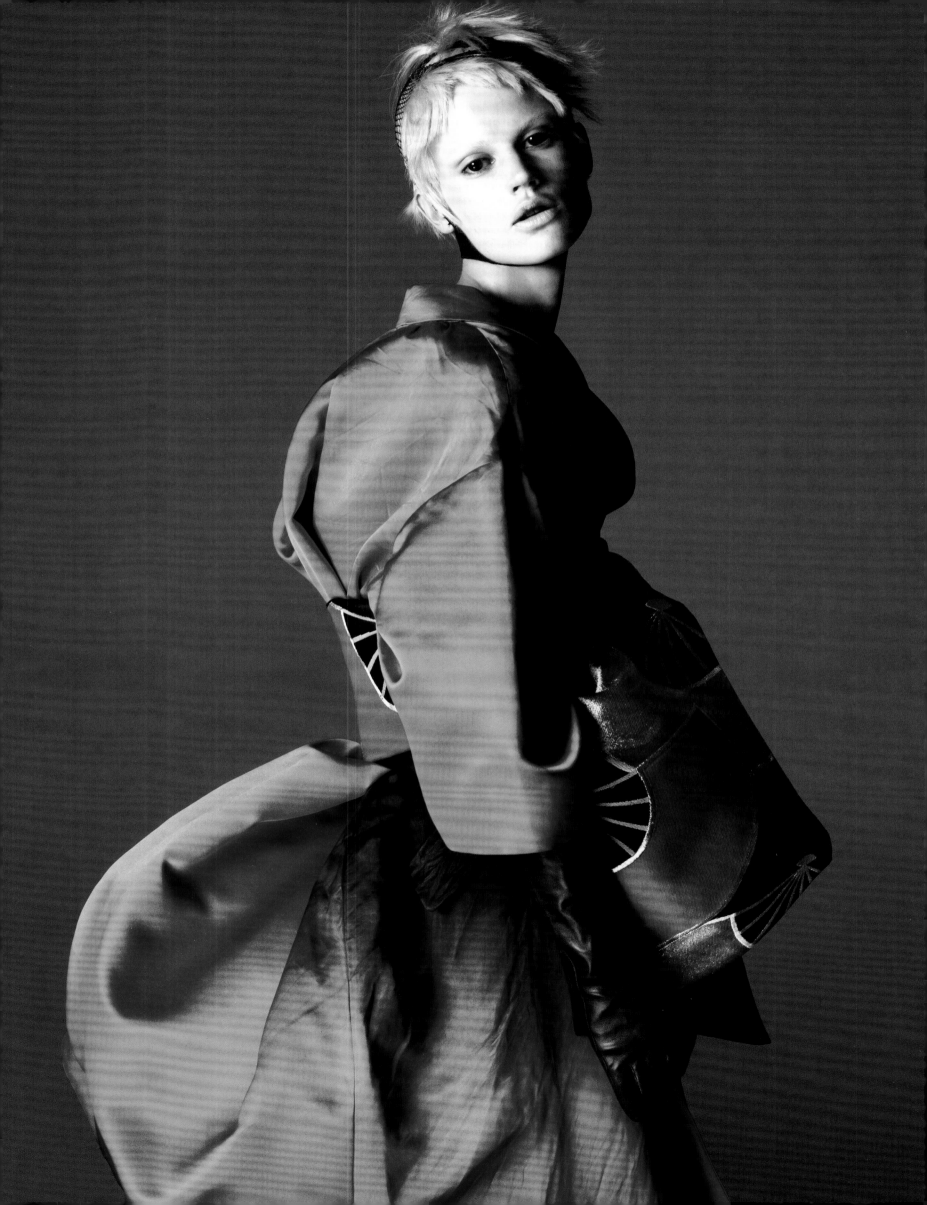

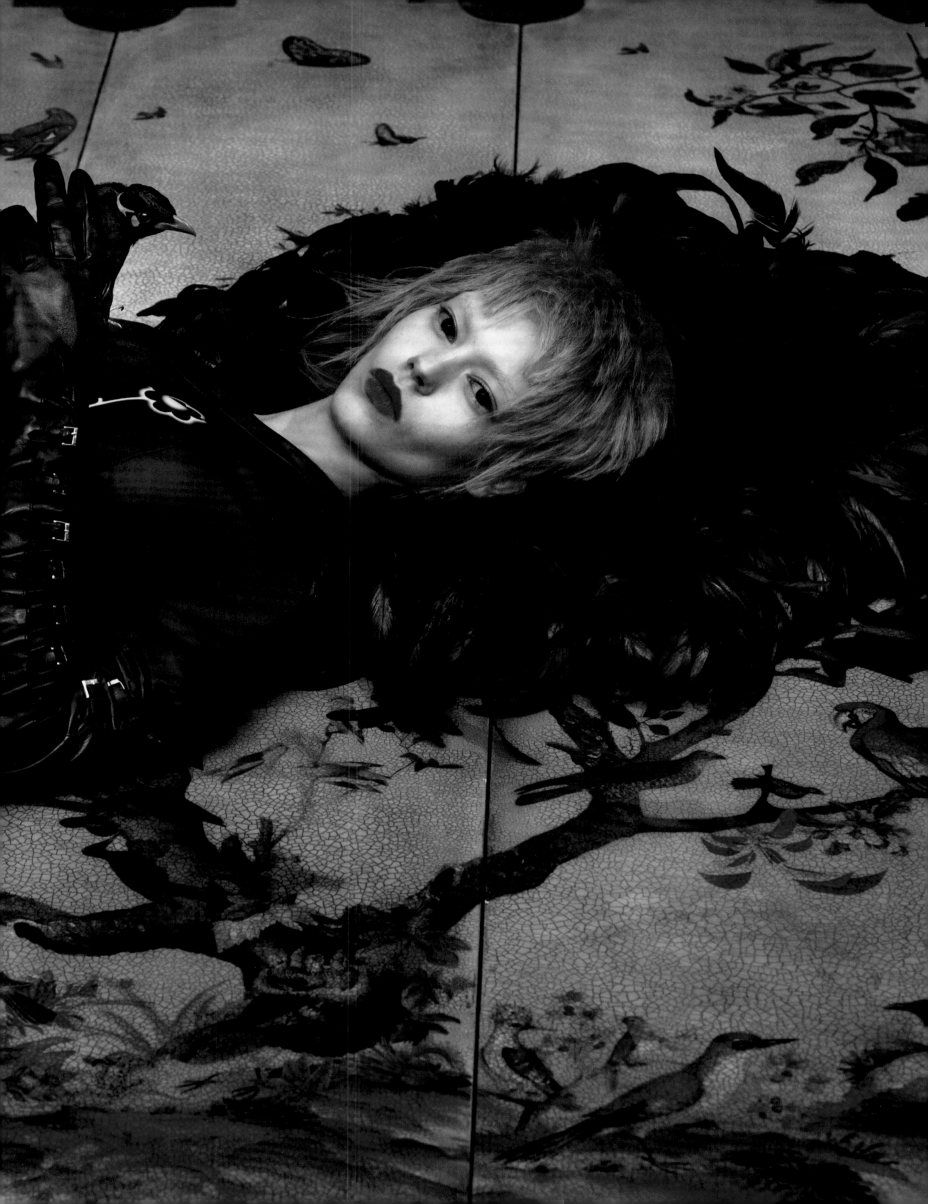

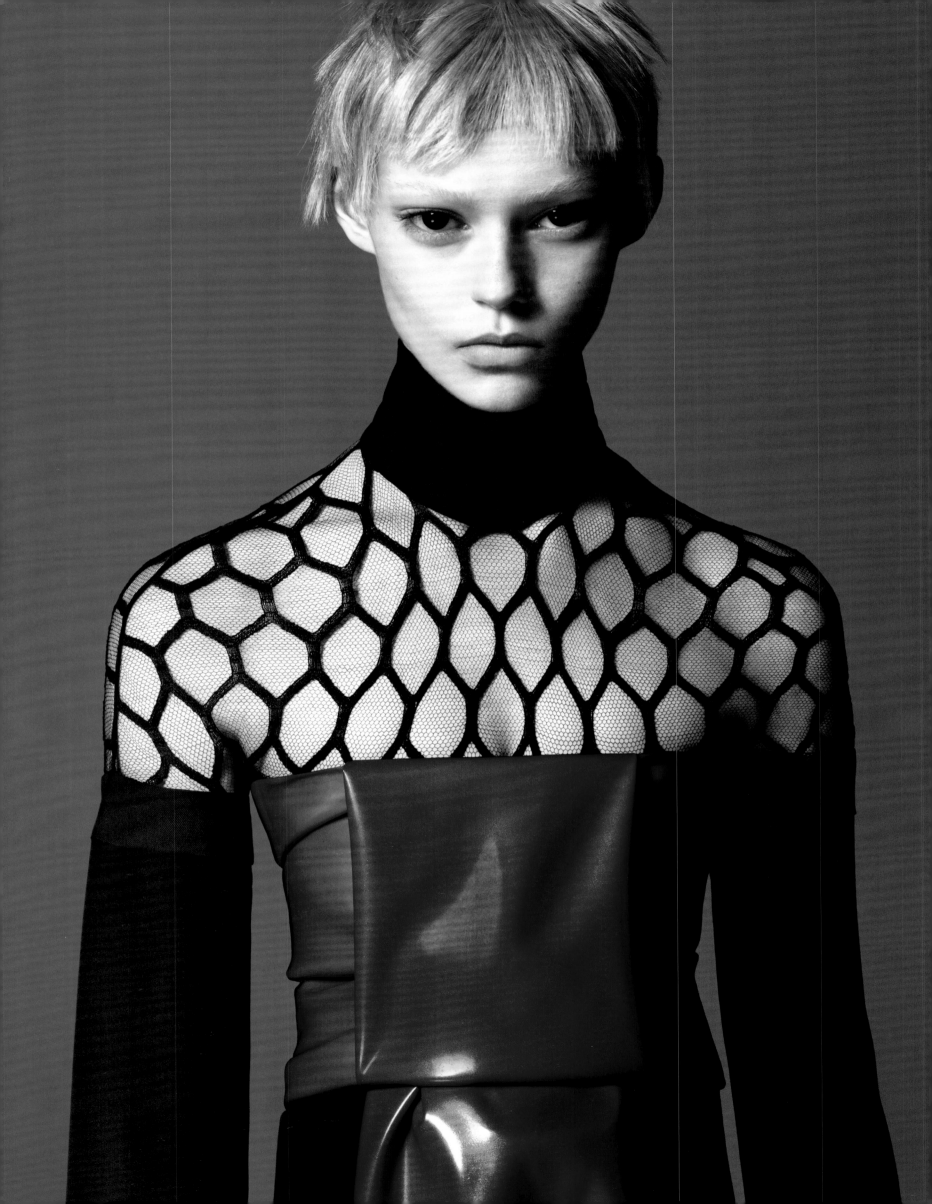

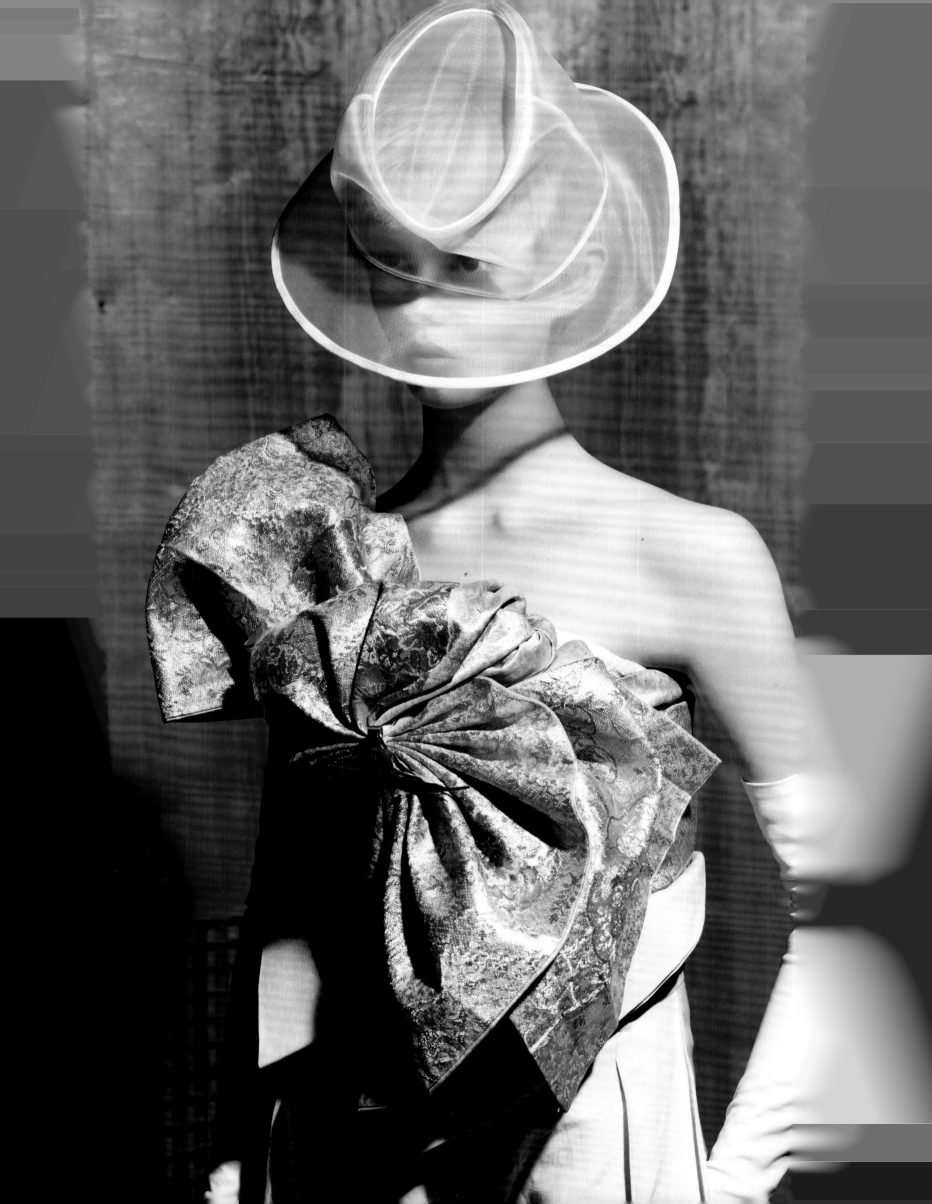

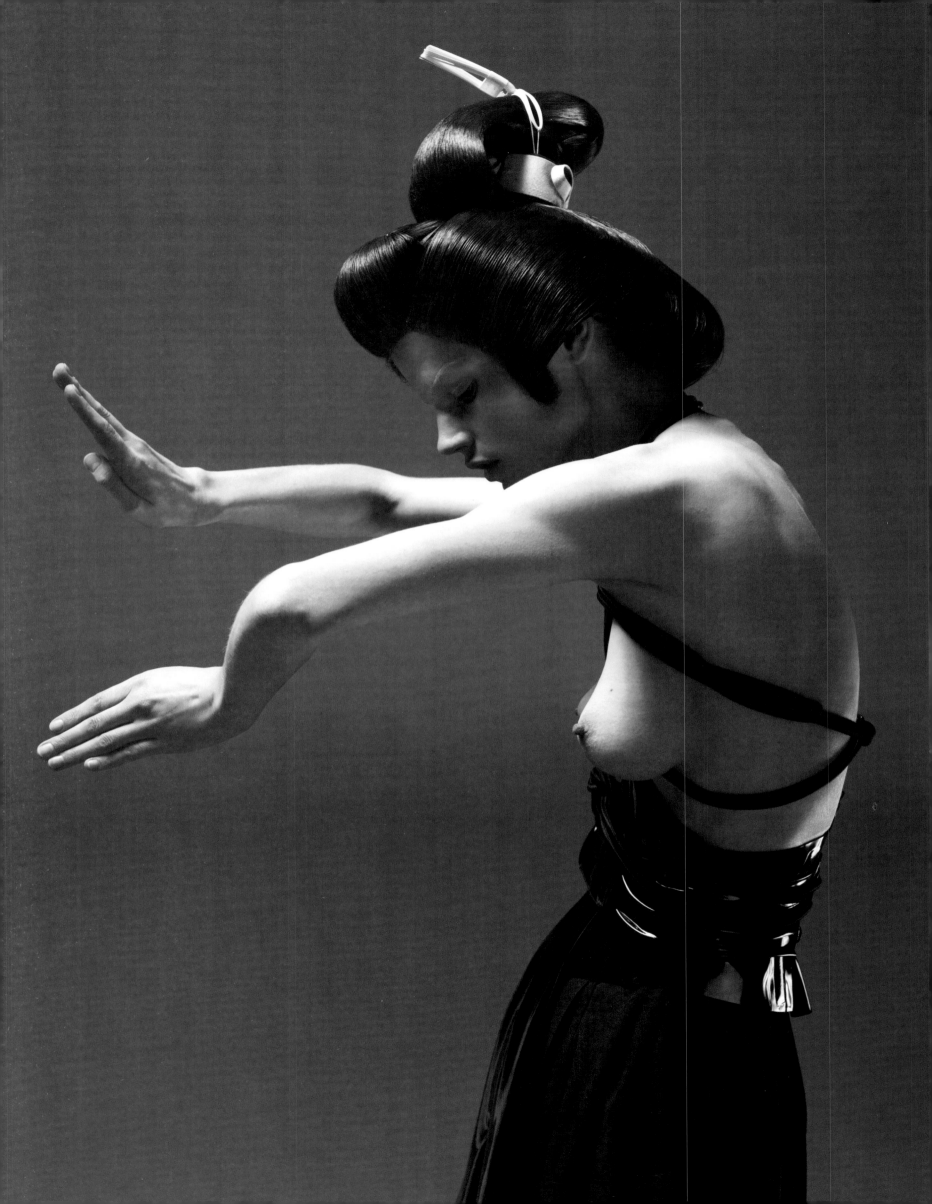

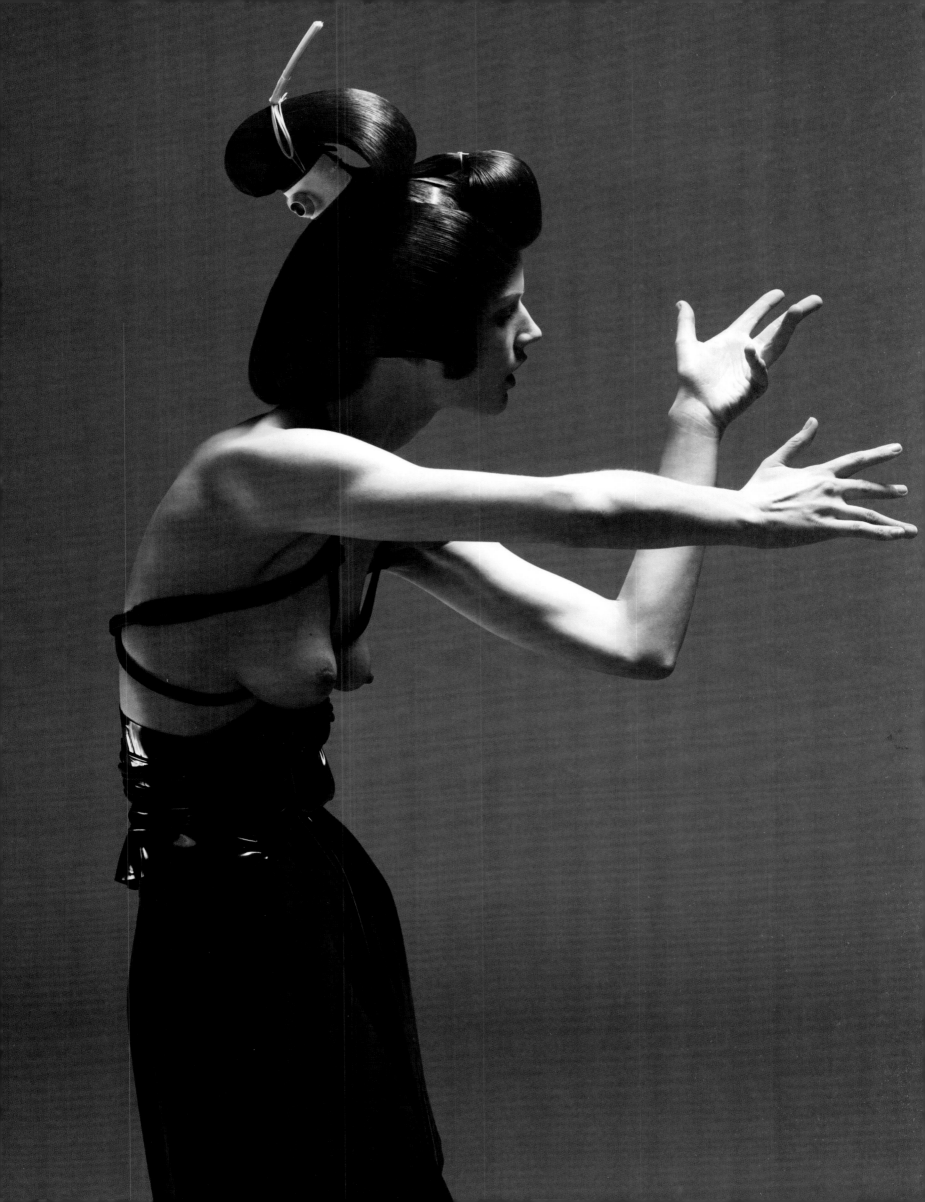

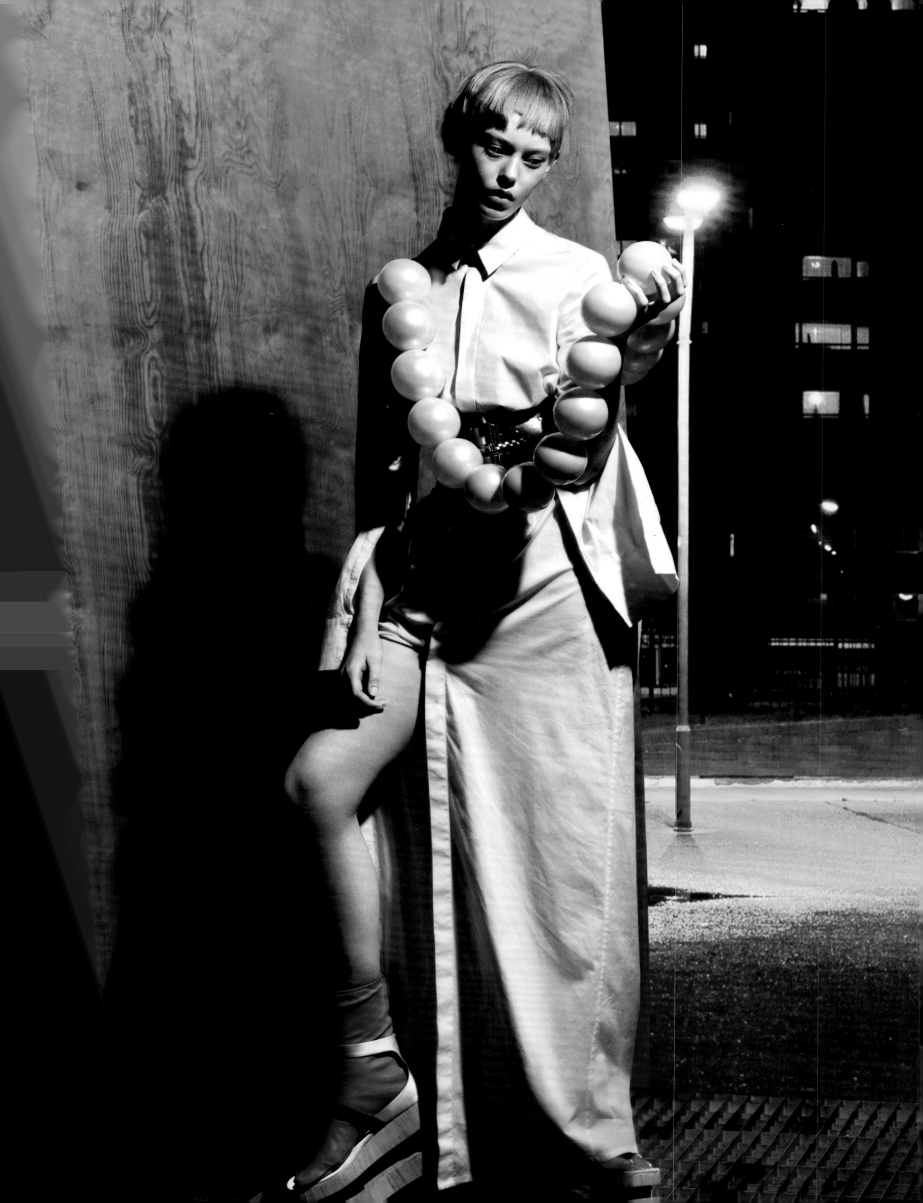

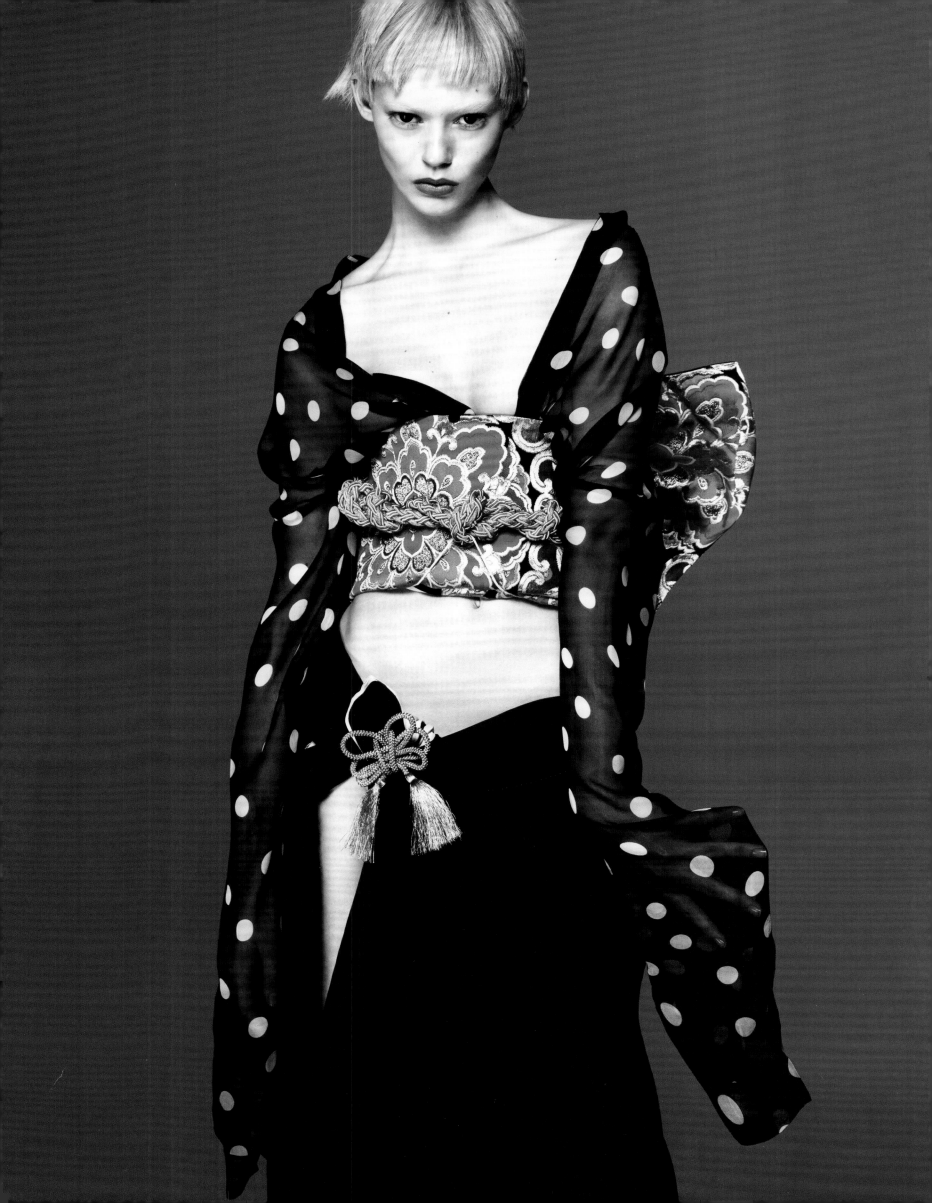

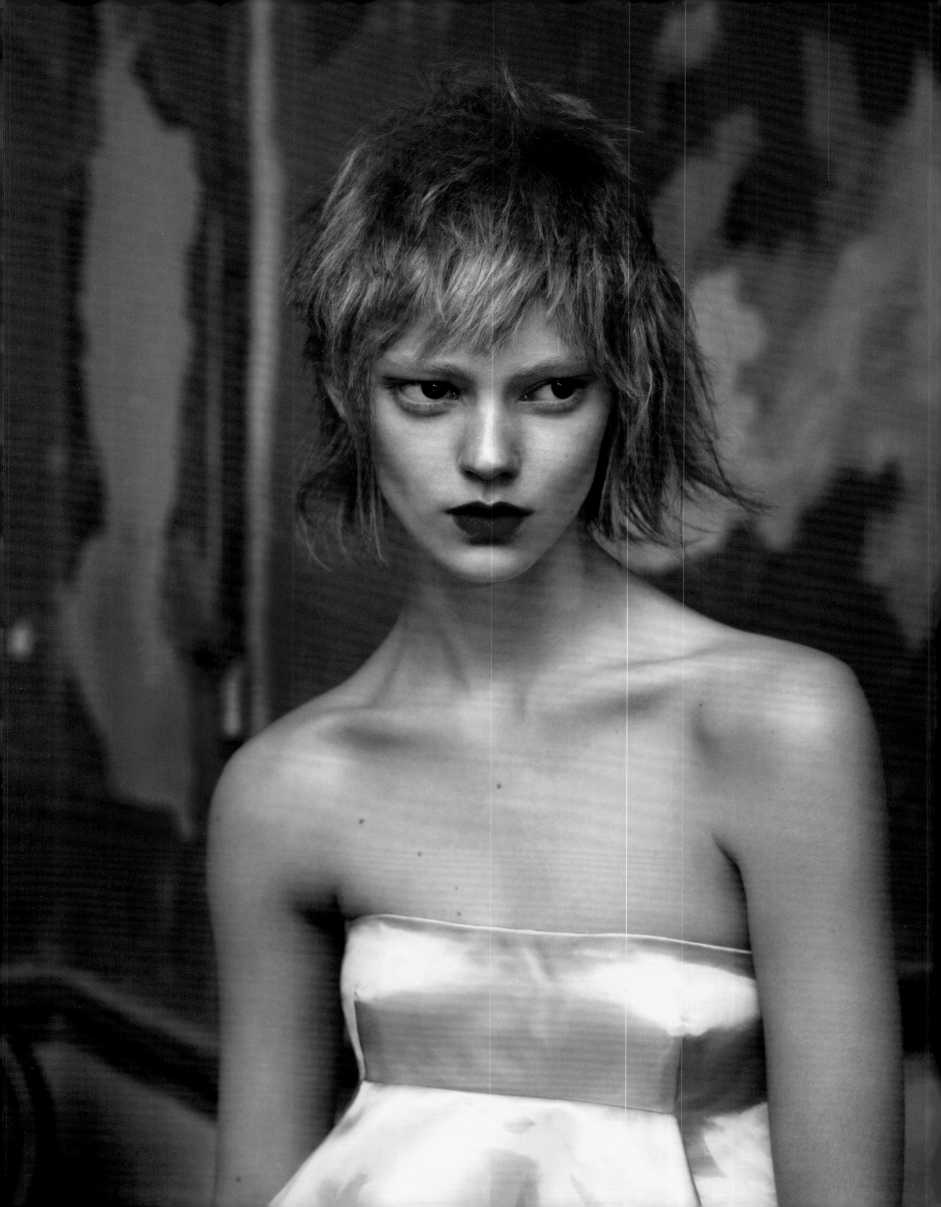

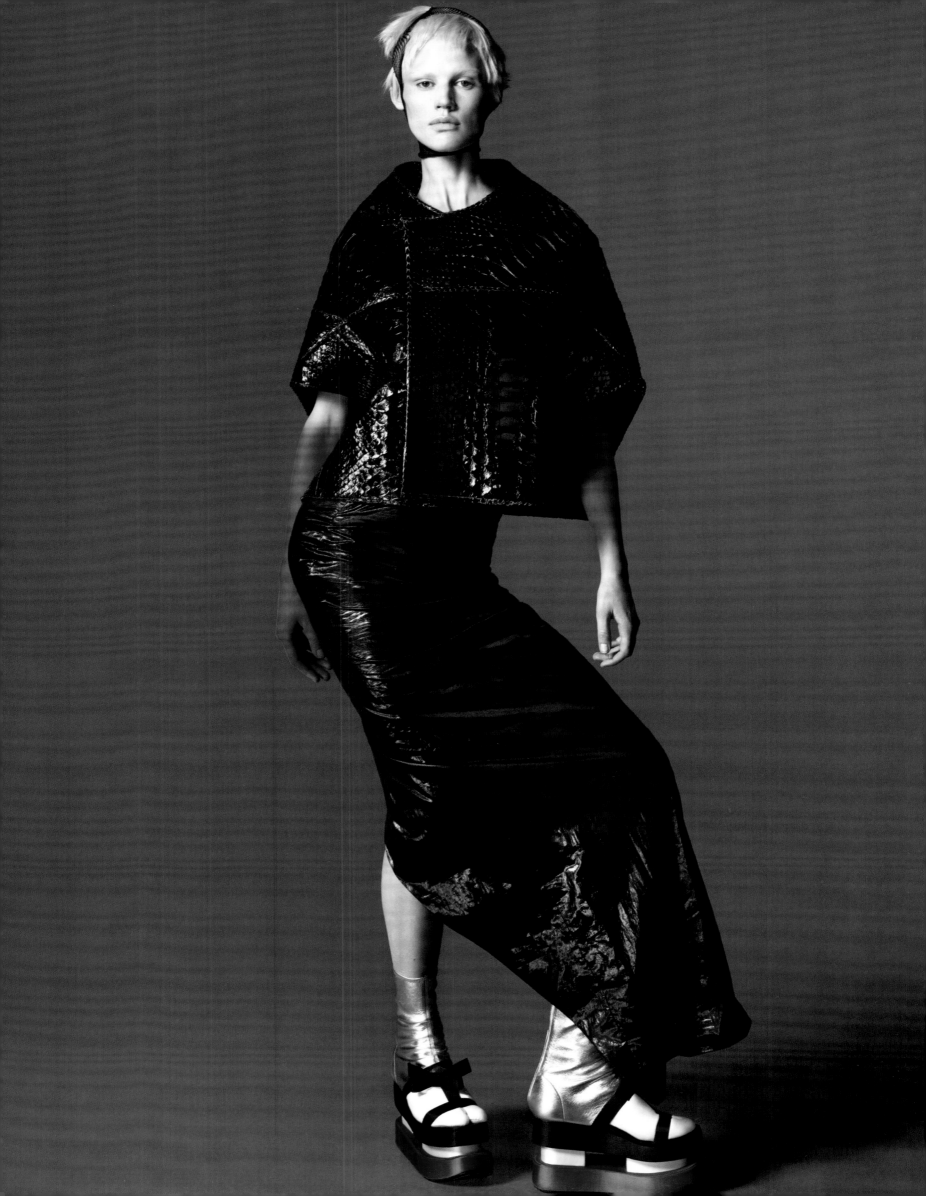

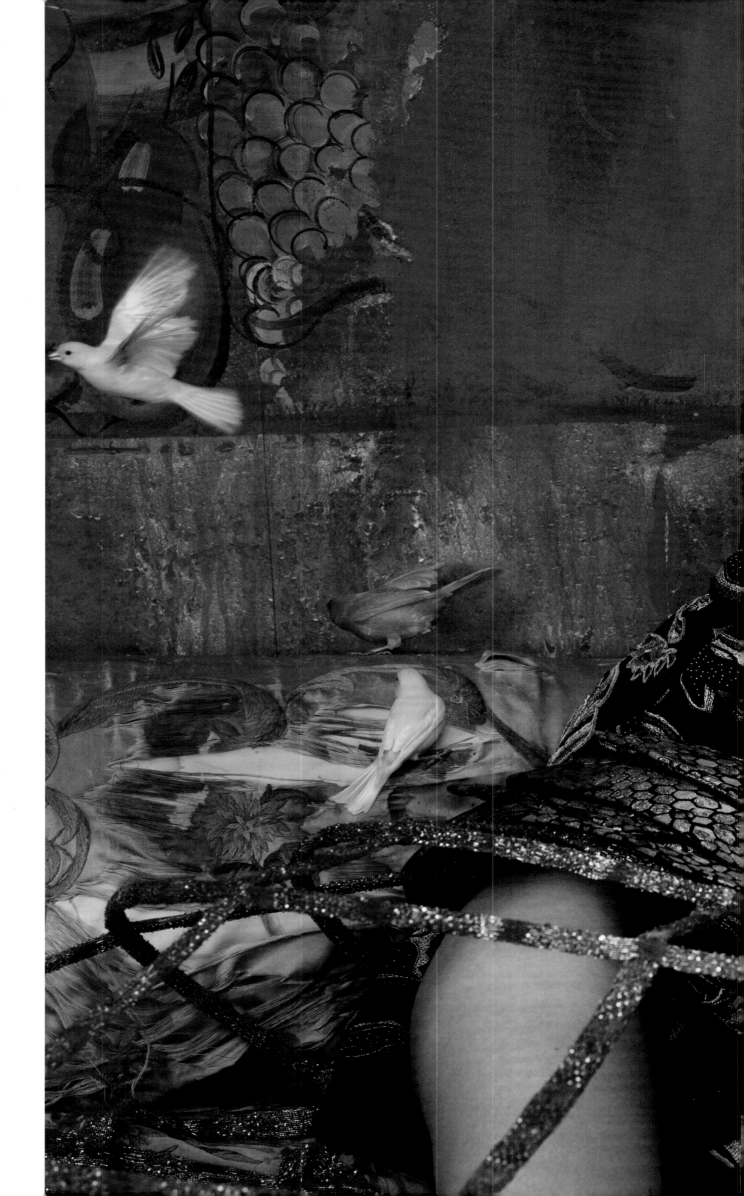

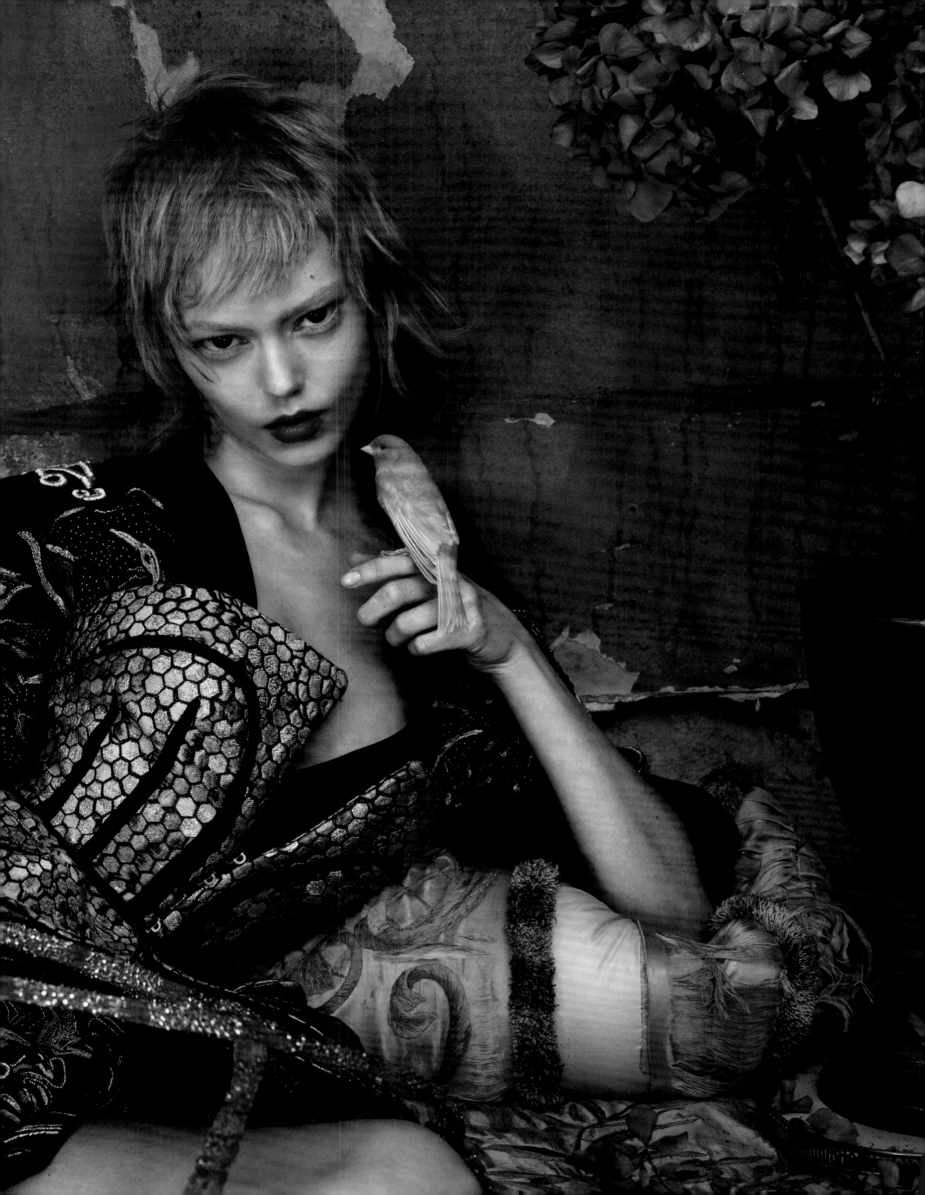

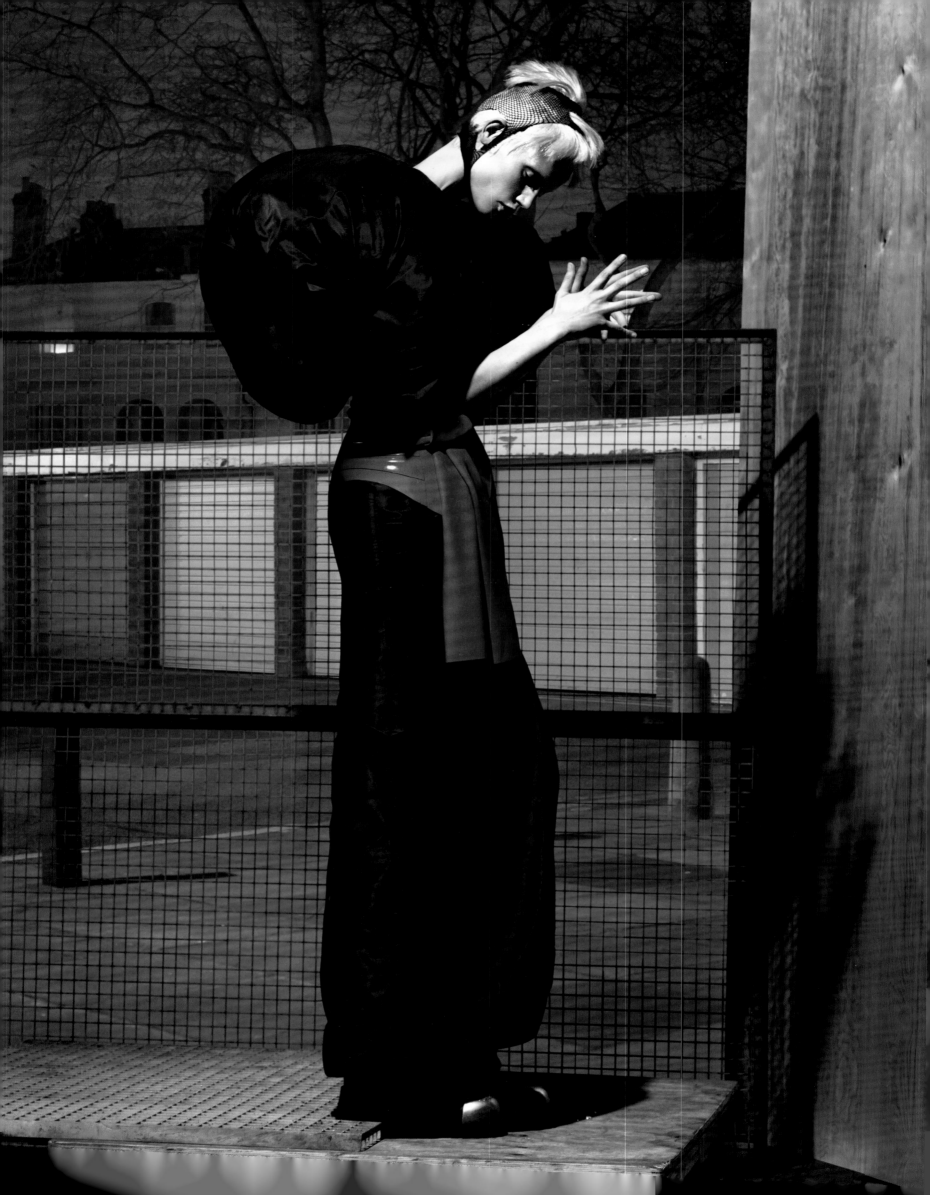

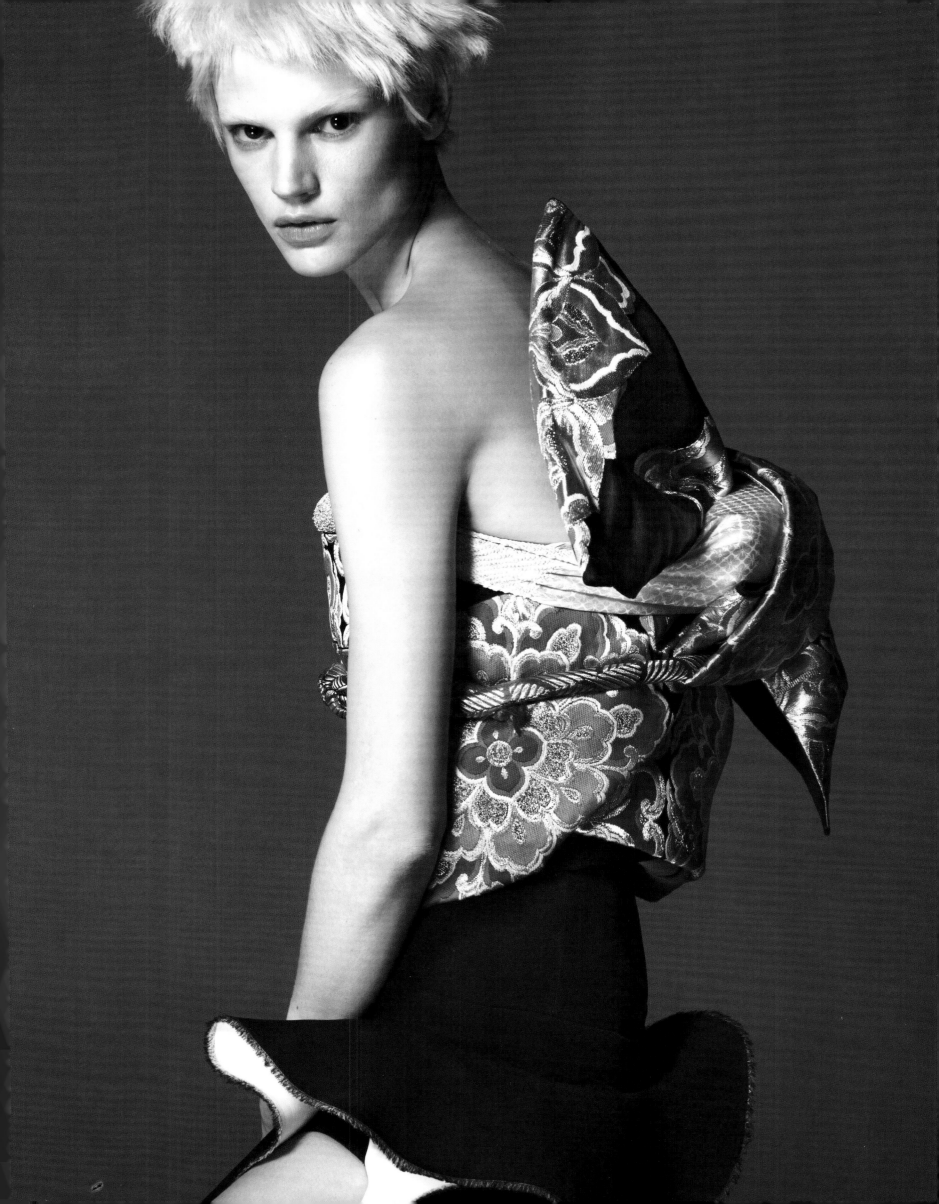

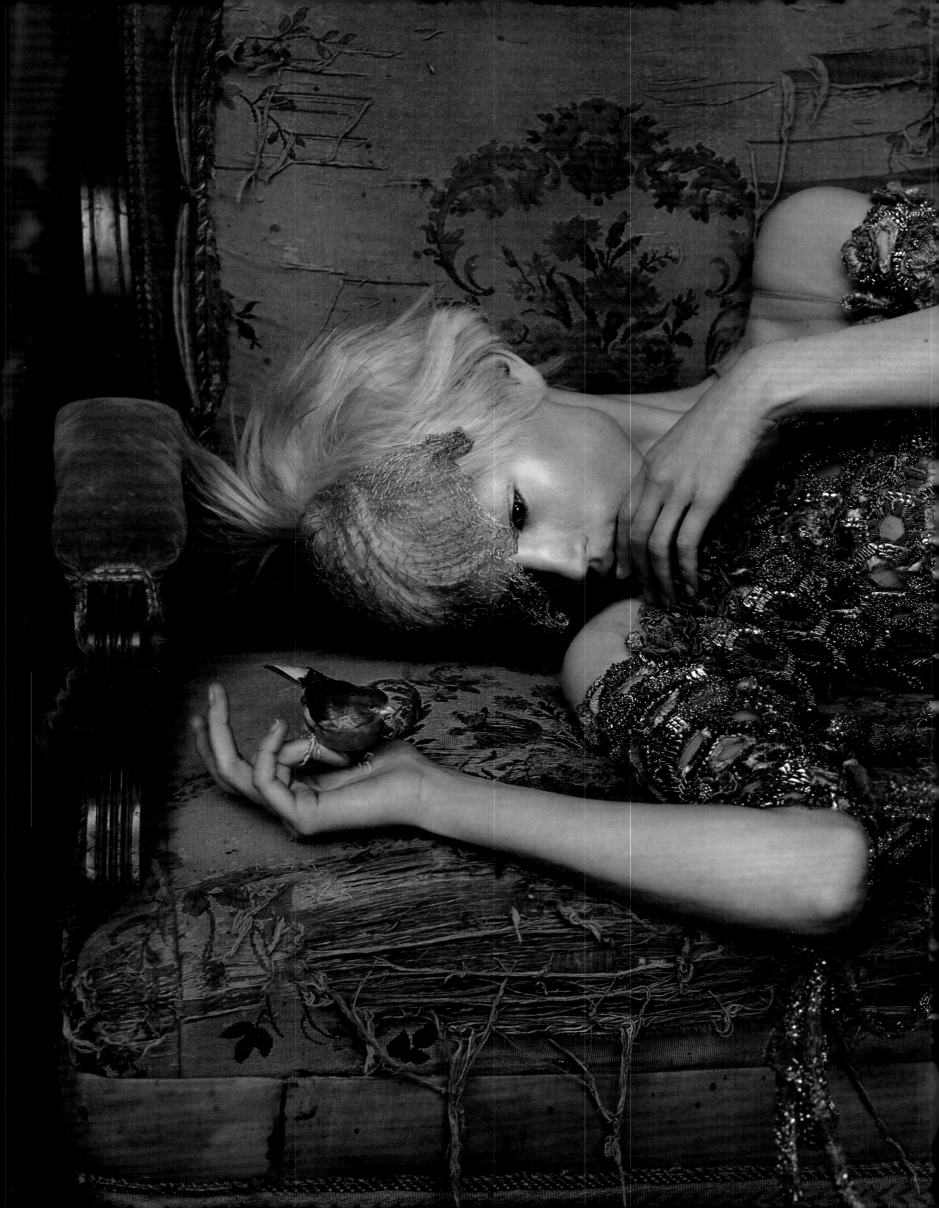

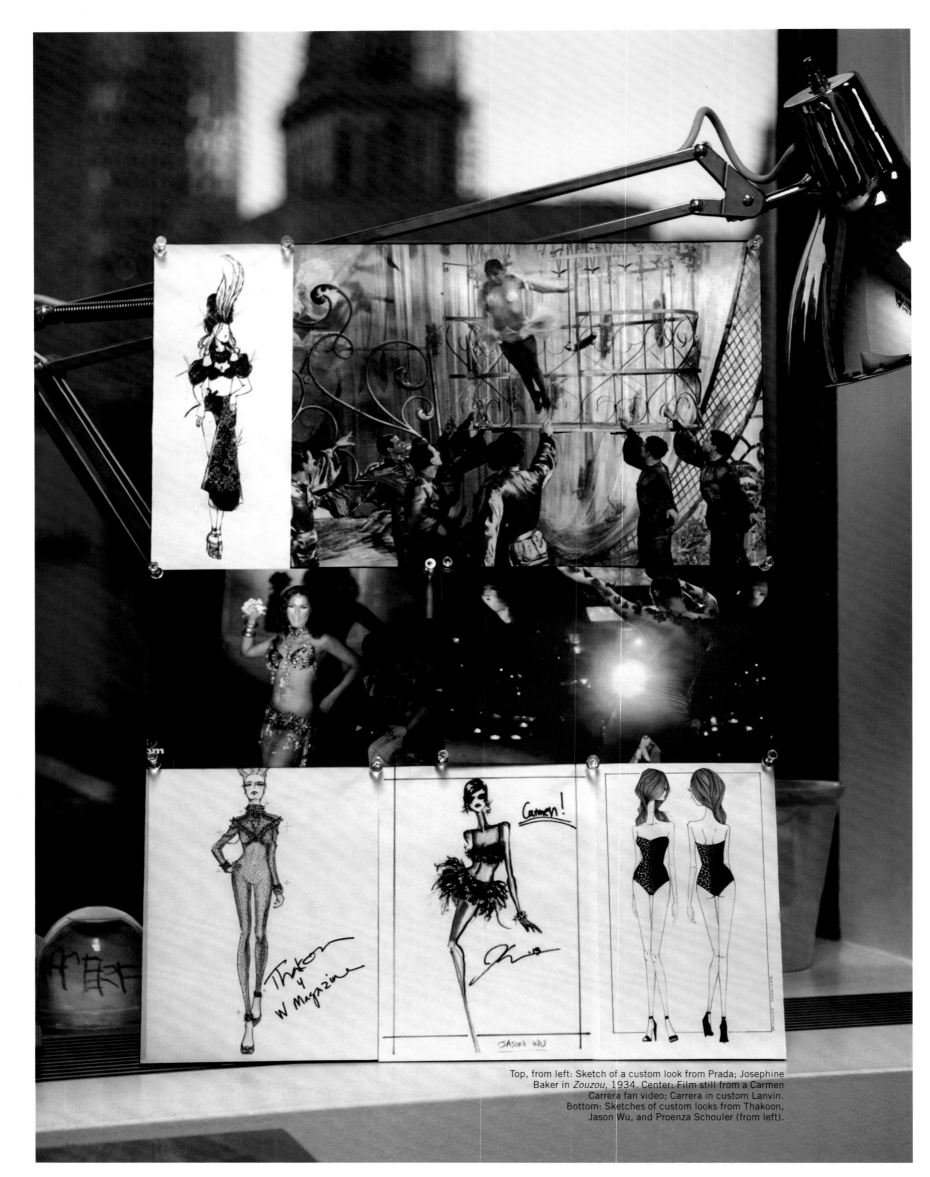

Top, from left: Sketch of a custom look from Prada; Josephine
Baker in *Zouzou*, 1934. Center: Film still from a Carmen
Carrera fan video; Carrera in custom Lanvin.
Bottom: Sketches of custom looks from Thakoon,
Jason Wu, and Proenza Schouler (from left).

SHOW GIRL

HOPING TO EMBOLDEN OTHERS, THE TRAILBLAZING TRANSGENDER SHOWGIRL CARMEN CARRERA PUT ON THE PERFORMANCE OF A LIFETIME.

I grew up in New Jersey with my mom—who was the flyest girl ever—my older sister, and my grandmother. There were always women around me because my father died of AIDS when I was two. But we were really happy, and there was a lot of love between us. My mom played the latest music—we'd always be singing—and she would put me in little improvised plays, which I loved. Often I'd wrap a T-shirt around my head and mess around with her makeup—she was such a beauty inspiration to me. As a little boy, I definitely knew that I was different, but I never thought I was wrong for it.

After high school, I started going to New York City and getting to know the gay and transgender scene. That's when I went to my first drag show, at a Latin club called Escuelita, in 2004. The finale was this stunningly beautiful goddess who was obviously a trans-woman, and she took my breath away. I started performing not long after. Being onstage gave me an escape: I got to be feminine, which is what I was on the inside. I've never felt like a gay guy, and I remember that as a child I'd pray that when I woke up I'd be a girl.

At a certain point, I didn't want to just act like a woman anymore—I really wanted to become one. Around the same time, I got a call from the producers of the reality show *RuPaul's Drag Race*, who had heard about me from a past contestant. I went along with it, but I wasn't sure what I had gotten myself into. I was suddenly in a position where the whole world was going to see me—not just people in a club. I didn't think the show would get me to where I am now, but I knew it would bring me more work. So literally the day after I finished filming, I decided it was time to begin my gender transition.

The photographer Steven Meisel was a fan of *Drag Race*, and he followed me on social media. He cast me in a shoot for *W*—a fake ad for a perfume called La Femme—and we got to know each other. I'm an Aries and he's a Gemini, so we work well together—he understands my fire. Then, about two years later, I got a call from *W*'s Fashion and Style Director, Edward Enninful, inviting me to dinner with him and Steven to discuss the concept for another shoot. Marc Jacobs, Naomi Campbell, and Pat McGrath were also there, with me at the head of the table. It was so surreal being surrounded by these amazing people—all idols of mine—discussing a big fashion story about me!

Steven had really done his research. When I showed up to the set, he had stills from fan videos of me performing. We shot over the course of three days at this beautiful space called the Edison Ballroom, in New York—playing my music, drinking champagne, and channeling a showgirl mentality. Most of the clothes were custom-made for me by Prada, Marc Jacobs, Proenza Schouler, Lanvin, and others. At one point, just as I was being showered with money, Linda Evangelista walked in. Steven had invited her, and I had no idea she was coming. She's been such a point of reference for me, and there she was, watching me act like a hoochie mama. It was very funny—and such a dream come true for me to share the frame with her.

But the most exciting thing about this shoot was having the opportunity to express myself to a new audience. It also allowed me to get a message across to transgender people who are in the midst of transitioning—or who are hiding at home and afraid of society—telling them that the world is not as bad as they thought it was. It's time for the trans community to have representation in fashion, and this shoot jump-started that process.

I feel like there are certain people who are put on Earth for a purpose, and I'm one of them. For many, the word "transgender" brings up weird thoughts. They think about all the negative things that come from ignorance. I don't have time to play psychologist and change everyone's mind, so I try to lead by example. That's why I'm as open as I can be in the media—I want to leave something behind. Hopefully one day everyone will look back and say, "Wow, remember when trans-people were discriminated against, and this person was like, 'Screw everybody! I'm going to model and do shows and parade around half-naked. And I'm going to be superproud about it, because that's how everyone should be'?"

PHOTOGRAPHED BY STEVEN MEISEL
STYLED BY EDWARD ENNINFUL
PUBLISHED IN SEPTEMBER 2013

To view the film inspired by this story, go to www.abramsbooks.com/wstories and enter access code wstories5films

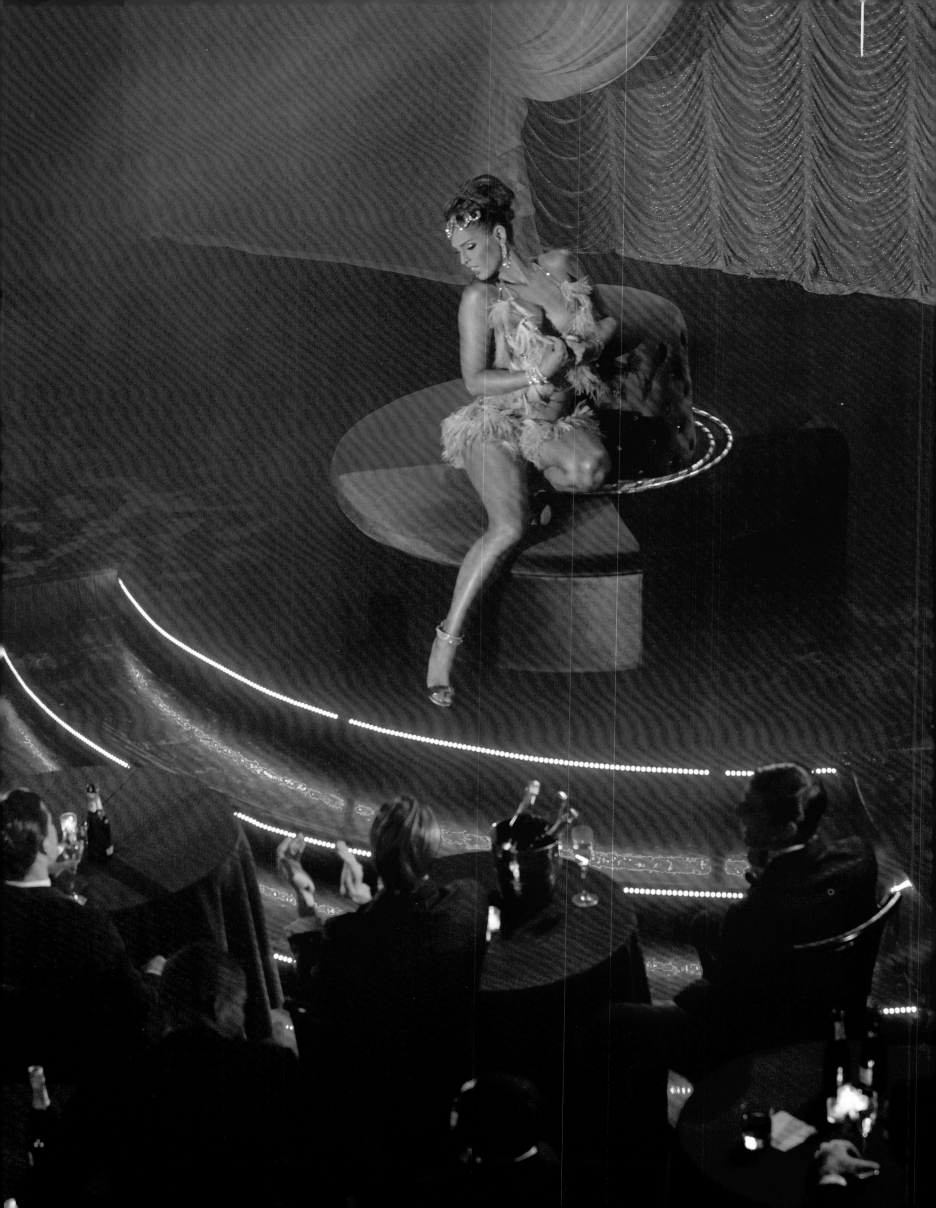

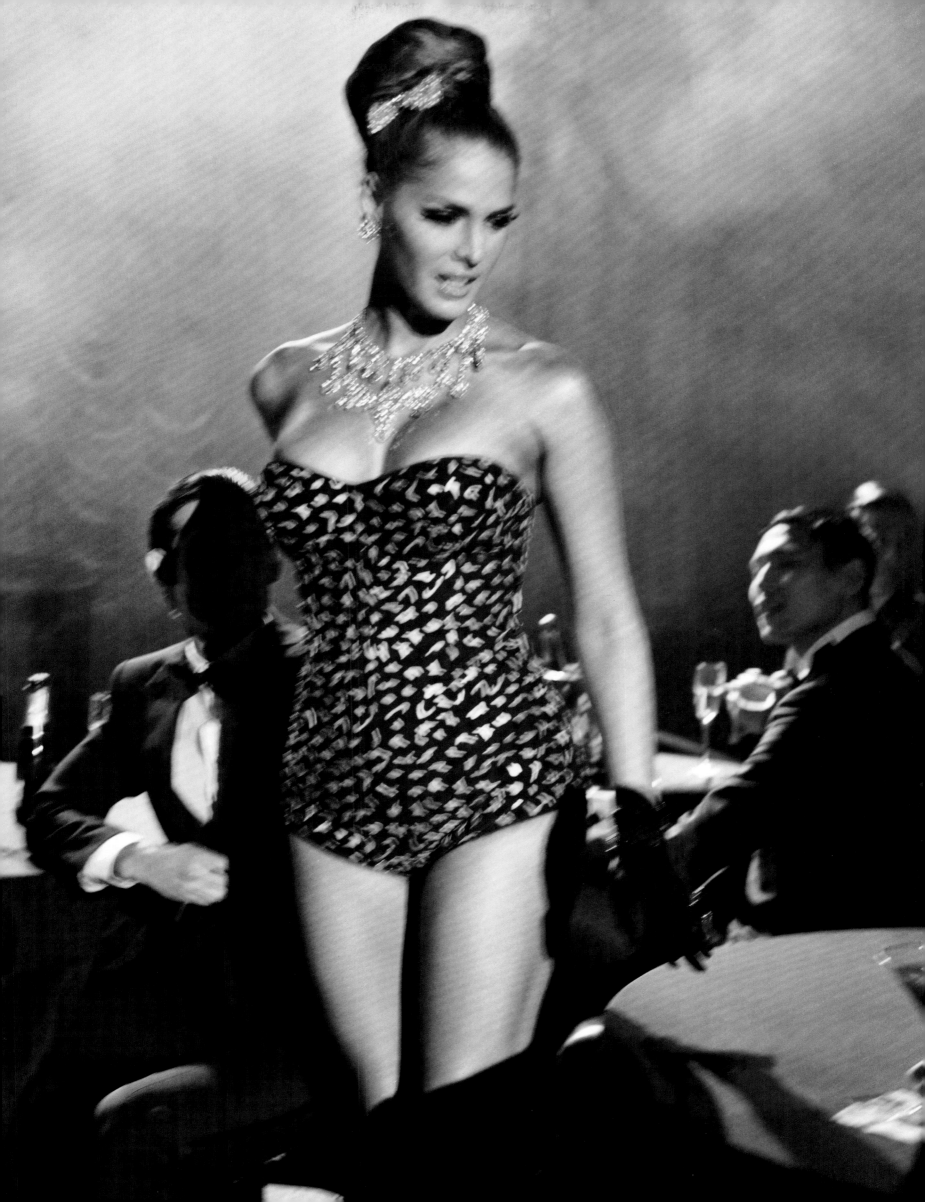

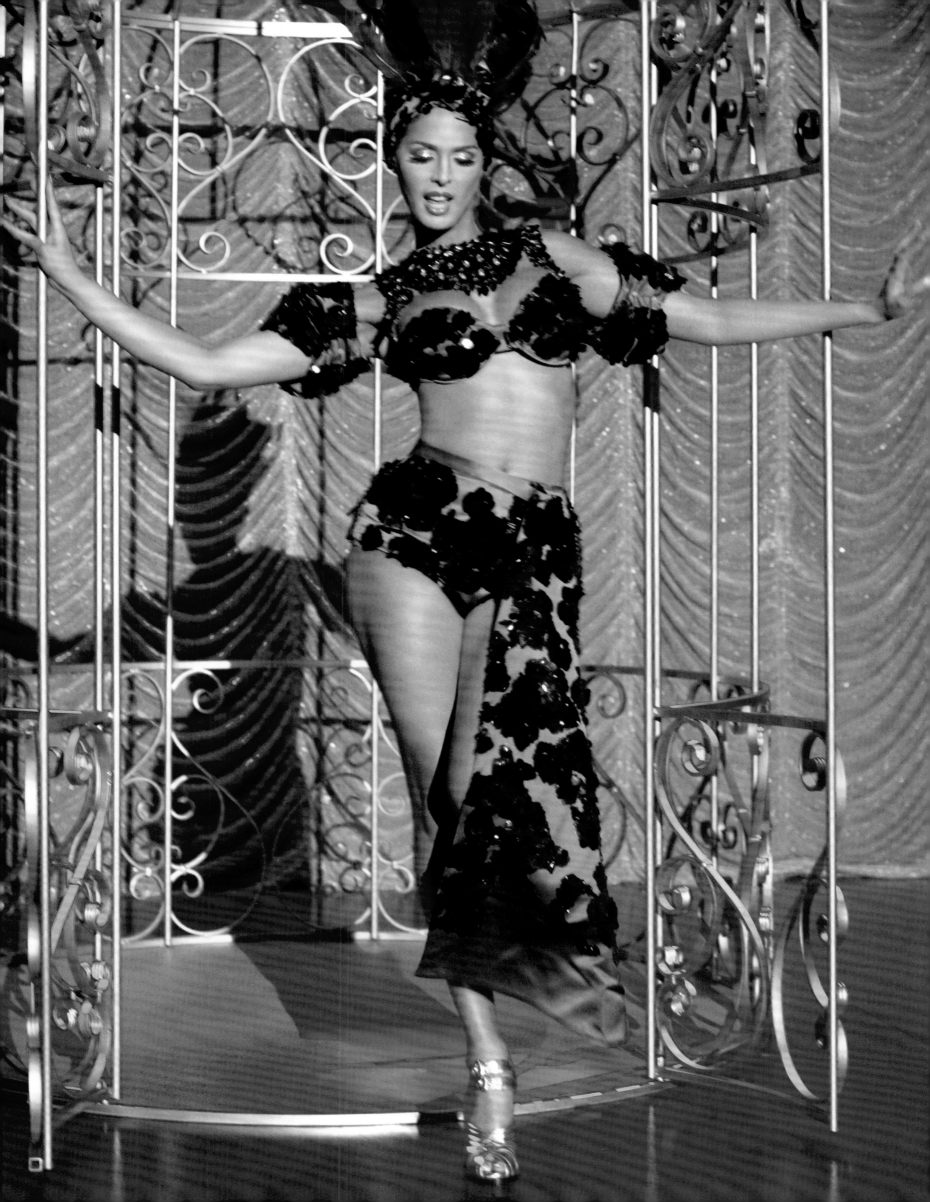

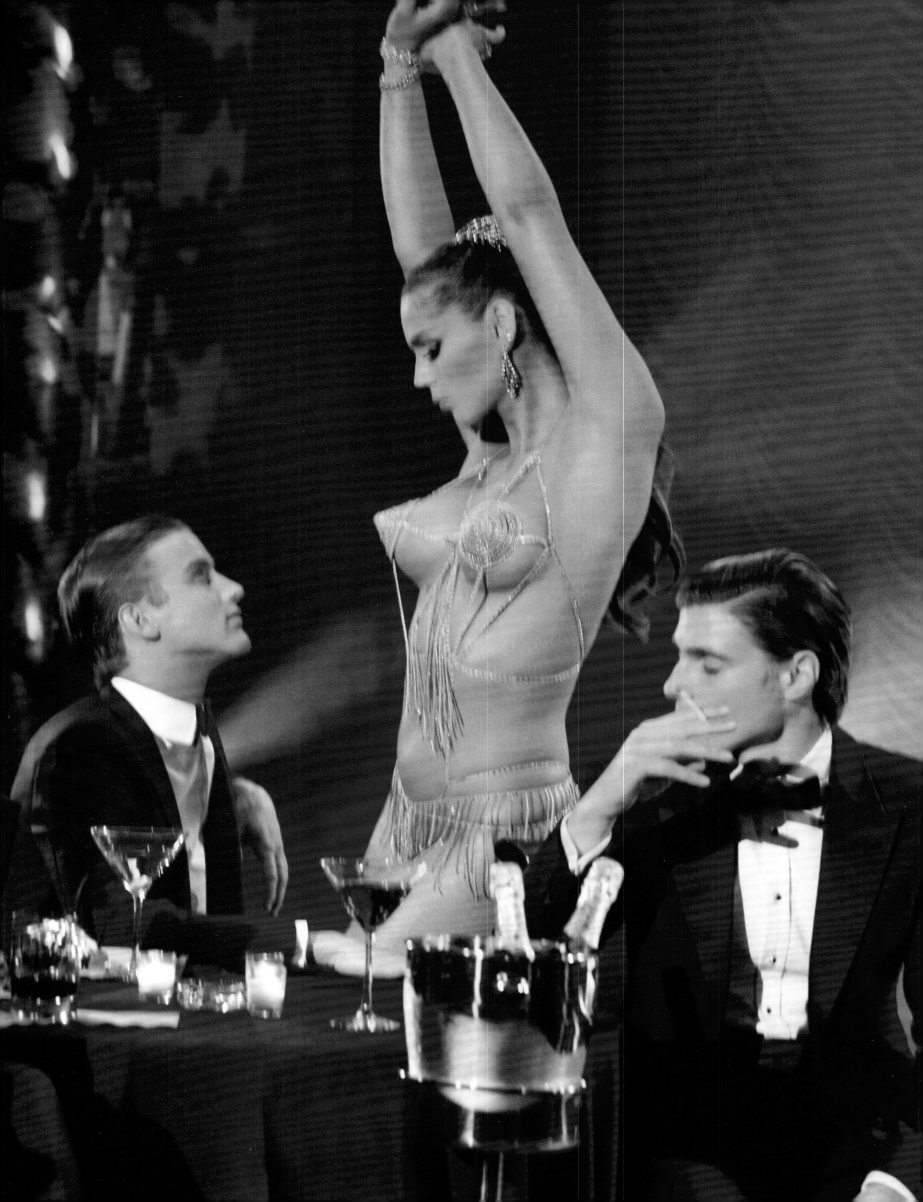

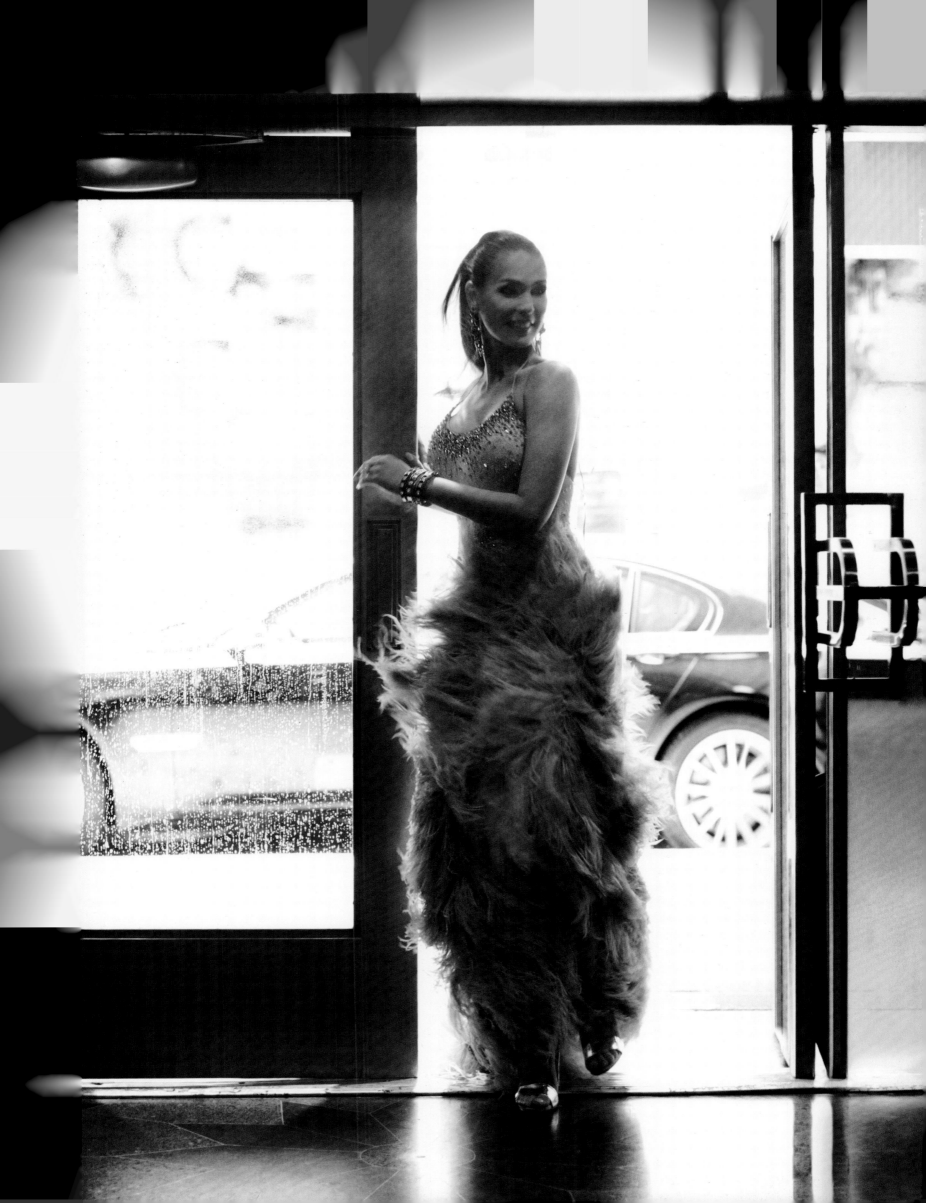

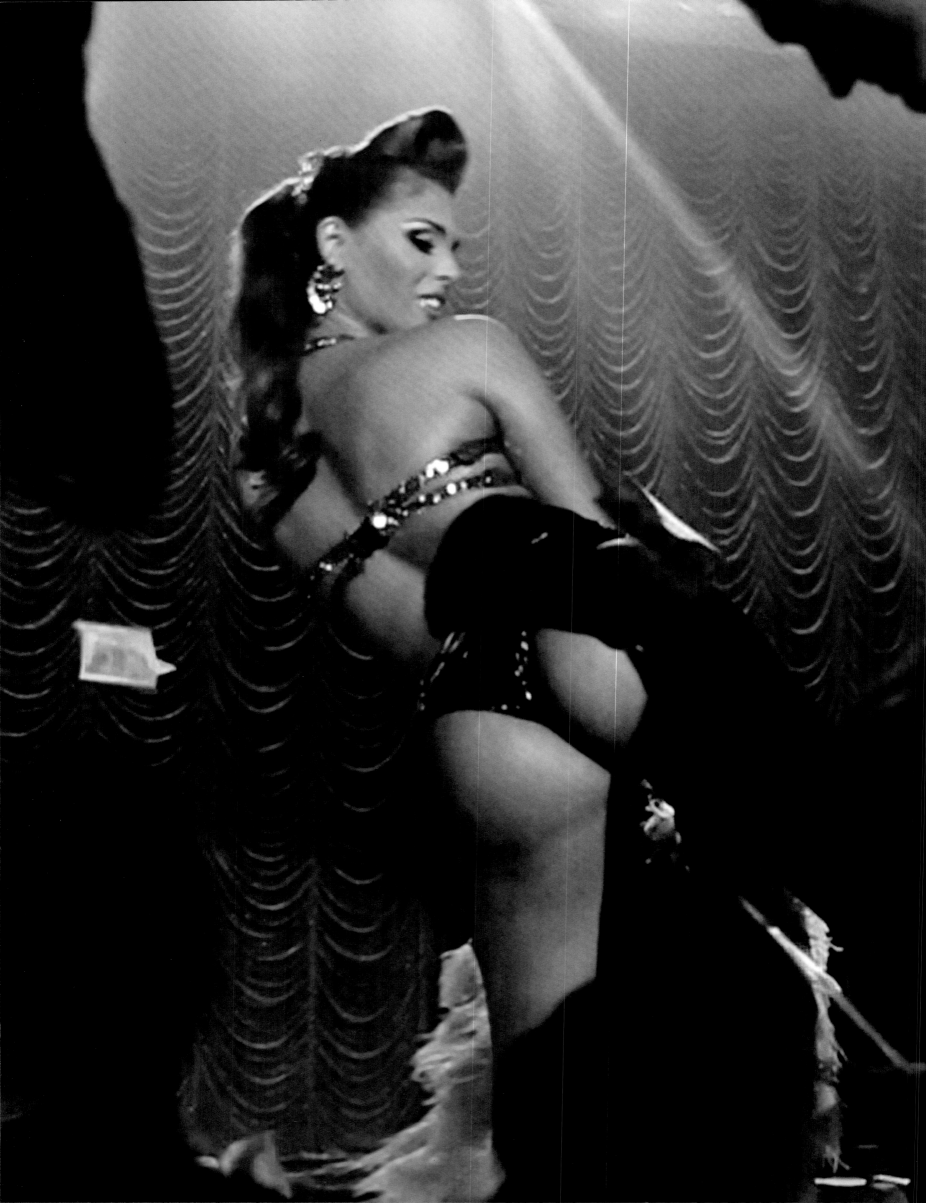

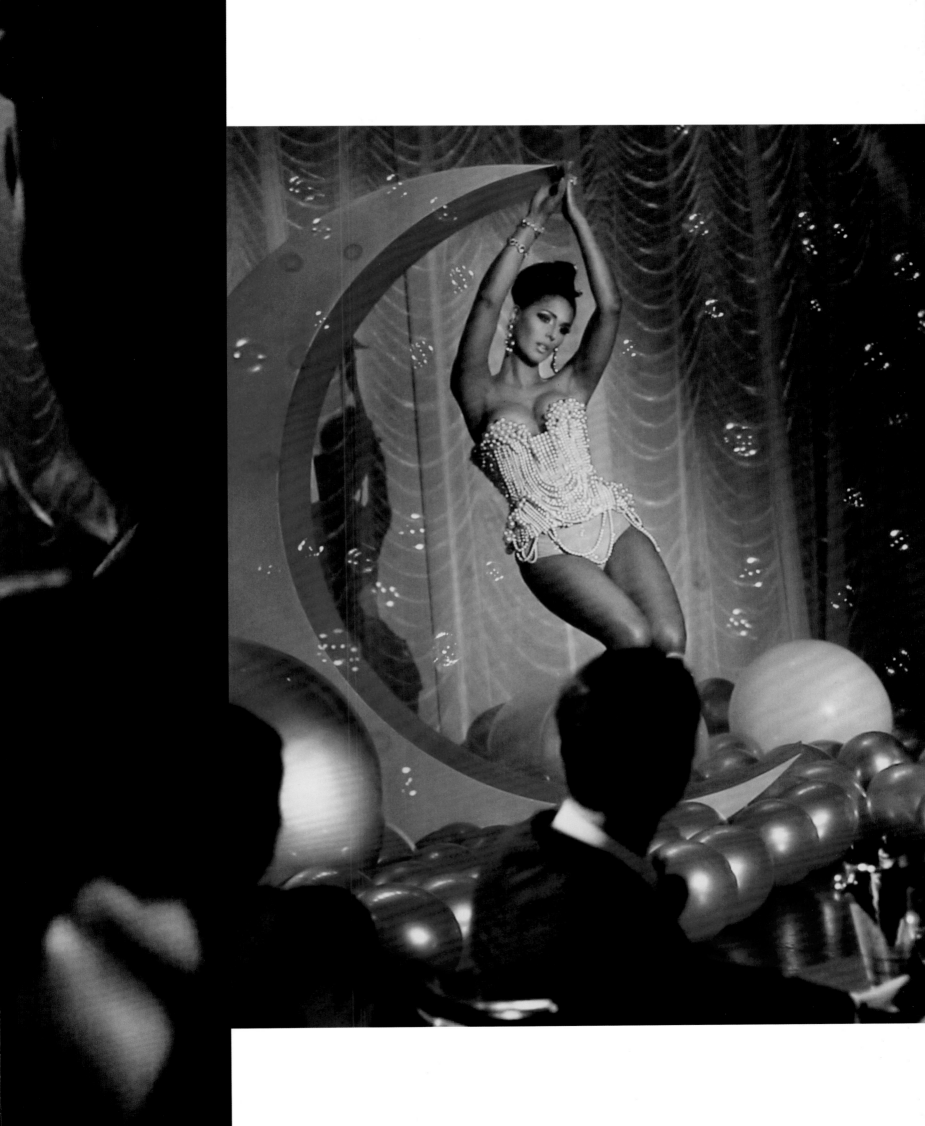

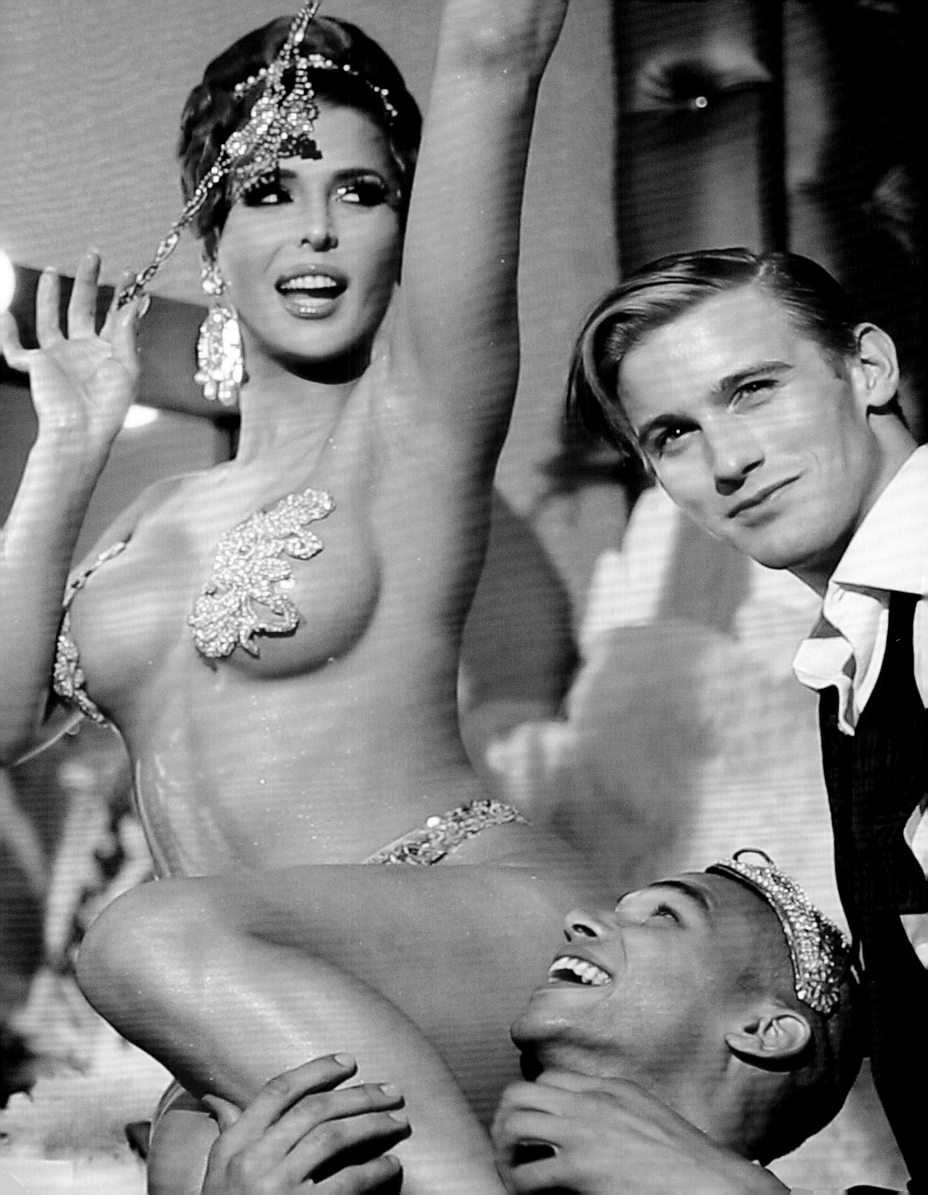

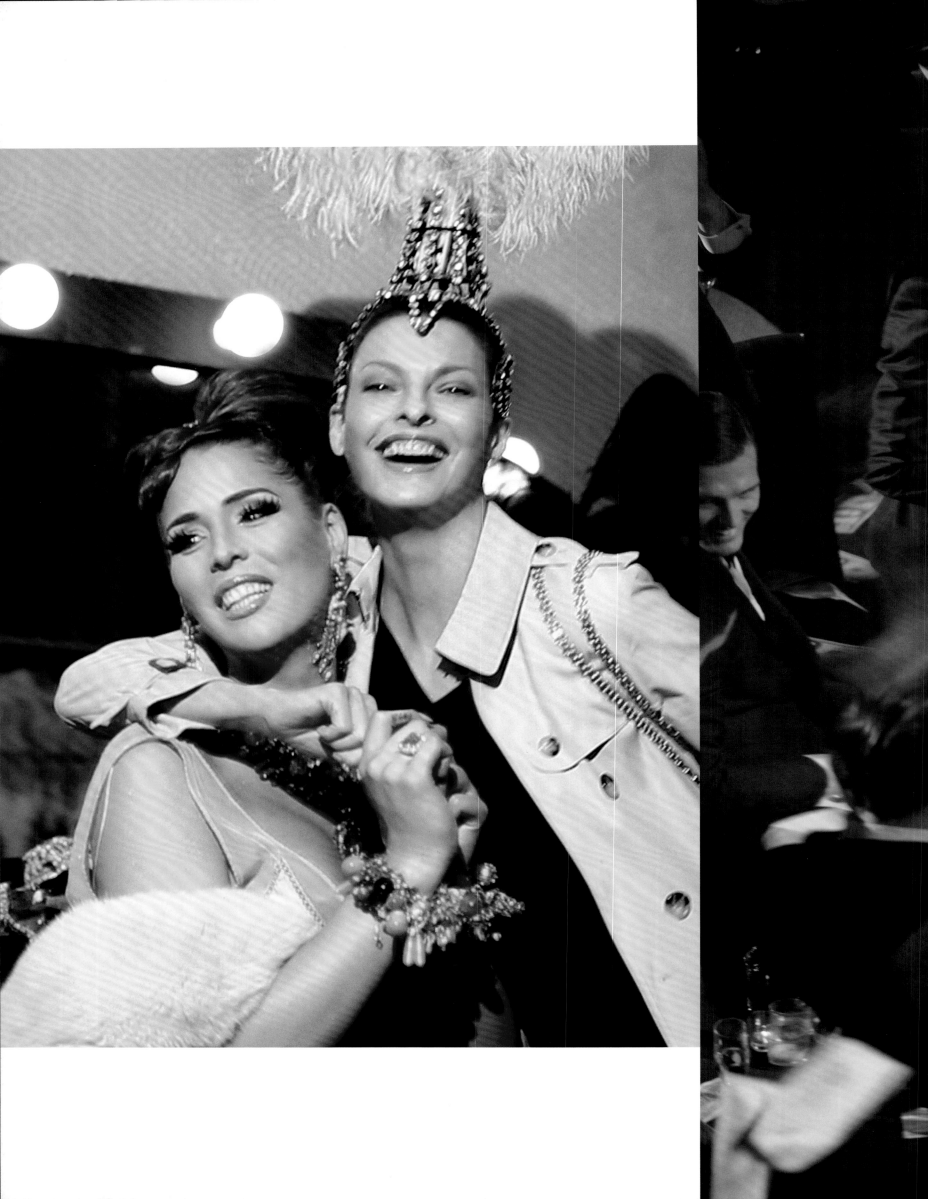

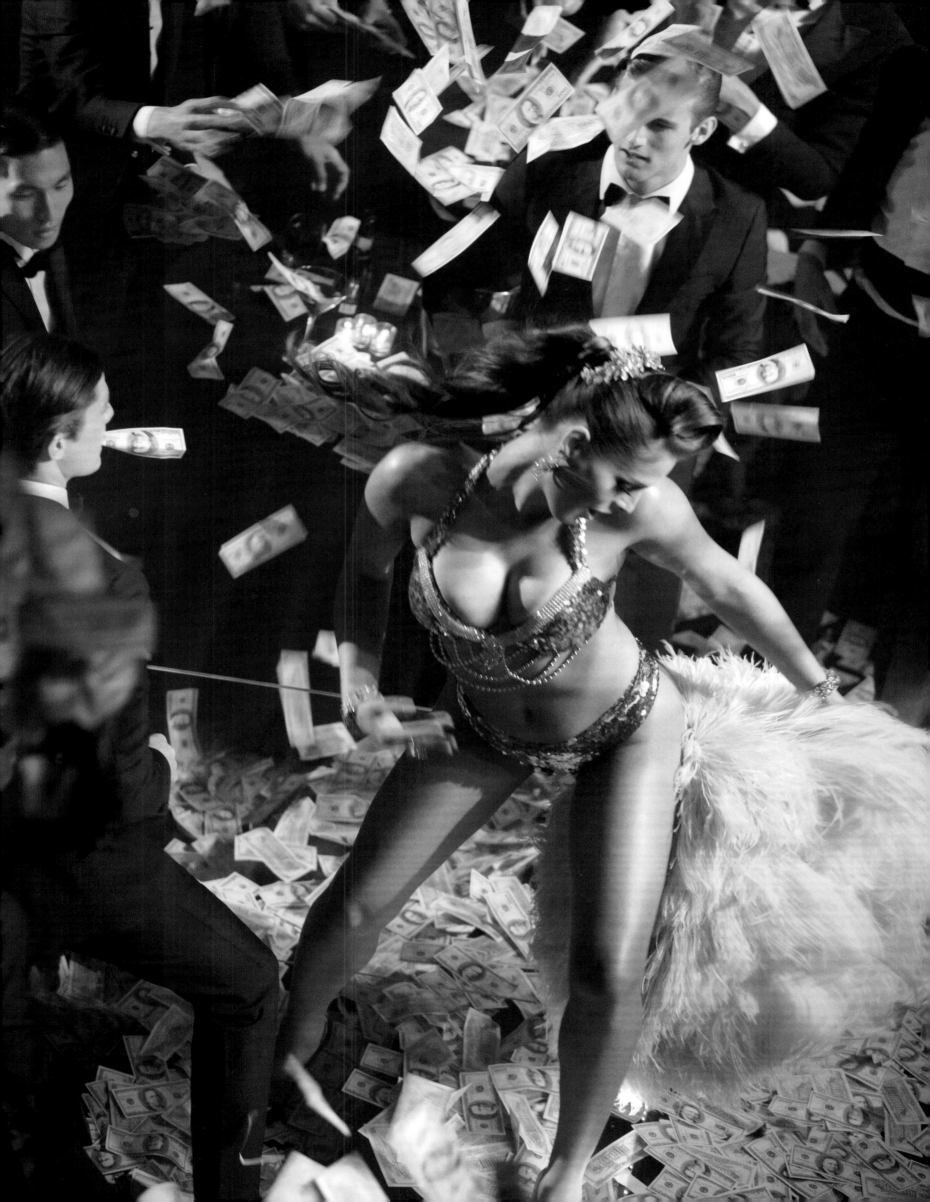

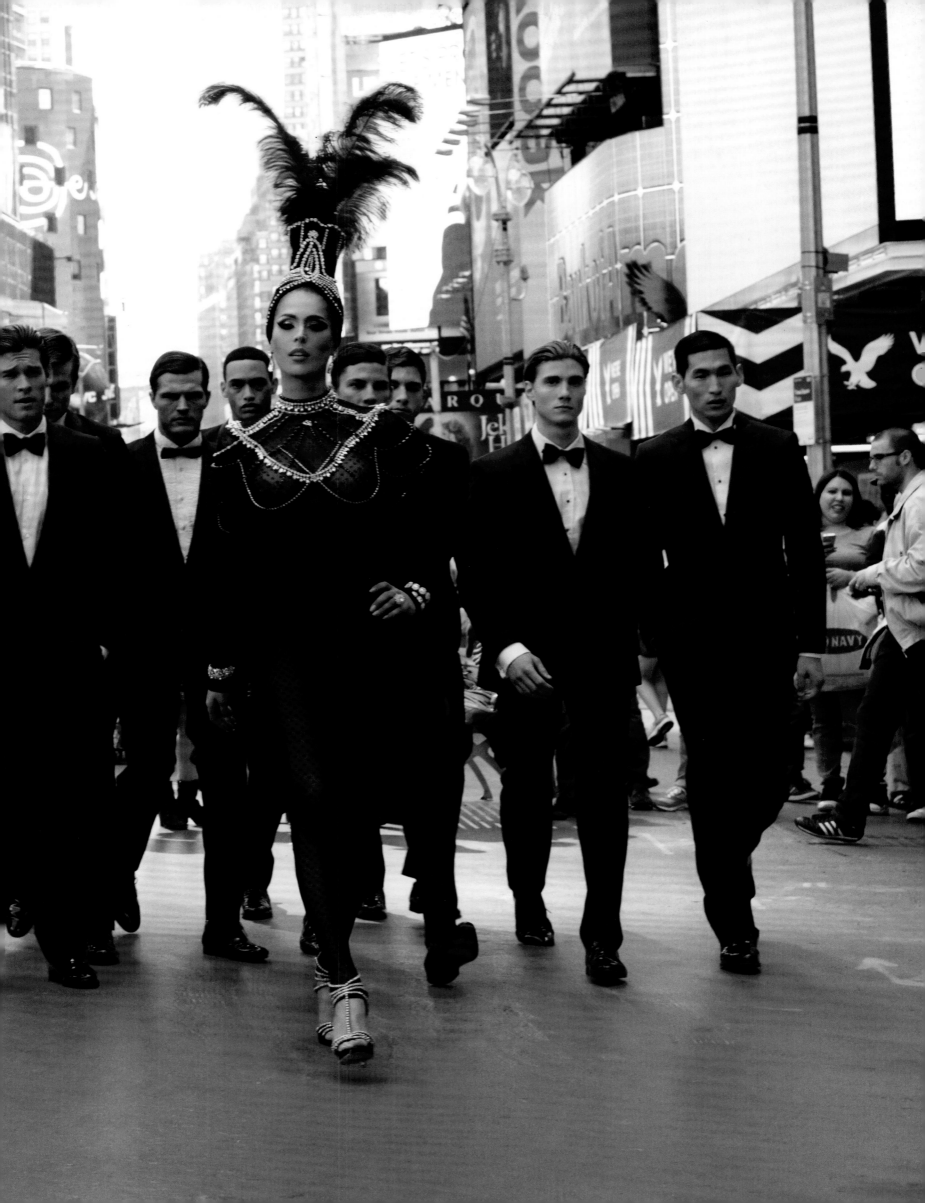

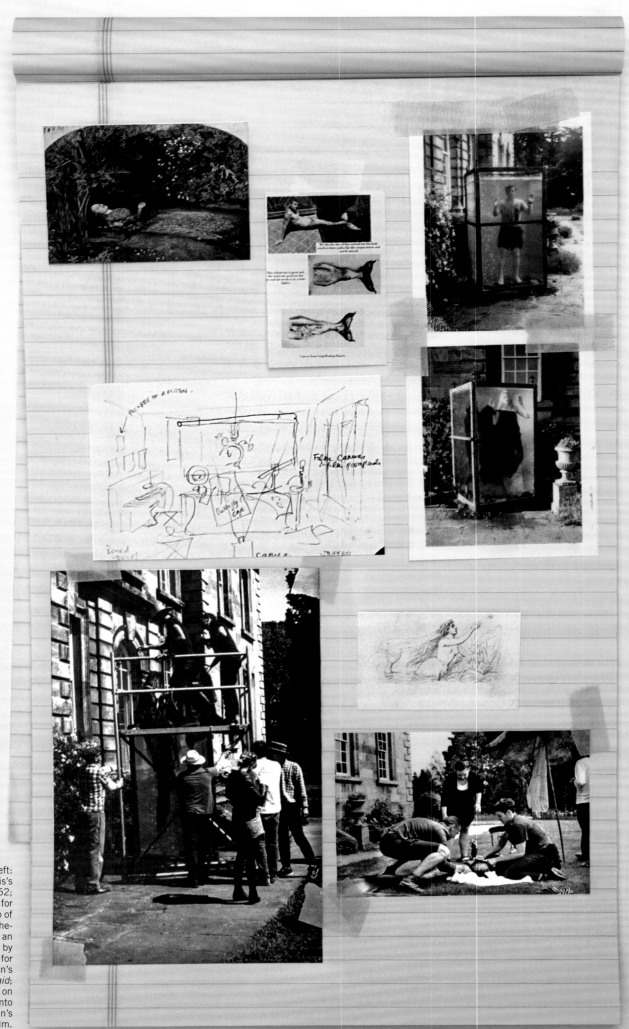

Clockwise, from top left: John Everett Millais's *Ophelia,* 1851–'52; Simon Costin's notes for the Mertailor; two of Walker's behind-the-scenes Polaroids; an 1849 illustration by Vilhelm Pedersen for Hans Christian Andersen's *The Little Mermaid*; fitting the tail on McMenamy; getting into the tank; Costin's sketches for Walker's film.

FAR, FAR FROM LAND

AFTER A YEAR'S WORTH OF PLANNING, THE PHOTOGRAPHER TIM WALKER BROUGHT HANS CHRISTIAN ANDERSEN'S CLASSIC FAIRY TALE *THE LITTLE MERMAID* TO LIFE.

A couple of years ago, I was shooting a Joan of Arc–inspired story for *W* with the model Kristen McMenamy. We were in Northumberland, England, looking out at the North Sea, and she mentioned that she had always wanted to play a mermaid—she reasoned that she had the hair for it. That's when I started thinking about this shoot. As the idea gained depth and backstory, I became more and more obsessed with it.

I read Hans Christian Andersen's *The Little Mermaid* and was surprised to find how very dark and twisted it is. That led me to Ophelia, the famous character in Shakespeare's *Hamlet*. She is walking through the countryside on a spring day, and in her ecstatic oneness with nature she climbs a tree—the branch breaks, she falls into a river, and floats merrily down it. But with her "clothes spread wide and mermaid-like," she is pulled "from her melodious lay to muddy death." It's such a beautifully written verse that it naturally added more to my story. I looked at paintings of Ophelia, particularly those by Pre-Raphaelites such as Dante Gabriel Rossetti and Edward Burne-Jones. At the Petit Palais in Paris I saw Paul Albert Steck's *Ophelia Drowning* and thought, *That's Kristen. That's what she wants to do.*

Then Jacob K, the stylist, thought it would be interesting to also look at Kristen's life. She's the girlfriend of the art dealer Ivor Braka, and in a way she's the best piece of art he's ever collected. Jacob suggested creating an exhibition cabinet for her, as though she were on display. We enlisted Simon Costin, who was the first set designer with whom I ever collaborated, and he conceived an antique-looking tank. He also found a guy in Florida named Eric Ducharme, aka the Mertailor, who designed a tail for Kristen, made-to-measure to fit her long legs. That took time to develop, because she had to be cast for it, and we didn't want it to look tropical, like most of his work. We wanted something murkier.

So finally Jacob, Kristen, and I went back to Northumberland with the tank and the tail and funneled a whole year of preparation into three intense days. I storyboarded some of the shots, but ultimately it was about Kristen. She looked at all the references we had—paintings, photographs, books—and made her performance contemporary and strong rather than pretty and twee. She portrayed romance, passion, aggression, solitude, loneliness, and desperation, encapsulating everything about Ophelia and *The Little Mermaid*.

Kristen reminded me of Elizabeth Siddal, a muse to the painter Sir John Everett Millais, who would pose as Ophelia in his bathtub. Millais wasn't rich and didn't have gas to heat the tub, so Siddal eventually got very sick with pneumonia. Kristen didn't get ill, but in a way this experience was torture for her. In the pictures you can see that her eyes are bloodshot from being underwater for so long. It's interesting to consider the lengths to which a muse will go in order to help bring a concept to life.

This shoot was definitely very important to me. I'm interested in narrative fashion photography because you can portray a fantasy. As a photographer, you're always trying to do more, to raise the bar, and I feel like with this shoot we pulled off the impossible. I also shot some Super 8 footage of Kristen—breathtaking imagery of her moving underwater—which I later showed to the actor Ben Wishaw. He was mesmerized by it, especially because he was preparing to play Herman Melville in Ron Howard's *Heart of the Sea*, so he was thinking about the ocean, mermaids, and folklore. It led to the idea of making my own 15-minute film. I spent a week totally engrossed in writing the script. The story is based on Kristen's character, and Ben plays a lonely artist who is obsessed with her. It's the 1950s, and he lives in a secluded crumbling mansion. In his studio he compulsively replays the movies he had shot of his love in happier times, but the mermaid is now gone—her tank is empty and full of algae. We are not sure why she left, but we are certain that she is never coming back.

PHOTOGRAPHED BY TIM WALKER
STYLED BY JACOB K
PUBLISHED IN DECEMBER 2013/JANUARY 2014

To view the film inspired by this story, go to www.abramsbooks.com/wstories and enter access code wstories5films

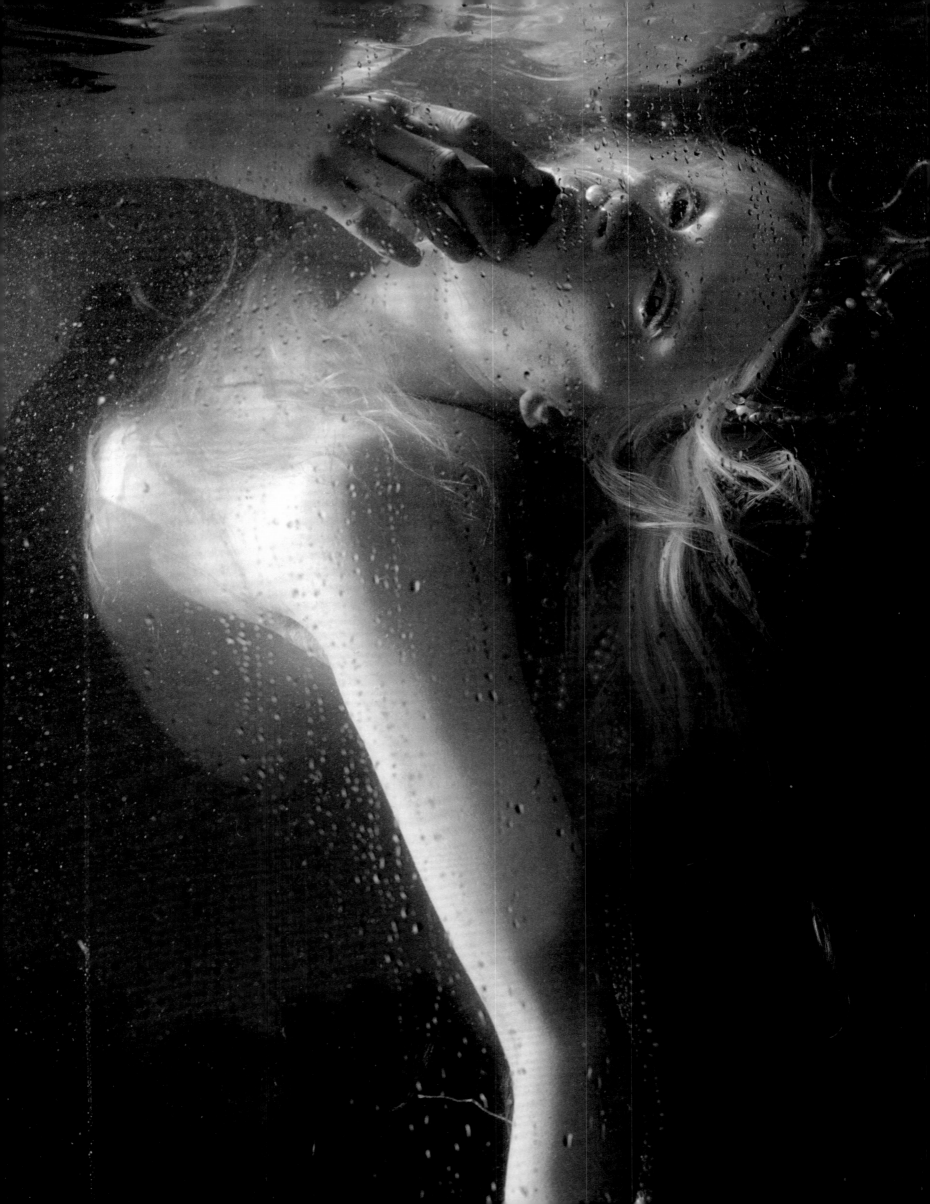

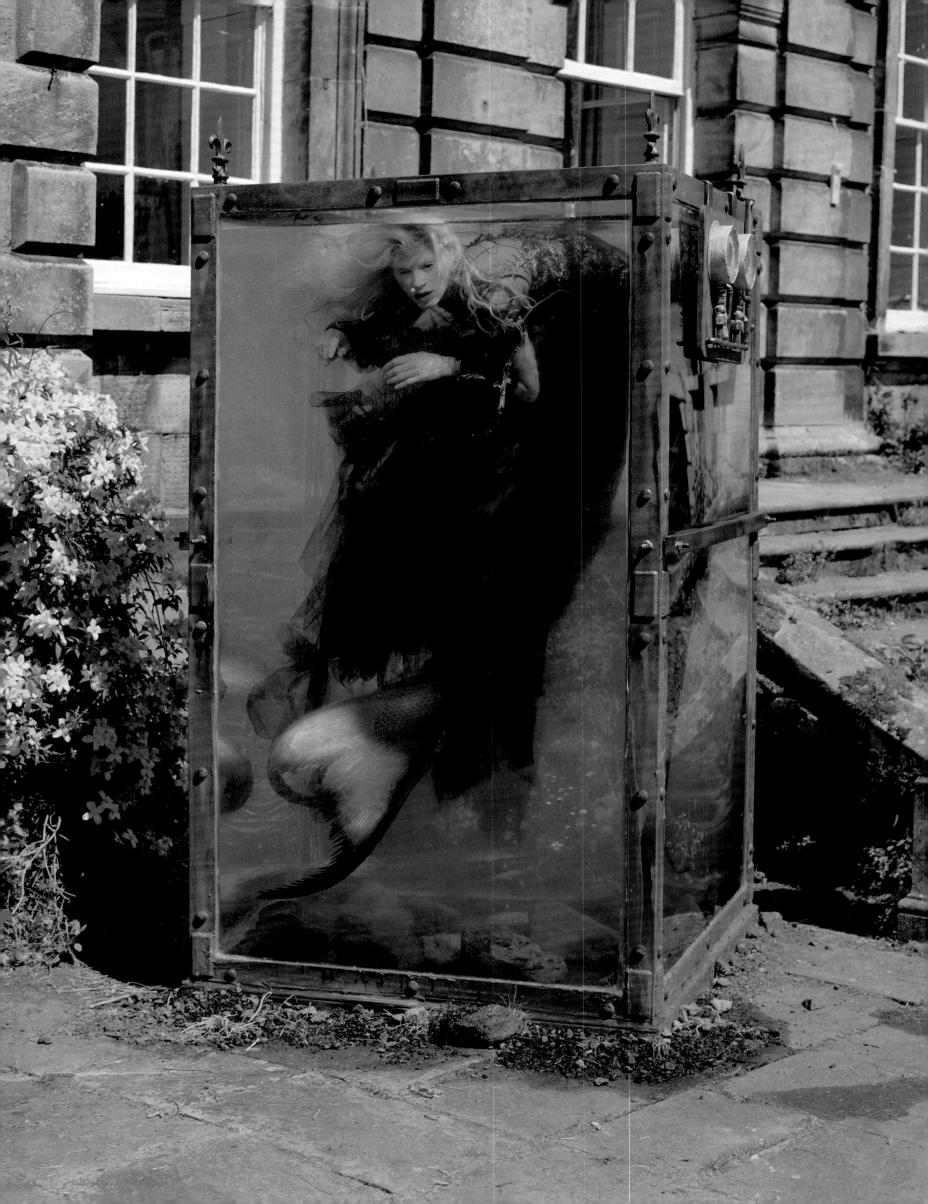

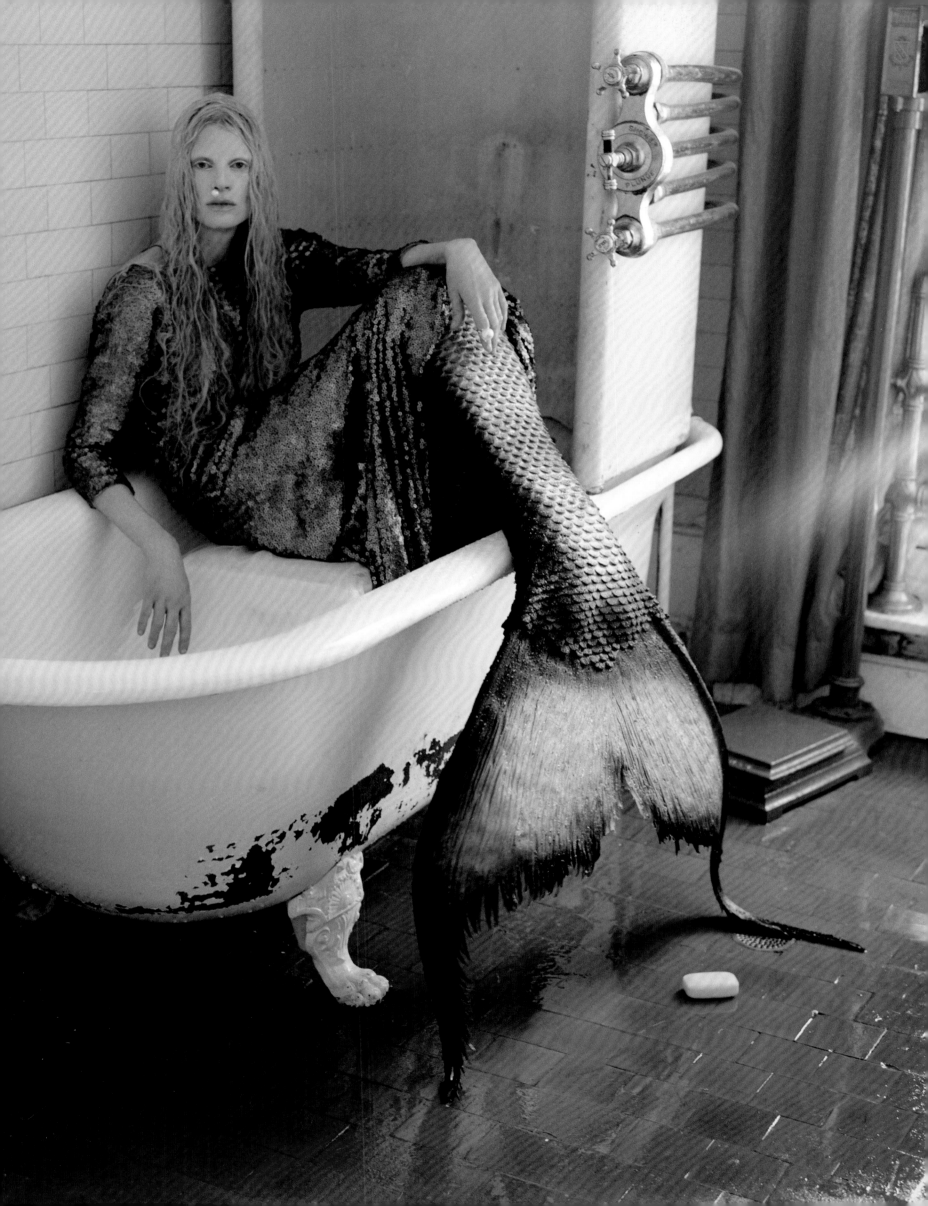

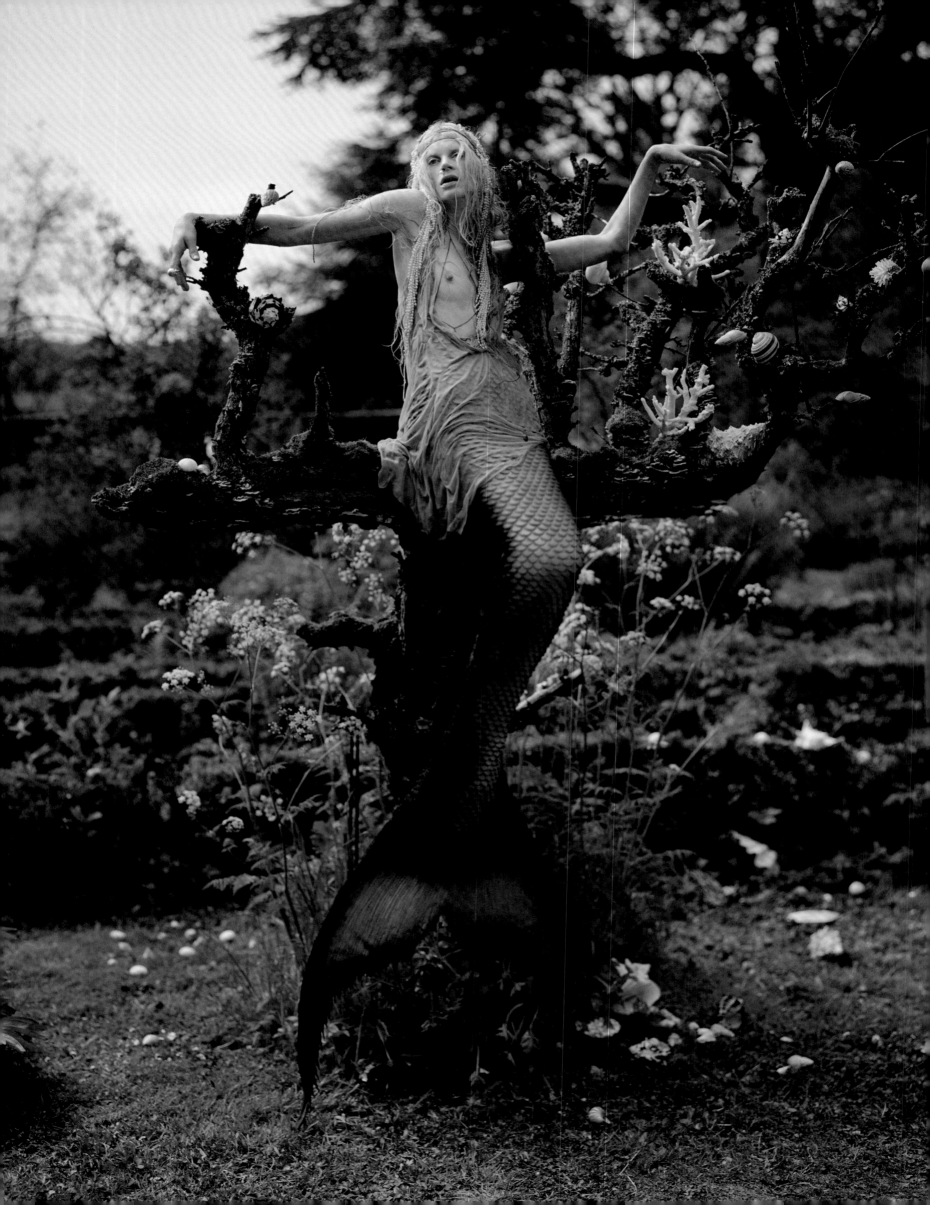

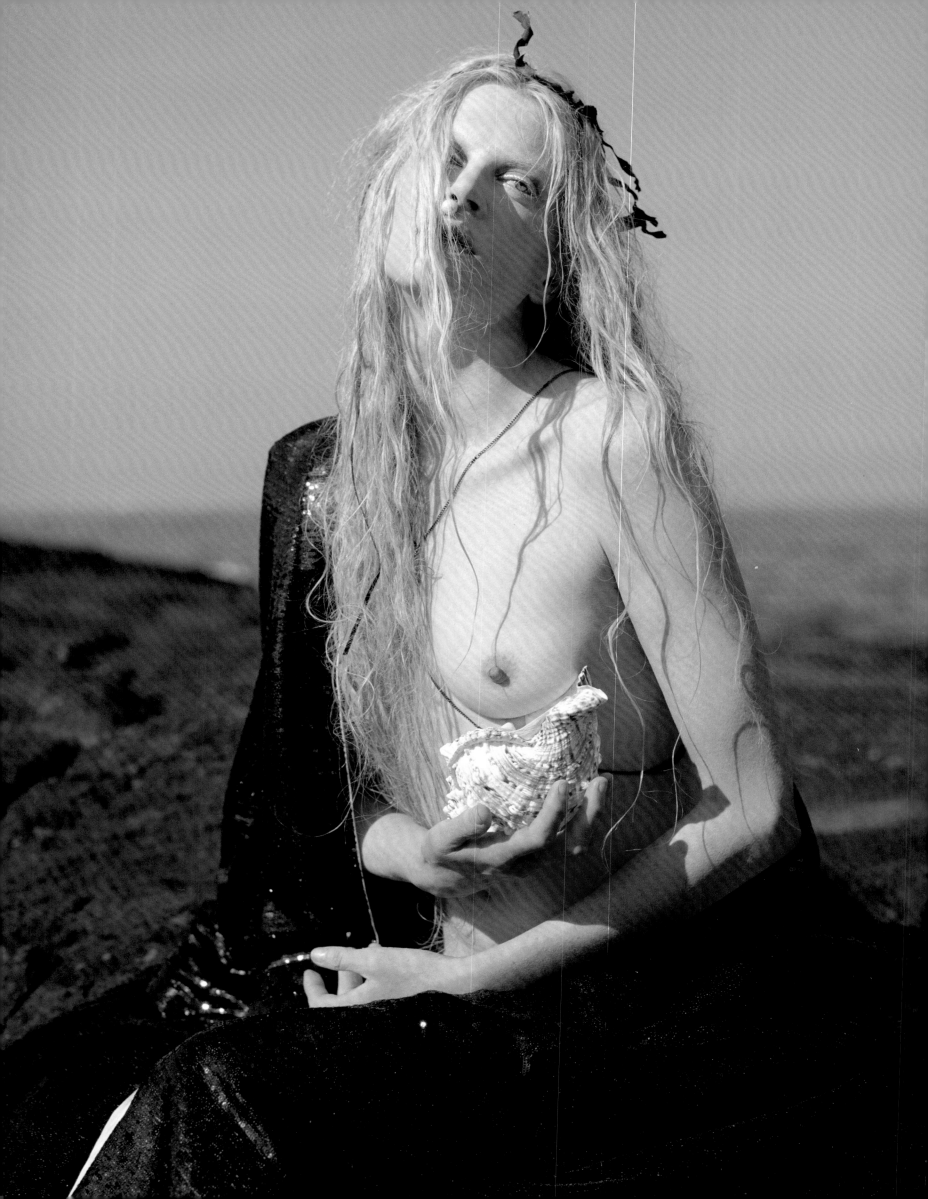

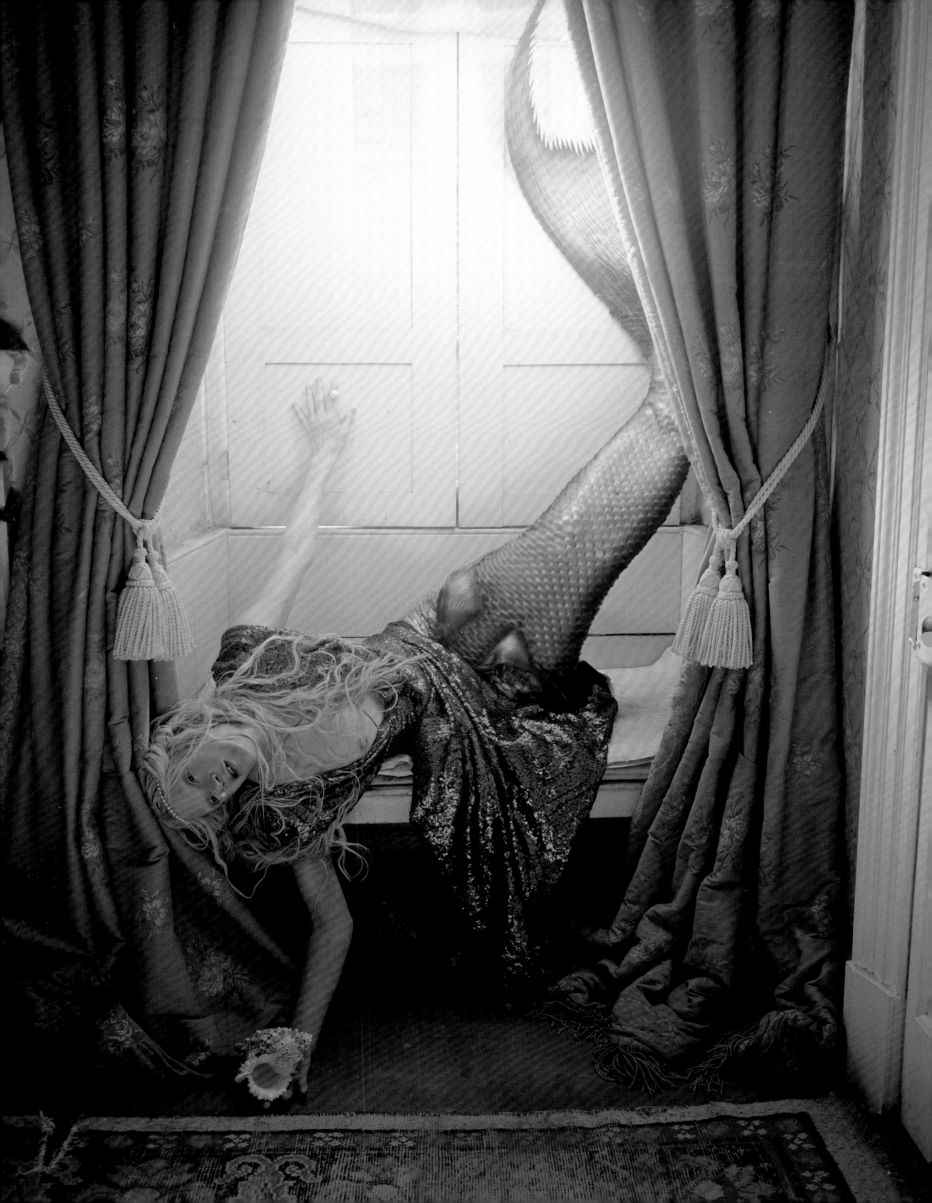

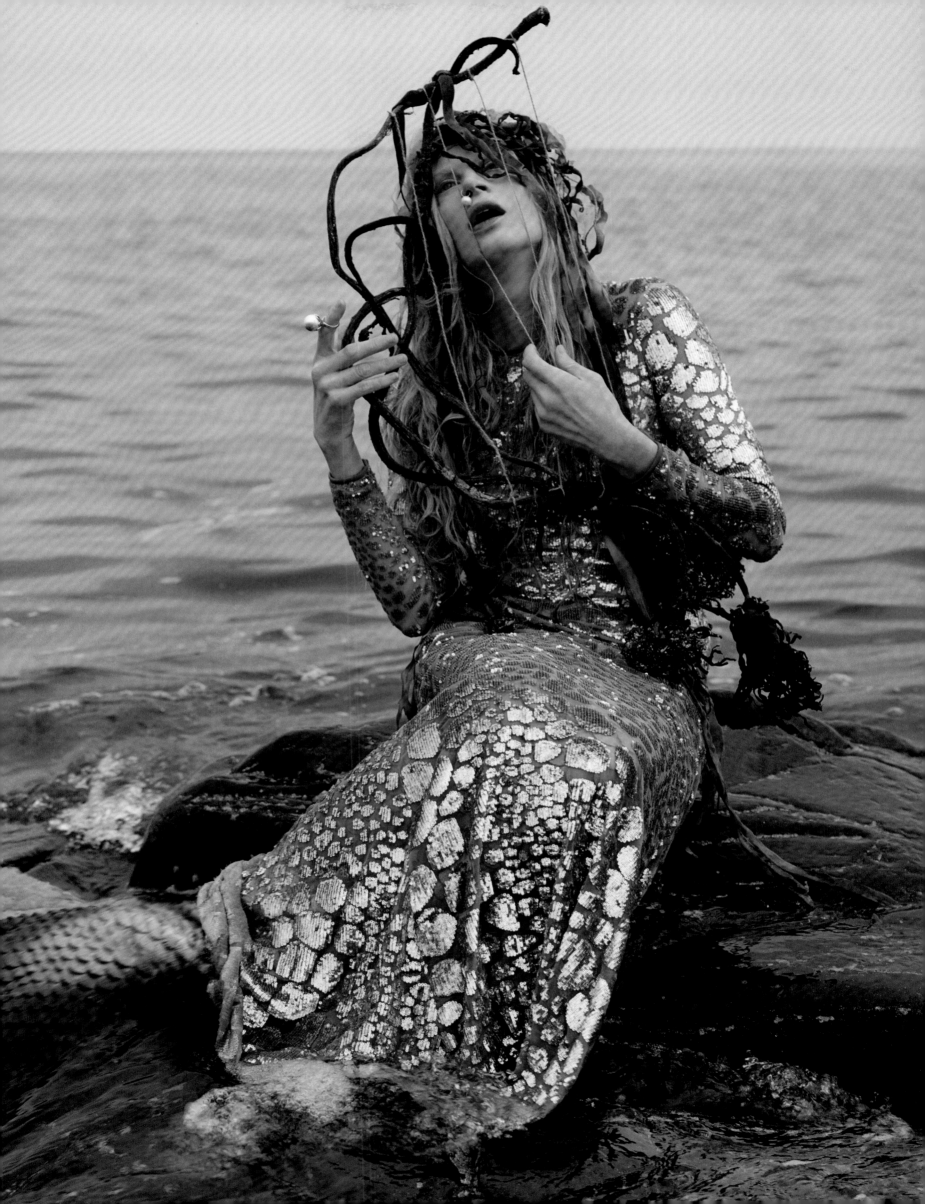

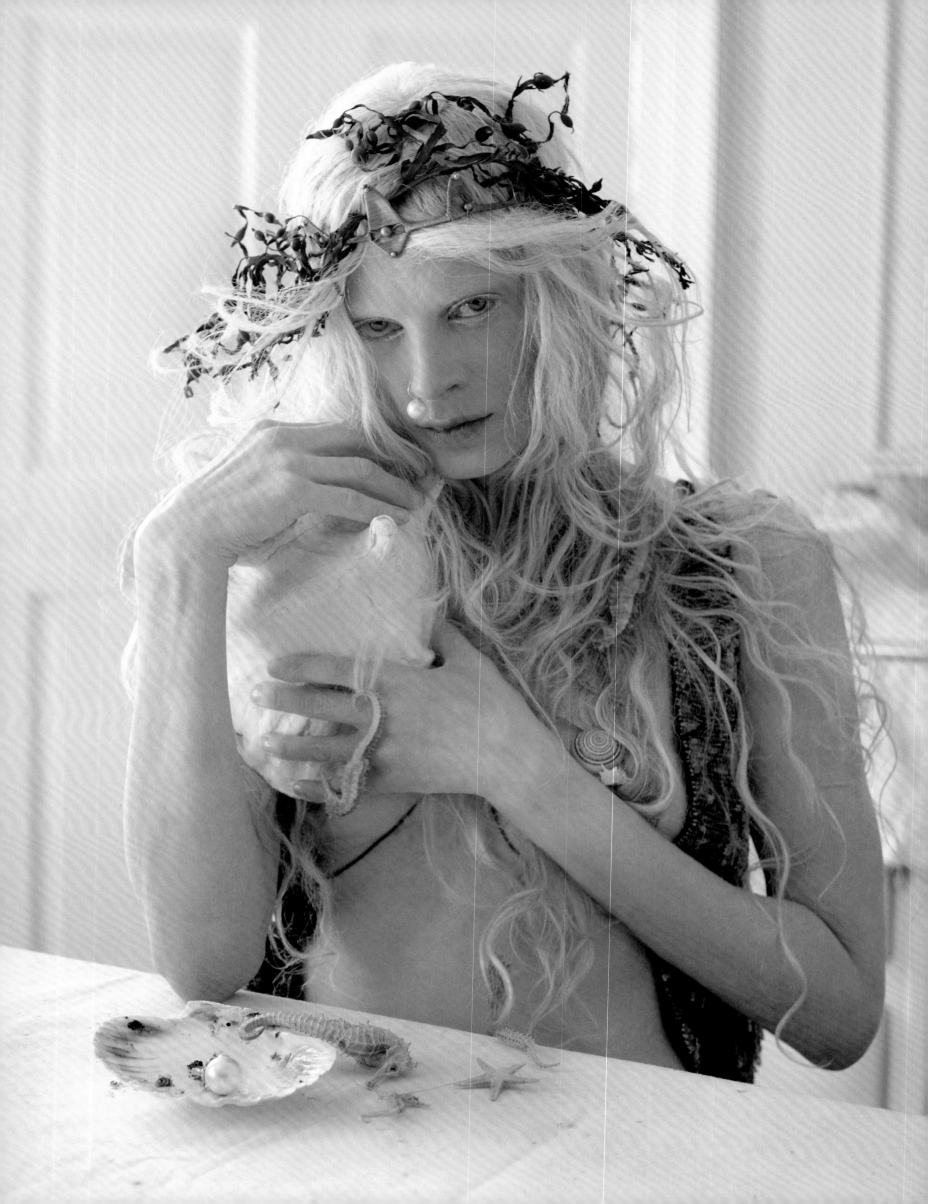

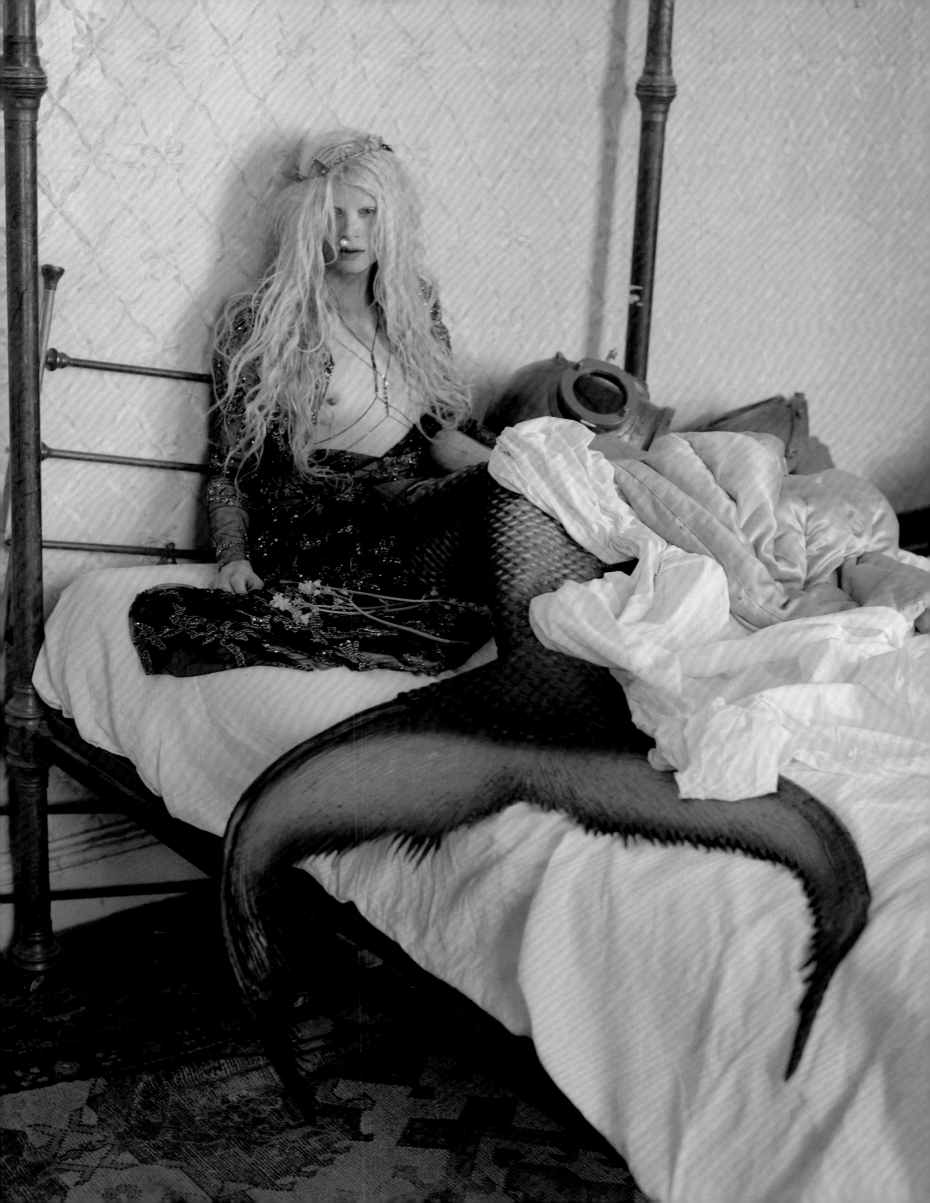

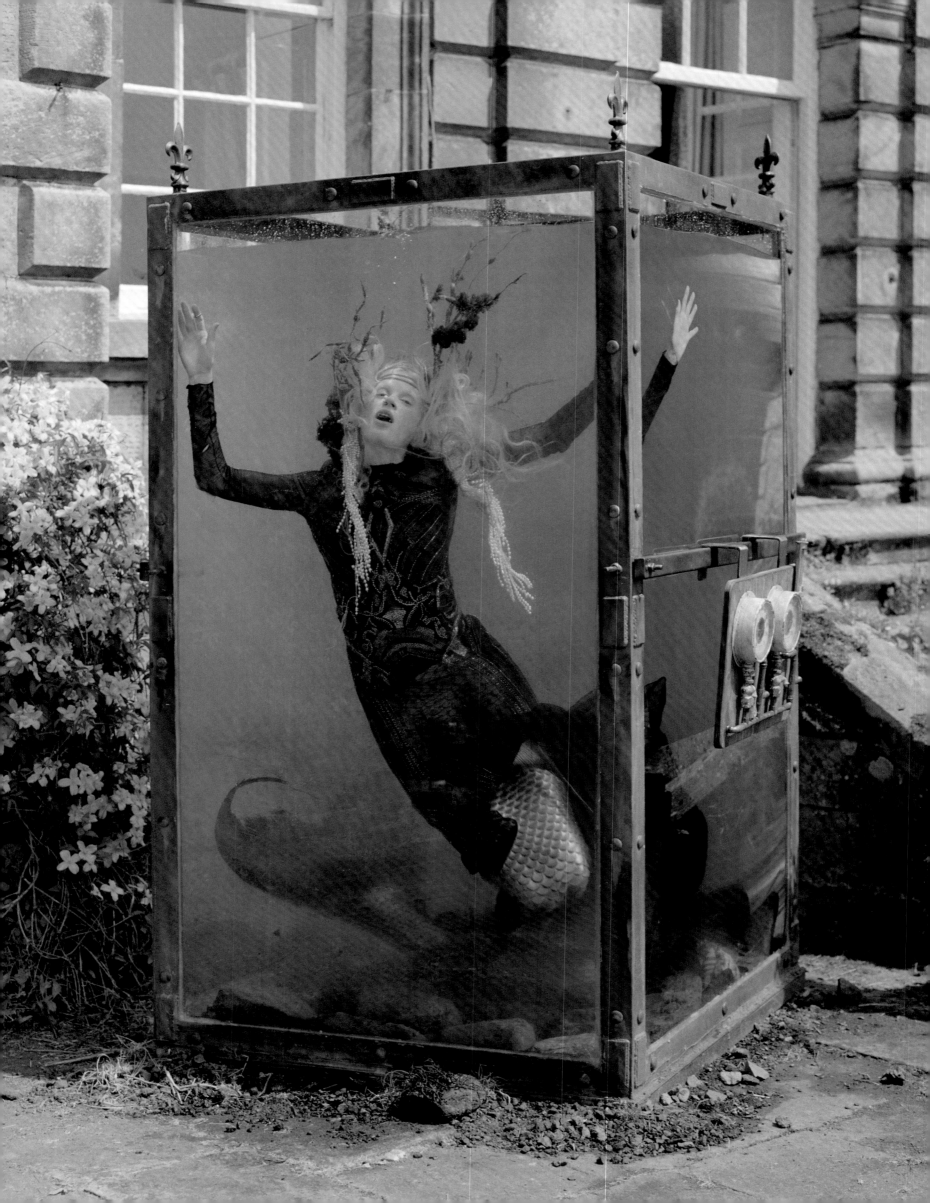

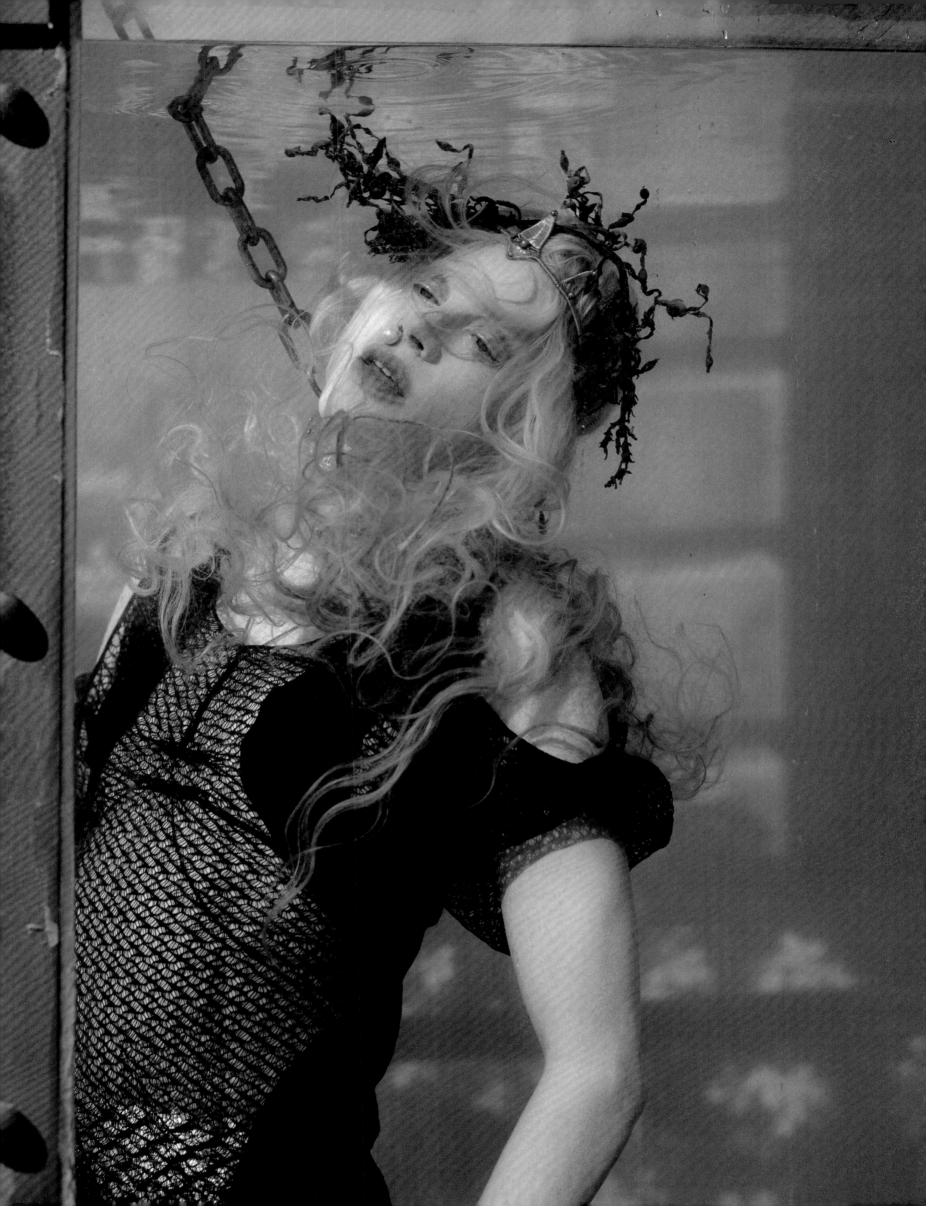

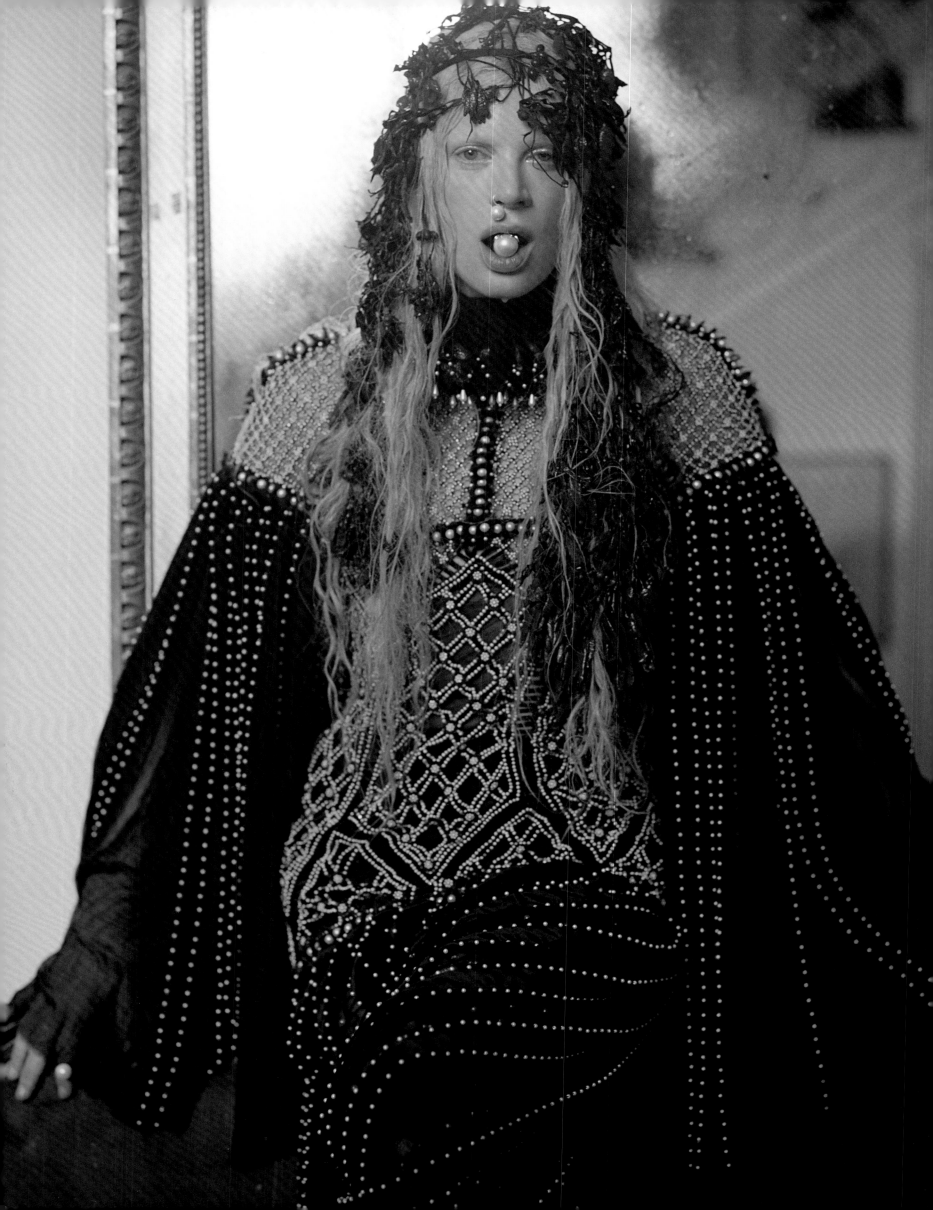

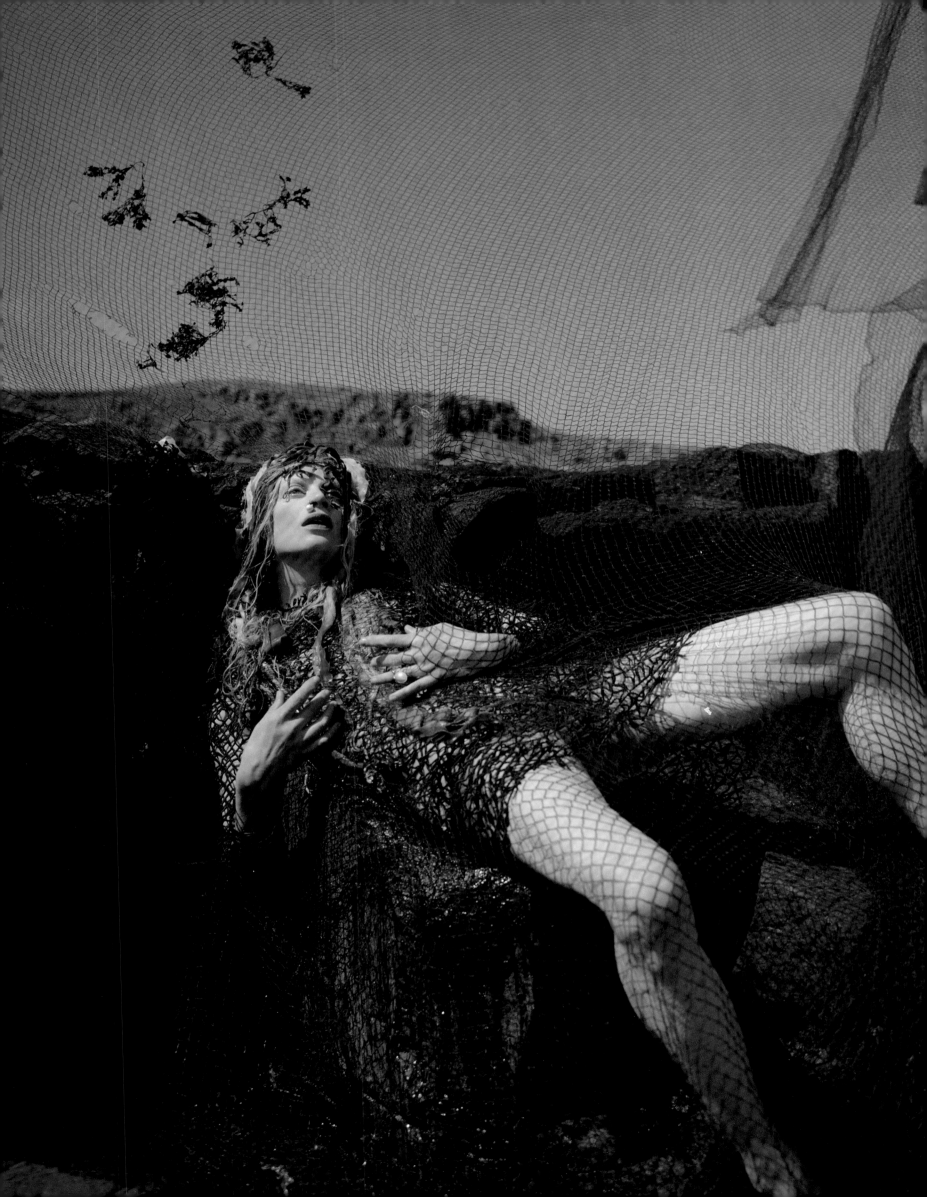

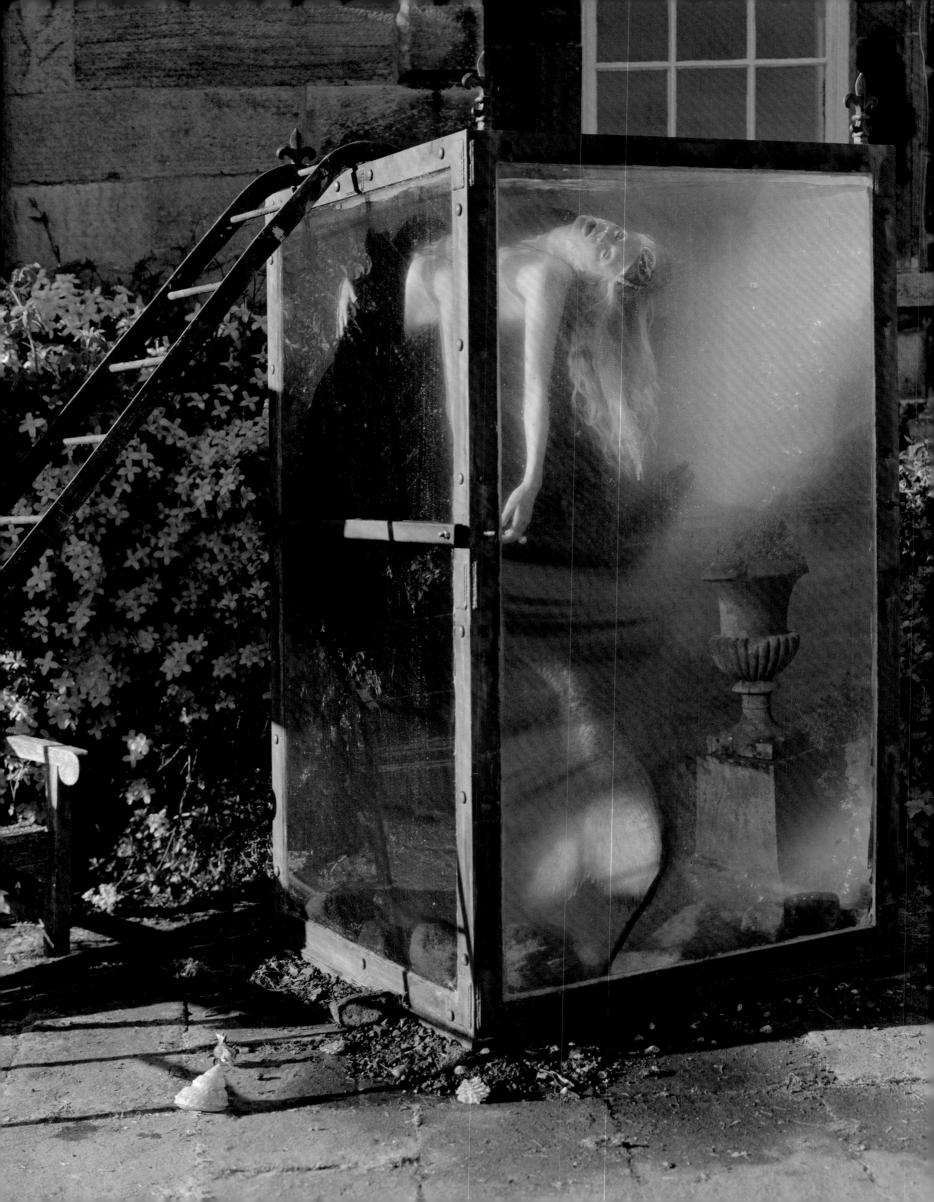

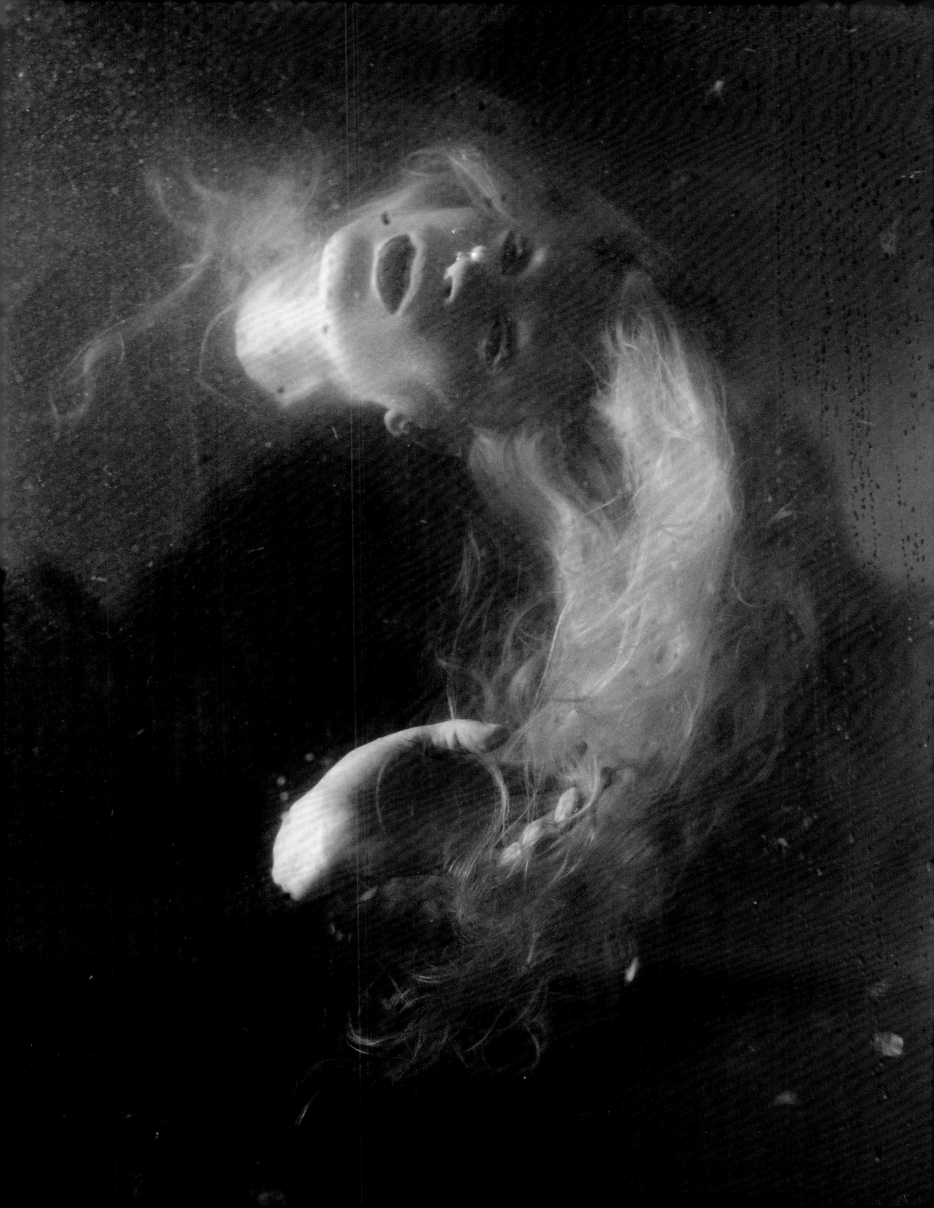

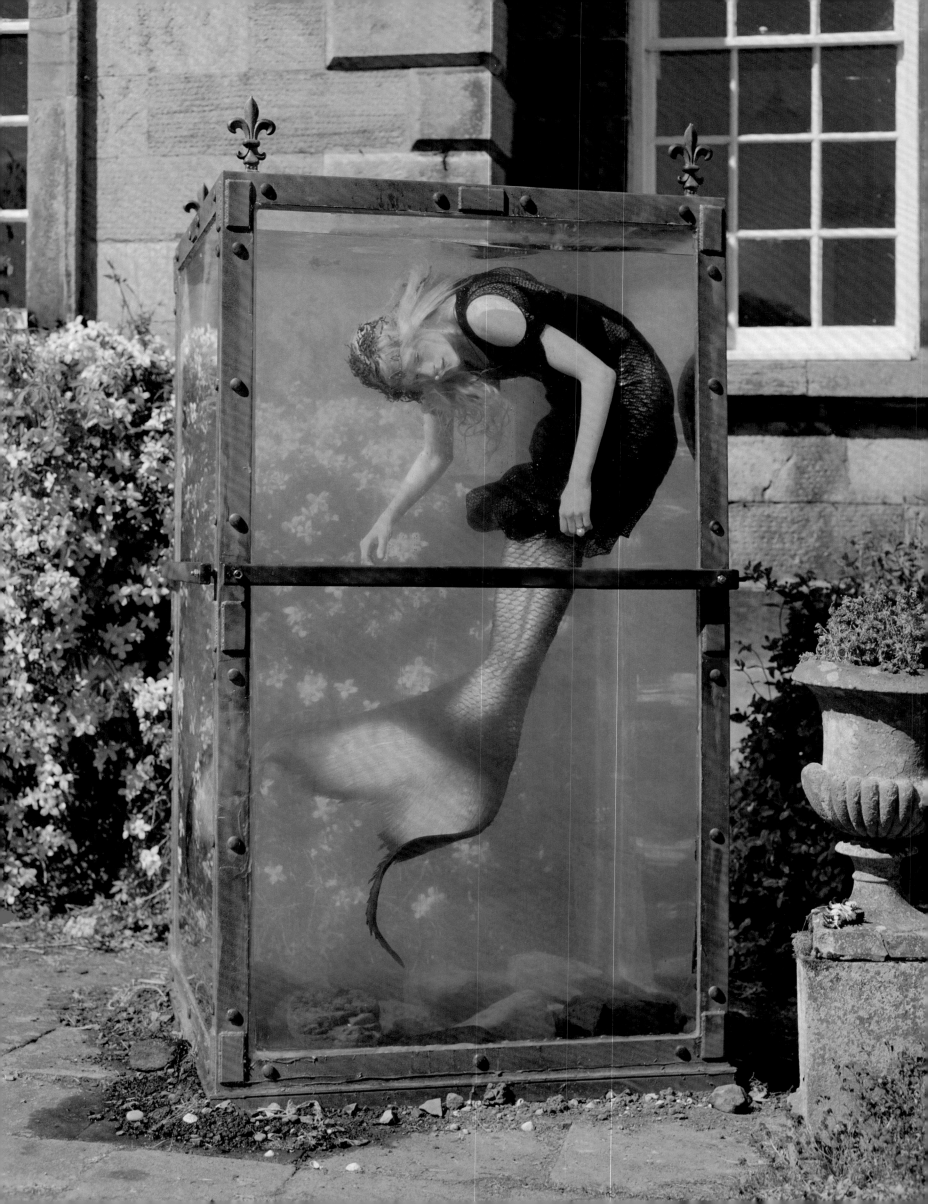

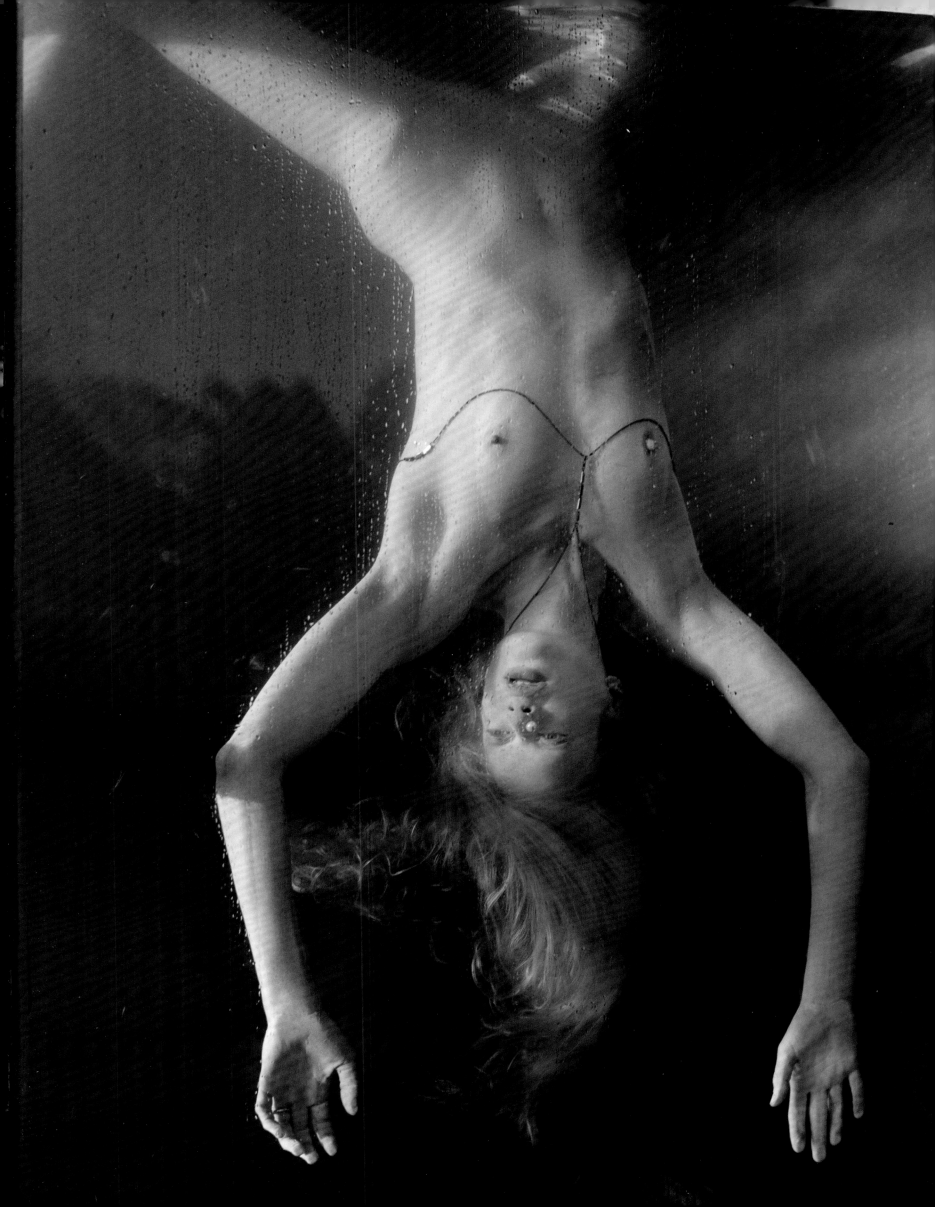

CREDITS

ASEXUAL REVOLUTION
Steven Meisel – October 2004

Photographer: Steven Meisel
Stylist: Alex White
Hairstylist: Guido
Makeup artist: Pat McGrath
Set designer: Jack Flanagan
Production: Stardust Visions LA

Page 12, mood board photograph by Biel Parklee; clockwise from top left: Photo by Michael Putland/Getty Images; © Warner Brothers/Courtesy: Everett Collection; Courtesy: Everett Collection; (2) Photograph by Giovanni Giannoni/CNP Archive; © MGM/Courtesy: Everett Collection.

Pages 14–15: Yves Saint Laurent Rive Gauche jacket, skirt, and shoes. On him: Ellie shoes.
Pages 16–17: From left: Luca Luca dress; Ellie shoes. Giles dress; Louis Vuitton shoes. Valentino dress. Victoria's Secret dress; Ellie shoes.
Pages 18–19: From left: Sonia Rykiel dress. Giorgio Armani dress; Van Cleef & Arpels necklace. Vera Wang dress.
Pages 20–21: Gaultier Paris dress.
Pages 22–23: On her: Yves Saint Laurent Rive Gauche skirt; Valentino Couture shoes. On the men, from left: Palace Costume vintage tap pants. Victoria's Secret garters. All wear Ellie shoes.
Pages 24–25: From left: Sabrina Nadal dress. Dior dress. Azzedine Alaïa shoes.
Pages 26–27: Viktor & Rolf dress.
Pages 28–29: From left: Valentino jacket. La Perla thong; Fendi shoes.
Pages 30–31: From left: Lanvin dress. Dolce & Gabbana shoes. Palace Costume vintage dress. Donna Karan dress; Palace Costume vintage cape. Azzedine Alaïa shoes. Phi dress.
Pages 32–33: Dior dresses.
Pages 34–35: From left: Ralph Lauren Collection dress. Yves Saint Laurent Rive Gauche jacket and skirt.
Pages 36–37: From left: Dior dress; Capezio dance briefs. Anne Valérie Hash Couture dress; Capezio dance briefs. La Perla bra. Dolce & Gabbana dress.
Pages 38–39: On her: Rochas skirt. On the men, from left: Palace Costume vintage tap pants; Agent Provocateur hosiery. Valentino shrug; Lanvin skirt.
Pages 40–41: From left: Calvin Klein dress. Dolce & Gabbana dress.
Pages 42–43: From left: Calvin Klein thong. On him: Vera Wang dress. On her: Ellagem earrings.
Pages 44–45: From left: Marc Jacobs dress. Jean Yu dress.
Pages 46–47: From left: Sabrina Nadal dress. Dior dress.
Pages 48–49: Jean Yu dress; David Yurman necklaces.
Pages 50–51: From left: Sonia Rykiel shrug. Collette Dinnigan vintage tap pants; Louis Vuitton shoes.

ONE FOR THE AGES
Steven Klein – September 2011

Photographer: Steven Klein
Stylist: Edward Enninful
Hairstylist: Luigi Murenu
Makeup artist: Lucia Pieroni
Special effects makeup artist: Dominie Till
Prosthetic-makeup designer: Christien Tinsley
Set designer: Jack Flanagan
Production: Dana Brockman

Page 52, mood board photograph by Biel Parklee; clockwise from top left: Giovanni Giannoni/CNP Archive; Photograph by Getty Images; © Aaron Spelling Prod./Courtesy: Everett Collection; Courtesy: Everett Collection; ABC Photo Archives/ABC via Getty Images; Giovanni Giannoni/CNP Archive; Cecil Beaton/*Vogue* © The Condé Nast Publications Ltd.; Photo by Jeff Kravitz/FilmMagic; © Bettmann/CORBIS.

Pages 54–55: Chanel jumpsuit; Tamsen Z necklace, Stephen Russell necklace; (right wrist, from top) Verdura bracelet, Verdura at F.D. cuff, Stephen Russell bracelet, Fred Leighton bracelet; (left wrist, from top), Ivanka Trump Fine Jewelry cuff, Fred Leighton bracelet, Verdura at F.D. cuff, Stephen Russell bracelet; L'Wren Scott shoes. On men, from left: Dolce & Gabbana suit and shirt. Dior Homme suit; Prada shirt.
Pages 56–57: John Galliano kimono; Stephen Russell bracelet (worn as choker), cuff (on right wrist), and bracelet (on left wrist); Harry Winston ring; John Galliano shoes. On man, standing: Dior Homme suit; Dolce & Gabbana shoes. On man in lampshade reflection: Dolce & Gabbana suit and shirt; Ray-Ban sunglasses; Tom Ford tie.
Pages 58–59: Miu Miu dress; Carolina Amato gloves.
Pages 60–61: Dolce & Gabbana bodysuit, and dress (on chair); Verdura ear clips; Mikimoto necklace; LaCrasia Gloves gloves; Falke hosiery; Manolo Blahnik shoes. On men, from left: Dior Homme suit; Prada shirt; Ray-Ban sunglasses; Dolce & Gabbana tie and shoes. Dolce & Gabbana suit, shirt, and shoes; Ray-Ban sunglasses; Tom Ford tie.
Pages 62–63: Prada dress; Imposter Fur coat (on chair); Vintage Lynn Ban earrings; Le69 by Paco Rabanne bag. On him: Dolce & Gabbana suit and shirt.
Pages 64–65: Gucci jacket, shirt, gaucho pants, hat, and boots; Jennifer Fisher earrings; Fred Leighton necklace; Bulgari necklace; John Hardy ring. On men, from left: Dolce & Gabbana suit, shirt, and shoes. Dior Homme suit; Prada shirt.
Pages 66–67: Salvatore Ferragamo coat, bodysuit, and skirt; Vhernier ear clips; Cartier necklace; Carolina Amato gloves. On men, from left: Dior Homme suit; Prada shirt; Dolce & Gabbana tie. Dolce & Gabbana suit and shirt; Tom Ford tie.
Pages 68–69: Tom Ford tuxedo, blouse, and jacket (on bed); Tia Mazza veil; Loree Rodkin ring; Christian Louboutin shoes. On him: Dolce & Gabbana suit, shirt, and shoes; Tom Ford tie. (On bed, from left) Prada suitcase; Louis Vuitton suitcase and bag.
Pages 70–71: Givenchy by Riccardo Tisci jacket, shirt, and glasses; Vintage Lynn Ban earrings. On him: Dolce & Gabbana suit and shirt; Tom Ford tie.
Pages 72–73: Alexander McQueen dress and harness. On men, from left: Dolce & Gabbana suit, shirt, and shoes; Ray-Ban sunglasses; Tom Ford tie. Dior Homme suit; Prada's shirt; Ray-Ban sunglasses; Dolce & Gabbana tie.

PLANET TILDA
Tim Walker – August 2011

Photographer: Tim Walker
Stylist: Jacob K
Hairstylist: Malcolm Edwards
Makeup artist: Sam Bryant
Creative director: Jerry Stafford
Production: Bryn Birgisdottir

Page 74, mood board photograph by Biel Parklee; clockwise from top left: Polaroids: Courtesy of Tim Walker; Photograph by Mary Evans/SVENSK FILMINDUSTRI/Ronald Grant/Courtesy: Everett Collection; Jersey Heritage Collections.

Page 76: Blumarine coat and dress; Stella McCartney turtleneck; Tommy Hilfiger pants; J.W. Anderson skirt; Patricia Underwood for Chris Benz hat; Comme des Garçons belt; Maison Martin Margiela gloves; Rick Owens boots.
Page 77: Céline turtleneck.
Page 79: Acne jacket; Akris dress; Tommy Hilfiger pants; LaCrasia Gloves gloves.
Page 80: Yves Saint Laurent sweater and blouse; Sermoneta Gloves gloves.
Page 81: Salvatore Ferragamo jacket and blouse; Acne pants and belt; Patricia Underwood for Chris Benz hat; Sermoneta Gloves gloves.
Page 82: Chloé jacket; Maison Martin Margiela dress; Jil Sander turtleneck; Maison Martin Margiela gloves; Rick Owens boots.
Page 83: Zero + Maria Cornejo coat; Hugo Boss turtleneck; John Rocha pants; Gucci dress; Eres cap; Rick Owens boots.
Page 84: Comme des Garçons jacket; Hugo Boss shirt; Acne skirt; Sermoneta Gloves gloves; Agent Provocateur hosiery; Givenchy by Riccardo Tisci shoes.
Page 85: Giorgio Armani jacket; Sermoneta Gloves gloves.
Page 86: VPL coat and dress; National Theatre Costume Hire bodysuit; Maison Martin Margiela boots.
Page 87: Chanel jumpsuit; Hussein Chalayan tunic; Rick Owens boots.
Page 88: Hermès dress; Stephen Jones cap; Hermès gloves; Rick Owens boots.
Page 89: Hermès dress; Stephen Jones cap.
Page 90: Haider Ackermann caftan and pants; Ralph Lauren Black Label sweater; Haider Ackermann belt; Burberry shoes.
Page 91: Stella McCartney jacket, blouse, and pants; National Theatre Costume Hire bodysuit; Sermoneta Gloves gloves.

LAST EXIT TO BROOKLYN
Mert & Marcus – September 2010

Photographers: Mert Alas & Marcus Piggott
Stylist: Alex White
Hairstylist: Paul Hanlon
Makeup artist: Lucia Pieroni
Set designer: Gerard Santos
Production: Larry McCrudden
Special Thanks to Tree

Page 92, mood board photograph by Biel
Parklee; paintings: *Early Sunday Morning*,
1930 (oil on canvas) by Edward Hopper,
(1882–1967) / Whitney Museum of
American Art, New York, USA/ Superstock /
The Bridgeman Art Library; Photographs by
Biel Parklee; Photograph by Jennifer S.
Altman/Contour by Getty Images; Digital
Image © The Museum of Modern Art/
Licensed by SCALA / Art Resource, NY.

Pages 94–95: Prada dress; J. Crew shirt; Two
Starboard necklace.
Pages 96–97: Louis Vuitton jacket and skirt;
Nina Ricci bustier; Calvin Klein tank top; Two
Starboard necklace; Marc Jacobs
sunglasses; Louis Vuitton bag.
Pages 98–99: Dolce & Gabbana jacket and
bodysuit; Marc Jacobs skirt and socks; Louis
Vuitton shoes.
Pages 100–101: Marc Jacobs socks; Louis
Vuitton shoes.
Pages 102–103: Missoni coat; Dries Van
Noten dress; Secrets in Lace bra; Céline bag.
Pages 104–105: Oscar de la Renta coat and
skirt; Louis Vuitton sunglasses; Chanel
gloves; Miu Miu socks.
Pages 106–107: Marc Jacobs coat; Yves
Saint Laurent blouse.
Pages 108–109: Junya Watanabe coat; Marc
Jacobs vest and skirt; Band of Outsiders
shirt; Nina Ricci belt; Ralph Lauren bag.

CARNEVALE
Paolo Roversi – March 2002

Photographer: Paolo Roversi
Stylist: Alex White
Hairstylist: Recine
Makeup artist: Lucia Pieroni
Set designer: Jean-Hugues de Chatillon
Production: Shaheen Knox
While on location, the cast and crew stayed
at Hotel des Palmes, Palermo, Italy.

Page 110, mood board photograph by Biel
Parklee; outtakes: Courtesy of Paolo Roversi;
circus photographs: Courtesy of Zoppé
Family Circus

Page 113: Chloé top; Michael and Hushi
gloves; hat from Gallery of Antique Costume
and Texiles, London; fan from Kitsch,
Barcelona.
Page 114: Christian Lacroix jacket and skirt;
Herbert Johnson hat; cap and flower pin
from Chelsea Lace, London.
Page 115: Alberta Ferretti jacket; Freed of
London leotard; Viktor & Rolf chains;
Stephen Jones hat; Sheila Cook gloves;
Wolford hosiery; Dolce & Gabbana shoes.
Page 116: Chanel jumpsuit; bracelets,
headpiece, fan, and shoes from Angels &
Bermans, London.
Page 117: Donna Karan dress; Michael and
Hushi necklace (worn as headpiece).
Page 119: Valentino bustier, shawl, and
pants; Lola flower pins; Virginia's gloves; fan
from El Ingenio, Barcelona; Agent
Provocateur hosiery; Christian Louboutin
shoes.
Page 120: Prada top and shorts; Fogal
hosiery; Chloé hat.
Page 121: Ralph Lauren poncho; Michael
and Hushi bracelets.
Page 122: Burberry Prorsum jacket and
miniskirt; El Ingenio suspenders and hat.
Page 123: Gucci dress and jacket; Swaine
Adeney Brigg hat; Steinberg & Tolkien flower
pins; Sheila Cook scarf; Erickson Beamon
earrings.
Page 124: Alexander McQueen jacket and
skirt; Virgina's gloves; El Ingenio hat;
Alexander McQueen hosiery; Christian
Louboutin shoes.
Page 125: Jean Paul Gaultier dress; Cozmo
Jenks hat; gloves from Gallery of Antique
Costume and Textiles; Sheila Cook brooch;
Fogal hosiery.
Page 126: Versace top and skirt; Michael
and Hushi headpiece and earring; Steinberg
& Tolkien scarf; Virginia's belt; Fogal hosiery.
Page 127: D&G jacket and skirt; Freed of
London leotard; Stephen Jones hat; Basia
Zarzycka brooch; Gerbe hosiery; Dolce &
Gabbana shoes.

BEAT DWELLERS
Craig McDean – September 1995

Photographer: Craig McDean
Stylist: Alex White
Hairstylist: Eugene Souleiman
Makeup artist: Pat McGrath
Photographed in San Francisco, where the
crew stayed at the Fairmont Hotel

Page 128, mood board photograph by Biel
Parklee; outtakes: courtesy of Craig McDean;
photo by Fred W. McDarrah/Getty Images; ©
Allen Ginsberg/CORBIS

Pages 130–131: Anna Molinari sweater.
Pages 132–133: Marc Jacobs cardigan and
trousers.
Pages 134–135: Ann Demeulemeester
shirtdress and tie.
Page 136: Gucci blouses, pants, and shoes;
Alice in Wonderland bangles.
Page 137: Ann Demeulemeester shirtdress,
tie, belt, and pants.
Pages 138–139: Jil Sander sweaters.
Pages 140–141: Richard Tyler shirts; Alice in
Wonderland bangle.
Pages 142–143: Victor Alfaro turtleneck.
Pages 146–147: Dolce & Gabbana shirt; Max
Mara pants. Dolce & Gabbana shirt and
pants.
Pages 148–149: Jil Sander sweaters.
Pages 150–151: Max Mara sweater.

GOOD KATE, BAD KATE
Steven Klein – March 2012

Photographer: Steven Klein
Stylist: Edward Enninful
Hairstylist: Paul Hanlon
Makeup artist: Val Garland
Set designer: Jack Flanagan
Production: Nina Qayyum

Page 152, mood board photograph by Biel Parklee

Page 152, left board, clockwise from top left: *The Large Bathers:* Pierre-Auguste Renoir (1884–87), Philadelphia Museum of Art: The Mr. and Mrs. Carroll S. Tyson, Jr., Collection, 1963; Courtesy: Everett Collection; Sofia Sanchez and Mauro Mongiello / Trunk Archive; Photo by: Mary Evans/VIRGIN VISION/Ronald Grant/Everett Collection; Melia Marden, Tivoli, photograph by Annabel Mehran; Photo by Dave Benett/Getty Images; Courtesy: Everett Collection; This image was taken in the same shoot as Gordon Parks's iconic photograph, *American Gothic*. Aug. 1942.

Page 152, right board, clockwise: Photograph by Mike Lawn; Steven Klein (2005) + Art Partner; CSU Archives/Everett Collection; ©IFC/Courtesy Everett Collection; « ESPRIT HAUTE COUTURE », Photographer: ©IanAbela; Courtesy: Everett Collection; Steven Klein (2010) + Art Partner; Courtesy: Everett Collection; Steven Klein (2010) + Art Partner; THE LAST EXORCISM, Ashley Bell, 2010. ©Lionsgate/Courtesy Everett Collection; Steven Klein (2000) + Art Partner; ©Columbia Pictures/Courtesy: Everett Collection; Courtesy: Everett Collection; ©Miramax/courtesy Everett Collection; Courtesy: Everett Collection

Page 154: Vera Wang dress; Erdem habit; lace from Early Halloween, NYC.
Page 155: Gucci dress; Freire flower.
Page 157: The Row caftan; VBH Luxury necklace; Lorraine Schwartz ring; Carolina Amato gloves.
Page 158: Max Mara jacket and skirt; Pam Hogg headpiece; Shaneen Huxham gloves; Miu Miu shoes.
Page 159: Comme des Garçons dress; Paul Hanlon headpiece.
Page 160: Oscar de la Renta top and skirt; Ashley Lloyd headpiece; Stephen Jones for Giles headpiece.
Page 161: Atsuko Kudo dress and habit; House of Harlot briefs and hosiery; Balenciaga by Nicolas Ghesquière hat; Céline shoes.
Pages 162–163: Céline top; Lanvin skirt; Piers Atkinson headpiece; Céline belt; Shaneen Huxham gloves; Alexander McQueen shoes.
Page 164: Rochas bodysuit; Paul Hanlon headpiece; Shaneen Huxham gloves; Alexander McQueen hand piece; Céline belt and shoes.
Page 165: Louis Vuitton dress; Paul Hanlon headpiece.
Page 166: Balenciaga by Nicolas Ghesquière dress and hat; I.D. Sarrieri bra and briefs; Shaneen Huxham gloves; Wolford hosiery; Céline shoes.
Page 167: Céline dress; Atsuko Kudo headpiece.
Page 168: Jil Sander dress; Ashley Lloyd headpiece; Cornelia James gloves.
Page 169: Comme des Garçons dress; Cornelia James gloves.

SPELLBOUND
Alex Prager – November 2010

Artist: Alex Prager
Stylist: Carolyn Tate Angel
Background stylist: Callan Stokes
Hairstylist: Anne Morgan
Makeup artist: Nicole Servin
Set designer: Thomas Thurnauer
Production: GE Projects

Page 170, mood board photograph by Biel Parklee; clockwise from top left: Contact sheet and Inspiration sheets: Courtesy of Alex Prager; Stan Douglas' Hastings Park, 16 July 1955, 2008, Digital C-print mounted on Dibond aluminum, 59 1/2 x 88 3/4 inches (151.1 x 225.4 cm), Courtesy the artist and David Zwirner, New York/London; Business Page, 1995, by Larry Sultan from the series "Pictures From Home"; CRA/LA-DLA, Photograph by Frankie Carino; Photograph by Haywood Magee/Picture Post/Getty Images; Photograph by Al Fenn//Time Life Pictures/Getty Images.

Page 172: Dior dress.
Page 173: Missoni coat; Chloé blouse.
Page 174: Balenciaga by Nicolas Ghesquière dress; Hermès scarf.
Page 175: J. Mendel gown.
Pages 176–177: Back row: Marc Jacobs jacket. Middle row: Moschino shirt. Balenciaga by Nicolas Ghesquière jacket; Chloé blouse. Front row: Marc Jacobs jacket; Diane von Furstenberg romper. St. John jacket; Chanel blouse.
Page 178: Louis Vuitton blouse; Emporio Armani skirt. Background: Nicole Miller Collection shirtdress.
Page 179: Valentino blouse.
Page 180: Versace peacoat and shorts; Roberto Cavalli blouse; We Love Colors socks; Marc Jacobs shoes. Background, with newspaper: Fendi trenchcoat.
Page 181: From left: Missoni coat. Dior dress. Escada dress; Prada belt.

EAST OF EDEN
Mert & Marcus – March 2013

Photographers: Mert Alas & Marcus Piggott
Stylist: Edward Enninful
Hairstylists: Malcolm Edwards and Odile Gilbert
Makeup artist: Lucia Pieroni
Set designer: Poppy Bartlett
Production: Lalaland

Page 182, mood board photograph by Biel Parklee; Nick Knight / Trunk Archive; Malgosia Bela in Yohji Yamamoto Photography Paolo Roversi; Stella Tennant in Yohji Yamamoto Photography David Sims; Paintings by Ling Jian; Photographs by Nobuyoshi Araki

Page 185: Kate Moss wears Prada stole and bra; Philip Treacy headpiece; Kimono House, New York obi.
Page 186: Natalia Vodianova wears Burberry Prorsum coat; Angels the Costumiers obi.
Page 187: Lara Stone wears Saint Laurent by Hedi Slimane dress; Mokuba ribbon; Angels the Costumiers obi.
Pages 188–189: Prada satin stole and bra; Johanna O'Hagan hat; House of Harlot corset and belt.
Page 190: Rick Owens jacket; Kimono De Go by Mamiko wig.
Page 191: Miu Miu coat; We Love Colors fishnet knee-high (worn as headpiece); Kimono De Go by Mamiko obi; Perrin Paris gloves.
Pages 192–193: Prada dress; House of Harlot corset and belt; LaCrasia Gloves gloves.
Page 194: Gucci top; House of Harlot belt.
Page 195: Kimono De Go by Mamiko obi; Etro pants; A.F. Vandevorst hat; Maria Piana ring (worn as a pin); LaCrasia Gloves gloves.
Pages 196–197: Tom Ford harness; John Galliano pants; Kimono De Go by Mamiko wig; House of Harlot corset and belt.
Page 198: A.F. Vandevorst shirtdress and belt; Peter Jensen oversize necklace; Prada socks and shoes.
Page 199: Haider Ackermann top; Kimono De Go by Mamiko kimono (worn as skirt) and obi.
Pages 200–201: House of Harlot corset and belt; Mokuba ribbon.
Page 202: Dior dress.
Page 203: Rick Owens jacket and skirt; We Love Colors fishnet knee-high (worn as headpiece); Prada socks and shoes.
Pages 204–205: Alexander McQueen bustier and caged crinoline; Emilio Pucci kimono.
Page 206: Tom Ford dress; We Love Colors fishnet knee-high (worn as a headpiece); House of Harlot corset and belt; Underground boots.
Page 207: Kimono De Go by Mamiko obi; Balenciaga by Nicolas Ghesquière skirt.
Pages 208–209: Alexander McQueen dress and caged crinoline.

SHOW GIRL
Steven Meisel – September 2013

Photographer: Steven Meisel
Stylist: Edward Enninful
Hairstylist: Oribe
Makeup artist: Pat McGrath
Set designer: Stefan Beckman
Production: Steven Dam

Page 210, mood board photograph by Biel Parklee; clockwise from top left: Courtesy of Prada; Josephine Baker in *Zouzou*: Rue des Archives / The Granger Collection, New York; Courtesy of Steven Meisel; Courtesy of Thakoon; Courtesy of Jason Wu; Courtesy of Proenza Schouler.

Page 212: Roberto Cavalli dress; New York Vintage tiara; House of Lavande earrings; CZ by Kenneth Jay Lane bracelets; Giuseppe Zanotti Design sandals. Male models, from left: Louis Vuitton tuxedo; Thomas Pink shirt. Giorgio Armani tuxedo. Giorgio Armani tuxedo; Thomas Pink shirt. Burberry Prorsum jacket; Dior Homme shirt. Louis Vuitton tuxedo and shirt.
Page 213: Proenza Schouler bustier; Early Halloween, NYC vintage bow tie (in hair); Badgley Mischka earrings; Lynn Ban necklace. Male models, from left: Tom Ford tuxedo; Burberry London shirt; Thomas Pink bow tie. Calvin Klein Collection suit; Giorgio Armani shirt. Louis Vuitton tuxedo; Thomas Pink shirt.
Page 214: Gaultier Paris dress; Lynn Ban earrings.
Page 215: Prada top, bottom, hat, sleeves, and shoes.
Page 216: Agent Provocateur playsuit; Siman Tu headpiece; Fenton earrings; CZ by Kenneth Jay Lane rings and bracelets. Male models, from left: Louis Vuitton tuxedo; Thomas Pink shirt and bow tie. Gucci jacket; Giorgio Armani pants; Thomas Pink shirt and bow tie.
Page 217: Dsquared2 dress; Thorin & Co. for House of Lavande earrings; Lele Sadoughi bracelets; Giuseppe Zanotti Design sandals.
Page 218: Gillian Gardner for Show-Off Las Vegas bra and briefs; Giambattista Valli cape; Siman Tu tiara; Nicole Romano earrings.
Page 219: The Blonds corset; I.D. Sarrieri briefs; Iradj Moini earrings; (from top) Dannijo cuff; R.J. Graziano bracelet; Lynn Ban ring. Male model: Tom Ford tuxedo; Burberry London shirt; Thomas Pink bow tie.
Pages 220–221: Gillian Gardner for Show-Off Las Vegas G-string; Lynn Ban tiara, earrings, and bra (on mirror); Dannijo necklace (in hand); Carrera's own pasties. Male models, from left: Burberry London shirt; Atelier Lorand Lajos mask. Louis Vuitton tuxedo; Thomas Pink shirt and bow tie.
Pages 222–223: Jason Wu bra and skirt; Ranjana Khan earrings. Male models, from left: Louis Vuitton tuxedo; Thomas Pink shirt and bow tie. Burberry Prorsum jacket and trousers; Dior Homme shirt; Tom Ford bow tie.
Page 224: Louis Vuitton playsuit; Thorin & Co. for House of Lavande earrings and necklace; CZ by Kenneth Jay Lane ring; Pologeorgis fur scarf; Lynn Ban bracelets. On Linda Evangelista: Burberry London trenchcoat; New York Vintage headpiece; her own dress and bag.
Page 225: Gillian Gardner for Show-Off Las

Vegas bra and briefs; Giambattista Valli cape; Siman Tu tiara; Nicole Romano earrings; (right wrist) Lynn Ban bracelet; (left wrist) Bounkit cuff; Christian Louboutin shoes. Male models, clockwise, from bottom left: Tom Ford tuxedo; Burberry London shirt. Louis Vuitton tuxedo and shirt; Burberry London bow tie. Burberry Prorsum jacket and trousers; Thomas Pink shirt. Calvin Klein Collection suit; Giorgio Armani shirt; Thomas Pink bow tie. Louis Vuitton tuxedo; Thomas Pink shirt and bow tie.
Pages 226–227: Thakoon jumpsuit and jeweled body piece; Early Halloween, NYC vintage headpiece; Kenneth Jay Lane earrings; (right wrist) Ben-Amun bracelet; (left wrist) CZ by Kenneth Jay Lane bracelets; CZ by Kenneth Jay Lane ring; Jimmy Choo sandals. Male models, front row, from left: Burberry Prorsum jacket and trousers; Ermenegildo Zegna shirt; Thomas Pink bow tie; Burberry London cummerbund; Salvatore Ferragamo shoes. Louis Vuitton tuxedo; Thomas Pink shirt and bow tie; Burberry London cummerbund; John Lobb shoes. Tom Ford tuxedo; Burberry London shirt; Thomas Pink bow tie; Salvatore Ferragamo shoes. Gucci jacket; Giorgio Armani pants; Thomas Pink shirt; Ralph Lauren Black Label shoes. Calvin Klein Collection suit; Giorgio Armani shirt; Thomas Pink bow tie and cummerbund; Tom Ford shoes. Male models, back row, from left: Giorgio Armani tuxedo; Dior Homme shirt; Bruno Magli shoes. Dior Homme tuxedo; Thomas Pink shirt; Church's shoes. Prada jacket and shirt; Tom Ford pants; Gucci shoes; Louis Vuitton tuxedo and shirt; Burberry London bow tie; John Lobb shoes. Giorgio Armani jacket; Dior Homme pants; Thomas Pink shirt; Gucci shoes. Burberry London tuxedo; Dior Homme shoes. Ralph Lauren Black Label tuxedo; Church's shoes.

FAR, FAR FROM LAND
Tim Walker – December 2013/January 2014

Photographer: Tim Walker
Stylist: Jacob K
Hairstylist: Julien d'Ys
Makeup artist: Stéphane Marais
Set designer: Simon Costin
Production: AND Production
Mermaid tail by the Mertailor Eric Ducharme
Special thanks to April Potts of Eglingham Hall & SFX (GB) Ltd for the tank.
Text adapted from Hans Christian Andersen's *The Little Mermaid*, 1836.

Page 228, mood board photograph by Biel Parklee; clockwise from top left: *Ophelia*, 1851–52, Sir John Everett Millais (1829–1896), ©Tate, London 2014; The tails were created by the Mertailor Eric Ducharme (Mertailor LLC); Polaroids: Courtesy of Tim Walker; Vilhelm Pedersen's illustration: The Hans Christian Andersen Museum; Behind the scenes outtakes: Courtesy of Emma Dalzell; Sketch: Courtesy of Simon Costin.

Pages 230–231: Vionnet dress; Erickson Beamon necklace (worn in hair); Kenneth Jay Lane ring (worn as nose ring).
Page 232: Marchesa gown; Bliss Lau body chain; Kenneth Jay Lane ring (worn as nose ring).
Page 233: Marc Jacobs gown; Armor body chain; Dior ring; Kenneth Jay Lane ring (worn as nose ring).
Page 234: Vera Wang Collection dress; Armor body chain; Dior ring; Kenneth Jay Lane ring (worn as nose ring).
Page 236: Chanel cape; Bliss Lau body chain; Kenneth Jay Lane ring (worn as nose ring).
Page 237: Vivienne Westwood Gold Label dress; Armor body chain; Dior ring; Kenneth Jay Lane ring (worn as nose ring).
Pages 238–239: Michael Kors gown; Dior ring; Kenneth Jay Lane ring (worn as nose ring).
Page 240: Giorgio Armani vest; Bliss Lau body chain; Dior ring (in shell); Kenneth Jay Lane ring (worn as nose ring).
Page 241: Monique Lhuillier gown; (from top) Bliss Lau body chain; Armor body chain; Kenneth Jay Lane ring (worn as nose ring).
Page 242: J. Mendel gown; Dior ring; Kenneth Jay Lane ring (worn as nose ring).
Page 243: Dior dress; Bliss Lau body chain; Kenneth Jay Lane ring (worn as nose ring).
Page 244: Alexander McQueen dress; Dior ring (in mouth); Kenneth Jay Lane rings (on finger and worn as nose ring).
Page 245: Christopher Kane dress; Dior ring; Kenneth Jay Lane ring (worn as nose ring).
Page 246: Ralph Lauren Collection dress; Erickson Beamon necklace (worn in hair); Armor body chain; Dior ring; Kenneth Jay Lane ring (worn as nose ring).
Page 247: Carolina Herrera blouse; Blumarine dress; Kenneth Jay Lane ring (worn as nose ring).
Page 248: Dior dress; Bliss Lau body chain; Kenneth Jay Lane ring (worn as nose ring); Dior ring.
Page 249: Bliss Lau body chain; Kenneth Jay Lane ring (worn as nose ring).

ACKNOWLEDGMENTS Special thanks to Mia Adorante, Billy Albores, Bryn Birgisdottir, Dana Brockman, Philippe Brutus, Carmen Carrera, Gracey Connelly, Ashley Consiglio, Elise Crombez, Emma Dalzell, Steven Dam, Rebecca Dennett, Jason Duzansky, Karen Elson, Linda Evangelista, John B. Fairchild, Stefan Forrester-Walker, Dennis Freedman, Felicia Garcia-Rivera, John Gayner, Ondria Hardin, Shalom Harlow, Will Higdon-Sudow, Gabriel Hill, Boyd Holbrook, Claudine Ingeneri, Jessica Joffe, Xiao Wen Ju, Anne Kennedy, Harry Kinkead, Shaheen Knox, Hannelore Knuts, Yumi Lambert, Ginta Lapina, Irina Lazareanu, Rena Lazaros, Lucy Lee, Regina Limon Vega, Patrick McCarthy, Larry McCrudden, Kristen McMenamy, Chris McMillen, Kian Mitchem, Jimmy Moffat, Kona Mori, Kate Moss, S.I. Newhouse Jr., Kirsi Pyrhonen, Missy Rayder, Ruk Richards, RJ, Francine Schore, Anne-Gael Senic, Binki Shapiro, Adam Sherman, Gregory Spencer, Shea Spencer, Jessica Stam, Lara Stone, Tilda Swinton, Stella Tennant, Annemiek Ter Linden, Liza Thorn, Lia Trinka-Browner, Amber Valletta, Michael Van Horne, Natalia Vodianova, Lina Wahlgren, Lindsey Wixson, Anna Zantiotis.

Front and back covers:
Photographed by Steven Klein in 2012
for "Good Kate, Bad Kate"

For *W*

Editor in Chief: Stefano Tonchi
Managing Editor: Regan A. Solmo
Design Director: Johan Svensson
Photo Director: Caroline Wolff
Photo Research and Permissions: Biel Parklee
Assistant Managing Editor: Roseann Marulli Rodriguez
Copy Chief: Robin Aigner
Research Chief: Kristin Auble
Fashion Credits Editor: Natasha Clark

For Abrams, New York

Editor: Andrea Danese
Managing Editor: Emily Albarillo
Design Manager: Sebit Min
Production Manager: Anet Sirna-Bruder

Library of Congress Control Number: 2014932019

ISBN: 978-1-4197-1417-7

Printed and bound in China
10 9 8 7 6 5 4 3 2 1

Abrams books are available at special discounts when
purchased in quantity for premiums and promotions as well
as fundraising or educational use. Special editions can also
be created to specification. For details, contact specialsales@
abramsbooks.com or the address below.

115 West 18th Street
New York, NY 10011
www.abramsbooks.com